GOYA

Studio Vista London

XAVIER DE SALAS

GOYA

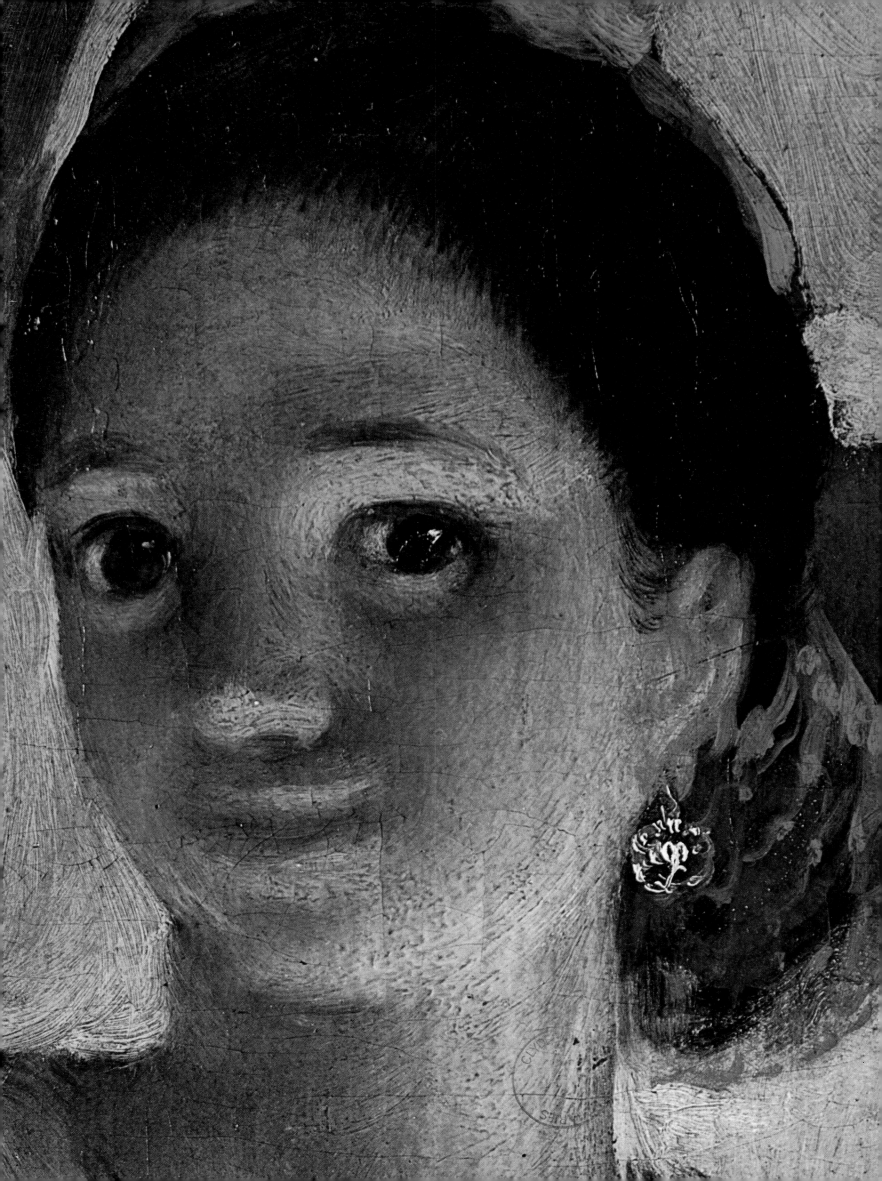

Overleaf
THE PARASOL
(detail)
Oil on canvas; 104 × 152 cm (41″ × 59⅞″)
1777
Madrid, Prado Museum (773)
(For full illustration see Pages 14-15)

GOYA

Text
XAVIER DE SALAS

Translation
G.T. CULVERWELL

A Studio Vista book published by Cassell Ltd.
35 Red Lion Square, London WC1R 4SG
and at Sydney, Auckland, Toronto, Johannesburg,
an affiliate of
Macmillan Publishing Co. Inc.,
New York

© 1978 Arnoldo Mondadori Editore S.p.A., Milan
1st Italian edition: October 1978
Libri Illustrati Mondadori

First English language publication 1979

ISBN 0 289 70887 7

Printed in Italy by Officine Grafiche di
Arnoldo Mondadori Editore, Verona

Contents

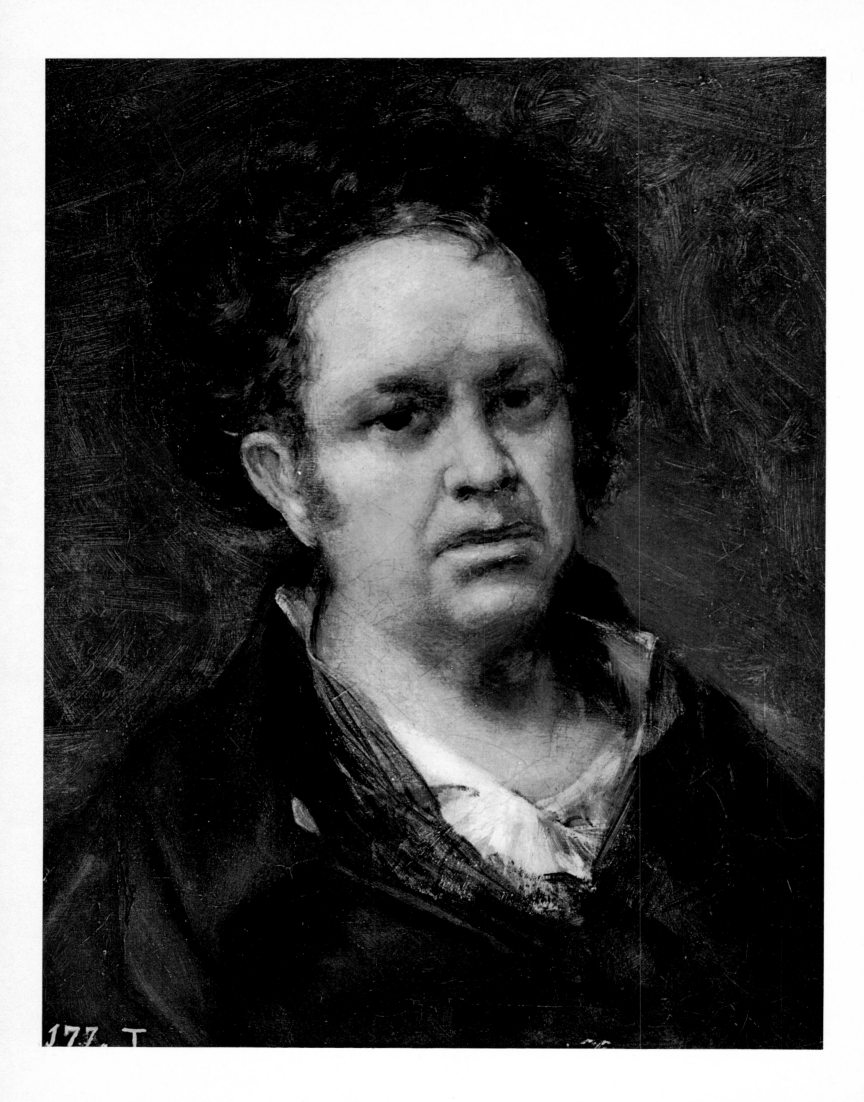

177 T

In 1747 a book was published in Madrid, in which the author, the lawyer
Don Joseph Francés de Castillo y Berenguer, a member of the Royal Assem-
bly of Magistrates, tried to evaluate 'the most memorable happenings in
Spain' between January and November 1746. In a suitably bombastic style
he dwelt on such events as the deaths of King Philip V and the Infanta María
Teresa, Dauphine of France, the proclamation of Ferdinand VI and the
latter's entry into Madrid, describing the processions, cavalcades, cere-
monies and festivities, the vast firework displays and illuminations, and
filling his account with quotations and all sorts of poetical interludes. Every
new saint's canonization and beatification, together with the festivals and
processions occasioned by such events, were described in minute detail, and
he also embarked on a eulogy of all the kings of Spain named Ferdinand,
and of the queens of Castile, the Infantas of Portugal, ancestors to Dona
Barbara, culminating in a lengthy treatise on the office of prince. It was a
strange volume, and nowadays it is quite rightly forgotten.
However, the one truly significant event that occurred in Spain in 1746 was
left unmentioned by the worthy member of the Royal Assembly of Magis-
trates. This is hardly surprising: nobody can be expected to be blessed with
second sight, and a person would have had to be possessed of such a gift to
realize that a genius had been born in a small forgotten village in Aragon to
parents who were of no consequence in contemporary society. The child's
father earned an honest living as a gilder, and his family was one of the
countless ones that live and die without ever making any mark on the
world.
But such a mark was made, when on March 30 1746, in Fuendetodos, not
far from Saragossa, Franciso de Goya y Lucientes was born, the son of José
Goya and Gracia Lucientes. The reasons why he was born in this forgotten
Aragonese village can, incidentally, only be guessed at; we shall never know
the true circumstances of his birth. It would seem that his mother's family
was originally from the village, or had some sort of connection with it, in
view of the fact that she herself was also born there. On the painter's bap-
tismal certificate his parents stated that they were 'natives of Saragossa',
thereby emphasizing that they were not from the village itself. It is pure
conjecture, as so often with Goya's early background, to suggest that his
father, having had no success as a gilder, had gone to work on the land for a
while. Goya's parents had been married in 1736 in San Miguel de los
Navarros, in the parish of Saragossa, and they lived in the Calle de la
Morería, situated in the parish of San Gil, the church in which the painter's
brothers and sisters had been or would be baptized: Rita in 1737, Jacinta in
1743, Mariano in 1750 and Carmilo in 1752.
His parents' lineage was, as we have already mentioned, undistinguished:
his mother belonged to a *hidalgo* family who must have had some money,

however little, because we know that Isabel Lucientes, Gracia's sister and the painter's aunt, brought her husband the sum of precisely 800 *Jaco* pounds as part of her marriage settlement. On his father's side, the artist belonged to a Basque family, one of whose branches (the one to which he himself belonged) had come down in the world: his grandfather, or possibly a great uncle, had been notary or public clerk, while his father, who was, as has already been mentioned, a gilder, died in 1781 unable to leave anything to his descendants. Other branches of the family, however, had prospered: one contemporary of the painter was José de Goya y Muniain, librarian to the king and auditor of the Nunciature, and several of these relations of the painter obtained recognition of their rights as an *hidalgo* family in the 18th century.

By making use of all the published documents, together with the unpublished facts assembled by the artist when he had triumphed at Court and was considering petitioning for the recognition of his *hidalgo* status, it can be established that he was descended from a Basque family, whose ancestral home was at Cerain, near Cegama. The branch to which Francisco de Goya y Lucientes belonged had moved to Saragossa from Fuentes de Jiloca; in any case they had been settled in Aragon for a number of generations. They clung to the fact that they were *hidalgos* and considered themselves to be better than their neighbours: it was this fact that led to the marriage of Goya's father, despite his being a manual labourer, to the daughter of an impoverished *hidalgo* family, a union that led to a life of poverty and mediocrity, whose fluctuations in fortune depended on the success of his work as a gilder.

We know little of Goya's childhood, but judging by his character in later life, the stories related by early biographers concerning his youth are most probably based on actual events, even though they have been somewhat romanticized. Throughout his life Goya showed periodic signs of violent impulsiveness, and it would come as no surprise to learn that as a child he threw stones and took part in street brawls with other children of his age. And yet there is no definite proof that he was forced to flee to Madrid as a result of one of these escapades.

We do know that he attended the Escuelas de Pías in Saragossa. In a letter to his friend Zapater he wrote, 'Sometimes you behave like you did in Father Joaquín's school'. Father Joaquín Ibanez de Jesus María was Master of the Congregation during the time in which Goya could have attended the school, and it is very possible that it is this man to whom he is referring.

TOBIAS AND THE ANGEL
Oil on canvas; cm 89 × 100 (35" × 39⅜")
Signed and dated: 'Goya 1762'
Granada, Private Collection

THE ADORATION OF THE NAME OF GOD
Fresco; c.7 × 15 m (c.274" × 585")
1772
Saragossa, Basílica del Pilar
The first preliminary sketches were commissioned in October 1771; the fresco was completed in June 1772

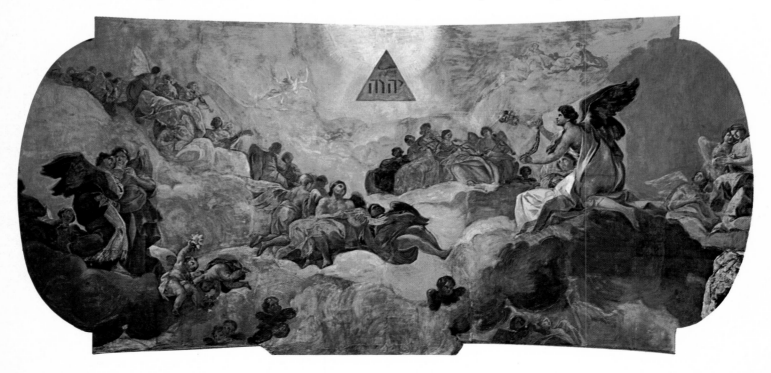

VENUS AND ADONIS
Oil on canvas; cm 23 × 12 (9″ × 4¾″)
Circa 1771
Signed: 'Goya'
Zürich, Private Collection

THE MARRIAGE OF THE VIRGIN
Oil on gesso; cm 306 × 790 (120½″ ×
311¼″)
1774
Saragossa, Monastery of Aula Dei

Pages 10-11:
THE PRESENTATION IN THE TEMPLE
(detail)
Oil on gesso; cm 306 × 520 (120½″ ×
204⅞″)
1774
Saragossa, Monastery of Aula Dei
This fresco, like 'The Betrothal of the
Virgin', forms part of the cycle of eleven
paintings dedicated to the life of Our
Lady.

We know that at the age of fourteen he entered the studio of José Luzán y Martínez, a mediocre painter and protégé of the noble Aragonese family of Pignatelli. Luzán had spent some time in Italy at the expense of this family, and on his return to Spain he set up a studio in Saragossa with a certain number of students, amongst whom was Goya. As an old man, Goya remembered his first teacher in an autobiography that he provided for the Prado Museum catalogue in 1828: 'He was a pupil of Don José Luzán in Saragossa, with whom he learned the principles of drawing and who made him copy the finest engravings that he possessed; he stayed with him for four years and his painting continued to be influenced by him until he went to Rome'.

Goya's formative years coincided with a movement by a group of illustrious Aragonese patrons of the arts, to provide formal artistic instruction in Saragossa. The private drawing academies, of which Luzán's was the most outstanding, sought to strengthen interest in the arts by establishing an Academy in which teachers and enthusiasts could meet and where officially recognized art classes could also be held. Their efforts were not to bear fruit until several years later, when Goya had already experienced his first triumph in Madrid. The 'Real Academia de Nobles Artes de San Luis' ('The Royal Academy of Noble Arts of St. Louis') was created by Royal decree in 1792. But the artistic involvement and patronage of different members of the great noble families, such as the Pignatellis, the Rodas, the Azaras and of rich businessmen like Goicoechea and Goya's close friend,

Zapater, meant that there was a great upsurge of interest in the arts such as had not been seen in Aragon since the 16th century.

Older than Goya, but also a follower of Luzán, Francisco Bayeu had gone to Madrid to work with the painter Antonio González Velázquez, and was making great progress in the capital. A number of famous foreign artists had arrived in the city to decorate the Royal Palace, which had only recently been completed. Besides Corrado Giaquinto, the two best known painters of the day were in Madrid: Anton Raphael Mengs, the foremost exponent of European Neoclassicism, who had arrived in 1761, and the last great Venetian painter, Giambattista Tiepolo, who reached the city a few months later accompanied by his two sons Giandomenico and Lorenzo. Tiepolo died in Madrid in 1770, after having completed the great Throne Room fresco in the Royal Palace, a work which marked the culmination of his career. Despite ill health, Mengs, who was a much younger man, had a great influence on the artistic undertakings of the Spanish Crown, as well as those of the Royal Academy of San Fernando, even though he frequently disagreed with its members.

Among the young painters influenced by Mengs was Francisco Bayeu, who worked at Court under him at a time when he was sole arbiter of artistic taste there. It is possible that Goya left for Madrid for no other reason than that

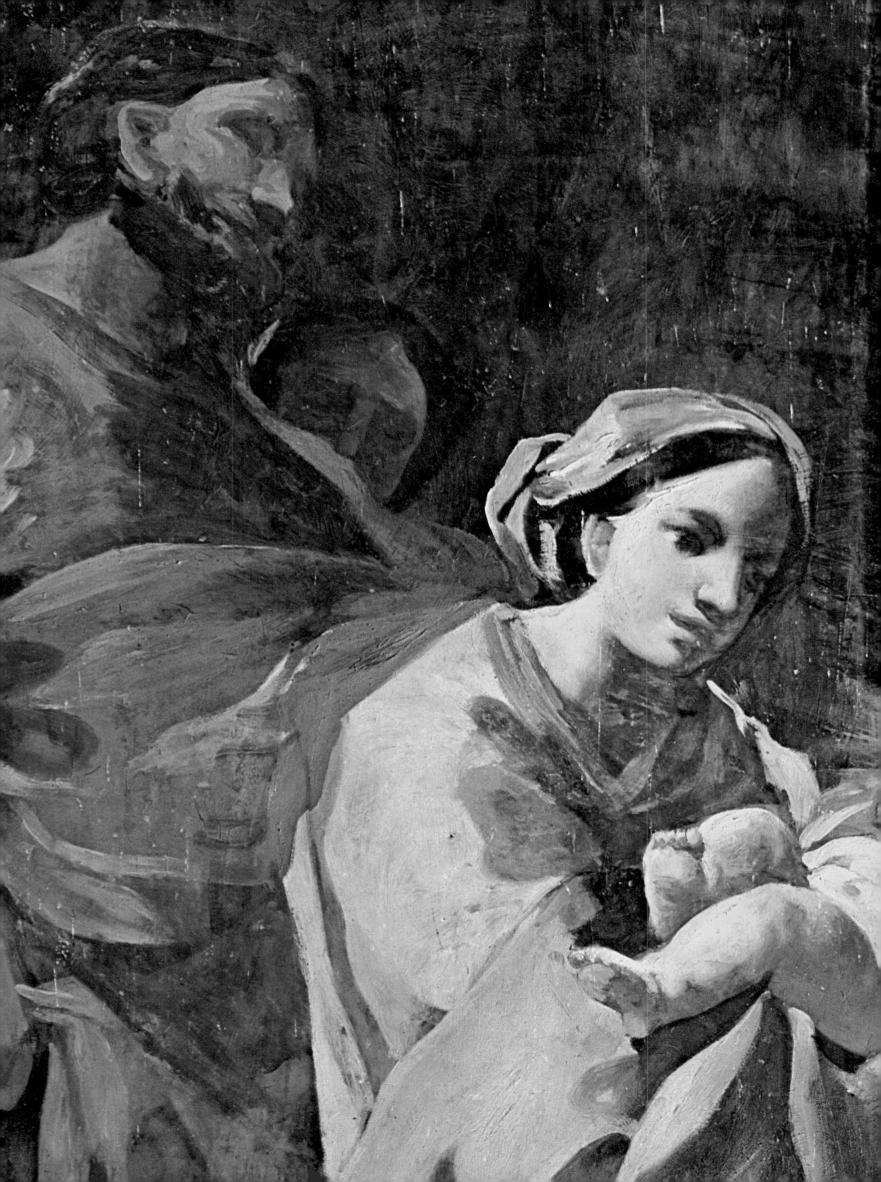

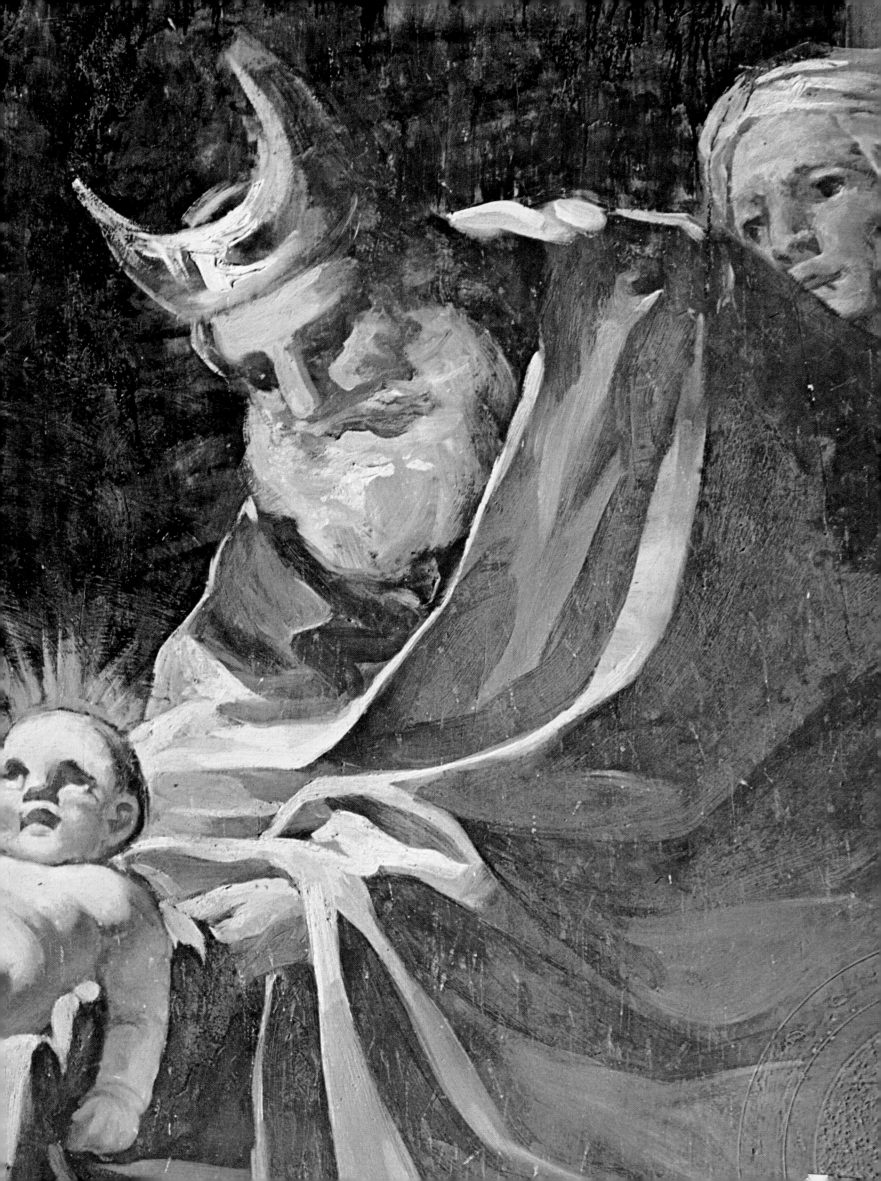

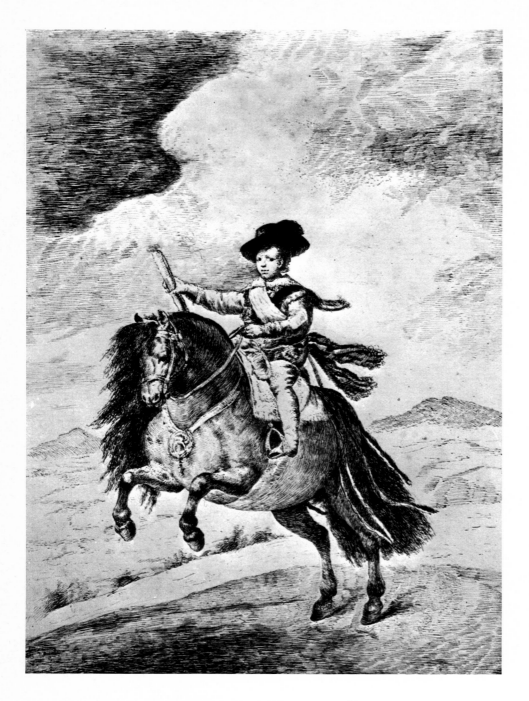

PRINCE BALTASAR CARLOS ON HORSEBACK
Etching; cm 35 × 23 (13¾″ × 9″)
1778
Madrid, Real Academia de San Fernando
Together with the succeeding illustration, this is one of the thirteen etchings that Goya did of Velázquez' paintings. The preparatory drawings of six of them have survived.

he wanted to establish himself as a promising young painter. However, his first two entries in competitions for the Spanish Royal Academy — the first in 1763, at the age of 17, and then again in 1766 — were disastrous. Ramón Bayeu had succeeded in being accepted by the Academy, no doubt as a result of his brother's sponsorship, as had Luis Paret, the most delicate of Goya's artistic contemporaries, whose taste and painting technique were heavily influenced by the French. Goya was twenty years old when he suffered his second failure. Shortly afterwards he set out on a journey to Italy, which he later maintained that he had undertaken at his own expense. Romantic legend has it that he crossed the peninsula in the company of a group of bullfighters! It has also been suggested that he embarked on his journey on the advice of Francisco Bayeu: this is perfectly feasible. Perhaps he was seeking the support of the Aragonese Don José Nicolás de Azara, a great lover of the arts and of Antiquity, and also a friend of Winckelmann, Mengs and Cardinal de Bernis, who had settled in Rome, first as *Agente de Preces* and later as Ambassador. Undoubtedly he had a dual motive in making this trip: Rome has always attracted artists, because it is the city that has preserved the largest number of Classical works of art, as well as a great number of very important works from the Renaissance, and at the time it

was an undisputed centre of the arts, to which artists flocked from all over the world, many of them spending several years there. It is hardly surprising, therefore, that Goya should have wanted to visit Rome, in order to make a career for himself there and so ensure his future success in Madrid, where hitherto he had been rejected. It is also possible that his friendship with Mengs started in Italy as a result of the good offices of Azara, who would have helped a fellow Aragonese. This relationship was a very fruitful one for Goya, since it resulted in his being given a post in the Royal tapestry works, under whose tutelage he developed his artistic style. It should be remembered that Goya started work in the factory only a few months after Mengs returned to Spain in 1775, following his second trip.

As it turned out, Goya enjoyed his first success in Italy: in the open competition run by the Academy of Parma in 1771. Although he failed to carry off the prize, he was commended for the quality of his work (which has since been lost). The jury widely praised this work, based on a verse by Vergil, saying that it excelled in its 'deft brushwork, the warmth of expression in Hannibal's face and the imposing character reflected in his bearing', even though they had reservations about its composition and its colouring. In the records of the Academy Goya is described as a follower of Francisco Bayeu. There are still in existence a number of small compositions by Goya

DON DIEGO DE ACEDO ('El Primo')
Etching; cm 22 × 16 (8⅝″ × 6⅜″)
1778
Madrid, Real Academia de San Fernando
There is a preparatory drawing of this work in the Victoria and Albert Museum, London.

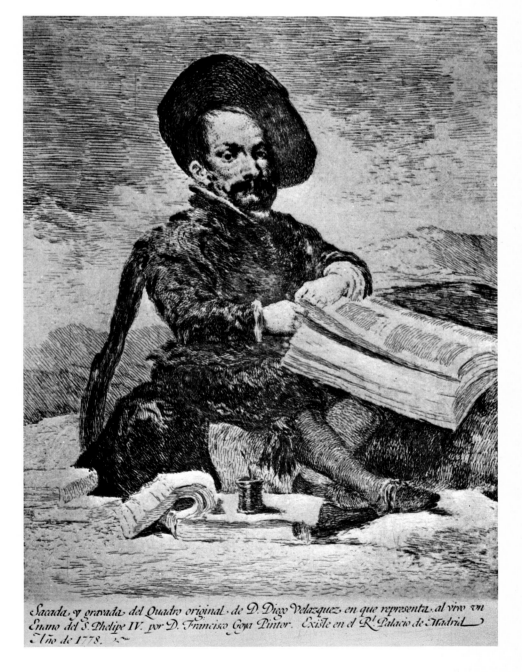

Sacada, y gravada del Quadro original, de D. Diego Velazquez, en que representa, al vivo vn Enano del S. Phelipe IV. por D. Francisco Goya Pintor. Existe en el R.l Palacio de Madrid. Año de 1778.

from that same year: paintings of themes from antiquity, executed in the contemporary Roman style. Goya's stay in Italy, however, was a brief one, and at the end of June 1771 he returned to Saragossa, summoned by his friends to take part in the decoration of the Basílica del Pilar.

In October the council in charge of the project asked him to provide preparatory sketches for the decoration of the chancel vault, which were to be subject to approval by the Real Academia de S. Fernando, and also to provide proof of his abilities as a fresco painter. Without waiting for the verdict of the Academy, the council granted Goya the commission as soon as they had seen the drawings that he submitted. On 1 June 1772 he had already completed *The Adoration of the Name of God* (page 8), a work whose importance lies in the way that it reveals the essential characteristics of Goya's art, which were to be confirmed in later works. It has a beautiful use of colour and a great freeness of composition; the most obvious influence is that of Corrado Giaquinto.

THE PARASOL
Oil on canvas; cm 104 × 152 (41″ × 59⅞″)
1777
Madrid, Prado Museum (773)
See detail on pages 2-3

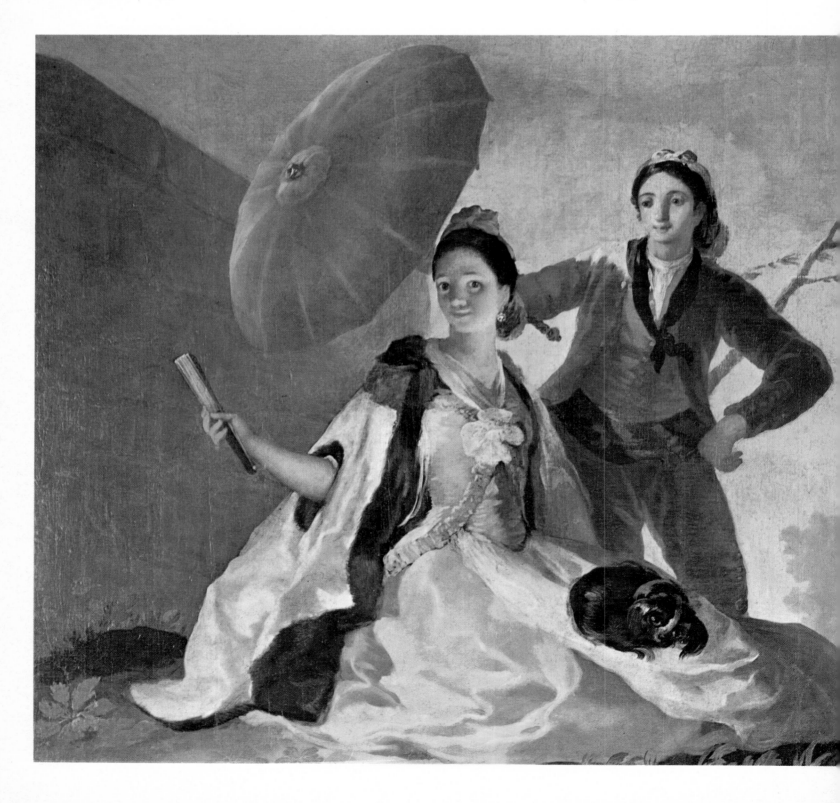

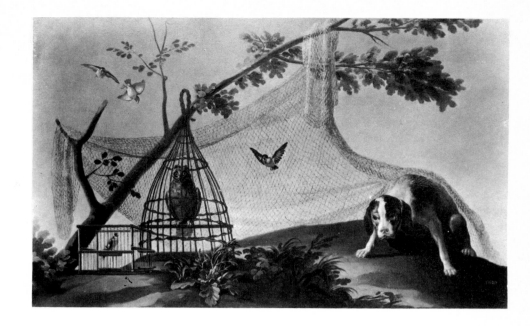

SHOOTING SCENE WITH DECOY
AND NET
Oil on canvas; cm 112 × 176 (44⅛″ ×
69⅜″)
1775
Madrid, Prado Museum (2856),
on loan to the Ministry of Finance

In Madrid, little more than a year later — on July 25 1773 — Goya married
Josefa Bayeu, the sister of three painters: Francisco, whose follower Goya
had declared himself to be, Ramón, and a third artist: the Carthusian monk
Manuel Bayeu. The latter was a fairly prolific painter, who painted a variety
of different subjects, but always quickly and in a rather haphazard way. Un-
doubtedly a study of his work would reveal several surprises, as it would lead
to his being credited with a number of religious works now attributed to
Goya. There is little we can say about Josefa, or 'Pepa' as she was known in
family letters; she presented her husband with a number of children, of
whom only Francisco Xavier survived. We also know that she took her hus-
band's side in the family quarrels that were to break out later and which we
shall deal with when the time comes, but she only appears in two portraits
out of all her husband's vast artistic output. One, from 1805, shows her in
later life, fattened and coarsened by the years, while the other, in the Prado
(page 74), has had its authenticity questioned by a number of people, but
on unconvincing grounds, since the painting had been handed down in the
artist's family, to judge by the identity of the person who sold it to the
State. This portrait is a rather characterless painting of a demure, fair
skinned woman, modestly dressed, who bears a definite physical resem-
blance to Francisco, her elder brother, but shows no signs of the latter's
sullenness.
The cycle of frescoes in the Carthusian Monastery of Aula Dei near Sara-
gossa appear to date from 1774, to judge by the accounts kept in the monas-
tery. From an artistic point of view, they differ somewhat from those he had
done in the Basílica del Pilar some years earlier. In the monumental quality
of the composition, however, and in the sureness of their execution they
show great progress (pages 9, 10-11).
 Towards the end of the same year Goya began to do cartoons for tapestries
to be woven in the Royal Santa Bárbara factory. Many years later, when he
had settled in Bordeaux, Goya wrote in a letter to the Spanish Crown, in
which he was petitioning for a pension as chief *pintor de cámara* or court
painter, that one of the reasons why he was pursuing his request was that he
had served the King's parents and grandfather 'after Mengs summoned me
from Rome'. Although it seems, as has already been said, that Goya arrived
in Madrid in 1773, since that was the year of his marriage, and since, as we
shall see later, his first cartoons were received by the factory in 1775, Mengs
may have been the person who intervened in order to obtain this work for
him. Mengs' influence at Court, particularly in the field of art, makes this a
possibility. All this despite the fact that Goya had become the most impor-
tant local painter in Saragossa; Gudiol tells us how in 1775 he paid his home
town the sum of 400 *reales* in tax during the preceding year, which made
him the greatest contributor amongst the painters. In 1772 he only paid

300 (his quota for the year 1771, part of which he spent in Italy) while Luzán and Mercklein paid 400 and 450 respectively in 1773 and 1774, their contributions diminishing at the same time as Goya's were increasing. In any case, his entry into the Royal tapestry factory marked a new era in his artistic production.

Up until this time, the works that we know are his for sure, or which can be justifiably attributed to him, can be narrowed down to a few religious paintings, most of them small in size; they are poorly executed, with *Tobias and the Angel* (page 8), a signed work from 1762, being the first one that we are able to date with certainty. There then follows the group in the chapel of the Sobradiel Palace, which were murals done in oils, some of whose compositions were based on engravings by Vouet and Carlo Maratta, and also the small paintings of mythological scenes, dating from 1771, which have already been mentioned, together with other similar ones. There are also one or two portraits — of which a self-portrait is the most prominent — but serious doubts have been cast on other works attributed to

THE BLIND MAN WITH THE GUITAR
Etching; cm 260 × 331 (102½″ × 122½″)
1778
Signed 'Goya', bottom left
New York, Metropolitan Museum of Art, Schiff Fund, 1922 (22.63.29) ·
This is Goya's largest etching, and the only one that relates directly to a painting by him. He completed it after having been obliged, at the request of the commissioners, to reduce the size of his tapestry cartoon of the same name (see opposite). It was the artist's way of keeping for himself a likeness of his original cartoon composition.

him from this period. Besides all the preceding works, Goya was also responsible for the rather clumsy paintings on the pendentives of the churches of Muel and Remolinos, which are heavily influenced by late Italian Baroque art. Along with these are the often cited, documented frescoes in the chancel of Saragossa's Basílica del Pilar, in which, as we have already mentioned, the most obvious influence is that of Corrado Giaquinto, but without the latter's pale colours. Next came the series of paintings in the Aula Dei, which show a familiarity with works of the Neapolitan School, but with the gravity and cold monumentality of Mengs' Neoclassicism. If people think that there is a certain 'sketchiness' evident in the chancel paintings — a predominance of mass over line — in the paintings of the Aula Dei, by contrast, the figures achieve an undeniable monumentality

THE BULLFIGHT
Oil on canvas; cm 259 × 136 (102″ × 53½″)
1780
Madrid, Prado Museum (787)
The figure of the young man turning towards us is traditionally held to be a self-portrait.

THE BLIND MAN WITH THE GUITAR
Oil on canvas; cm 260 × 311 (102½″ × 122½″)
1778
Madrid, Prado Museum (778)
This was the only cartoon to be engraved, albeit with variations.

thanks to Goya's deft draughtsmanship. The composition has a strong schematic quality in the grouping of the figures, in their shapes and also in their clothes.

Leaving the other works to one side, these two groups of paintings show us a young artist, like any other on the threshold of his career, undecided and wavering between two distinct techniques, both of which were trying to assert themselves. At the same time they show what great progress he was making with commissioned works, the majority of which involved religious themes, an artistic inevitability in Spain, a country where the Church and the religious orders were the main patrons and therefore the best clients for Spanish artists.

His arrival in Madrid and his work in the Royal factory opened up new horizons for Goya: it gave him the opportunity to paint subjects different from those he had hitherto been used to, as well as giving him constant access to examples of works by the world's greatest artists. Although he continued to accept and execute religious commissions for churches and

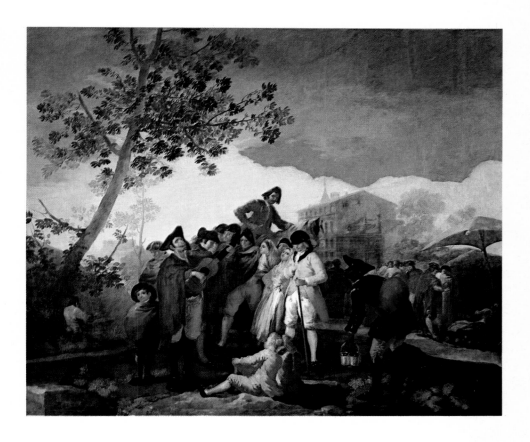

convents during the following years, the fact that scenes from everyday life were an integral part of this preparatory or cartoon work led him to depict the world about him in his other paintings. Goya, a man with a great love of life, a man who thrived on friendships and who was deeply interested in other people, found, in his work at the factory, something that suited both his genius and his personality.

But that was not all. Besides contemplating and studying works by artists of the highest calibre, in Madrid he came into contact, not only with Mengs, but also with the Tiepolos; we know for sure that he was acquainted with Domenico. He saw the works of the French court painters who were working in Madrid, as well as those of other artists, and also got to know the Spanish academicians of the day: Calleja, for example, and the González Velázquezes, all of whom he must have seen at work. There was something else of great importance, which Sánchez Cantón wrote about so graphically: his discovery of Velázquez. Proof of his having studied that artist's paintings in the Spanish Royal Collection are the engravings that he did of a number of

them. We do not know who it was that introduced him to the techniques of etching; it is my personal belief that the Tiepolos may well have been responsible. Even though his vast output of engravings began with some rather amateurish work, it could be said that Goya as an engraver developed from these copies of Velázquez (pages 12, 13).

The first plates that he did of Velázquez work in the Royal Collection appeared on the market in 1778 — directly after a spell of illness, it seems. In letters written by his brother-in-law Ramón Bayeu to Martín Zapater, dated the 15th August of that year, mention is made of the series sent to Saragossa to friends there. Even though these early works show a beginner's lack of finesse and sophistication, his technique soon became more assured in copies which, rather than being mere reproductions of the original, could be described as 'interpretations'. Finally, in Madrid he found patrons who commissioned him to do portraits, thereby initiating one of the most vital facets of his artistic production. As a portrait painter he very soon learned how to convey the features and personality of his sitters, achieving this in a unique way, as we shall see later.

But, before dealing with these, we should perhaps provide more information about the Royal tapestry works, in order to gain a better understanding of what exactly Goya was involved in. Following Spain's loss of Flanders by the Treaty of Utrecht (1713), the country found itself without its usual

THE MAJA AND THE MEN IN CLOAKS
Oil on canvas; cm 275 × 190 (108⅜" × 74⅞")
1777
Madrid, Prado Museum (771)

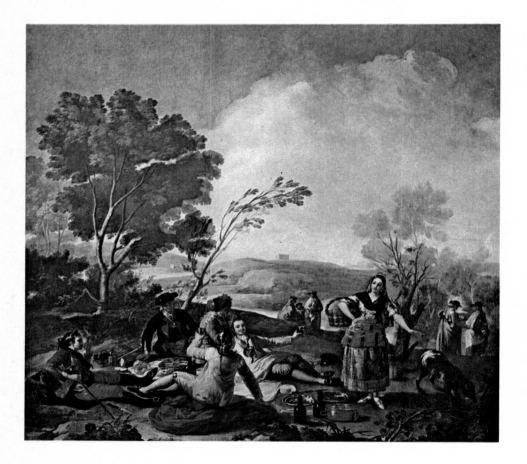

THE PICNIC
Oil on canvas; cm 272 × 295 (107⅛" × 116¼")
1776
Madrid, Prado Museum (768)
This forms part of the series of ten cartoons for the dining room of the Pardo Palace, delivered between 1776 and 1778, in which, for the first time, there appear the popular themes of *majos* and *majas*.

supply of tapestry from those provinces. Philip V, the first Bourbon king, who was used to Gobelin tapestries, had the idea of encouraging the weaving of tapestries in Spain, and on the advice of Cardinal Alberoni (whose hatred of the French is well known) in 1720 he brought to Madrid the most famous Flemish tapestry maker of the day, Jacob Van der Gotten, who came from a long line of tapestry makers. The works were set up between 1720 and 1727, the year of Jacob's death, on a site adjoining the Puerta de Santa Bárbara, from which they took their name. It used looms with a low warp and produced mainly reproductions of Flemish paintings. From 1727 it was managed by Jacob's son, Francis Van der Gotten, who,

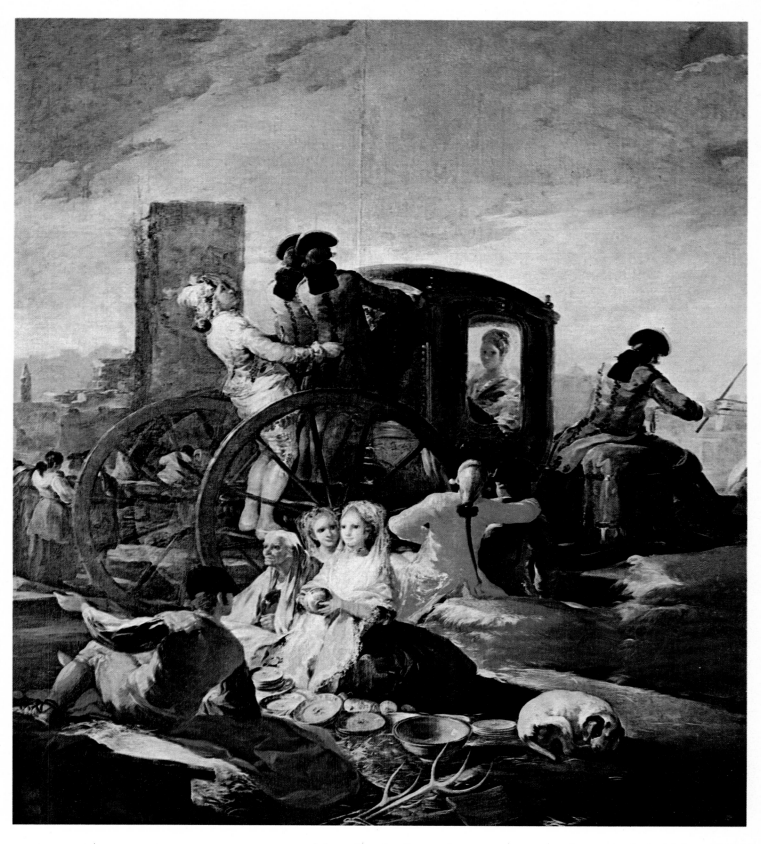

THE CROCKERY VENDOR
Oil on canvas; cm 259 × 220 (102″ × 86⅝″)
1779
Madrid, Prado Museum (780)
See pages 20-21 for detail

recognizing that the factory's output was not of a particularly high quality, brought in Antoine Lainger from Paris to weave in the high warp technique, establishing another works in the Calle de Santa Isabel run by his younger brother Jacob. In 1744, because of the high cost of maintaining two factories, a single one was founded under the name of Santa Bárbara, on the understanding that the Van der Gottens would provide the materials and that the King would supply the drawings or the artists to produce models to the correct scale.

From 1750 on, under Ferdinand VI, tapestries that hitherto had hung in folds were now stretched out on the walls like paintings, sometimes even

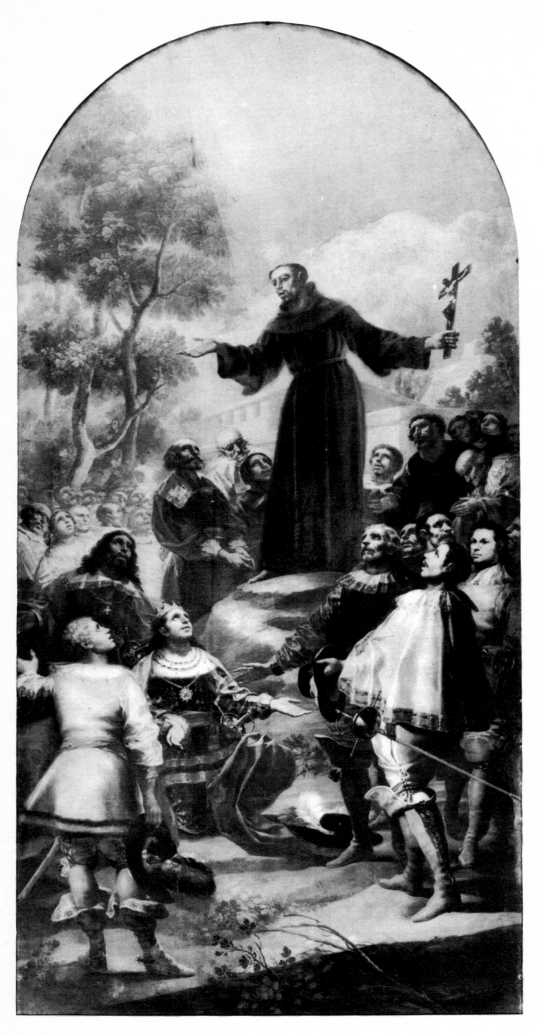

ST. BERNARDINO OF SIENA
Oil on canvas; cm 480 × 300 (189⅛″ ×
118¼″)
1782-1783
Madrid, Church of San Francisco el
Grande
There are three preparatory sketches of
this work still in existence, in private
Spanish collections.

REGINA MARTYRUM
Preparatory sketch
Oil on canvas; cm 85 × 165 (33½″ × 65″)
1780
Saragossa, Diocesan Museum

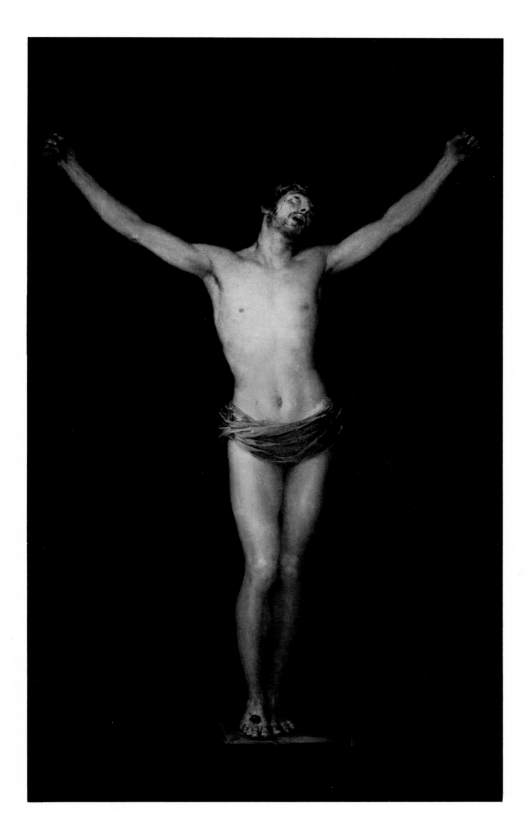

CRUCIFIXION
Oil on canvas; cm 255 × 154 (100½″ × 60⅝″)
1780
Madrid, Prado Museum (745)
It was thanks to this work that Goya was elected to membership of the Royal Academy of San Fernando in Madrid, on 5 July 1780.

surrounded by a moulding made to look like a frame. Subsequently the artistic direction was entrusted to the Italians Procaccini and Corrado Giaquinto; the subjects continued to be Flemish or were based on new works by Italian or French painters. The advent of Charles III to the throne led to Anton Raphael Mengs being placed in charge of the Royal Santa Bárbara factory in 1762. He replaced the usual foreign subjects with scenes from Spanish life, and it was during this period that Goya entered the works, starting his career there by providing cartoons showing scenes of life as he saw it around him each day.

Mention should be made of something that illustrates the lowly status that Goya enjoyed during those years. The receipt for the first five tapestry cartoons, which he delivered in 1775, is in the name of Francisco Bayeu,

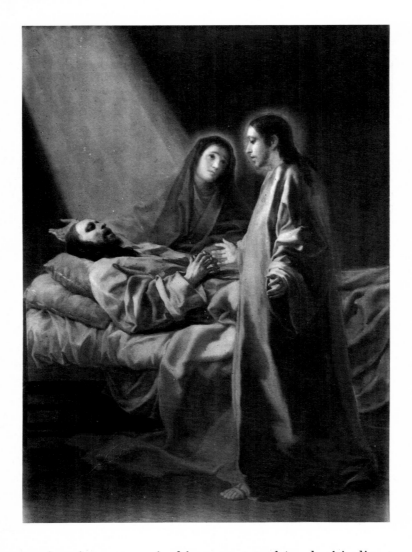

THE DEATH OF ST. JOSEPH
Oil on canvas; cm 220 × 160 (86⅝" × 63")
1787
Valladolid, Convent of Santa Ana

THE MIRACLE OF ST. BERNARD
Oil on canvas; cm 220 × 160 (86⅝" × 63")
1787
Valladolid, Convent of Santa Ana

ST. LUTGARDE
Oil on canvas; cm 220 × 160 (86⅝" × 63")
1787
Valladolid, Convent of Santa Ana
These three canvases form part of the decorations completed for the convent's Neoclassical church, designed by the architect Sabatini.

with the statement that the cartoons had been executed 'under his direction by Don Francisco Goya'. As Goya's first child was born in the Bayeus' house, we have to suppose that from the time of his arrival at Court — perhaps also before his trip to Italy — the artist was closely involved with Francisco Bayeu, working under him and living in his house. This would explain the remarks made in connection with the competition in Parma, as well as the position each adopted in later disagreements. Goya's work for the tapestry factory lasted for many years; to begin with he was extremely productive and completed a number of series, each of which was composed of a great many cartoons. Then, as his career progressed and he gained other commissions, he lost interest in the work and finally — in 1792 — he fell out with the management of the factory, who considered that he was not carrying out his job properly.

In 1775 he completed his series of nine tapestries for the 'Comedor de los

Principes' in the Palace of San Lorenzo in the Escorial, which are identical to the kind of work that Francisco Bayeu was doing. It is for this reason that for many years — until the receipt was published — they were attributed to either Francisco or his brother Ramón.

They show no traces of Goya's personality, apart from an expression of his love of hunting, a sport to which he was passionately attached, as can be seen in letters to his friend Martín Zapater, in which he repeatedly refers to it. He was even fonder of hunting than he was of bull-fighting, an interest that he shared with his brother-in-law Francisco, many of whose letters to the same Zapater reveal his passionate involvement in that sport, as well as his boundless enthusiasm for Costillares and his dislike of Romero. For those who are not well versed in the history of *Tauromaquia* — the art of

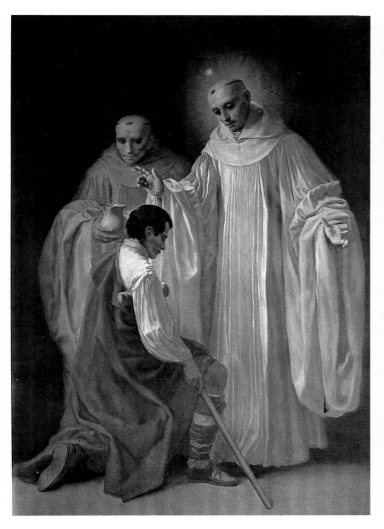

bull-fighting — it should be pointed out that during these years interest was centred on the exploits of these two *toreros*: Pedro Romero and Costillares, who, according to contemporary accounts, each had their own distinctive technique. It was at this time, following the decline in horseback bull-fighting, the domain of the nobility, that bull-fighting on foot, its popular form, took over. It was also during this period that the rules and etiquette of the art were laid down, when the ritual of the bull-ring that is still practised today was established. The *toreros* still dress in the style of the closing years of the 18th century, as do the *picadores*.

The second series of cartoons, completed between 1776 and 1778, consisted of ten scenes destined to decorate the walls of the 'Comedor de los Príncipes' in the Pardo Palace, showing popular customs. In these we can see, for the first time in Goya's work, a representation of the *majo* and *maja* in their characteristic costumes, often used by Madrid society as a disguise

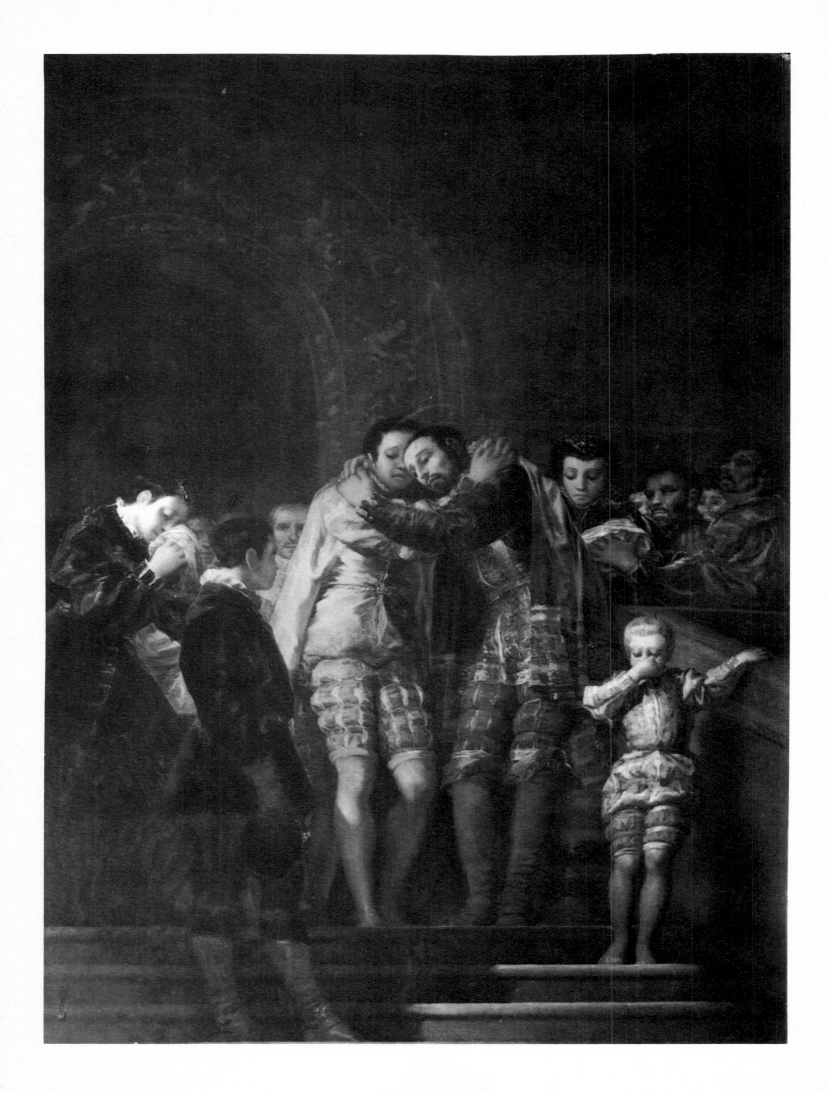

ST. FRANCIS BORGIA BIDDING FAREWELL TO HIS FAMILY
Oil on canvas; cm 350 × 300 (138″ × 118¼″)
1788
Valencia Cathedral

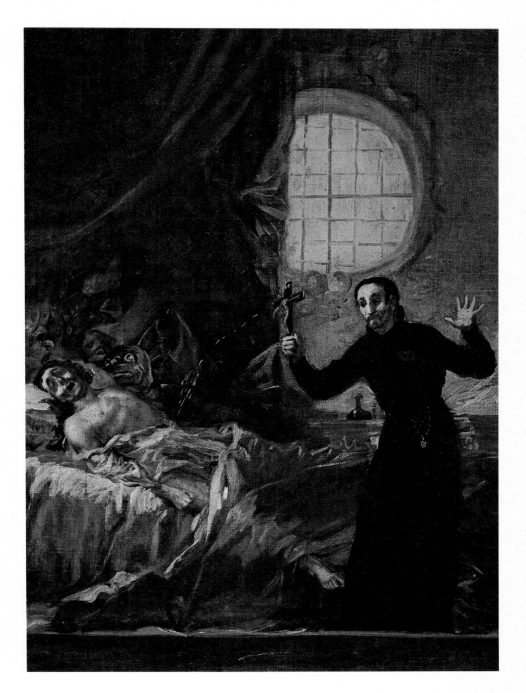

ST. FRANCIS BORGIA AND THE DYING IMPENITENT
Preparatory sketch
Oil on canvas; cm 37 × 26 (14⅝″ × 10¼″)
1788
Madrid, Collection of the Marqués de Santa Cruz
The final version was commissioned by the Duke and Duchess of Osuna for the Chapel of St. Francis Borgia in Valencia Cathedral.

ST. FRANCIS BORGIA AND THE DYING IMPENITENT
Oil on canvas; cm 350 × 300 (138″ × 118¼″)
1788
Valencia Cathedral

when attending popular entertainments. He contrasts them with the dandies, dressed in the French fashion, thereby underlining his nationalistic reaction to foreign fashions and manners. If Goya was able to interpret them in his painting, making them the central figures of his compositions, other artists collaborating with him on different series of tapestries for the Royal factory did likewise, depicting scenes with themes similar to those painted by Goya: men such as the brothers Francisco and Ramón Bayeu, Aguirre, José del Castillo, and others.

As has often been remarked, in literature we can also find a parallel movement in the comedies of Don Ramón de la Cruz, whose characters entertain us both by the situations in which they find themselves and also by the dialogue that they exchange, reflecting, as they do, the personality of the people of Madrid and the lives that they led in those days.

These series of tapestries by Goya not only show *majos* and *majas*: some of them also depict children's games, a theme that the artist was very fond of through his life. He portrays them with a great deal of affection and, at the same time, with a deep understanding of shape and movement.

In the 1776-1778 series the most outstanding work was *The Parasol* (pages 14-15), a most beautiful painted over-door, and the two great compositions

27

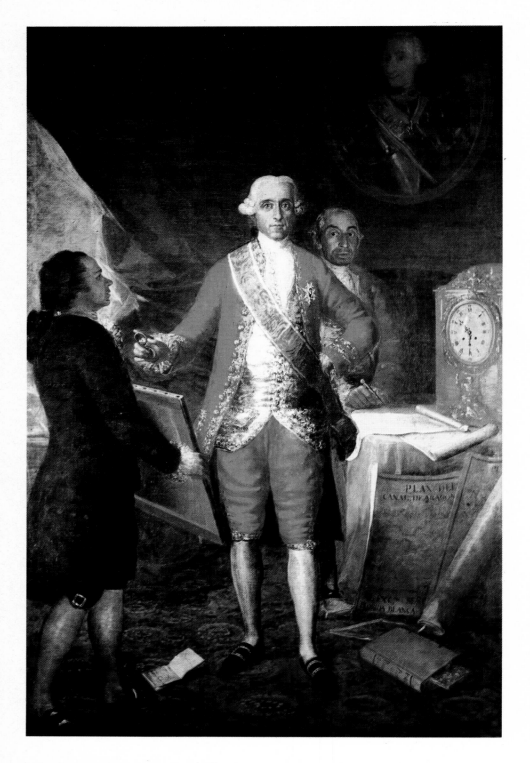

The Picnic (page 18) and *The Dance on the Banks of the Manzanares*. Special mention should also be made of the cartoon designed for the tapestry to hang in the 'Antedormitorio de los Príncipes', which was delivered in April 1778: *The Blind Man with the Guitar* (page 17). Contemporary documents tell us a great deal about this work, which was, apparently, based on a scene witnessed by Goya in the Plaza de la Cebada in Madrid. In October the cartoon was sent back to him by the management of the factory, so that corrections could be made to its size: we have no way of knowing if this was due to a mistake by the painter or by the people who had commissioned it from him. Perhaps it was decided to hang it in a different place from that originally intended, but, whatever the reason, Goya was obliged to reduce its size by radically altering both sides of the original composition to fit its new dimensions. The most significant point of the affair is that Goya, at that time involved in doing engravings of Velázquez' works, did an engraving of the original cartoon, which proves that it was reduced and its compo-

sition substantially altered by the disappearance of an ox-driver and his team on the left and a group of people in the far distance in the right, whose place has been taken by trees and some rather ill-defined buildings. The original shape was that of a pyramid, its main outlines heavily emphasized: in that respect it followed a type of composition much loved by Neoclassicists, even though its subject matter had little to do with Neoclassicism. Goya's action in making an engraving of one of his cartoons is unique, and it shows his desire to perpetuate its memory, very possibly in order to show that his first version was much better than the one he was ultimately obliged

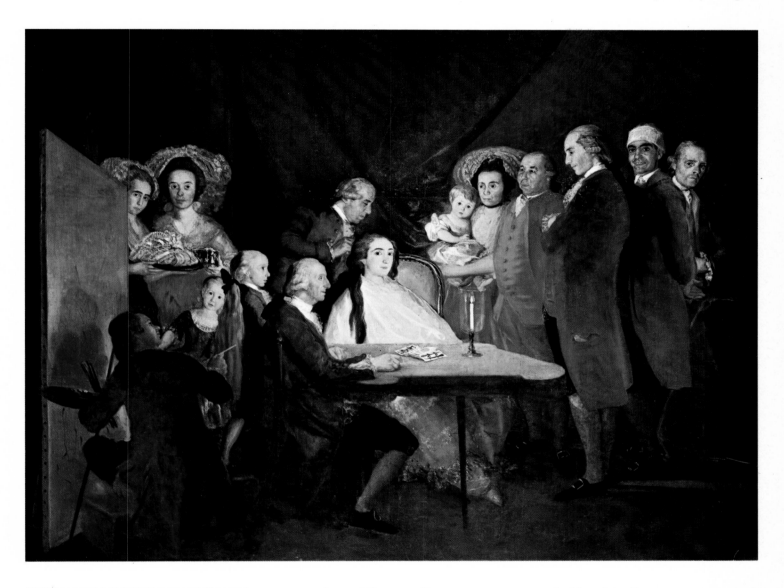

THE FAMILY OF THE INFANTE DON LUIS
Oil on canvas; cm 248 × 330 (97¾″ × 130″)
Italy, Private Collection
Completed during the artist's stay at Arenas de San Pedro; in the foreground, bottom left, is Goya's self-portrait.
Pages 30-31: Detail

to produce. His compliance was accompanied by this silent protest — and quite possibly by other more vociferous, verbal ones that we will never know about.

This group of tapestries must have pleased the Royal Family, since he was immediately commissioned to do another, larger series for the bedchamber and antechamber in the Pardo Palace, which involved twenty cartoons. The first ones were completed in January 1779, while the last ones were finished a few days after the end of the year, in January 1780. They vary greatly in both their dimensions and their subject matter, with *The Game of Bat and Ball* dominating the others by its sheer size. Other outstanding ones in this series are the beautiful portrayal of *The Crockery Vendor* (page 19), the one showing small boys at play and another of a *Bullfight* (page 17), in which the artist has portrayed himself making a pass with the cape, proof that his enthusiasm for the sport led him to fight bulls himself on occasion. There are no reports of him having fought bulls in public, but he did what *aficio-*

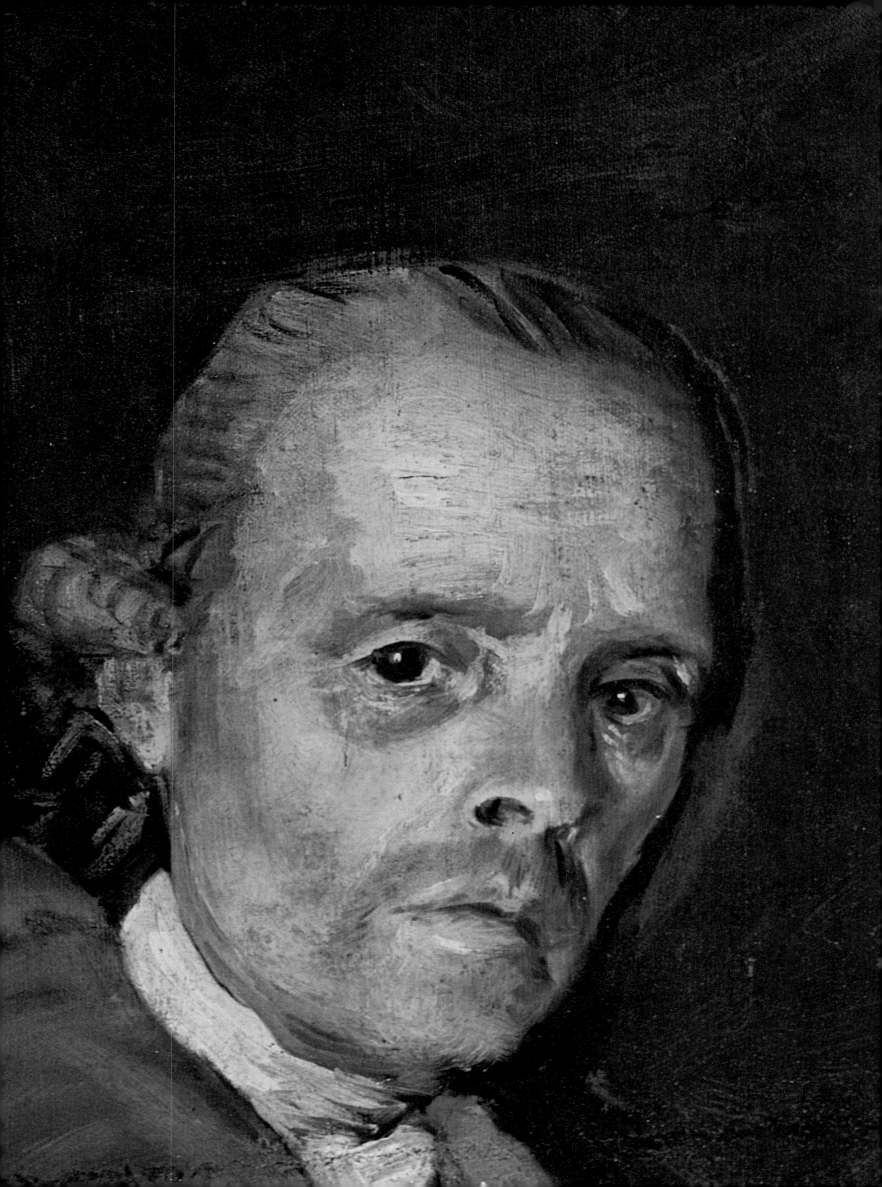

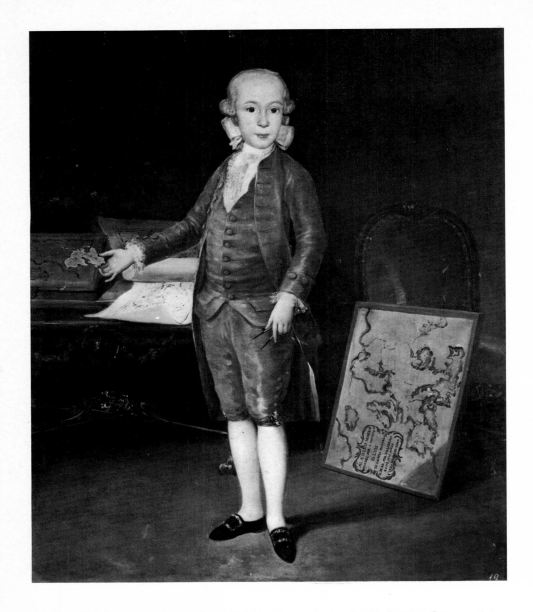

nados still do nowadays when they try out young bulls in the farms where they are reared. This confirms what Moratín wrote in a letter in 1825, when he reminisced about Goya in what is, in fact, a very good character portrait of him. He wrote that the artist had told him 'that he has fought bulls in his day and that with the sword in his hand he fears nobody. In two months time he will be eighty years old...' Four of these cartoons were presented personally by the painter to the King and the Royal Family, as he proudly told his friend Zapater in a letter dated 9 January 1779.

Meanwhile, the decoration of the Basílica del Pilar had been entrusted to Francisco Bayeu, in order to ensure an overall unity. In 1775 and 1776 Bayeu painted two vaults and four medallions, which gained the approval of the Cathedral Chapter. After his intercession two cupolas, together with their pendentives, were assigned to his brother Ramón for decoration, while Goya was given another cupola and its pendentives. The cartoons that he was executing for the Royal tapestry factory delayed until 1780 his starting on this commission. He had to provide, in the cupola, an evocation of the Rosary — *Regina Martyrum* — the Virgin as 'Queen of Martyrs' (page 23).

In fact, the rough sketches that Goya submitted pleased neither the factory nor — according to one document — the public. To understand what happened between the factory council, Francisco Bayeu and Goya, it should be borne in mind that it was Bayeu who was responsible for the whole project and for ensuring its overall harmony. At the same time we should remember Goya's character and also the fact that, having spent his early days in Francisco Bayeu's studios, under the latter's tutelage, he was now being recognized as a painter in his own right. It was, in fact, in the same year of 1780 that he was elected to the Royal Academy of San Fernando; in a letter

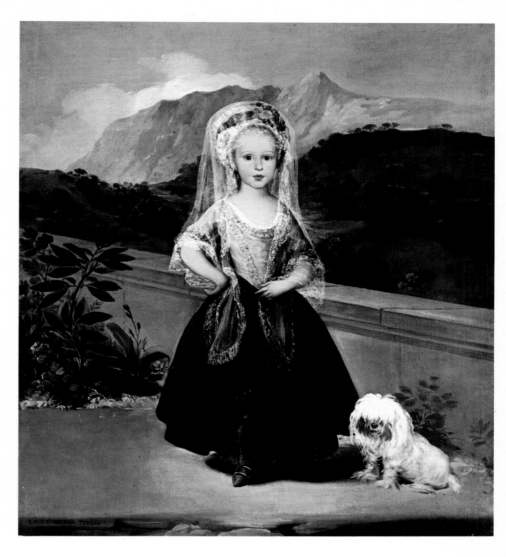

MARÍA TERESA DE BORBÓN
Oil on canvas; cm 132.3 × 116.7 (52⅛″ × 46″)
1783
Washington, Bruce Mellon Collection
There is an inscription, below left: 'LA S. MARIA TERESA / HIXA / DEL SER. INFANTE / D. LUIS / DE EDAD DE DOS AÑOS Y NUEVE MESES'. Years later, when María Teresa was Condesa de Chinchón and wife of Manuel Godoy, Príncipe de la Paz, Goya painted her portrait once more (page 91).
See pages 34-35 for detail.

to Zapater he wrote 'that I want to please myself and to hell with anyone who takes any notice of the affairs and fortunes of the Court and the world', a sentiment which, although expressed here in a different context, could well be regarded as a statement of his desire for independence. These two factors were the underlying causes of his refusal to allow Bayeu to correct his sketches, as the council had requested. On the one hand he no longer considered himself to be still a pupil of his brother-in-law, but his equal, while on the other hand he had a very independent spirit. And finally, we have already seen in the incident of the engraving which he made when he was forced to alter the composition of his cartoon how he believed in his own artistic worth. In May 1781 the council of the tapestry works finally rejected the sketches for the pendentives, fiercely criticizing the one of *Charity*. Goya organized a lengthy petition in defence of his project and his refusal to let his brother-in-law alter it, and proposed that his fellow painters of the Academy should act as arbitrators. The dispute was the cause of a family rift and it was to be many years before Goya would talk to his in-laws. But friends finally intervened, as is shown by the letter from Francisco Bayeu, written on 1 April 1795, when he was on the brink of death, in which he begged forgiveness of Martín Zapater and Martín de Goicoechea if he had offended them during his disagreement with his brother-in-law. We also know that Brother Félix Salcedo, the Carthusian Prior of Aula Dei, wrote to Goya begging him to give in as proof of his Christian feelings. In the end, everyone in Aragon who was concerned with the arts and interested in the great Basílica del Pilar — which is the same as saying the whole of Aragon — took sides in the affair. Even though Goya, a man with a ready genius and an equally ready temper, finally accepted the enforced amendments, he submitted with ill grace and always recalled the incident with bitterness.

If one compares the fresco of *The Queen of Martyrs* with the one in the chancel, completed a few years previously, it shows what great progress Goya had made in his art: the composition, without being particularly original or new in concept (since it remains faithful to the conventional pattern of Italian fresco artists — once more, particularly Corrado Giaquinto) is executed with greater freedom in the way that the groups are arranged and also shows a much richer and more vibrant use of colour. It cannot, therefore, be regarded as an artistically innovative work, even though the council of the factory, on seeing it for the first time, exclaimed that it was not 'finished'. We have no idea, however, what it was that the council objected to, as the rough sketch has not survived. But the work's 'unfinished' quality — its nervous and restless technique, similar to that of

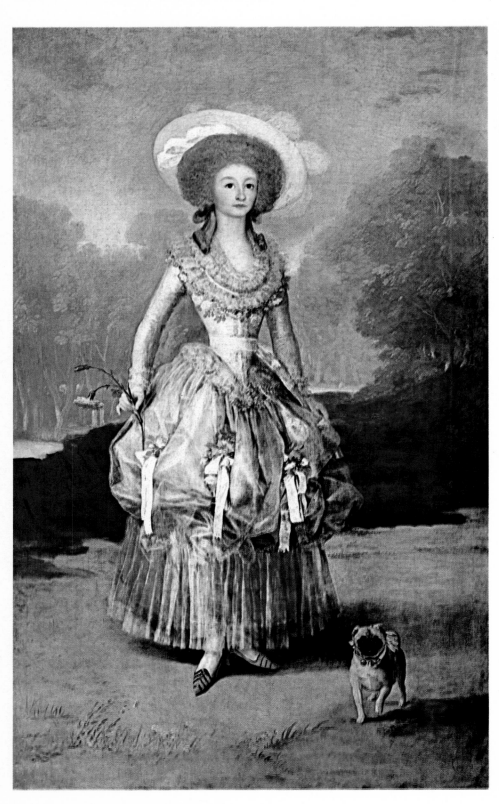

THE MARQUESA DE PONTEJOS
Oil on canvas; cm 211 × 126 (83⅛″ × 49⅝″)
Circa 1786
Washington, National Gallery (Mellon 85)
In 1786 she married a brother of the Prime Minister Floridablanca, Don Francisco Munino.

Facing:
THE CONDESA-DUQUESA DE BENAVENTE
Oil on canvas; cm 104 × 80 (41″ × 31½″)
1785
Madrid, Bartolomé March Collection
See pages 38-39 for detail.

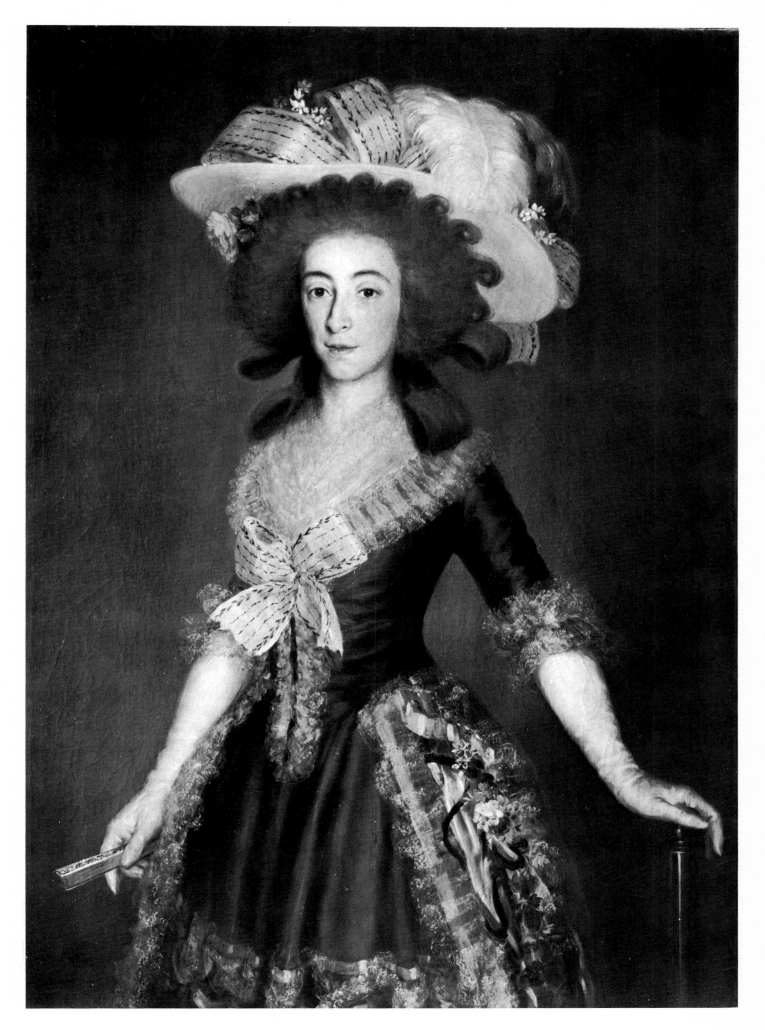

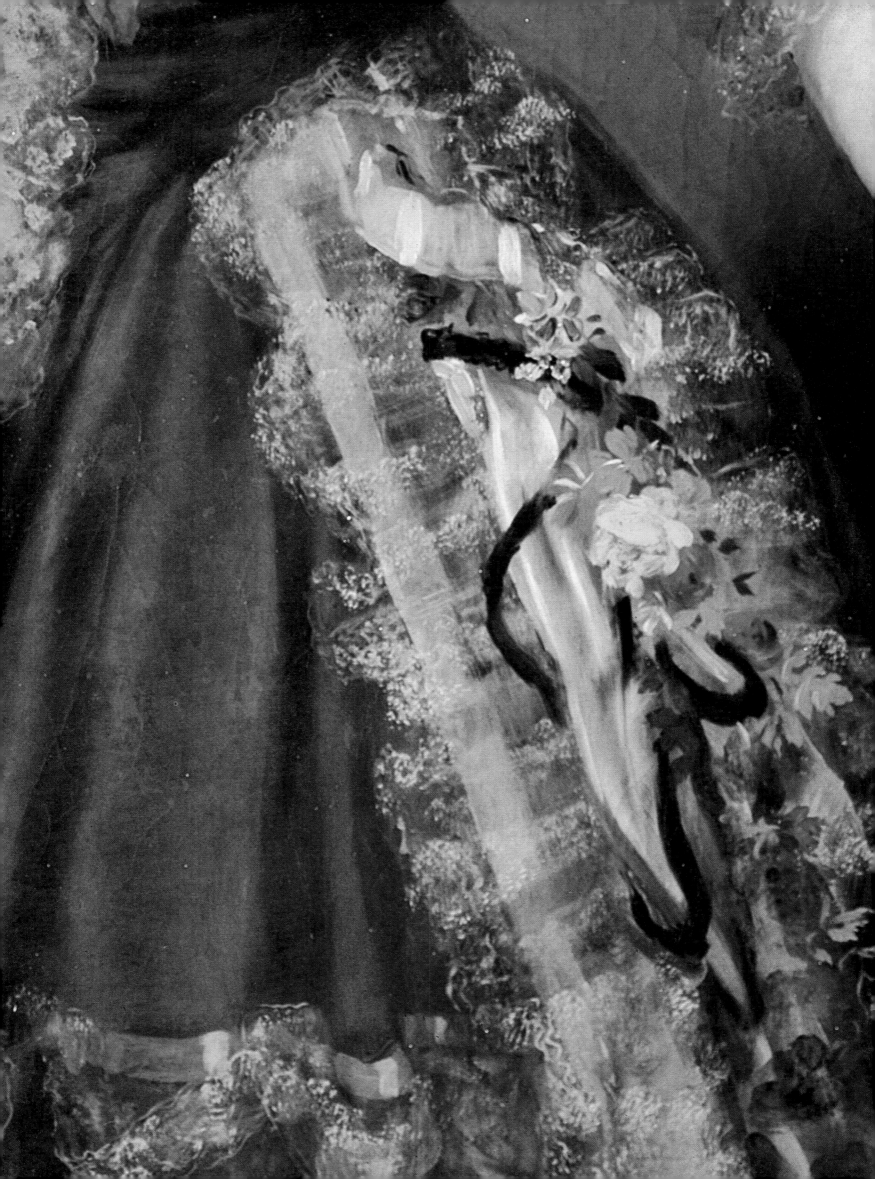

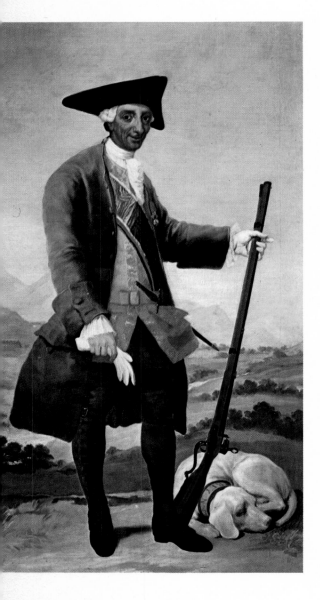

a preparatory drawing — was called *bocetismo* ('sketchiness') by Lafuente and is one of the characteristics of Goya's work. Over the years it led to amazing artistic innovations, which heralded the more definitive tendencies of 19th century painting.

In May 1781 Goya again found himself in Madrid, where another major commission gave him the chance to display his talents. The great church of San Francisco el Grande, the building of which had been a long and complicated affair, was ready to be decorated. A letter from Ramón Bayeu to Martín Zapater tells how the commissions for the various altars were allotted: 'The Minister of State as Protector of the Academy, has received orders from His Majesty and been entrusted with the task of distributing them for a year now; as there are six paintings, they gave one to Maella, another to Don Antonio Velázquez and another to Andres Calleja, three artists in the King's service. The remaining three paintings, at Señor Muñino's suggestion, were given to three young members of the Academy as a special favour.........The following have been retained: Don Jossef Castillo, at the request of Pons, secretary to the Academy; Don Gregorio Ferro, at the request of the Vice Protector of the Academy, and thirdly Goya, at the request of Don Vicente Belmudez, a retainer of Señor Muñino's to whom he presented the drawings from Saragossa and who was responsible for all of them receiving their summons from the King. It was Señor Muñino who, as soon as he knew of the arrival of my brothers in Madrid, gave Francisco the commission to paint the great altar, which is three times the size of anything entrusted to the other artists mentioned.'

The wording makes it unclear as to whether it was the Conde de Floridablanca who received 'the drawings from Saragossa' or whether it was Vicente Belmudez, his retainer (a member of the household), who intervened in his favour after receiving the said drawings. In any case, his support influenced the minister, the Conde de Floridablanca, either directly or indirectly.

Goya set to work feverishly on the great painting, regarding it as a chance to recover his self-respect after the humiliation he had undergone at Saragossa: an opportunity to prove his worth. The picture, painted on a very large canvas, was to show San Bernardino of Siena preaching in the presence of Alfonso V of Aragon (page 22), and a number of the preparatory sketches still survive. He worked on it for two years — from July 1781 until the end of October 1783 — and in November 1784 the paintings were put in their final positions. In early December Goya wrote exultantly to Zapater about the success that he had achieved, but perhaps the success was not as unqualified as he either genuinely thought it was or merely pretended it to be. The Secretary of State, the Conde de Floridablanca, for example, observed in a note authorizing the late payment of a sum of money owing: 'The pictures have not been particularly good, even though these ones are the least bad.' Amongst 'these ones' was the one by Goya, but the truth of the matter is the Count's remarks were perfectly justifiable.

Goya put all his efforts into achieving a pyramidal composition, in which the disposition of the standing figures in the foreground builds up towards the vertical figure of the Saint on the rock, his arms spread outwards. The sketches in the collection of the Marqués de Torrecilla must be the earliest ones for a number of reasons, one of them being that they show a greater number of figures, which obscures the work's basic configuration. They do not show the Saint holding the Cross but the symbol IHS, which is apparently how he was normally portrayed. Nor does the artist's self-portrait appear, as it does in other preliminary sketches and also in the finished work.

Even though Goya emphasized how much work he had put into the painting, he did not mention its originality — the originality of his own devising — as he had done when presenting his *Crucifixion* (page 23) to the Academy (1780), which was the work that had gained him entrance to that

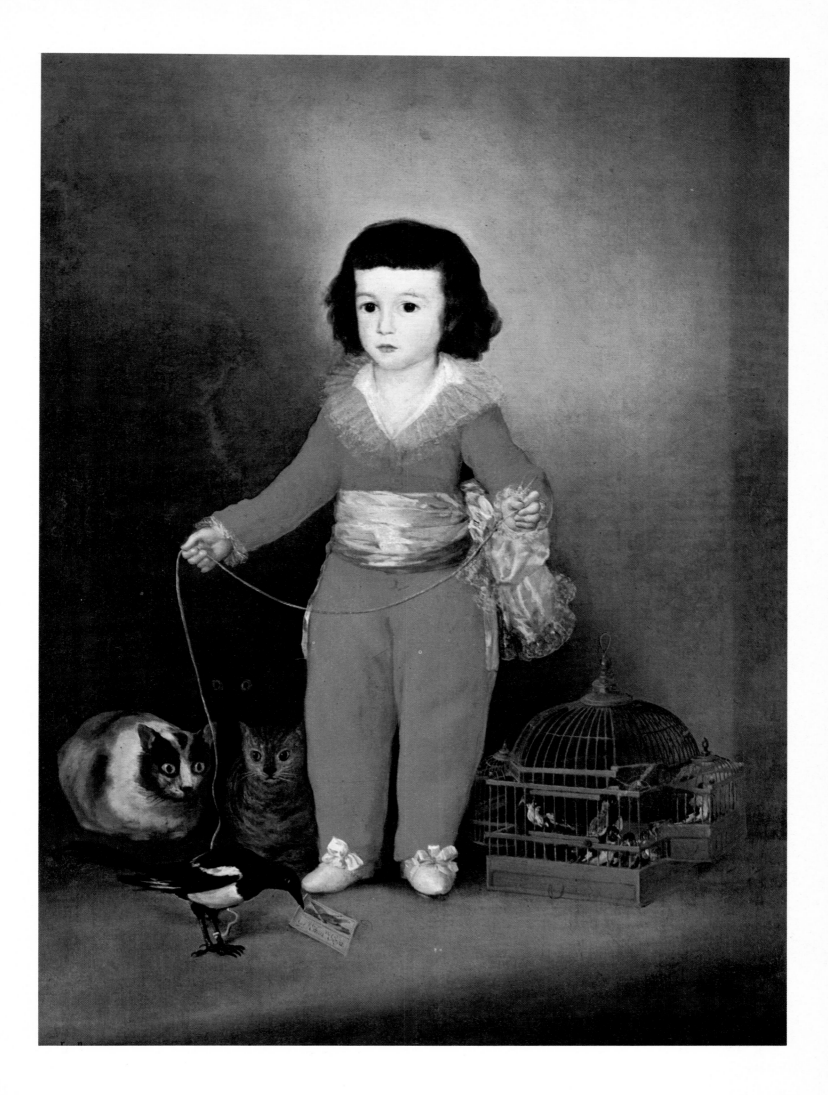

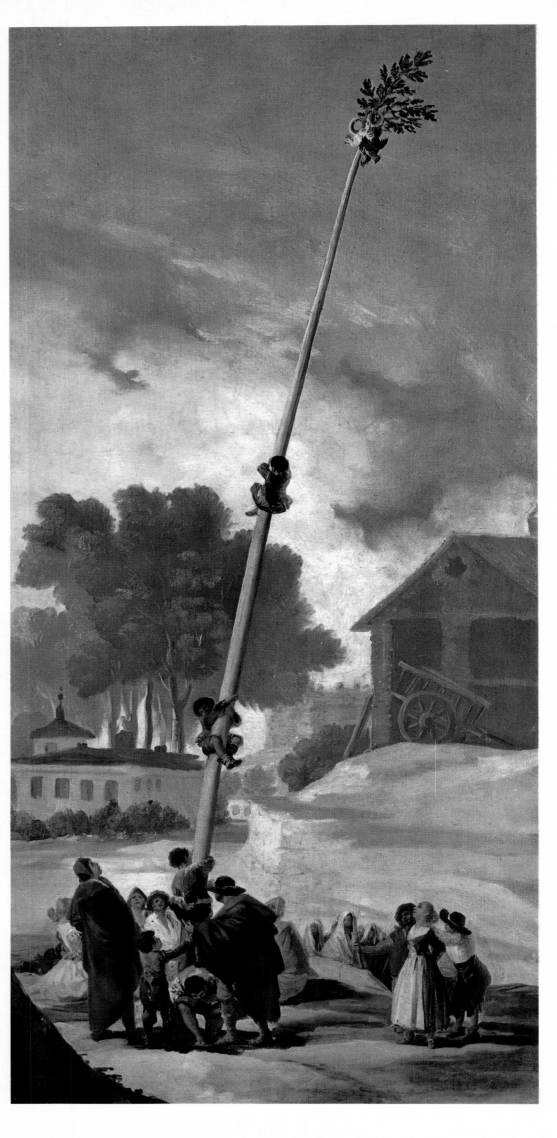

THE GREASY POLE
Oil on canvas; cm 169 × 98 (66½″ ×
38⅝″)
1786-1787
Madrid, Collection of the Duke of
Montellano
This work forms part of the series of seven
canvases destined for 'El Capricho', the
country residence of the Duke and Duch-
ess of Osuna, which were commissioned
by the owners.

body. It has been frequently stressed that the configuration of this *Crucifixion*, with the four nails and the *suppedaneum*, follows those of Mengs and Bayeu, the former painted between 1765 and 1770 for Aranjuez, the latter only drawn, but with great care. The neutral background was inspired by Velázquez, but the indisputable originality of his work is not apparent to modern eyes: it lies in the trilingual inscription, which was written on a strip of material hanging from the head of the Cross instead of a piece of wood, as had been the custom since time immemorial. It was, in fact, later overpainted, as was revealed only a short time ago. It was for this reason that Goya wrote, many years later, that it had been 'mutilated'.

This illustrates how Goya, even at the beginning of his academic career, was eager to experiment with new themes, even if he contradicted conventional

THE ATTACK ON THE COACH
Oil on canvas; cm 169 × 127 (66½″ × 50″)
Madrid, Collection of the Duke of Montellano
This work forms part of the same series as the preceding canvas and its subject is closely related to the theme of Goya's cartoons for the Royal tapestries.

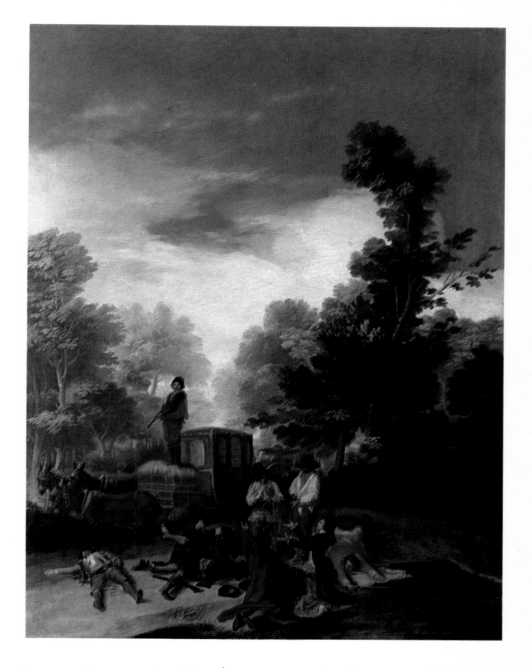

iconography. It may well be that his inspiration for this particular innovation came from the many portrayals of St. Veronica's Veil, a particularly popular subject at the time.

The following year, as a result of the intervention of Don Gaspar Melchor de Jovellanos, a major figure in the Spanish Enlightenment, Goya was commissioned to do four canvases for the church of the Colegio de Calatrava in Salamanca. This building, together with all its contents, was destroyed by

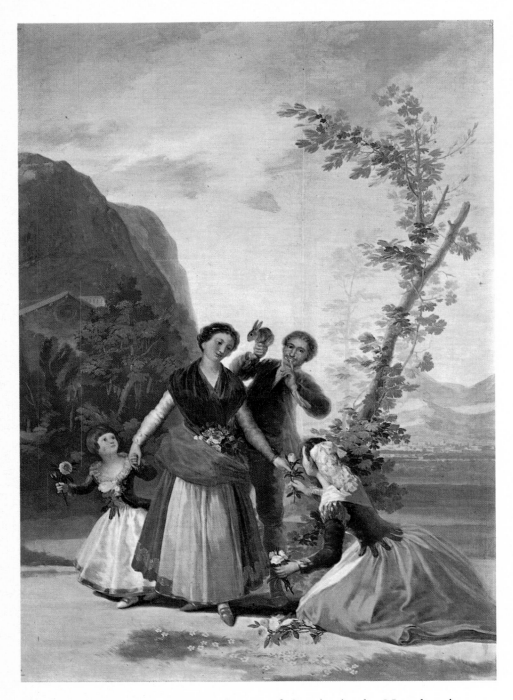

SPRING
Oil on canvas; cm 277 × 192 (109⅛″ × 75⅝″)
1786-1787
Madrid, Prado Museum (793)
This canvas forms part of a group of paintings of the Four Seasons. The preparatory oil sketches for all four of them have survived. See the facing page for detail.

the French during the bombardment of the city in the Napoleonic wars. The preliminary sketch for *The Immaculate Virgin*, which was the property of Jovellanos, has recently been discovered. In it we see the Virgin standing with her robe falling vertically, and from what we know from letters written by Jovellanos, he considered the conventional Baroque portrayal of Our Lady with swirling, floating robes to be inappropriate. The delicate portrayal of the Virgin's face in this painting closely resembles certain works by Mengs. The paintings were well received, as we know from the official communication, signed by Jovellanos in his capacity as Secretary to the Council, in which the works are highly praised and payment approved. Immediately prior to this group of paintings Goya did another work with a religious theme: *The Annunciation*, for the Convent of San Antonio del Prado in Madrid, whose chapel and altarpiece were consecrated in December 1785. The large painting that Goya did for the convent shows, in the figure of the angel with its outstretched wings, much stronger traces of Tiepolo's influence than any other of his works, and there is also in existence a preparatory drawing that differs in several respects from the final version.

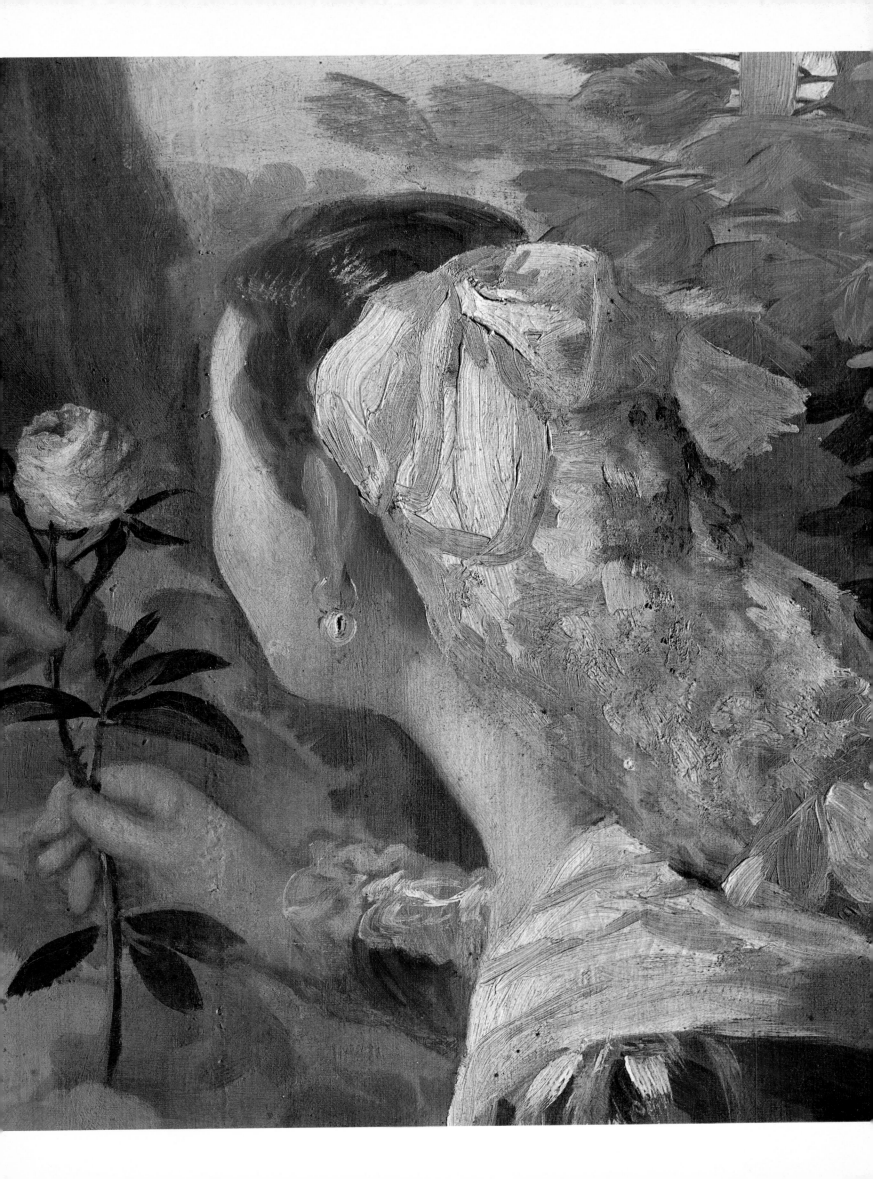

In April 1787 he received a commission to do three large altar paintings for the little Neoclassical chapel in the Convent of Santa Ana in Valladolid: *The Death of St. Joseph*, *The Miracle of St. Bernard* and *St. Lutgarde* (pages 24, 25). They all share the same cold and austere composition, and the same cool, pale colours, with a great use of white to contrast with the browns and greys and to highlight the figures against their neutral background. Goya painted them with their architectural surroundings in mind, and they are, without doubt, the clearest examples of the Neoclassical influence on his art that we have so far encountered: the 'architectonic style', as he himself defined Neoclassicism in a letter written after the completion of these pictures. They possess none of his usual 'nervousness', none of the 'sketchiness' that is so apparent in the *Annunciation* painted two years earlier. Furthermore, if the sketch of *The Death of St. Joseph* was executed as a study for the painting in Santa Ana (which I myself doubt) it must have been done as an experiment in synthesizing and reducing the composition to its barest essentials, eliminating everything that was not absolutely vital. First the paintings in the Aula Dei, and then the attempts at a pyramidal composition, the pictures in the Colegio de Calatrava, the ones on the altar in the Convent of Santa Ana and those in Valdemoro after 1790: they all illustrate how Goya's desire to rationalize coexisted with a strong expressionist streak, which was inherent in his art as it is in that of the majority of Spanish artists.

But, following his natural inclinations, he showed great expressive qualities in two paintings that he was commissioned to do by the Dukes of Osuna for their chapel in Valencia Cathedral. In October 1788 he presented his bill, which we still have. We also have his rough sketches and his preparatory studies of the paintings' themes: *St. Francis Borgia bidding farewell to his family* (page 26) and *St. Francis Borgia and the dying impenitent* (page 27). In the latter picture, whose composition is based on a work by M.A. Houasse that still hangs in the Church of the Novitiate in Madrid, we can see the earliest example of Goya portraying the devils and supernatural beings that were to play such an important part in the imaginative development of his later paintings and engravings. This dramatic composition shows Goya turning his back on Neoclassicism. In his swing between expressionism and rationalism, the Santa Ana altar-piece is the complete opposite of the paintings in Valencia Cathedral: the latter are characterized by darkness, passion and emotion, while the former are soberly painted and clearly drawn.

The time has now come to pause in our account of Goya's artistic development to examine what little we know about his private life during this period. We have already mentioned his marriage in 1773 to Josefa Bayeu, the sister of three well known painters; by her he had a number of children. We have also mentioned how he arrived in Madrid and worked for several years in the shadow of his brother-in-law Francisco. Mengs summoned him to work in the Royal tapestry factory; shortly afterwards, in an official document, he praised him for what other people considered to be one of his most reprehensible traits. Mengs, besides adhering strictly to his theoretical principles in his painting, was a man of great sensitivity and open-mindedness. We have also seen how Goya successfully completed a number of series of tapestries in the Royal factory. In 1777 it seems that he fell ill, and that it was as a result of this illness that he embarked on his engraved copies of Velázquez' work in the following year. This connection between illness and working on engravings is stressed since this is the first instance of something that occurred after other illnesses. As we shall see in due course, Goya completed other series of etchings during times of convalescence.

In 1780 he entered the Academy, but we do not know whether up until then he had been the reluctant protégé of Francisco, his brother-in-law, who gave him almost the same support as he did to his own brother Ramón, whom he always treated very much as his junior. Francisco Bayeu's char-

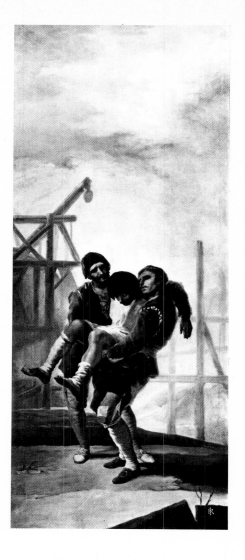

THE INJURED MASON
Oil on canvas; cm 268 × 110 (105½" × 43⅜")
1786-1787
Madrid, Prado Museum (796)
The subject of this canvas is thought to be connected with an edict of Charles III, designed to ensure greater safety for men working in the building trade.

acter had certain facets that one would never guess from his work, and undoubtedly some of them made him feel close to Goya, while others led him to feel alienated, deceived and finally antagonistic.

As a painter Francisco Bayeu (1734-1795) was correct and precise: he was an extremely punctilious man, who was very protective of his position in the Palace and who moved heaven and earth to obtain pedigree dogs for the King because of a remark the latter once made to him about some he had, writing pleading letters in his search for them. He was a man who liked to be fashionably, even expensively, dressed (the inventory of his personal possessions is very revealing in this respect), but he also had his *majo* costumes. His letters, which show him to be an ardent fan of bull-fighting, a fanatical supporter of Costillares and 'enemy of Romero', also reveal his love of hunting, both of which interests he shared with Goya, who was a hunting and bull-fighting enthusiast. But who, on seeing his paintings in the cloister of Toledo Cathedral, would ever think that the man responsible for them could write to Zapater wanting 'to sing you [τηε sονγ] that I learnt from two gypsies in Toledo, who took me to their house to teach me it, and I did not stop until I had learned the whole caterwauling thing because I have a craving for that kind of love song and that sickly style'?

By means of Bayeu and other Aragonese friends, Goya obtained the commissions for the frescoes in Saragossa's Basílica del Pilar and the paintings in the Aula Dei, and he gained his later commissions thanks to the sponsorship of certain influential figures with whom he was acquainted, but how he came into contact with them we do not know. We have already mentioned the part played by the Conde de Floridablanca, King Charles III's Secretary of State, who was instrumental in obtaining the commission for San Francisco el Grande, and Gaspar Melchor de Jovellanos, the most intelligent and deep-thinking member of the Enlightenment, who was

TWO CHILDREN WITH TWO MASTIFFS
Oil on canvas; cm 112 × 145 (44⅛″ × 57⅛″)
1786-1787
Madrid, Prado Museum (2524)

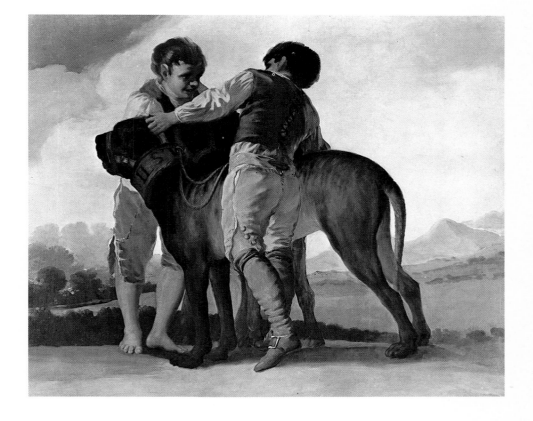

responsible for the Salamanca paintings. The architect Sabatini, who completed San Francisco el Grande, was also the architect for the church of Santa Ana in Valladolid, and it was he who obtained the commissions for Goya and Ramón Bayeu to do the paintings there. It was undoubtedly as a

result of his Aragonese friendships that Goya gained entry into the small court of the Infante Don Luis, the brother of Charles III, who lived out of Madrid, at Arenas de San Pedro, following his morganatic marriage to an Aragonese woman, Doña María Teresa Vallabriga. Or perhaps the connection resulted from the architect Ventura Rodriguez, whom Goya knew in Saragossa when he painted the frescoes in the Basílica del Pilar. It was to Ceán Bermúdez, by profession a businessman, but an art historian by inclination, that he owed the commissions for the Bank of Spain, which will be discussed later; Ceán Bermúdez also had an Aragonese wife. The majority of Goya's friendships were with Aragonese or connected with Aragon in some way or another.

He did a large portrait of the Conde de Floridablanca in 1783 (page 28), a

THE MEADOW OF ST. ISIDORE
Oil on canvas; cm 42 × 90 (16½″ × 35⅜″)
1788
Madrid, Prado Museum (750)
Preparatory sketch for a cartoon that was never realized; this study was acquired by the Duke of Osuna.

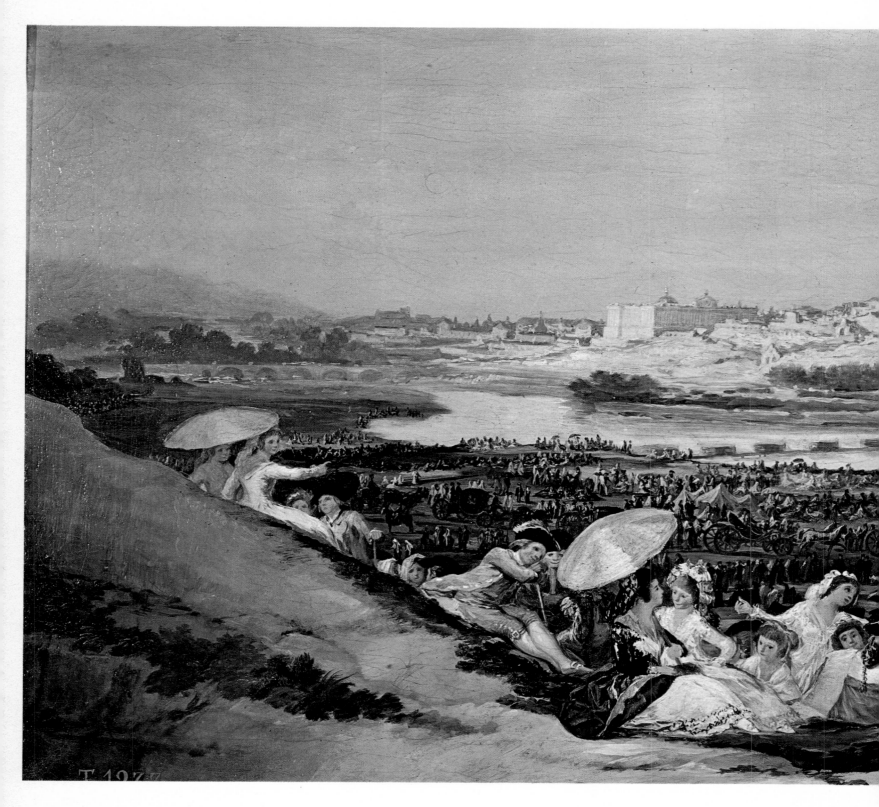

work which should be viewed in connection with the commission for San Francisco el Grande. The result did not please the sitter very much, and Goya made other versions, which lacked the bombastic quality of this large painting with its complex and baroque composition and its confused lighting. One of its most noticeable features is the almost servile attitude of the painter, shown presenting the Minister with a sketch or small painting, and the way in which the latter faces us fair and square, his whole figure radiating a feeling of cold aloofness.

Goya did a number of portraits for the Infante Don Luis, one of which is a family portrait (page 29), showing the Prince seated at a table playing patience, while his wife María Teresa is having her hair dressed. The couple's children, their steward and their servants appear in the painting as

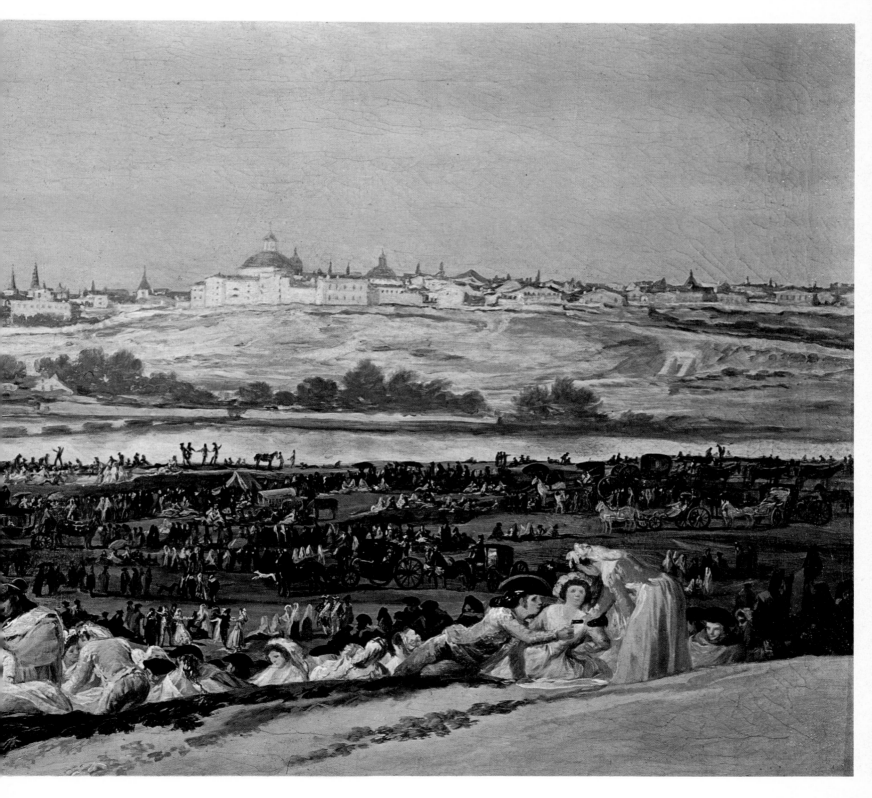

onlookers, and Goya has also portrayed himself, seated on a very low stool in the corner of the picture, trying to capture the silhouette of the Infante on a large canvas, or perhaps paint his portrait by reflection. The painting as such is a very daring one, but, although it is beautiful in parts, Goya failed to achieve complete success in what was, after all, the most exacting work that he had undertaken up until that time. A group of portraits of the Infante, of Doña María Teresa, and of their children, are the result of two stays by the artist at Arenas de San Pedro. He also did a rough sketch for a double portrait of the Infante together with his architect Don Ventura Rodríguez, which was never actually painted.

Some of these portraits are finer than anything else Goya had done up until then. In some we can clearly see the influence of court portraits, as Mengs

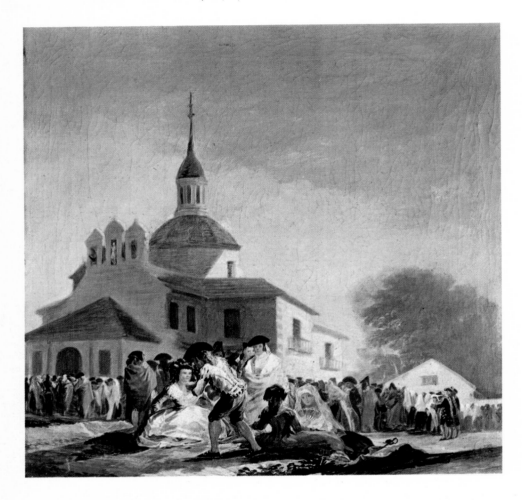

HERMITAGE OF ST. ISIDORE
Oil on canvas; cm 42 × 44 (16½" × 17⅜")
1788
Madrid, Prado Museum (2783)
Another preparatory work that never reached the cartoon stage, from the same series as the preceding one.

understood them, whilst others, whose style is rougher and less polished, are amongst his most charming works. The ones of the Infante's elder children are outstanding: the one of the daughter who subsequently became the Condesa de Chinchón (page 33), and the recently discovered one of the young Duchess of San Fernando. Unfortunately, however, Goya soon lost his patronage, for the Infante died in 1785.

But that year was not one of total disaster, because his academic career received a considerable boost when he was made Assistant Director of Painting by the Academy. Shortly before this, very possibly at the same time as he was given the commission for the Colegio de Calatrava in Salamanca, Goya painted a portrait of Don Gaspar Melchor de Jovellanos. It was the first portrait that he had done of him, and it is almost as important as the second one, which we will discuss more fully when the time comes. The former, which shows Don Gaspar standing with his legs crossed, is somewhat stiff both in composition and design, and follows a compositional style that Goya had learned from English portraiture; there is, however, a great deal of movement in the silhouette of the figure. Much more pleasing

are some of the female portraits that he did during this period: the one of the *Marquesa de Pontejos* (page 36), and particularly that of the *Condesa-Duquesa of Benavente* (page 37), who became, by her marriage, the Duchess of Osuna, a woman of intellectual tastes and a prominent member of Madrid society. With his portraits of the Duke and Duchess Goya started a relationship with this family, one of the most highly placed in the Spanish aristocracy, that was to last until the closing years of his life.
In 1785 Goya also became connected with the Bank of San Carlos (that later became the Bank of Spain), possibly, as we have already said, through Ceán Bermúdez, who was secretary of that institution at the time. The result was that he did several portraits of its directors through the years, five in all, as well as a portrait of *King Charles III*.

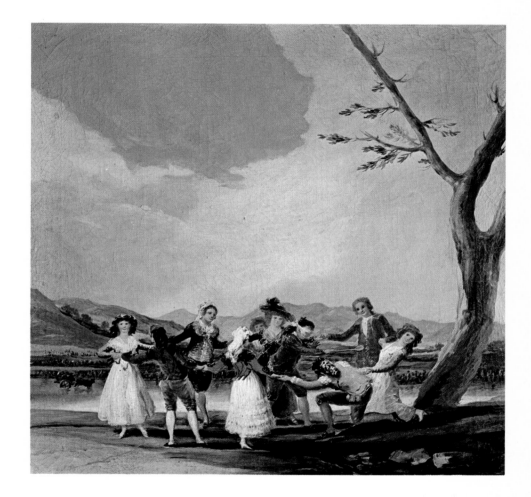

This royal painting differs in both style and technique from the ones that he did of the *Conde de Altamira* and the *Marqués de Tolosa*, for which he received payment at the same time. This difference has been accounted for by a theory that the portrait of *Charles III* was done at an earlier date than the other two, but was kept for some time by the artist in his studio. It is my personal view that it was probably completed several years earlier, being based on memories of a visit Goya paid the King in 1780 to present him with a number of tapestry cartoons. In it he shows the old King upright, taking a few tottering steps; the painting has captured his expression for posterity, as well as his ruddy complexion, the result of prolonged periods in the open air, since his passion for hunting was notorious. This aspect of his character has also been immortalized in a hunting portrait, which shows him with mastiff at his feet (page 40). The painting, commissioned by the Banco Exterior and later repeated graphically in a number of different versions, each one more developed than the last, is the best example of Goya's turn of the century style. Also connected with these portraits is the

one that he did of the man who was to be a life-long friend of his: Don Augustin Ceán Bermúdez.

His professional life received a further boost in 1786. On the death of Van der Gotten, the director of the Royal tapestry works, the factory was reorganized, as a result of which Goya and Ramón Bayeu were designated painters to the King, at a salary of 15,000 *reales*. Bayeu was proposed by his brother Francisco, and Goya by Maella, at Francisco's prompting. A portrait of Francisco dressed in black velvet, which now hangs in Valencia Museum, is proof of the way in which friendly relationships had been reestablished within the family after the differences caused by the affair of the Basílica del Pilar frescoes. The portrait is one of the most beautiful from this period of Goya's career, and it is worthy of mention even though its circumstances have no direct bearing on the course of the artist's life. We should also mention the portrait that he did of the Conde de Altamira for the Bank, as a result of which he was commissioned to do others, of the Count's family: the one of the *Countess and her daughter*, and the two of *Vicente* and *Manuel Osorio* (page 41), the young sons of the Count and Countess. With these he continued the series of child portraits that he had begun with the ones of the Infante Don Luis' children. We have already noted how paintings of children were something that interested Goya throughout his life: in them he expressed his basic feelings of tenderness, which remained hidden in the majority of his works.

1784 marked the birth of Francisco Xavier, the only one of his children to survive him. Goya now felt settled in Madrid, and we see in a letter which he wrote to Martín Zapater, telling him how he had been promoted to the post of King's painter, that he signed himself Francisco *de* Goya. From now on he would never again portray himself in the inferior position that we saw in the portrait of the Conde de Floridablanca, or in the painting of the Infante Don Luis' family. Indeed, shortly afterwards he was to begin the task of assembling the necessary data for the recognition of his *hidalgo* status. He was able to indulge in various extravagances: he bought a four-seater carriage, a *birlocho*, which overturned on its first outing. He subsequently bought another carriage which, although less fashionable, was more secure. In the meantime he was working on scenes from everyday life for his important clients. The Duke and Duchess of Osuna commissioned, for El Capricho, an estate on the outskirts of Madrid, nowadays known as the Alameda de Osuna, a series of paintings to decorate one of the rooms. The themes are similar to those represented in the series of cartoons delivered to the Royal tapestry works and destined for the decoration of the dining room in the Pardo Palace. Four of them depicted the seasons, while a further two showed scenes everyday life and reveal a certain degree of social commitment. One of them portrays some *Poor People at the Fountain*, while the other is of the *Injured Mason* (page 46), which appears to have been directly inspired by an ordinance passed by Charles III, much praised by members of the Enlightenment. This ordinance was concerned with the use of scaffolding for public works, to avoid deaths and injuries amongst the work force, and it made works supervisors responsible for ensuring that the necessary precautions were taken. People have noticed that in this series Goya has sided with the Enlightenment, applauding the measure, while at the same time making use of it to express his gratitude to Charles III for the appointment that he had be given. However, in the picture that he sold to the Duke and Duchess of Osuna, which may have been a preparatory sketch or perhaps just smaller version of the original, the theme was changed and the social comment removed. The mason is no longer injured, but drunk, as we can see from the bottle lying on the ground.

In his small painting of *The Meadow of St. Isidore* (pages 48-49) Goya depicted an actual landscape in full colour, something that he had never done before. A pencil study has survived that includes a detailed portrayal of the Madrid landscape in the background. It also contains a sketchy repre-

THE FAMLIY OF THE DUKE OF OSUNA
Oil on canvas; cm 225 × 171 (88⅜″ × 67⅜″)
1788
Madrid, Prado Museum (739)
The Dukes of Osuna were for many years amongst Goya's chief sponsors.

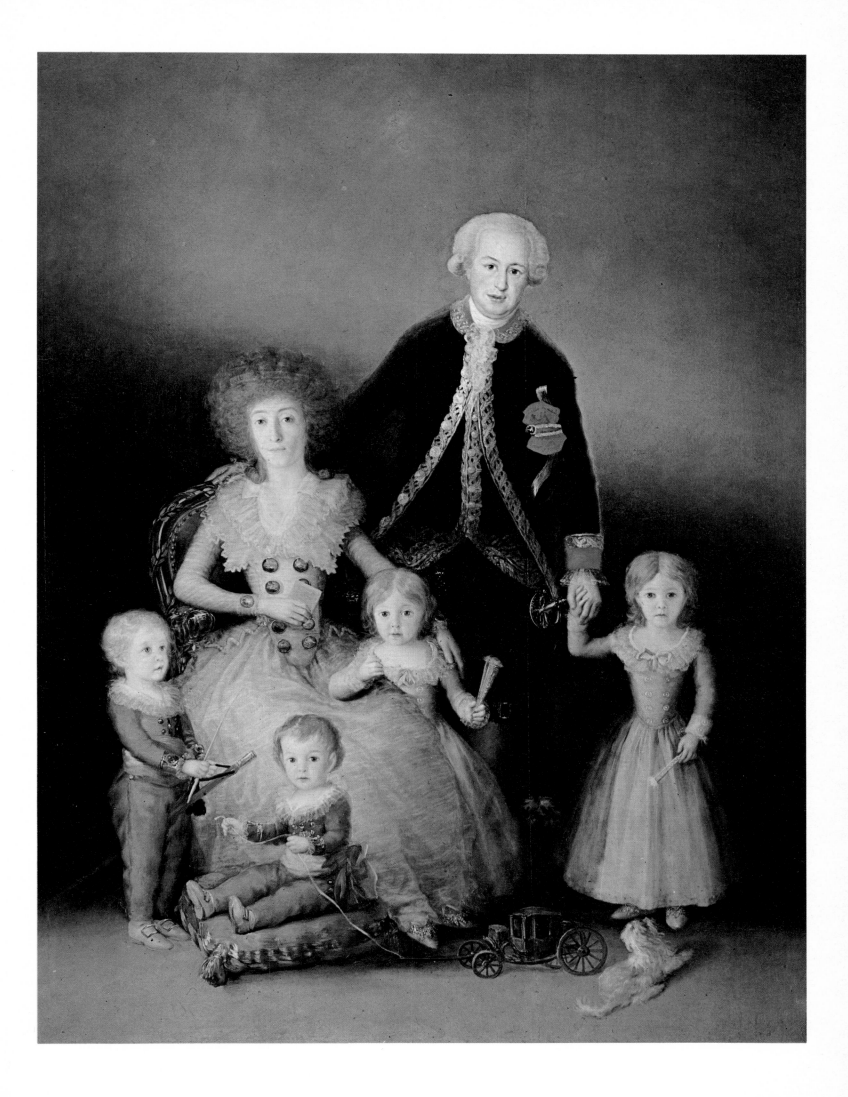

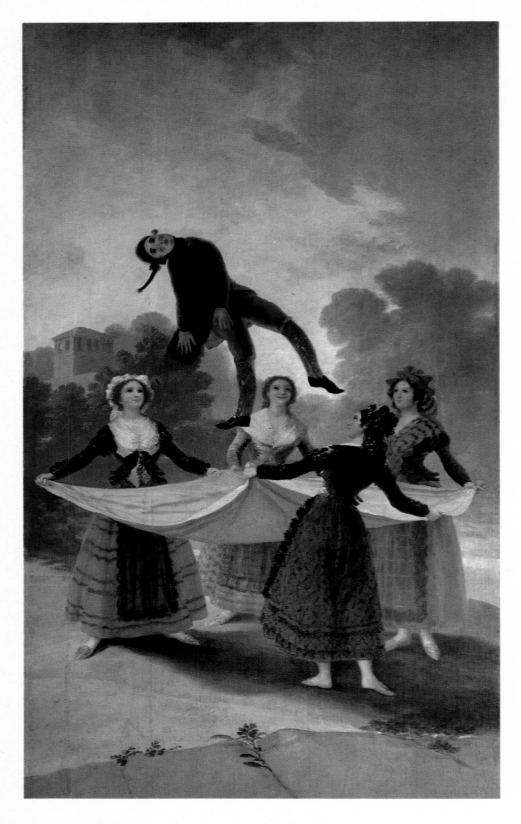

THE MANIKIN
('El Pelele')
Oil on canvas; cm 267 × 160 (105 ⅛″ ×
63″)
1791-1792
Madrid, Prado Museum (802)

sentation of a group of female figures seated on the ground, in front of
whom two men are conducting a conversation. The two seated *majas* on the
left correspond, albeit with many variations, to the two figures in the main
group sheltering beneath a parasol. It is this sketch which much have been
used as a study for the figures in the foreground.

Before *The Meadow of St. Isidore* Goya had confined himself, both in his
cartoons and his portraits, to painting distant views: some were vaguely
inspired by the scenes done by Velázquez as a background for his portraits,
while others just showed indefinable landscapes. In one or two of his
cartoons the landscape is identifiable, but for the most part they are not.
The Royal tapestry works planned to weave a second series to decorate the

bedroom of the Infantas in the Pardo Palace. Goya, therefore, presented a number of sketches to the King and the Royal Family (referred to in a letter of May 31 to Zapater), but only one cartoon of this series was ever actually turned into a tapestry: *Blind Man's Buff* (page 51). Everything else ground to a halt following the death of Charles III in December 1788.

The preparatory studies were sold by the artist to the Dukes of Osuna, and three of them are now in the Prado Museum. The most outstanding one is *The Meadow of St. Isidore* (page 50). It is to this first work that Goya refers in his letter to Zapater, in which he tells of the problems that he was having: 'Things are very difficult as I have a lot to do, like the Meadow of St. Isidore on the Saint's feast day, and I have to compete with all the usual disturbances that there are here in Madrid.'

In this preparatory cartoon sketch, for reasons that we can only guess at, Goya has depicated the Madrid landscape, with the great buildings of the Royal Palace and the church of San Francisco el Grande towering over the surrounding houses, as they would have appeared from the far side of the Manzanares. In its execution the work is reminiscent of ones done by the travelling Italian landscape painter Antonio Joli, who was living in Naples at the time when Charles III left to become King of Spain. During his time in Spain (1750-1754) Joli completed a number of works depicting the Madrid landscape, as well as others of Aranjuez and its gardens. Several of his views of Madrid from the far side of the Manzanares are still in existence; they are carefully executed and unassuming paintings (possibly completed with the aid of a camera obscura) filled with detail and sparingly drawn. An artist who has still not been studied as he deserves, Joli died in England in 1777.

Goya wanted to achieve a different effect in his painting. He was not content just to capture the marvellous pink and white colouring of the background that epitomized Madrid on a spring evening in those days: he

THE WEDDING
Oil on canvas; cm 267 × 293 (105⅛″ × 115½″)
1791-1792
Madrid, Prado Museum (799)
The theme of this work is a bitter attack by Goya on marriages of financial convenience.

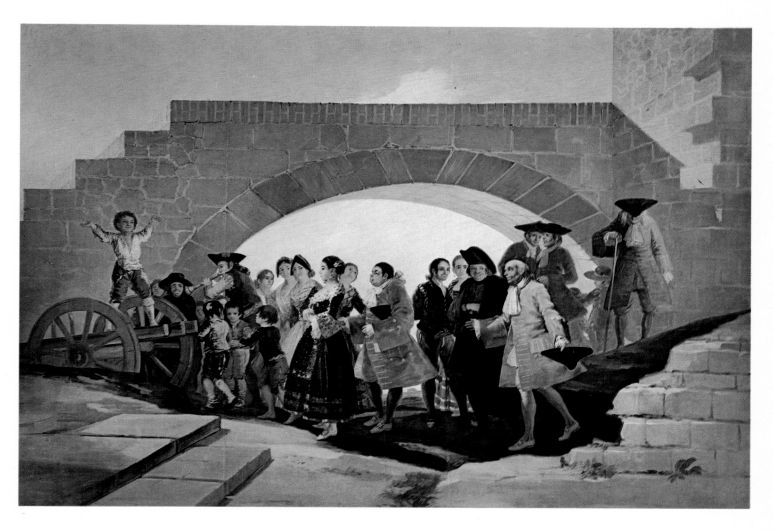

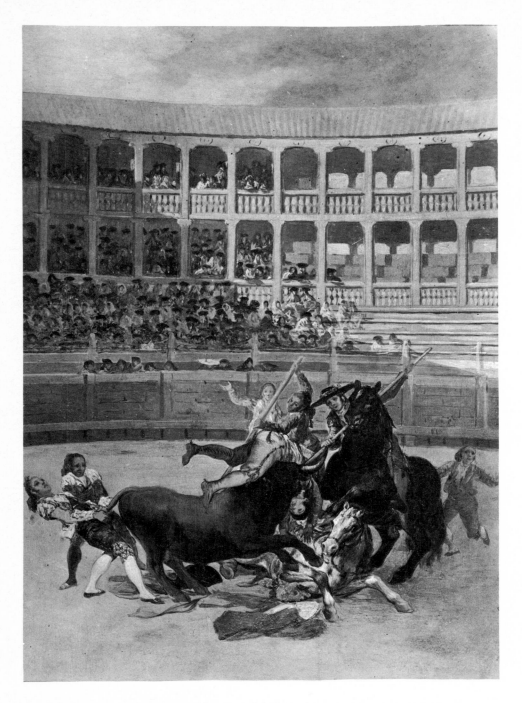

PICADOR CAUGHT ON THE HORNS
Oil on tin; cm 43 × 32 (17″ × 12⅝″)
1793
New York, Cotnareaunu Collection
Together with 'Strolling Players' and
'Fire', illustrated on the pages following,
this work forms part of a group of small
paintings done by Goya during his con-
valescence in Seville, and sent to his friend
Bernardo de Iriarte for him to present to
the Academia de San Fernando.

peopled his canvas with *majos* and *majas*, picnicking or chatting on the
river banks, and he portrayed them with great grace and delicacy, both in
their expressions and in their overall configuration. There is, however, one
detail that reveals the source of his inspiration: next to the river, far
removed from the scene in the foreground, there appear a number of small
figures shown only in silhouette. These figures, which Joli had included in
his paintings of the same subject, were remembered by Goya when he did
his *Meadow of St. Isidore* during what was one of the happiest periods of his
life.
We have already mentioned the fact that the series which Goya had been
commissioned to do in 1788 was never completed due to the death of
Charles III. This does not mean to say that Goya fell from favour: on the
contrary, one of the first things that Charles IV did after his coronation was
to make him *pintor de cámara* in 1789. This is hardly surprising, not only
because of Goya's artistic merits, but also because of his close relationship
both with the King and with his wife María Luisa. His letters to Zapater
contain a number of very revealing anecdotes: he mentions, for example,
how pleased the royal couple were with the cartoons for tapestries that
adorned the rooms in which they lived.
This appointment led to a period of considerable tension between Goya
and the management of the Royal tapestry works when, on being commis-

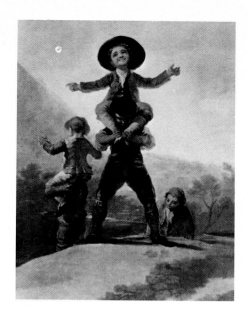

THE LITTLE GIANTS
Oil on canvas; cm 137 × 104 (54″ × 41″)
1791-1792
Madrid, Prado Museum (800a)

STROLLING PLAYERS
Oil on tin; cm 43 × 32 (17″ × 12⅝″)
1793
Madrid, Prado Museum (3045)
This painting belongs to the group of small paintings done during Goya's illness in 1793.

sioned by them in 1791 to complete a new series of cartoons for the King's study in the Escorial, the artist refused to do so, citing his status as *pintor de cámara*. It was only after being threatened with the withdrawal of his salary, and also after the intervention of his brother-in-law, that Goya finally agreed to embark on this last series for the Royal tapestry works. It contained, in fact, some of his most accomplished works in this genre; the most outstanding one, and not just for its size, is *The Wedding* (page 55). For the first time a certain note of satire had crept in — the beautiful village girl marrying the fat and ugly rich man — an element that had hitherto been absent from his work. *The Manikin* (page 54) and *The Stilt-Walkers*, and some over-doors depicting children's games, are also from the same series.

But this elevation of Goya's status in the Palace and the by now universal recognition of his artistic merits, was accompanied on the one hand by illness and on the other by political tension, when his friends in the Enlightenment, having seized power, were rapidly thrown out as a result of the violent reaction caused by political events in Europe, especially the French Revolution.

I should perhaps explain, however briefly the significance of some of the terms that have already been used and also what was and is understood by the 'Enlightenment', particularly in regard to its influence on Goya.

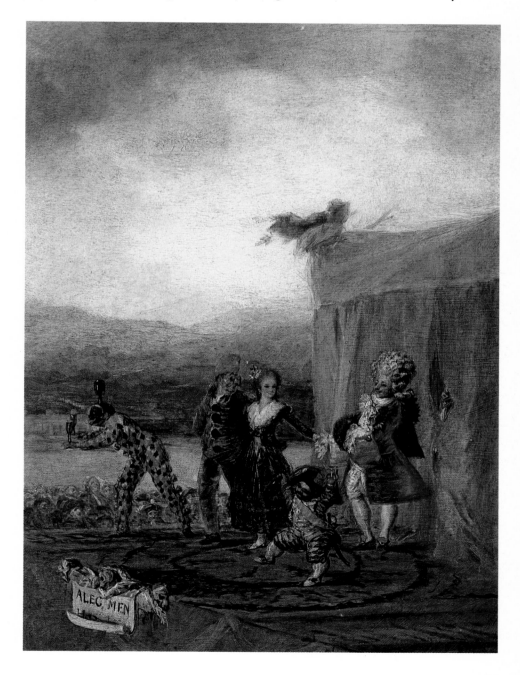

First, we should recall the letter that the artist sent Zapater in 1790, in which he stated that he no longer heard certain '*seguidillas* and *tiranas* ... because I do not go to places where I could hear them as I have got this idea into my head that I should maintain a certain attitude and a certain dignity befitting a man'. This statement has often been quoted; I myself see it as a direct result of the artist's new social position. Having risen to the status of *pintor de cámara* and having enjoyed considerable success at Court, as well as knowing and mixing with the rich and famous, he considered that he should no longer mix with the common people in the world of *majos* and *majas*, where *tiranas* and *seguidillas* were sung. And this was something that he did not altogether find to his liking, as he says in the same letter. The world of Madrid into which he had risen was not only that of the Court: he had also come into close contact with many members of the Enlightenment. Such people were cultured men whose ideas differed from those accepted, for reasons of tradition or sheer indifference, by the majority of Spaniards. They formed a small group, their members scattered throughout Spain, united by their common interests and theories. Gaspar Melchor de Jovellanos was the leading light, both because of the range and depth of his learning and intellect and also because of his prominent position in society (he belonged to an old, noble provincial family of considerable means). He was, in addition, a man of irreproachable character and great

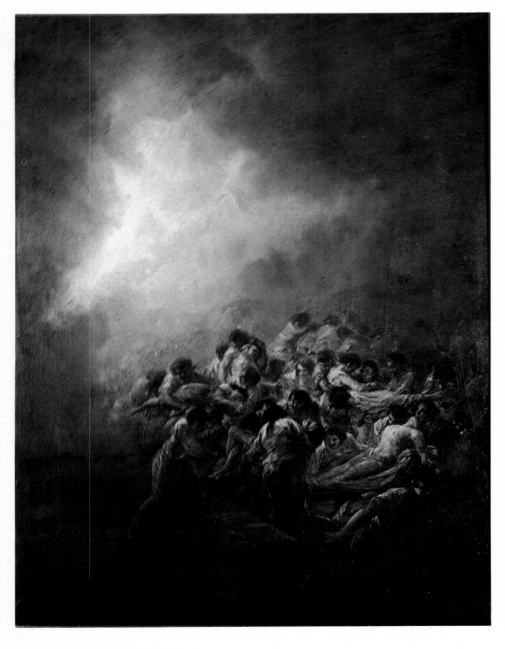

FIRE
Oil on tin; cm 43.8 × 32 (17¼″ × 12⅝″)
1793-1794
Madrid, José Luis Varez Fisa Collection
The subject of this painting has been connected with a fire that broke out one night in a theatre in Saragossa.

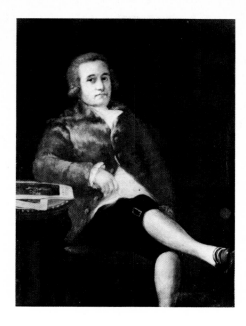

JUAN AGUSTÍN CEÁN BERMÚDEZ
Oil on canvas; cm 122 × 88 (48″ × 34⅛″)
Circa 1792-1793
Madrid, Collection of the Marqués de Perinat
The sitter was a great art lover and friend of Goya, and throughout his life he obtained commissions and contracts for him.

energy. For many years he was a patron of Goya, whose art he admired greatly, and the altar paintings for the Colegio de Calatrava in Salamanca are proof of his patronage.

From the *Novadores* ('innovators'), who were active in Spain at the beginning of the century, the Enlightenment inherited its interest in science, even at the risk of coming into conflict with popular opinion of the time. Their spirit of criticism made them fight against superstition and prejudice, particularly where these led to forms of oppression and injustice. They also espoused the idea of continual improvement, of 'progress', applying it to the whole of society, taking interest in works of economic and social reform and always retaining a strong practical sense. It was for this reason that they entered politics, so as to be able to use political power to bring about an improvement in society, and all these elements combined to produce a radical reassessment of basic beliefs by Enlightenment thinkers.

As a group they had little power, despite the fact that they governed the country for a short time, as has already been mentioned. Their real position was revealed in a letter from Moratín to Forner: 'Believe me, Juan: the age in which we are living favours us very little, if we go against the current and speak the language of the credulous, foreigners mock us, and even in our homeland there are those that treat us as simpletons, and if we try to dispel fatal errors and teach the ignorant, the Holy and General Inquisition will correct us in the manner it is accustomed to.'

The majority of the Enlightenment were, as regards art, fervent Neoclassicists. It is to his relationship with these men and the influence of his friendship with members of their group, that one must attribute Goya's markedly Neoclassical period, culminating in the paintings of Santa Ana in Valladolid, which we have already mentioned, and the drawings copied from John Flaxman's engravings in 1795. This holds true even though his work showed signs of Neoclassical influence before his involvement with the Enlightenment and also afterwards. We shall deal with the 'Davidism' that appeared in certain commissioned works after the war later in the book.

However, this group of friends, to whom Goya owed a great deal of the ideology that he displayed in his drawings and engravings, was only a part of the world in which he moved. As a courtier, and as a painter in search of clientèle, he cultivated other groups in the political high society of Madrid. It would, therefore, be appropriate to provide some background information on conditions during the reign of Charles IV, the period in which, economically and socially, Goya enjoyed his greatest success. It should be emphasized that Goya was an astute man and that he always managed to extricate himself from the difficult situations that he often found himself in. He was not a person who openly displayed his thoughts and opinions, and he was capable of adapting himself to difficult situations and even acting contrary to his basic beliefs.

Charles IV was a weak man, of little consequence. Having married María Luisa of Parma at an early age, he became dominated by her, while she in turn fell under the spell of Manuel Godoy, a man much younger than herself. This young courtier, a member of the lesser nobility, clever, ambitious and unscrupulous, insinuated himself into the Queen's favour, and thanks to her enjoyed a meteoric career that ultimately led to his becoming the *de facto* political leader of Spain. In 1792, at the age of twenty-six, eight years after his conquest of the Queen, he succeeded the Count of Aranda as Secretary of State; in other words he became Prime Minister. Prior to this he had already been made Field Marshal, Duke of Alcudia and State Counsellor. All those who opposed his will or his whims were disposed of, starting with the old politicians such as Aranda and Floridablanca; members of the Enlightenment, too, some of them acquaintances or friends of Goya's — Jovellanos, Saavedra, Urquijo, Ceán Bermúdez, all four of whom had sat to him — were got rid of, ministers and officials alike. Some were exiled and some imprisoned, while Jovellanos, the head of the group, suffered both

penalties for a great number of years, only gaining his freedom following the favourite's downfall. Godoy was made *Príncipe de la Paz*, an unheard-of honour, since in Spain only the heir to the throne bears the title of prince (*Príncipe de Asturias*), and he also married into the Royal Family as a result of his wedding to the Condesa de Chinchón, daughter of the Infante Don Luis and first cousin to the King. He became the central figure and mainstay of the 'Trinity', a word Queen María Luisa herself used to describe herself, her husband and her lover. For twenty years Spain was ruled by the whims of the Queen's favourite: he controlled her, while she, in turn, controlled the King.

There was growing opposition, however, and for a short time between 1797 and 1799 Godoy's opponents succeeded in displacing him, but he regained power as a result of his personal influence and also because of the fear induced in the ruling classes by the events of the French Revolution. Nevertheless, opposition to him personally and to his policies still continued.

All this was happening at the same time as the Revolution in France: the Fall of the Bastille, and the 'Declaration of the Rights of Man and of the Citizen' in 1789, followed by the Convention and the trial of Louis XVI (1792) and the subsequent execution of both him and Marie Antoinette, both events that shook Europe to the core. There then followed the Directory (1795), the victorious campaigns by the French in Italy and Egypt

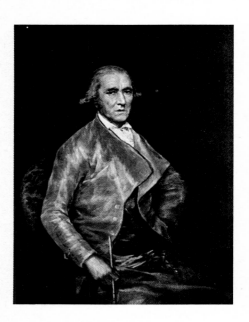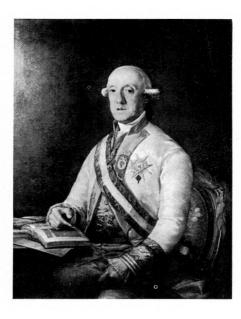

FRANCISCO BAYEU
Oil on canvas; cm 113 × 84 (44½″ × 33⅛″)
1795
Madrid, Prado Museum (721)
This work was exhibited at the Academia de San Fernando a few days after the death of Francisco Bayeu, the artist's brother-in-law, on 4 August 1795.

THE MARQUÉS DE SOFRAGA
Oil on canvas; cm 108.3 × 82.6 (42⅝″ × 32½″)
Circa 1795
San Diego, Fine Arts Gallery (38.244)
In 1795 the Marqués de Sofraga was elected director of the Royal History Academy.

(1799), Napoleon's nomination as First Consul, then Consul for Life (1802) and finally his coronation as Emperor in 1804.

Charles IV felt under an obligation to Louis XVI for political and family reasons and tried to obtain his freedom. Godoy actively supported this policy, but it was a combination of terror at events in France and the lack of confidence felt by the traditionalists that resulted in his return to power. He was, however, no match for the genius of Napoleon.

Traditional French policies became even tougher with the rise of Napoleon, who tried to impose the Continental Blockade on England. In the Iberian peninsula, after a victorious war against Portugal, the brief, so-called 'War of the Oranges' (1801), Godoy's personal reputation was greatly enhanced, but Spain's alliance with France resulted in the loss of the Spanish squadron at the Battle of Trafalgar, a disaster that paved the way for the loss of her South American colonies. In addition, with the ostensible aim of occupying Portugal, an ally of England, in order to complete the blockade of that country, France sent a number of troops to Spain, who traitorously occupied several strategic positions.

Opposition to Godoy became increasingly strong; his opponents included

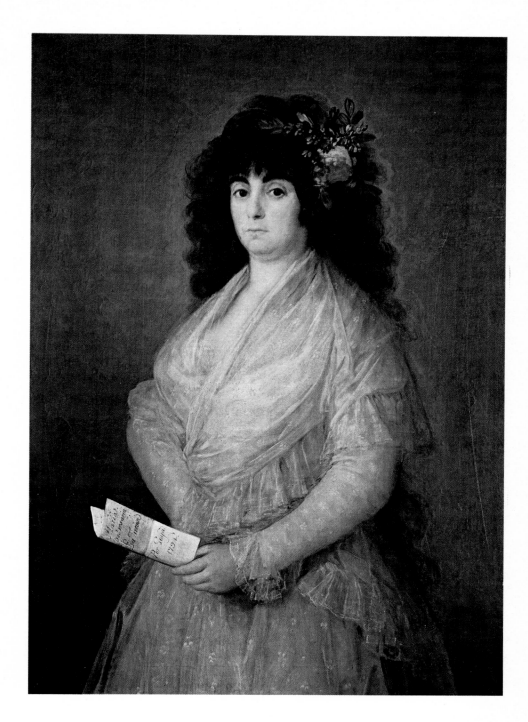

MARÍA DEL ROSARIO FERNÁNDEZ
('LA TIRANA')
Oil on canvas; cm 112 × 79 (44⅛″ ×
31⅛″)
Signed and dated: 'Maria / del rosario /
La Tirana / Por Goya / 1794'
Madrid, Juan March Collection
The subject was a very famous actress,
nicknamed 'la Tirana' because her hus-
band generally acted the part of the tyrant
in theatrical productions.

members of the Enlightenment, traditionalists and personal enemies.
Amongst them was also the heir to the throne, Prince Ferdinand, later King
Ferdinand VII, who expressed a deep loathing for his mother's favourite,
and finally managed to get the better of him after having been himself
humiliated following the discovery of his plans to obtain Napoleon's
support against Godoy. These intrigues against the Queen's favourite
culminated in the Aranjuez riots (19 March 1808), which overthrew the
Príncipe de la Paz, who only narrowly escaped with his life. The main
demand of the insurgents was the abdication of Charles IV in favour of his
son. In the interim, however, as we have already mentioned, the armies of
France had occupied Spain, but their presence and their actions led to an
uprising by the Spanish in Madrid on 2 May 1808, thereby leading the
country into war with France and opening a new chapter in Spanish history.
These chaotic years between 1792 and 1808 marked the zenith of Goya's
artistic life, but they were also a period in which, as well as sharing all the
anxieties of his fellow countrymen, he underwent two serious bouts of ill-
ness that had a dramatic effect on his personality. The first bout of illness,
from which he recovered despite its severity, left him completely deaf.

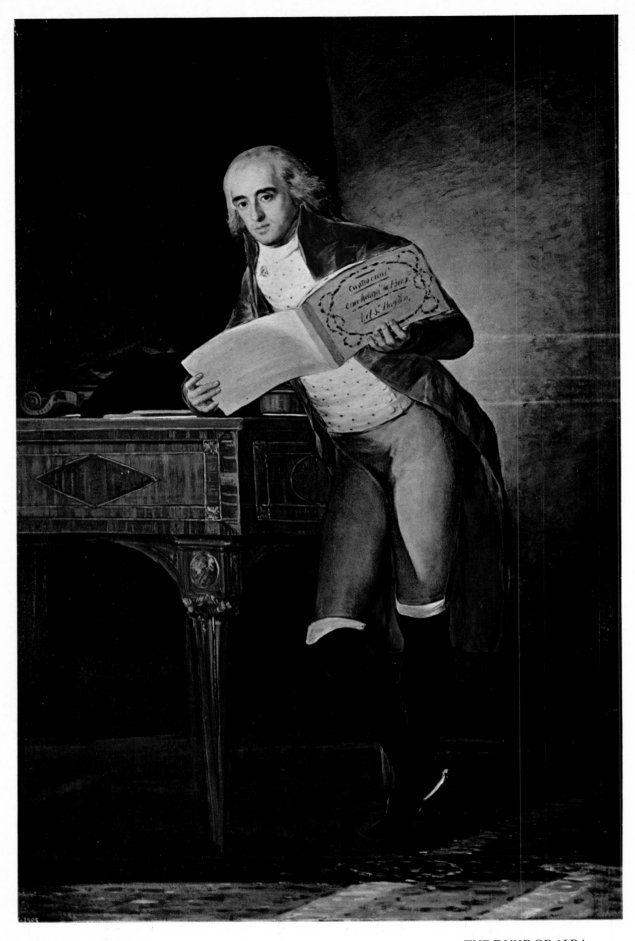

THE DUKE OF ALBA
Oil on canvas; cm 195 × 126 (76⅞″ × 49⅛″)
1795
Madrid, Prado Museum (2449)
Passionately fond of music, the Duke was familiar with all the best known musicians of his day.

Besides this problem, caused by his illness, he also suffered a deep and unrequited love for the Duchess of Alba. Gómez Moreno has defined as 'crises' these two events, which are reflected in Goya's work and which were caused either by sickness or external circumstances. They were crises of a physical nature or crises due to the fact that Goya felt himself torn between two different sets of values at the same time. Examples of the first type were

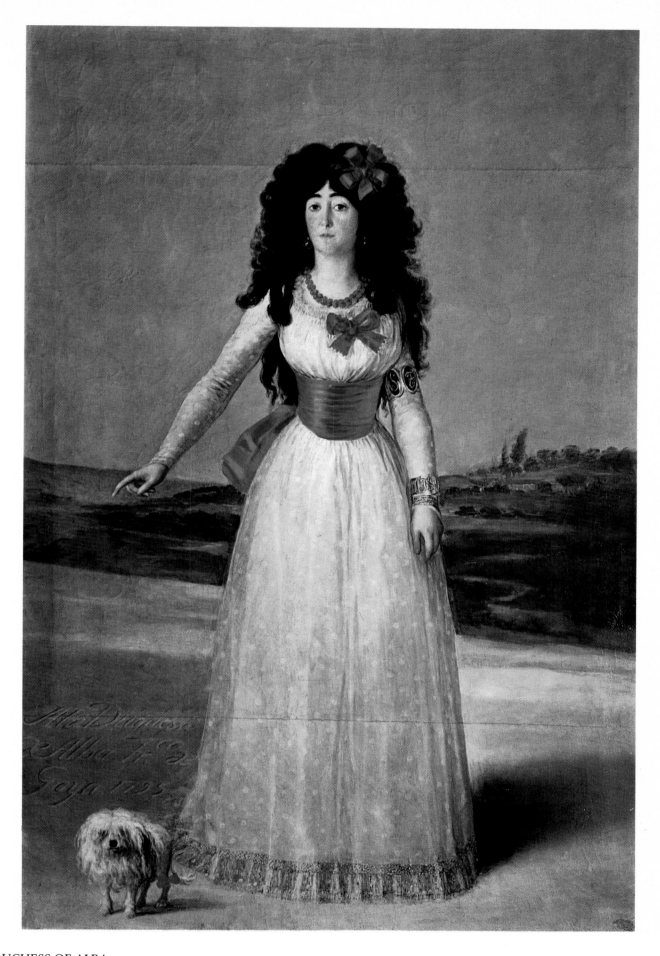

THE DUCHESS OF ALBA
Oil on canvas; cm 194 × 130 (76½″ × 51¼″)
Signed and dated: 'A la Duquesa / de Alba Frcº de / Goya 1795'
Madrid, Alba Collection
At the time of this painting the Duchess was thirty-three years old.

the illnesses that he suffered in 1777 (which resulted in his copies of Velázquez), in 1783 (the origin of the *Caprices*) and in 1819, when he was at death's door (reflected in the *Proverbs*, his 'black paintings' and his first lithographs). This is not to say that Goya suffered from no other illnesses, lesser crises, during his lifetime, nor that he experienced no other difficulties or misfortunes but we have very little solid evidence about him to go on,

and much of what we do have is hard to interpret. Several doctors have tried to diagnose his illnesses and use their medical knowledge to explain why it was that Goya developed his art in the way that he did.

Various explanations have been put forward, some of them contradictory, and we cannot deal with them all as that would divert us from our main theme. There is, in fact, an element of illogicality in these studies: doctors try to classify Goya according to the character types suggested by the German psychiatrist Ernst Kretschmer, using surviving contemporary data as the basis of their theories, and then they try to interpret these same data on the basis that he possessed the human characteristics that they have attributed to him.

The first man to try and analyse Goya medically, Doctor Royo Villanova, stated that from 1787 the artist had suffered from hardening of the arteries and from rheumatism, and that, as well as having suffered at some stage from partial paralysis, he had also contracted typhoid in 1819. In addition, he suggested that Goya's deafness had been caused by an attack of otitis resulting from mumps during his youth. Another Spanish doctor, Sánchez Rivera, tried to show that Goya's illness was syphilis — which would explain the death of so many of his children — a theory that had been hinted at by early biographers, although the vagueness of certain phrases may or may not support this conclusion. Doctor Blanco Soler, however, in his 1946 study of the Duchess of Alba, considered Goya to have been an irascible person, basically more interested in his work than in affairs of the heart, and he based his researches on the sexual symbolism apparent in some of the

THE DUCHESS OF ALBA TYING UP HER HAIR
Brush and India ink with watercolour; cm 171.1 × 10.1 (6¾″ × 4″)
1796-1797
Madrid, National Library (B. 1271 'recto')

WOMAN WASHING HERSELF
Brush and India ink with watercolour; cm 171.1 × 10.1 (6¾″ × 4″)
1796-1797
Madrid, National Library (B. 1271 'verso')
These two works are the two sides of a page from the *Sanlúcar Album*, so called because its drawings were done by Goya near Sanlúcar, during his stay in the summer residence of the Duchess of Alba.

artist's engravings, which were connected with his relationship with the Duchess. He denied that Goya was a syphilitic, but maintained that he was a schizophrenic and that certain elements in his art resulted from his deafness, which caused paranoid obsessions. We should, however, bear in mind that most of Doctor Blanco Soler's studies were published in a book destined to illustrate that the love affair between the Duchess of Alba and Goya had no foundation in truth, and that the Duchess was not the model for the *Majas*. But this brings us to another problem, which we shall deal with at a later stage.

On the basis of the symptoms described by Sebastián Martínez in his letters to Zapater, and also on the basis of actual facts, such as the repeated miscar-

THE DUCHESS OF ALBA
Oil on canvas; cm 210.2 × 149.3 (82⅞"
× 58⅞")
Signed and dated: 'Solo Goya 1797'
New York, Hispanic Society (A.102)
The Duchess is wearing the mourning
dress of a widow: the Duke had died on 9
June of the preceding year, at the age of
forty, and the funeral had taken place in
Madrid on 4 and 5 September. On the
ground at the Duchess's feet we can read
the words 'Solo Goya' ('Goya Alone') and
the date 1797, while on the two rings on
her right hand appear the names 'Goya'
and 'Alba' (see detail).

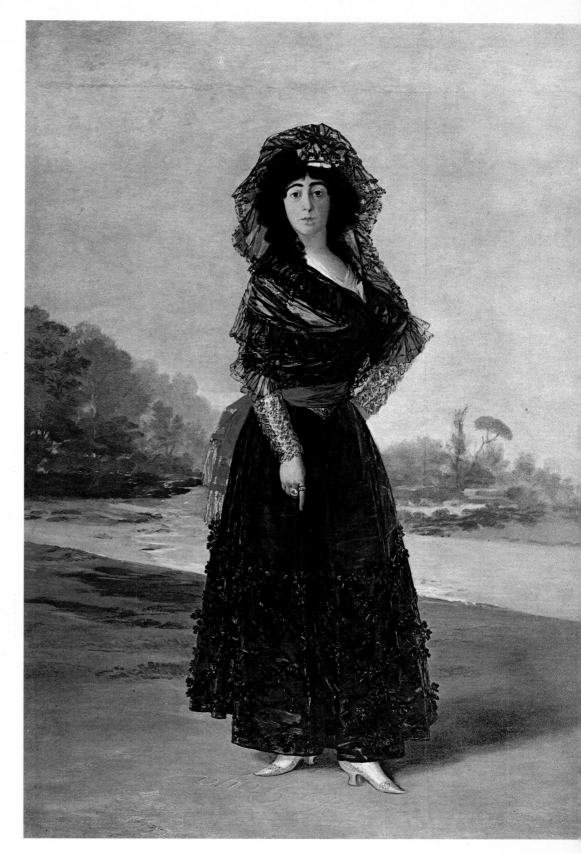

riages and deaths of his children, Doctor Gregorio Marañón (according to
verbal reports by Sambricio) diagnosed Goya's illness as syphilis, either
inherited or acquired, which he transmitted to his wife — hence the miscar-
riages — and which revealed itself in arthritis and arterial hypertension,
with his deafness being caused by the development of auricular sclerosis,
hastened or fostered by his syphilis.
The explanation of his work in terms of schizophrenia has been defended
by such psychologists as Reitman, Carstairs and Rouanet, while Terence
Crowthorne, after an assessment of the relevant data, has suggested that
Goya's illness was a form of Menière's disease, which affects a person's
hearing and sense of balance and also leads to partial blindness. He has

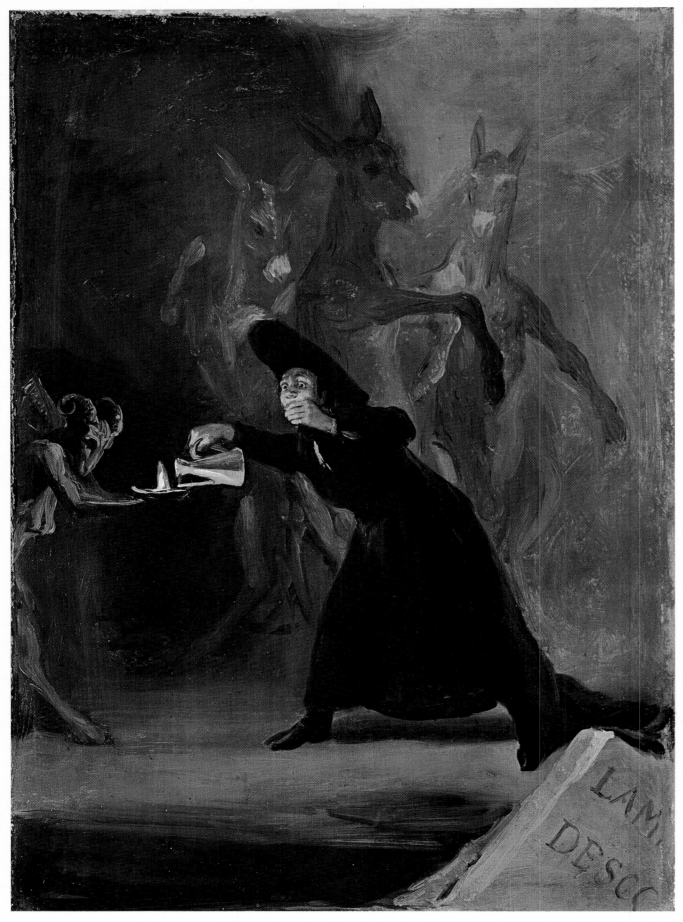

diagnosed the Vogt-Koyanagi syndrome, which affected Goya's art and led to its ranging 'from the cheerful to the macabre, from the colourful to the sombre, from pleasant dreams to terrifying nightmares'. Another Spanish doctor, Riquelme Salar, has diagnosed recurring bouts of depression: in his opinion, Goya's personality was unbalanced, fluctuating between moments of tranquillity and moments of violence and vengefulness. The causes for his feelings of resentment were his deafness, his relationship with

THE DEVIL'S LAMP
Oil on canvas; cm 42 × 32 (16½" × 12⅝")
1797-1798
London, National Gallery (1472)
This work forms part of a series of small paintings done for the Duchess of Osuna, on themes of witchcraft.

the Duchess, his rejection by her and his exile in Bordeaux, but these reasons, when analysed as they stand, do seem relatively trivial, except for the deafness. Yet another theory that has been advanced is that Goya suffered from lead poisoning, contracted from the pigments with which he worked. However, we would do well to conclude by repeating what Gassier very sensibly wrote in his book on Goya: we know that Goya suffered from illness, that he was at one stage at death's door, and that for a time he was partially paralysed, having lost his sense of balance, but his robust constitution saved him and he lived to a ripe old age, with all his faculties intact, except for his hearing, which he lost completely during the crisis of 1792. Between this crises and the one suffered in 1796, when he became victim both of physical illness and of the mental suffering caused by his relationship with the Duchess of Alba, Goya produced a group of portraits that are amongst the most beautiful and inspiring works of his vast *oeuvre*; he drew and engraved his series of *Caprices*, and he painted a series of small pictures that contain many totally new elements and reveal the extraordinary depth of his artistic originality. Undoubtedly, his illness or his unstable and painful mental state acted as a stimulus for his art.

We must now pinpoint certain dates in Goya's life and also in the illnesses that he underwent over the years, because they act as important reference points in dating his works, as well as allowing us to study his artistic development.

On 2 September 1792 Goya attended a meeting of the Real Academia de Bellas Artes de San Fernando and on 14 September he presented a report on the teaching of the arts. In December of the same year, during a visit to Cadiz, he fell seriously ill and spent several months in the house of his friend Don Sebastián Martínez, a wealthy merchant and art collector. The documents that we have for this period are hard to interpret, owing to the fact that the painter appears to have left Madrid without obtaining the permission that, as *pintor de cámara*, he needed. His brother-in-law Francisco Bayeu and his friends obtained a pre-dated permit for him, valid for two months. After the two months were up, although he was somewhat better, Goya was still an invalid in Sebastián Martínez' house, and so the latter wrote to ask for an extension of the artist's permit. His letters of March 1793 are the most explicit that we have in their description of Goya's ailments. He had, according to Martínez, completely lost his sense of hearing, something that he was never to regain. One extract from a letter written on 29 March 1793 states: 'The noise in his head and the deafness are still

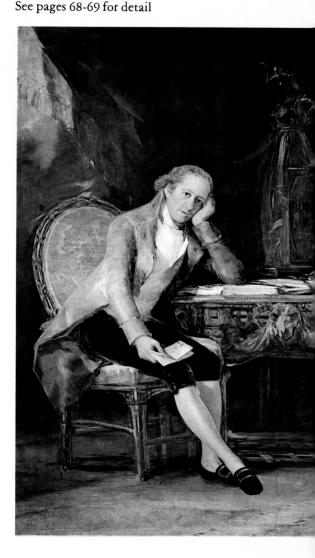

GASPAR MELCHOR DE JOVELLANOS
Oil on canvas; cm 205 × 123 (80¾" × 48½")
Signed: 'Jovellanos / por / Goya'
1798
Madrid, Prado Museum (3236)
See pages 68-69 for detail

'THE DREAM OF REASON PRODUCES MONSTERS'
('El sueno de la razón produce monstruos')
Sepia pen and ink drawing;
1797-1798
Madrid, Prado Museum (470)
Design for the *Caprices* (Plate 43)
This work was used by Goya for the opening etching of the *Dreams* series, and it shows the artist asleep at his work table, surrounded by monsters conjured up by his imagination.
Goya added to the etching the sentence: 'The imagination abandoned by reason generates improbable monsters; added to this, it becomes mother to the arts and the fount of every marvel'.

IT IS TIME
('Ya es ora')
Etching and aquatint; cm 21.7 × 15.2 (8½" × 6")
1797-1798
From the *Caprices* (Plate 80)

present, but his sight is much better and he no longer has the disturbance that he had before, which caused him to lose his balance. He now goes up and down the stairs very well, and he can even do things that he once was unable to...' He then writes that in May 'we will see'. In fact, Goya returned to Madrid in the summer, since on 11 July he once more attended a meeting of the Academy.

Without being prejudiced by the possible exaggeration of what the director of the Royal tapestry works wrote in a letter in early March concerning a petition presented by the painter Zacarias González Velázquez, 'I am led to believe that Goya finds himself totally unable to paint' — or indeed by the assertion of Jovellanos, who was in Asturias at the time and who wrote in his diary on 7 February 1794, on the basis of news that he had received from mutual friends in Madrid, — 'Goya, as a result of his apoplexy, has become incapable even of writing' — there is a third, forgotten text, which I consider to be uncoloured by emotion and much nearer the truth. It is the report dated April 1794 on that same petition by González Velázquez, signed jointly by the two *pintores de cámara*, Francisco Bayeu and Mariano Salvador Maella. In it we read that 'although it is true that Don Francisco Goya has suffered a serious illness, it is equally true that he is partly recovered and is painting, albeit without the same firmness and constancy as before'. The truth of the matter is that in the February of that same year, Goya, together with the *pintores de cámara* Francisco Bayeu and Jacinto Gómez, had inspected and appraised the paintings in the Palacio Nuevo. Obviously, however, it is possible that Goya's signature was just a simple formality, merely a signature placed on a document prepared by his brother-in-law and another colleague.

If, then, we examine all these documents, the conclusion is obvious: Goya was ill and remained so for the whole of the year. On 4 January 1794, however, the artist wrote a letter to Don Bernardo de Iriarte, Viceprotector of the Academy, which has been published on several occasions and commented on even more frequently. Accompanying it was a series of small paintings, 'a set of *peintures de cabinet*' in which, he wrote, 'I have succeeded in making observations that commissioned works do not give scope for and in which caprice and intervention are restricted'. Some years ago, in showing which pictures belonged to this series, presented to the Academy, I indicated that their purpose was to demonstrate that Goya was still in possession of all his faculties: that the illness from which he had been suffering was now a thing of the past. Besides this group of paintings, it is possible that some of his great portraits were also done in the same year: that of *Colón de Larriategui*, for example, and of *María del Rosario Fernández* (page 61), both of which bear the date 1794.

It is important to analyse the technique of these small compositions, defined by the Academy as 'different popular diversions', some of which were dedicated to bullfighting (page 56). These show bulls from their days in the meadow right up until the time that they are dragged out of the arena after the *coup de grâce* has been administered. The remainder depict a variety of scenes that range from one of *Commedia dell'Arte* figures (page 57) to others of disasters, such as a fire (page 58) and a flood. I am convinced that the small picture included by Gassier and Wilson as no. 325, *'The Puppet Seller'*, does not form part of the series, given the proportional disparity of the figures in relation to their surroundings, but I would include the one of the interior of a prison (catalogue no. 241), whose proportions and colouring correspond to the others in the group, as I proposed when publishing the series. All the paintings are finely executed, with minute brush strokes, and the figures are well defined, with a nervous and vibrant attention to detail. They somewhat resemble the drawings of *Dreams*, the precursors of the *Caprices*, except for the differences that naturally result from the medium used. However, we will come to these later and deal with the whole series of problems posed by this series of engravings.

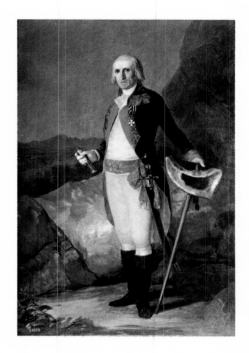

GENERAL JOSÉ DE URRUTIA
Oil on canvas; cm 200 × 132 (78⅞″ × 52″)
Signed: 'Goya al General / Urrutia'
1798
Madrid, Prado Museum (736)

FERDINAND GUILLEMARDET
Oil on canvas; cm 185 × 125 (73″ ×
49¼″)
1798
Paris, Musée du Louvre (M.I.967)
The subject was French ambassador to
Spain.
See pages 72-73 for detail

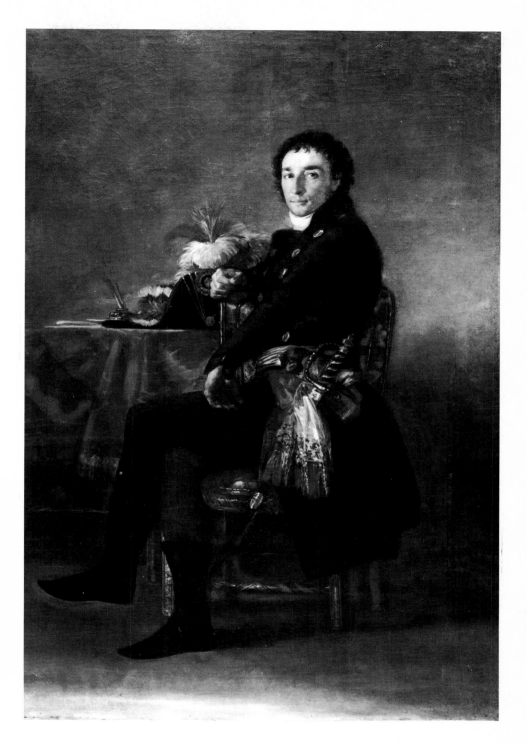

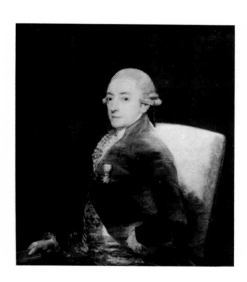

BERNARDO DE IRIARTE
Oil on canvas; cm 108 × 84 (42½″ ×
33⅛″)
Signed and dated along the bottom (not
visible in the illustration): 'Dⁿ Bernardo
Yriarte Vice Protʳ. de la Rˡ. Academia de
tres nobles / Artes, retratado por Goya en
testimonio de mutua estimacⁿ. y afecto,
ano de / 1797'
Strasbourg, Musée des Beaux Arts (308)
A cultured man, an art collector and
friend of Goya, Iriarte was Minister of
Agriculture, of Commerce and of
Colonial affairs during his lifetime. He
died in exile, in Bordeaux, in 1814.

In 1795 Goya painted the portraits of the *Duke* and *Duchess of Alba*; the
one of the Duke is now in the Prado, while that of the Duchess, in a white
dress, with an inscription and the date, is in the Alba family home in
Madrid (pages 62 and 63). A letter written by the artist to Zapater gives
positive proof of what was an inevitability, given the position of the artist at
Court: that he had been in close contact with the Alba family for some
time. We do not know, however, whether he had painted the Duke and
Duchess before writing this letter, but the letter does reveal that by 1794
the Duchess had already begun flirting with the artist. There is no other way
of interpreting her desire to have him paint her face: 'It would be better for
you to come and help me paint the Alba woman, who installed herself in
my studio so that I could paint her face, and then left as she was; it was
certainly more pleasant than painting on canvas …' The fact that this
resulted in a certain familiarity is proved by the two small paintings of
domestic scenes, in which the figures are traditionally identified as the
Duchess and an old family retainer nicknamed '*la Beata*'. Both paintings
bear an inscription with the date of 1795 (catalogue nos. 266-267). During
the succeeding year Goya suffered greatly, as a result both of his love for the

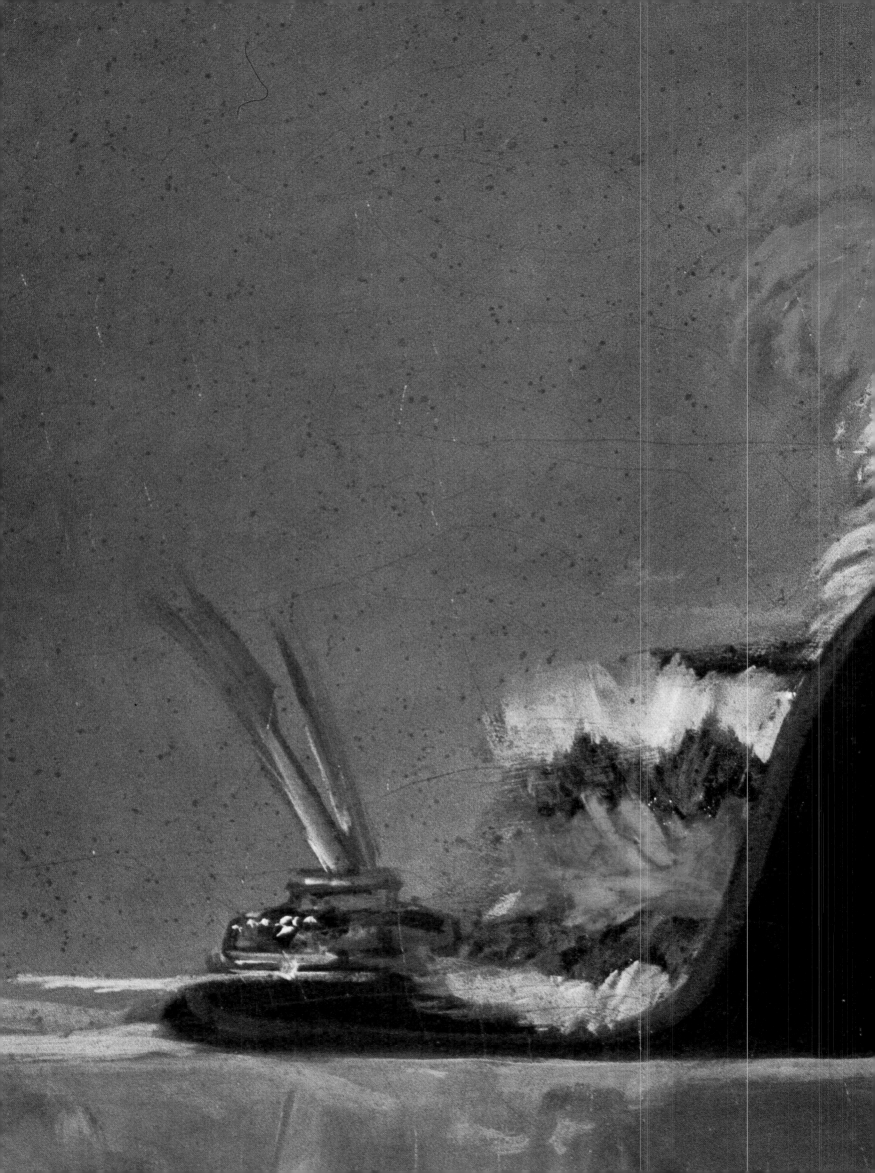

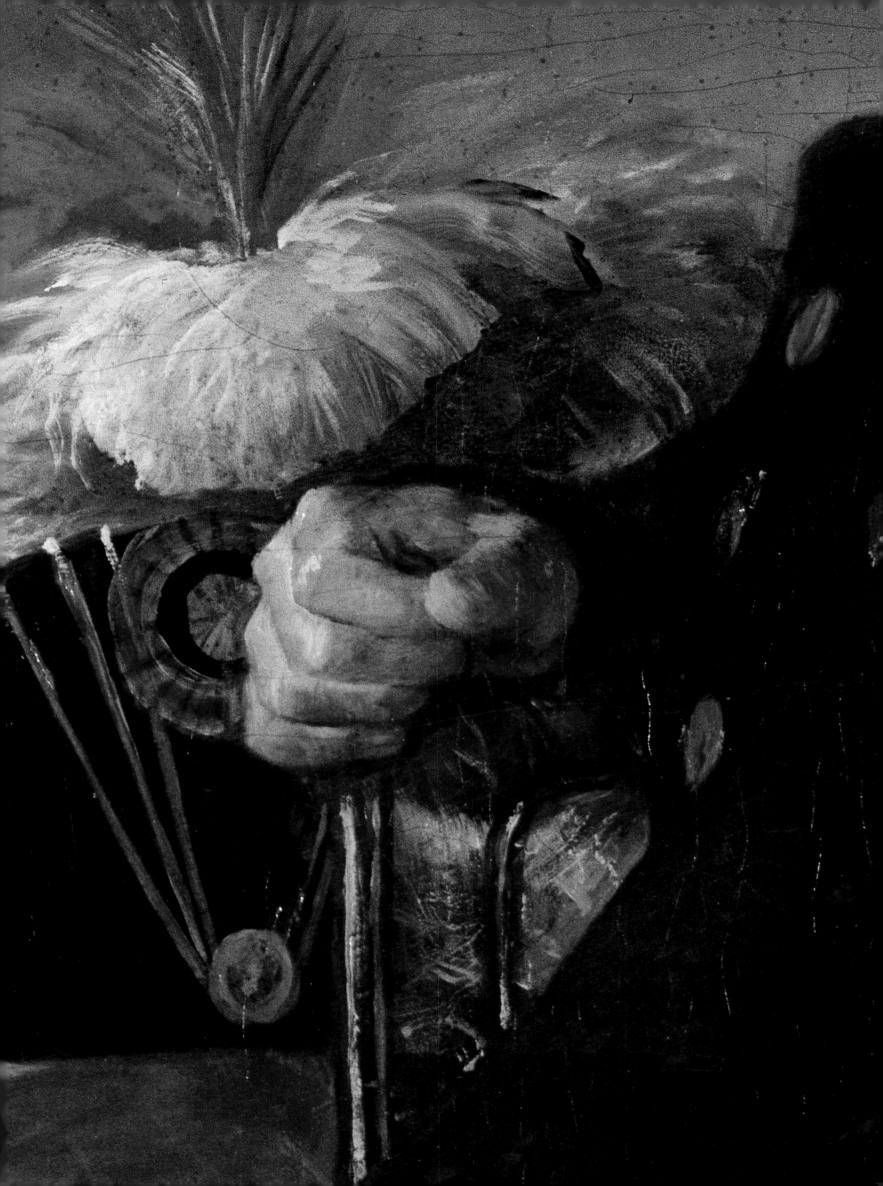

Duchess and of the jealousy caused by her indifference: pangs of jealousy that coincided with a new illness, again suffered in Cadiz. It is possible that his second journey to Andalusia is connected with the paintings done for the Santa Cueva in Cadiz, which we will discuss later.

In May 1796 Goya was in Seville, staying with his friend Ceán Bermúdez; in the summer he was with the Duchess of Alba in Sanlúcar de Barrameda (the information published by Ezquerra del Bayo makes it impossible to maintain that Goya's relationship with the Duchess developed during his first trip, since in that year the Alba family had rented out their house in Sanlúcar). We know from documents that the Duchess was in Madrid, when the Duke, during a visit to Andalusia, was stricken by a fatal illness in Seville and died on 9 June at the age of 40. The Duchess, who was 34, left for Seville and then settled in Sanlúcar, where she was during July. Goya's stay must have been during the summer months, as is shown, by the drawings in his small album, known as the *Sanlúcar Album* from its description thus by Carderera; the costumes worn by the figures in these small scenes is summer dress, and in more than one of the drawings its carelessness implies a warm climate (page 64).

The Duchess left Sanlúcar for Madrid in order to attend her husband's funeral, celebrated on September 4 and 5, returning subsequently to

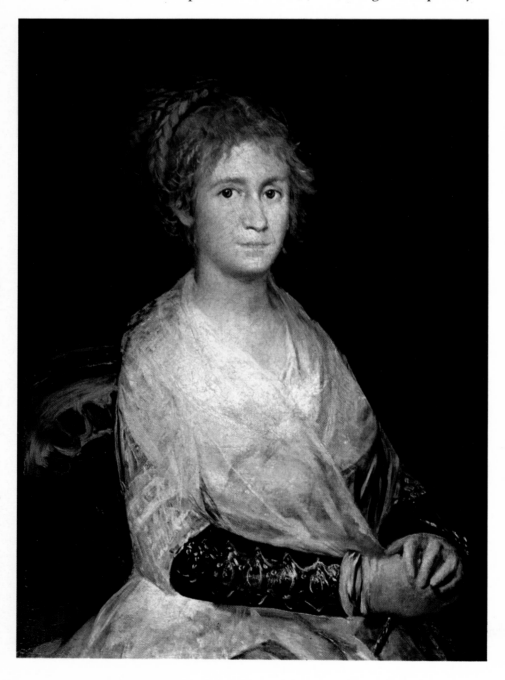

JOSEFA BAYEU
Oil on canvas; cm 81 × 56 (31⅞″ × 22″)
Circa 1798
Madrid, Prado Museum (722)
One of the two portraits Goya did of his wife.

Facing:
LA TIRANA
Oil on canvas; cm 206 × 130 (81⅛″ × 51¼″)
Signed and dated: 'La TIRANA / Por Goya a 1799'
Madrid, Real Academia de San Fernando (677)

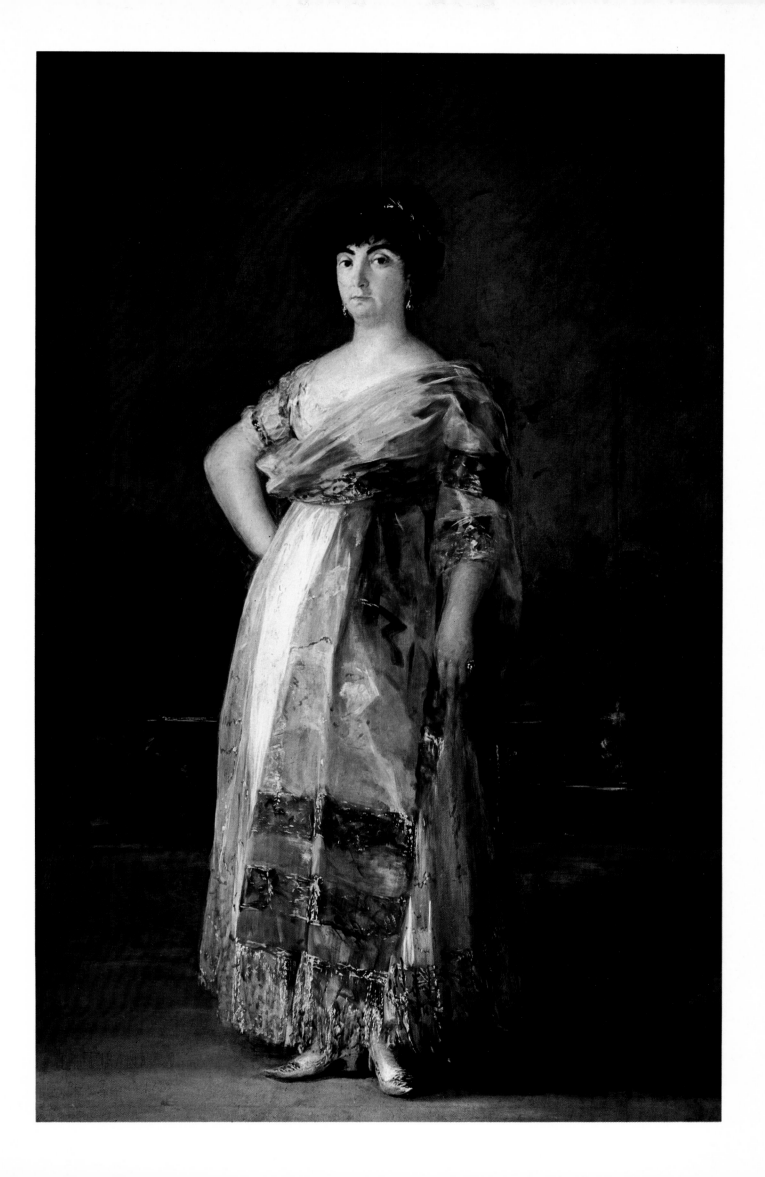

Sanlúcar to spend her period of mourning there. It was there, on 16 February 1797, that she made and signed her will. We also know from a letter that Goya was in Cadiz during January 1797 and that on 10 April of the same year he resigned as Director of Painting in the Royal Academy. This means that, between May 1796 and April 1797, Goya was absent from Madrid in Andalusia. He was 50 years old at the time of his love for the Duchess, which reached its climax in Sanlúcar during the summer of her widowhood. Whatever his relationship with her may have been, it is certain that it assumed a far greater importance for Goya than it did for the Duchess, whether for reasons of indifference, coquetry or pride. The artist's love stands revealed in his portrait of the *Duchess in mourning*, now in the Hispanic Society in New York (page 65). In it the Duchess is portrayed wearing two rings, one of which bears the inscription 'Alba' while the other is inscribed 'Goya'. Her right arm points to the ground, on which there is another inscription which says 'Solo Goya' ('Goya Alone'). The portrait, which the artist kept until his death, is the confession of a proud and contented love. But soon disillusionment crept in, and with it jealousy. The drawings in the *Sanlúcar Album* are reflections of Goya's feeling of intimacy, and certain unpublished etchings, which would seem to refer to the Duchess (for example, *The Dream of Falsehood and Inconstancy*),

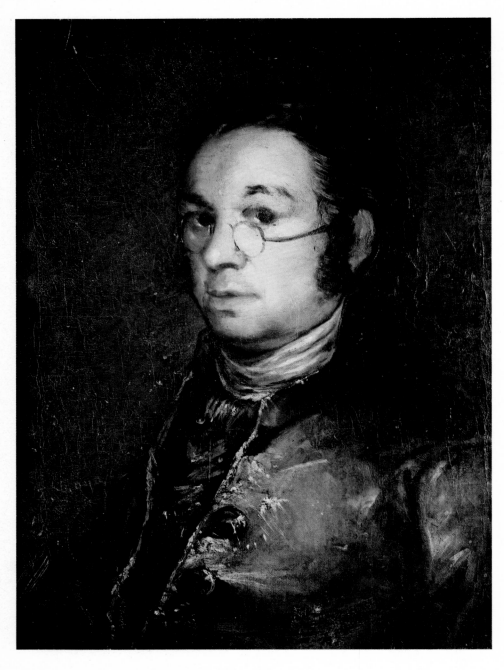

SELF-PORTRAIT
Oil on canvas; cm 63 × 49 (24⅞" × 19¼")
Signed: 'Goya'
Circa 1797-1800
Castres, Musée Goya
The artist has here shown himself wearing the glasses he used for engraving: we are able to date the painting to a period that coincides with the *Caprices*.

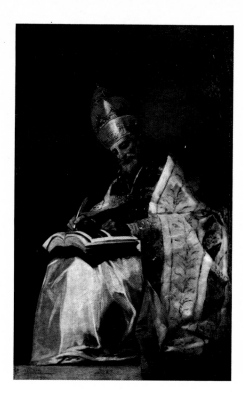

ST. GREGORY THE GREAT
Oil on canvas; cm 190 × 115 (74⅞″ × 45⅜″)
Circa 1796-1799
Madrid, Museo Romántico (21)

ASENSIO JULIÁ
Oil on canvas; cm 56 × 42 (22″ × 16½″)
Signed: 'Goya a su / Amigo Asensi'
1798
Lugano-Castagnola, Thyssen-Bornemisza Collection
Juliá was a pupil of Goya's and collaborated with him on the frescoes in San Antonio de la Florida.

denounce his love and his pangs of jealousy. Later, on the death of the Duchess, he completed several painting projects for her tomb, and perhaps a sepulchral monument.

If the Duchess was only playing a game, Goya was the victim of a very real passion; and it was this that caused, or contributed to, the illness from which he suffered during his stay in Cadiz. The time has now come to deal with the problems relating to his relationship with the Duchess, the cause of a legend and of many comments. I refer to the two paintings of *Majas*, the one naked and the other clothed, which, according to the legend, are of the Duchess and therefore one more proof of the intimacy that existed between her and Goya.

It was Viardot in 1845 who first propounded the theory that the Duchess had posed for the *Majas*, a theory that proved a great success, despite the fact that it has no basis in any known truth. The history of the paintings, which has been gone over on a number of occasions, certainly does not support it. They first appear in the inventory of Godoy's possessions in 1803: Godoy, the Queen's valiant lover, who refers in one letter to the intimacies that he had enjoyed with the Duchess. After his disgrace, his collection of paintings was confiscated by the King, and when the war was over, Goya was summoned by the Inquisition to give evidence as to the authorship of certain obscene paintings, amongst which were the two *Majas*. However, we only know the beginning of this story because the trial never proceeded, but it seems to have had no effect on Goya. The two *Maja* paintings then passed into the possession of the Real Academia de San Fernando, from whence they were transferred to the Prado at the beginning of this century. It is there that they have acquired the reputation and universal admiration that they now enjoy. Nevertheless, the little that we know of their history does not reveal with any certainty for whom they were painted, nor does it tell us when they were painted or the identity of their sitter.

After the death of the Duchess of Alba in 1802 with no direct heir, Godoy managed to acquire a number of pictures from her collection, but it does not follow, however, that the *Majas* were amongst them. Although we know that they both belonged to him in 1803, we know nothing of their previous history.

I consider it important to reaffirm my own personal belief that the two paintings cannot have been done at the same time since they are technically so different. The *Naked Maja*, because of the way in which it is painted, its delicate modelling, the greenish grey shades of its background and the careful attention to detail in the drapery, must be considered to date from about 1790 to 1795, whereas the *Maja Clothed* must be from about 1803 to 1805, or perhaps even from the years immediately following, since the brushwork in the latter is lighter and the general colouring is altogether different: the dress that she is wearing is a sort of tawny colour, similar to others painted in the latter part of the first decade of the 19th century (pages 84-85). This would seem to suggest that the *Maja Clothed* was commissioned to cover, as it were, the naked one. Whoever the woman was that Goya portrayed in the nude, he altered her face in doing so, in such a way that it seems like a mask, which leads one to suspect that both the person who commissioned the work and the painter himself wanted to conceal her true identity. It does not seem possible that she could have been a woman of more than thirty years old, the age of the Duchess at the height of her relationship with Goya. She would appear to be about twenty years old, maybe a little more, possibly some young and beautiful woman. It has been suggested, also without any proof, that she may have been Pepita Tudó, Godoy's mistress, by whom he had children. There is, however, no evidence to support this theory.

Judging by the drawings in the *Sanlúcar Album*, there were, in the entourage of the Duchess during those happy days, a number of young women whom Goya drew in poses that reveal a very high degree of intimacy. We have no idea who they were, nor if it was one of them who posed naked for

the artist; all we have are suspicions and doubts. The identity of his model still remains a mystery that may never be resolved.

We now have to return to Goya's second stay and second illness in Cadiz, since they are inextricably linked to the problem of his drawings and hence to the origins of his series of *Caprices*. There are two albums of drawings in existence, the first called the *Sanlúcar Album* and the second, the larger of the two, called the *Madrid Album*, even though it may have been started in Cadiz. It is the Sanlúcar one that portrays the everyday activities of the care-free little group in which Goya discovered his love for the Duchess. The second one, whose drawings are more elaborate, shows different character-istics, not only in its technique, but also in its whole spirit, which in many instances is critical of society, and it seldom acts merely as a record of fleeting moments of pleasure, like the Sanlúcar one. Many of the drawings in the *Madrid Album* were subsequently used for his series of *Caprices*.

We have already mentioned that in May 1796 Goya was in Seville, staying with his friend Ceán Bermúdez, and that he later spent some of the summer

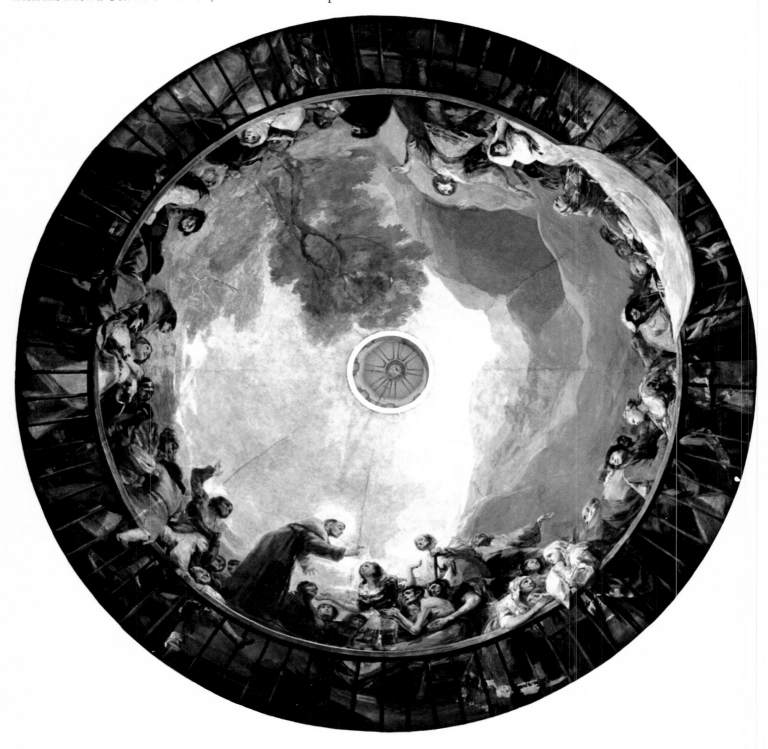

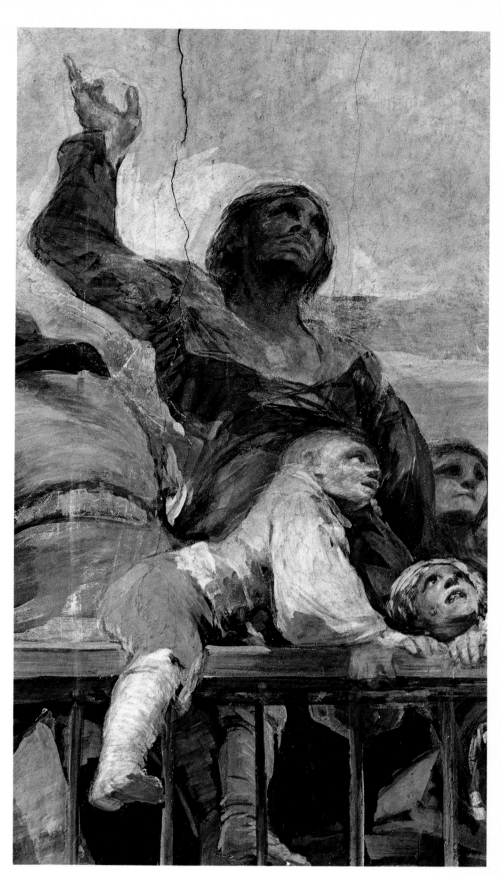

THE MIRACLE OF ST. ANTHONY OF
PADUA
Fresco; diameter cm 550 (216¾")
1798
Madrid, San Antonio de la Florida
Jovellanos used his influence to ensure
that Goya obtained the commission for
this fresco, which the artist painted in a
highly individual style.
Right: detail

months with the Duchess of Alba in Sanlúcar de Barrameda. We also know
that in September he was in Cadiz, ill. He was still there in December, still
ill, possibly staying in a house of his own. We know this from the diary of his
friend Leandro Fernández de Moratín, who not only wrote several impor-
tant plays, but was also the author of a lively and copious correspondence
with his friends, from which we have already quoted certain passages.
Moratín had returned to Cadiz after two years abroad, and he noted in his
diary that, after dining with Sebastián Martínez, they had both gone to visit
Goya during his illness. Moratín paid further visits to the artist during the
rest of the year; he also recorded a number of other meetings in January
1797, and his stay in Cadiz is confirmed by other letters still existence.

Goya tendered his resignation as Director of Painting to the Academy on 1 April 1797; his resignation was accepted and it is probable that he was already in Madrid by that time. I have already stressed the importance of this meeting between Goya and Moratín, something which Hellman also sensed. During his long absence abroad Moratín had spent a number of months in England. Besides keeping a diary and writing numerous letters, he also wrote a collection of *Observations*, in which he noted down his ideas on various aspects of daily life that attracted his attention, as well as making a variety of reflections on life in England. In one of these observations he wrote something that is of great importance in trying to understand the development of Goya's art: it is the passage in which he deals with the English art of caricature. After explaining the overwhelming success of this

art form and the licence enjoyed by the caricaturists in their portrayal of the King, his Ministers, Parliament and anyone else who counted for anything in English life, he then went on to describe some of the caricatures and also to expound a theory as to the significance of the genre, comparing it to different types of theatre. We must bear in mind the fact that Moratín was himself a playwright, some of whose works had been very successful.

'Liberty, prosperity! Long live the Constitution! If this is the way they treat their king and his ministers, we should not expect them to act with any more restraint towards other nations: never have I seen the royal person more debased than in English caricatures; nor is there any European sovereign, however feared and powerful, who has succeeded in escaping being made into a figure of fun in them and being served up as cheap entertainment for the people of London. The element of ridicule in the caricatures consists of three things: first, in the satirical way in which the whole thing is presented, which is equivalent to the plot of a comedy; secondly, the actions of the personalities, which corresponds to theatrical situations; thirdly, in the accentuation of gestures, which is the same as the way in which the visible characters introduced into a drama express themselves. A caricature is to a pleasing drawing what a farce is to a good comedy. Amongst the many works of this type that are published every day there are some that have a certain degree of merit.'

We must bear in mind what kind of education Moratín had had, in order to appreciate his interest in caricatures. His father had prevented him from studying in Alcalá and had made him study drawing so as to follow in the family trade: both his father and his grandfather were jewellers to the Royal Family. Leandro Fernández de Moratín did not abandon his career as a jeweller until after his mother's death, by which time he had already made

THE MIRACLE OF THE LOAVES AND FISHES
Oil on canvas; cm 146 × 340 (57½" × 134")
Cadiz, Santa Cueva
This work, and the other two large canvases of *The Parable of the Wedding Banquet* and *The Last Supper*, was commissioned from Goya for the oratory of the Santa Cueva in Cadiz, in 1792, but the serious bout of illness that struck him shortly afterwards prevented his starting work on them until the opening months of 1796. The three works were finally completed after the oratory's inauguration, which took place in Cadiz on 31 March 1796.

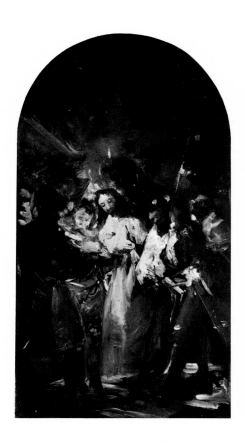

THE TAKING OF CHRIST
Preparatory sketch
Oil on canvas; cm 40 × 23 (15¾″ × 9″)
1798
Madrid, Prado Museum (3113)

THE TAKING OF CHRIST
Oil on canvas; cm 246.5 × 138.5 (97⅛″ × 54½″)
Toledo, Cathedral Sacristy
The picture was commissioned from Goya by the Archbishop of Toledo

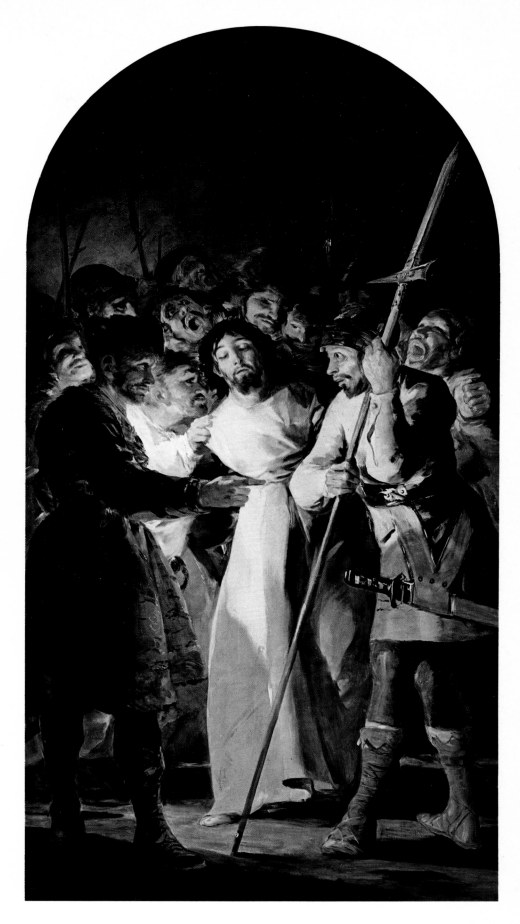

his name as a writer. From then on he concentrated exclusively on his literary career. He was, however, still very knowledgeable and interested in the problems of drawing, which he continued to practise, as is proved by the examples of his work that have survived.

Everything points to the likelihood of Moratín having discussed his English experiences with Goya; he may also have shown the artist the caricatures that he had brought back with him, explaining his theories concerning them and their value to society.

This influence would also explain the change that becomes apparent at a certain stage in the so-called *Madrid Album*. We cannot specify the exact page number with any certainty since there are some pages missing from the sequence proposed by Gassier, but at any rate it occurs after the 50th illustration and undoubtedly after the 55th (nos. 51-54 are missing). In the early pages of the album we still encounter, in similar situations, the same figures as are in the compositions in the *Sanlúcar Album*: that is to say, *majos* and dandies indulging in different games of courtship. Many of

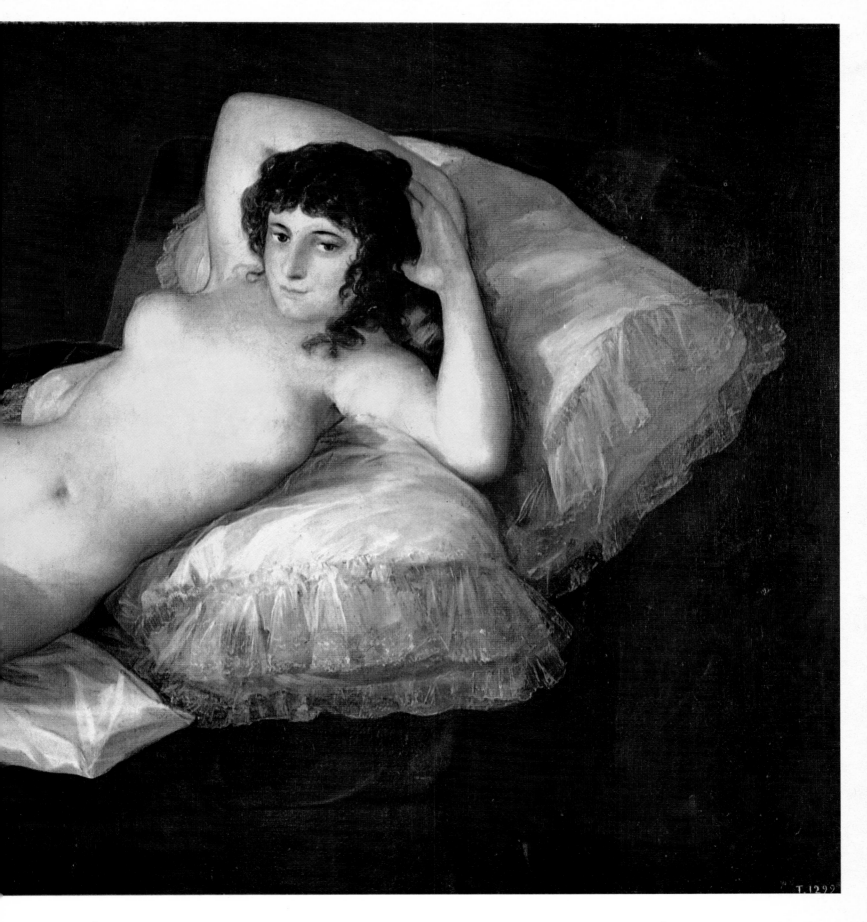

THE NAKED MAJA
Oil on canvas; cm 98 × 191 (38⅝″ ×
75¼″)
Circa 1790-1795
Madrid, Prado Museum (742)
The impossibility of identifying the sitter
has, over the years, given rise to the most
various and far-fetched conjectures.

those in this second album seem not to have been copied from life, unlike
most of those in the *Sanlúcar Album*; they are compositions to which the
artist has tried to impart some meaning. There then occurs an abrupt and
complex change; for one thing, the drawings are, on the whole, more
rapidly executed, and also the artist has placed increasing emphasis on the
shading of the background. It is as if he had taken less care with them than
with the preceding ones. It should also be pointed out that they contain in-
scriptions, in which can be seen words such as 'caricature', 'masquerades'

or 'witches', while the characters that they portray are ridiculous or grotesque, with deformed faces and exaggerated expressions. The example of the English caricatures and Moratín's theories about them coincided with the bitter vision of the world that Goya had at that time.

He was ill once more; his love had been rejected by the Duchess, and after the idyllic summer spent at Sanlúcar, Goya, devoured by jealousy, seems not to have returned to the Duchess's residence during the second part of his stay in Andalusia.

It was against this background that Goya drew his *Caprices*, a work which is, in every respect, of major importance. The series of etchings that comprise the *Caprices* mark a high point in the engraver's art and also led to Goya's work becoming appreciated outside his native country; for many years his reputation abroad rested solely upon them. The complexity of the technique employed, much of which was of Goya's own invention, and the spirit of criticism revealed by the images, were also something new in the history of engraving.

The series was put on sale in 1799, in a single volume containing eighty plates of different subjects: some reflect his concern as a member of the Enlightenment and criticize the misconceptions and superstitions of the common people, presenting a graphical résumé of the ideas that inspired the small group of intellectuals who were clamouring for reforms in Spain. Some deal with the relationship between men and women in society, while others have as their theme dreams and fantasies. The uncompromising representation of reality goes hand in hand with escapes from it. But when did Goya originally get the idea of this series of engravings? There is one fact that seems clear: the first plates conceived by the artist are those in the group whose preparatory drawings are headed *Dreams*. Carderera, who was extremely knowledgeable about Goya, stated categorically on two occasions that preparatory work on the series began round about 1793 and that it finally appeared between 1796 and 1797. More recently, Gassier has reaffirmed the truth of this statement. There can be no doubt that Goya had for some time toyed with the idea of producing a series of engravings with fantastic themes, mainly witches and goblins, and that he subsequently decided to add others with a more satirical and critical content. But

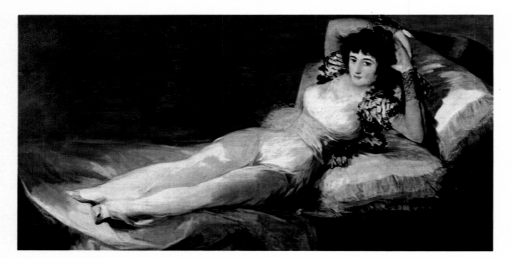

THE MAJA CLOTHED
Oil on canvas; cm 95 × 188 (37⅜" × 74")
Circa 1803-1805
Madrid, Prado Museum (741)
Both 'The Naked Maja' and 'The Maja Clothed' came from Godoy's collection, but technically the two works differ in many respects, which is the reason for assigning different dates to them.
Facing: detail

it should be also pointed out that a number of them had their origins in drawings in the *Madrid Album*. At a later date we should return to this topic and discuss it more fully, but for the moment we must content ourselves with saying that the number of plates gradually grew, since Goya, in order to convey his thoughts fully, only used symbols and allegories on a very few occasions. He expressed himself by means of interrelating compositions, which must be regarded as forming a single entity. It is in these series that the artist's thoughts concerning a particular subject stand revealed in their entirety, and it is for this reason that there are groups of

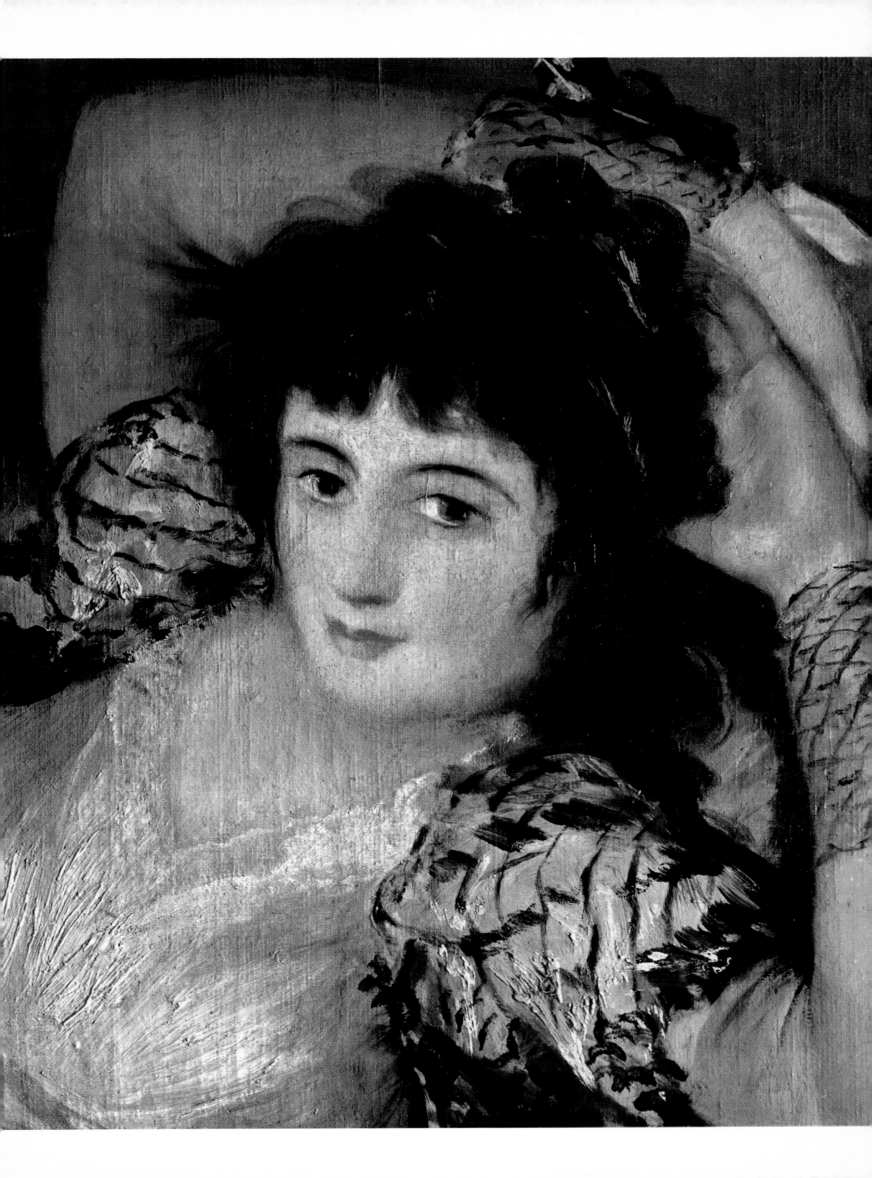

drawings or engravings of similar themes which must be viewed within their overall context.

In some instances we can see that the captions which he gave them refer to either preceding or succeeding compositions, both in his albums of drawings and in his engravings; sometimes they can almost be made into a complete sentence. This is why the set of engravings that was to form *Dreams* grew into the immortal *Caprices*, in which the majority of the plates have a critical and moralizing content that relates them one to another. The large number of preparatory sketches that are still in existence confirm this, as well as substantiating what Carderera wrote. The sketches fall into three categories: the first and least numerous group are meticulously executed pen and ink drawings framed by a border of small hatched lines; the second group, the majority, are swiftly drawn sketches in *sanguine*, very occasionally finished in ink or gouache; the third and final group comprises a small number of drawings done with a wash of *sanguine* or India ink. Again it should be remembered that a certain number of the preparatory drawings were based on earlier ones, some from the *Sanlúcar Album* and others from the *Madrid Album*. There are a number of reasons for believing that the first plates in the series were those depicting witches and such like, but the main one is that they were all very accurately done with a pen. The reason for the care taken in their execution is, perhaps, twofold. The first is that, stylistically, they are closely related to the small paintings sent to Iriarte in 1793 or 1794; as in these, the figures are small and portrayed in great detail, possibly so as to convince everyone that he was totally recovered from his illness. The second reason is to be found in Goya's relative inexperience as an engraver. Before the *Caprices*, apart from one or two isolated prints, Goya had only ever done the series of Velázquez copies, making use of drawings carefully transferred onto the plate. This series of copies showed how quickly Goya came to terms with the art of engraving, but, nevertheless, at the start of the *Caprices* he had still not completely mastered the technique even though it was not long before he had. In addition, he had never before attempted the different techniques of aquatint, resin, and so on which he experimented with in the *Caprices*. When starting work on engraving the *Dreams*, therefore, Goya had to use very carefully executed drawings to transfer onto the plate in order to make the process as easy as possible. In this way he managed to engrave those scenes of fantasy and witchcraft, as well as a very small number portraying

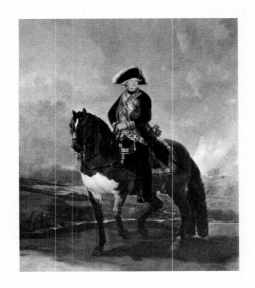

CHARLES IV ON HORSEBACK
Oil on canvas; cm 336 × 282 (132⅜″ × 111⅛″)
1800
Madrid, Prado Museum (719)

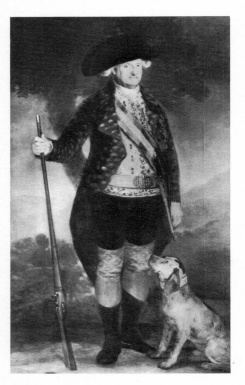

CHARLES IV IN HUNTING DRESS
Oil on canvas; cm 210 × 130 (82¾″ × 51¼″)
1799
Madrid, Royal Palace

MARÍA LUISA IN A MANTILLA
Oil on canvas; cm 210 × 130 (82¾″ × 51¼″)
1799
Madrid, Royal Palace

QUEEN MARÍA LUISA ON HORSE-
BACK
Oil on canvas; cm 378 × 282 (133⅛″ ×
111⅛″)
1799
Madrid, Prado Museum (720)
We have a great deal of first-hand information about the two equestrian portraits, thanks to the letters from María Luisa to Godoy. From these we know that the Queen's portrait was painted in October 1799, and that the horse, whose name was Marcial, had been a present from Godoy.

costumes. Later on, when he became more proficient, he restricted himself to preparatory sketches that were little more than bare outlines, and these red chalk drawings form the basis of the majority of the plates in the series. Few of the *Dreams* engravings are derived from the *Madrid Album*, but of those that do, four are of witchcraft, while the remainder, about a dozen in all, have other themes.

In my opinion, Goya must have begun the *Dreams* before his second trip to Andalusia and then completed others in Cadiz, since some are based on drawings in this album; the remainder, which deal critically with society in general and Spanish society in particular, must have been completed during the months between his return to Madrid and the start of the collec-

tion's sale in February 1799, a period of just under two years. As we have already stated, they were the ones that were based on nothing more than sketchy drawings in *sanguine*: it is in these that we encounter the critical spirit of the caricaturist, which appeared in the *Madrid Album* as a result of Goya's conversations with Moratín.

We should also bear in mind that, besides the explanations dating from Goya's own lifetime, which he may himself have been responsible for and which see the plates as being a general criticism of society, there are others that identify the specific targets of this criticism. They regard certain scenes in the *Caprices* as being violently critical of recognizable personalities, such as María Luisa and Godoy (the *Príncipe de la Paz*) amongst others. This view of the *Caprices* was expressed by the important political writer Joseph de

 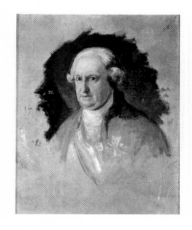 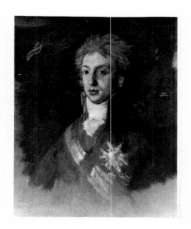

Maistre, even during Goya's lifetime. We have no way of completely refuting his suggestions, despite the fact that both the *Caprices* and de Maistre's writings were acquired by the King without Goya suffering any kind of repercussions. De Maistre's assertions play an important part in our attempts at interpreting the etchings, despite the fact that we know, from the way in which other drawings gained their titles, that Goya, ever cautious, each time gave a vaguer and more general explanation of what had originally been criticism aimed at a specific target.

In order to protect himself after the publication of the *Caprices*, the following notice appeared in the *Diario de Madrid* on 6 February 1799, undoubtedly at Goya's instigation: 'in none of the compositions that make up this collection has the author intended to ridicule the defects of any particular individual … this would indeed mean placing too narrow a limit on talent and abusing the means by which the imitative arts produce perfect works.' However, we should add what many authors, amongst them López-Rey, have observed: that the use of dreams as a satirical medium has precedents in Spanish literature, notably in the widely read and often published *Sueños* of Francisco de Quevedo. Also, in order to weaken the critical content and make it harder to understand each personal reference, the order of sequence given to the *Caprices* by their author is intentionally confused: in the words of Sánchez Cantón, they have been 'shuffled'. In the *Dreams* series the first plate, the one which ought to have acted as its frontispiece, is the one that now bears the number 43 (page 67), which should have preceded the scenes with witches and sorcerers.

Everything so far has been concerned with the development of the *Caprices* and the varying degree of meaning that Goya sought to either reveal or hide in his plates. But, as yet, we have not touched on the most important aspect of the series: the way in which Goya cleverly adopted the techniques of the past masters of engraving. He managed to capture the brilliant *chiaroscuro* of Rembrandt, whom he regarded as his master, and succeeded in achieving a dramatic compositional effect by means of a precise portrayal of the varying degrees of light and shade. At the same time he succeeded in

culling from Tiepolo's *Vari Capricci* and *Scherzi di Fantasia* his mysterious figures, his configurations and certain representational methods that give a feeling of ambivalence to the characters suspended half way between reality and fantasy, making them both spectators and participants in the events that surround them.

Another aspect of Goya's relationship with Moratín and his friends lay in the latter's love of attending traditional theatrical productions and magical comedies complete with complicated mechanical effects. Moratín had been brought up by his father and his father's friends to appreciate the principles of Neoclassicism: the theatrical 'unities' of the French dramatists and the poetical works of Boileau. His ideas are contained in the *Lección poética*, a work which gained him a prize from the Academy in 1782. The theories

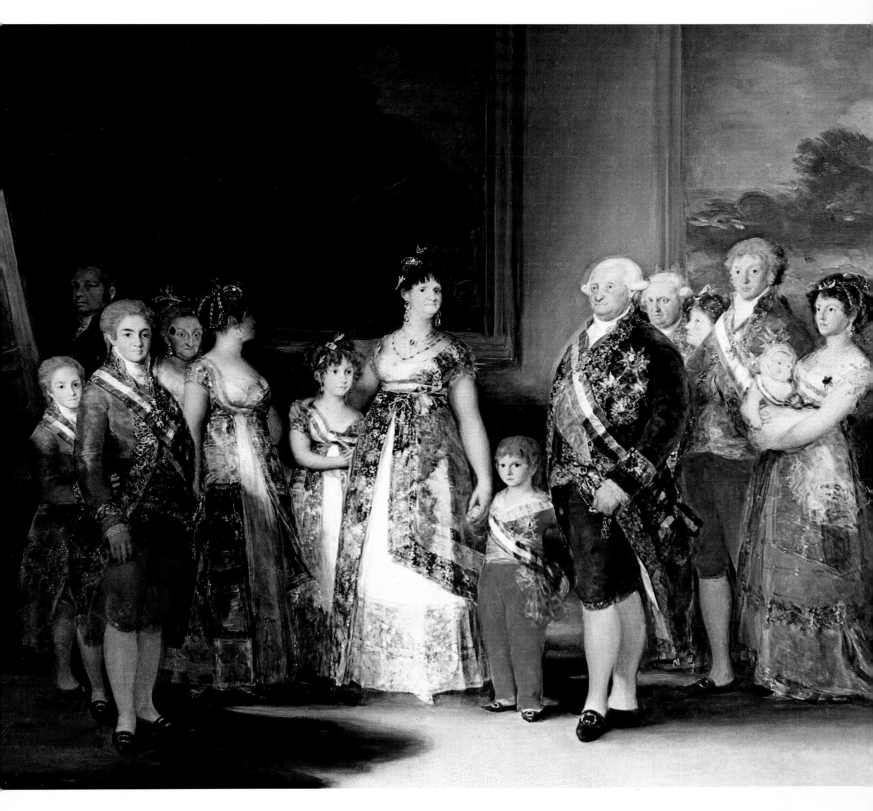

contained in that work were the ones that he subscribed to and which he put into practice in his most outstanding comedies. But everyday life was somewhat different, thanks to his sense of enjoyment. In his *New Comedy* Antonio, his theatrical 'alter ego', confessed that he went to see both bad plays (that is to say, traditional ones and ones with a magical element) and good ones: 'if' as he says 'the production is a good one, one watches and applauds; if, on the other hand, it is full of inanities, one laughs and passes the time...' Moratín and his friends had a reserved box, and they watched, day after day, a wide variety of different performances. We know that they then used to gather in Tineo's house, in what they called the *Sociedad de los Acalofilos*, in order to laugh at what they had just seen or to read other equally varied comedies. In Enlightenment circles the same kind of thing must have gone on, and they probably criticized the same comedies, even if they lacked the assiduousness and 'professionalism' of Moratín and his friends.

All this explains the reason for the themes of the small paintings done for the Duchess of Osuna, for which Goya received payment in June 1798 (page 66). This means that they were contemporary with the *Caprices*, having been painted while he was completing that series. It should also be added that very possibly they were the paintings exhibited at the Royal Academy in 1799 under the title of *Six Curious Caprices*. It has been revealed that two of them were inspired by two comedies of Antonio Zamora: *El hechizado por fuerza* and *El burlador de Sevilla*, both of them filled with mechanical effects and built around themes in which the supernatural dominates.

It is amazing how prolific and how varied Goya's artistic production was during the closing years of the century. In examining it we come across a growing number of paintings, as well as a great variety of themes. Goya found inspiration in everything.

Goya's decorations for the Godoy Palace were works in which, exceptionally, he made use of conventional symbolism: two large paintings from the series, as well as a few circular compositions, are still in existence (*Agriculture*, *Industry* and *Commerce* are in the Prado, while a fourth painting, which in all probability represented *Navigation*, has since been lost). It seems that they were painted to adorn the staircase, while the two largest canvases, portraying *Poetry* and *History*, were intended for the library. The circular compositions are very freely yet brilliantly executed, since they were to be viewed from a distance.

Goya also prepared a series of portrait drawings of painters, as illustrations for the *Dictionary of Artists* being compiled by his friend Don Agustin Céan Bermúdez, which was published in 1800. In addition, he drew a portrait of Bermúdez himself, on the same scale and also intended for inclusion in the book.

A large number of his best oil portraits date from this same period. The most outstanding one is that of his friend and patron *Don Gaspar Melchor de Jovellanos*; it shows him full-length, seated at his writing desk and holding a piece of paper in his hand, his expression one of distant melancholy (pages 67, 68-69). On the desk there stands a bronze statue of Minerva. The sitter's intelligence and disenchantment are clearly revealed in this subtle and richly harmonious portrait, painted during his brief spell at the Ministry before he fell into disfavour. A similar portrait is that of the Minister *Francisco de Saavedra*, which was painted in shades of blue, but is now in a poor state of conservation. The subject here is also portrayed next to his desk, but the pose is different and the expression that of a pompous and arrogant man (catalogue no.285). Comparable to it is the portrait of the ambassador of the French Republic, *Ferdinand Guillemardet* (pages 71, 72-73), which also depicts him by his desk, but in profile, with arms akimbo and facing directly towards us. He is in full uniform, and Goya has tried to emphasize the splashes of colour in the stripes and plumes of the hat against the dark colour of the uniform. Guillemardet, who seems to

THE CONDESA DE CHINCHÓN
Oil on canvas; cm 216 × 144 (85⅛″ × 56¾″)
1800
Madrid, Collection of the Duchess of Sueca
Goya had already painted his subject as a two year old; at the time of this portrait she was married to Manuel Godoy.

90

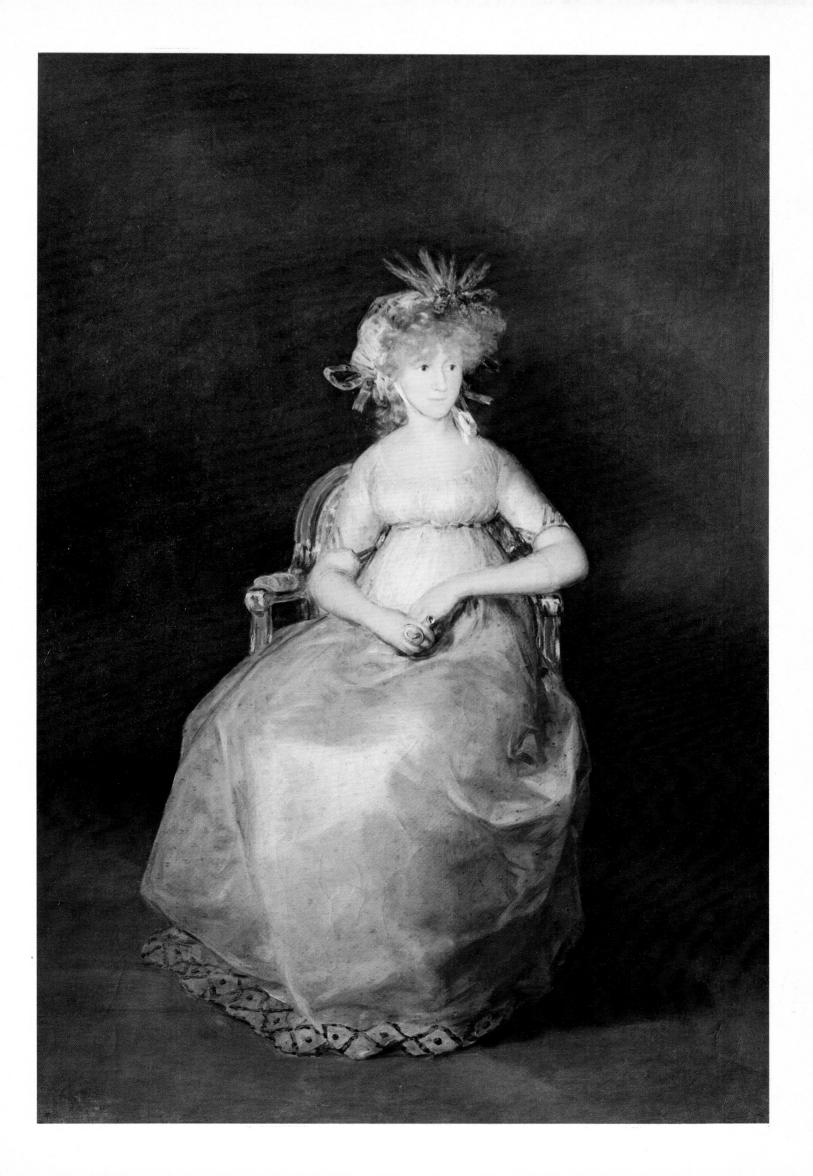

have been a complete nonentity, is portrayed as a man radiating conceit. Also from the same year are the portraits of the actress called '*La Tirana*' (page 61), *General Urrutia* (page 70) and the *Marqués de Bondad Real*, but the list does not end there because, amongst other portraits, Goya did at least two of himself. In one of these he portrayed himself wearing the glasses of an engraver, which allows us to fix the date, since it corresponds to the time when he was doing the *Caprices*; in fact, it shows him pausing from work on them, which is why he is looking over the top of the glasses (page 76). The portrait of his closest and dearest friend, *Martín Zapater*, was undoubtedly painted during his journey to Madrid, which we know occurred in 1797. There are other portraits of his friends *Bernardo de Iriarte* (page 71), *Menéndez Valdés*, *Leandro Fernández de Moratín* and *Mariano Luis de Urquijo*, a friend of Goya's who subsequently became a Minister, in fact, his 'Enlightenment' friends. By way of redressing the balance: he also painted Pedro and Juan Romero, bullfighters whose names Francisco Bayeu placed well below that of their rival Costillares.. These portraits show, once more, Goya's capacity for remaining above partisan loyalties and rivalries. Goya also completed some very important religious works: four life-size 'Holy Fathers of the Church', whose ultimate destination we do not know. If three of them remind us of the paintings by Murillo in Seville Cathedral (*St. Isidore* and *St. Leander*), then *St. Jerome* recalls a similar work by Titian, the last version of which hangs in the Escorial. His decoration of the Santa Cueva in Cadiz, however, with its scenes from the New Testament, shows more originality. We have already suggested that this commission may have been the reason for his stay in Cadiz, or perhaps the cause of its prolongation. The oratory was, in fact, under construction in 1792 and consecrated in 1796. But we have also already dealt at length with Goya's illness in Cadiz, the development of the *Caprices* and the artist's friendship with Sebastián Martínez, a devotee of the arts.

The paintings in the Santa Cueva, despite their beauty and despite their importance as an artistic *ensemble*, pale into insignificance when compared with the frescoes decorating the Ermita de San Antonio de la Florida in Madrid, which were undertaken in 1798 and represent one of Goya's greatest triumphs. The actual hermitage, which took the place of other, earlier ones, was designed by the architect Felipe Fontana and had been joined to the Royal Chapel, which enjoyed the privilege of being an independent parish. The commission was, therefore, a Royal one and not

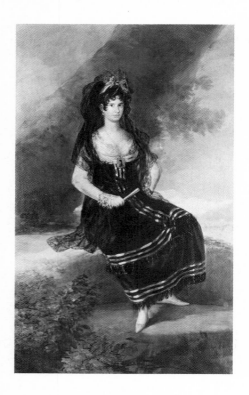 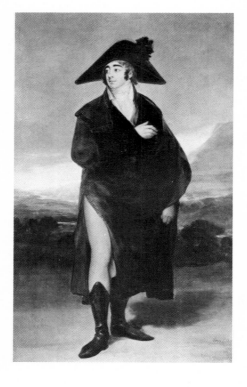

THE CONDESA DE FERNÁN NÚÑEZ
Oil on canvas; cm 211 × 137 (83⅛″ × 54″)
Signed and dated; 'Goya f. a 1803'
Madrid, Collection of the Dukes of Fernán Núñez

THE CONDE DE FERNÁN NÚÑEZ
Oil on canvas; cm 211 × 137 (83⅛″ × 54″)
Signed and dated: 'Goya f. 1803'
Madrid, Collection of the Dukes of Fernán Núñez

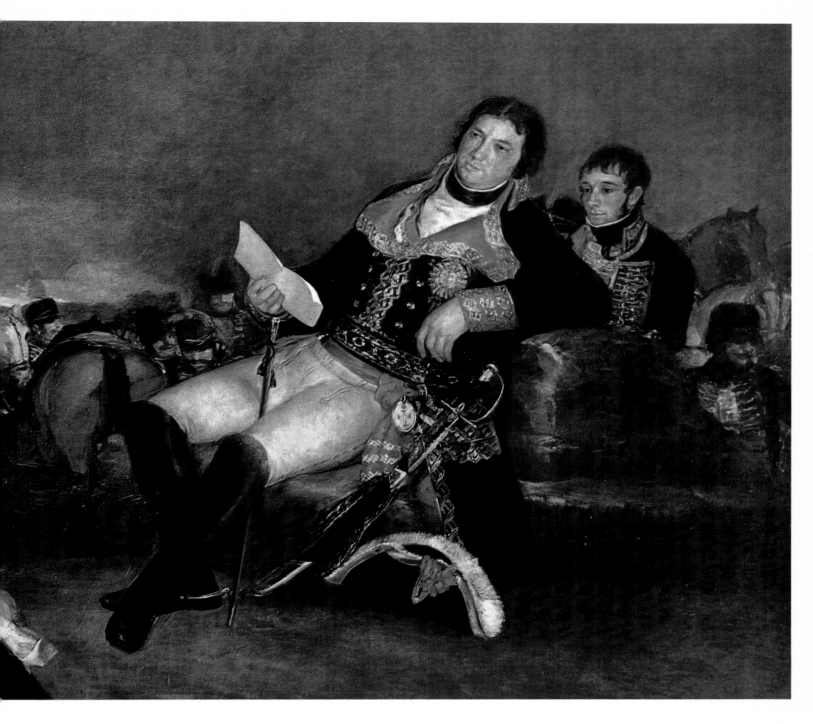

MANUEL GODOY
Oil on canvas; cm 180 × 267 (71" ×
105⅛")
1801
Madrid, Real Academia de San Fernando
(670)
Godoy is portrayed here as commander of
the Army and Navy, during the time of
the so-called 'War of the Oranges' against
Portugal.

subject to approval by any secular or lay body, which allowed the artist to paint as he wished. Work began with due solemnity on 11 July 1799.
As the theme for his cycle of frescoes Goya chose the miraculous resurrection of a dead man by St. Anthony, the patron saint of the hermitage. The event occurred, according to the official life of the saint, in Lisbon during the 13th century, in the courtroom where the saint's father found himself being falsely accused. There was no attempt, on Goya's part, at representing the scene in an historical way: the figures in it are shown wearing contemporary Spanish dress. They are identical to the people that inhabited the world of his tapestry cartoons; he made no effort to clothe them in an historically accurate manner, as he had in his painting in San Francisco el Grande. But this was not the only liberty, nor the most significant one, that he took. The scene of the saint's miracle comprises only a part of the great circular frieze embracing the cupola in the transept, with its great central lantern. The composition unrolls behind an iron railing, which visually encloses the rounded vaulting. Behind the railing, leaning on it with their bodies or their elbows, or crowded against it, there are a large number of

figures, some of whom are deeply involved in the miracle being performed by the saint, who is shown standing on a stone block that raises him above the general level of the spectators. The majority of them, however, unconnected with the miracle, are depicted looking towards us or busy talking amongst themselves.

The overall effect was a great innovation, even though the positioning of figures behind a balustrade or railing had already been used in a painting by Tiepolo in Würzburg, a composition that Goya may have been familiar with through his friendship with that painter's family. In any case Correggio had already done something similar in the church of San Giovanni in Parma, and this is the precedent that is always cited. In addition, according to Ceán, Francisco Herrera the Younger had painted a cupola in the church of Nuestra Senora de Atocha in Madrid depicting the Ascension of Our Lady, with the apostles leaning against a balustrade painted above the rim of the dome. Goya's real innovation lay in the way that he depicted the scene of the saint's miracle in the place traditionally reserved for the Gloria, while the latter is situated above the main altar in the form of an *Adoration of the Trinity*. In this he has followed, to a certain extent, the composition of the first fresco that he painted for the Basílica del Pilar in Saragossa, that of *The Adoration of the Name of God*, in which the name was inserted in a triangle. Now, in the Ermita de San Antonio, we see it surrounded by rays, which in a preparatory sketch seem to be painted, but ultimately turned out as relief sculptures. Angels and cherubim completely fill the vaults, the spandrels and the spaces on both sides of the windows; the former, who have a distinctly androgynous quality, are clothed in loose robes, in which the dominant colours are white, red and yellow, and are extremely freely painted. Photographs have revealed that Goya traced the outlines of his composition on the plaster, thereby allowing himself a great deal of freedom to alter the composition as he went along. A portrait traditionally said to be connected with this work is that of Goya's assistant *Asensio Juliá*, nicknamed 'el Pescadoret', because he was the son of a fisherman from Valencia (page 77). But the portrait shows him wearing clothes that cannot possibly have been his working costume, and even though he is depicted against a background of scaffolding, this could just as well be the framework of one of the wings in a theatre. There is no doubt as to the subject of this portrait, since the dedication tells us exactly who it is, but there is doubt as to whether it was painted in connection with Goya's work in the hermitage, and whether the background shows the scaffolding used in that building's decoration.

Goya's versatility is illustrated by lesser works from that same year of 1798. There are, for example, the preparatory sketches for the decoration of the Ermita de San Antonio, which differ in many respects from the finished painting, but which give a good overall likeness of it, and the rough draft of another work with a religious theme, painted in the same year: *The Taking of Christ* in the Toledo Cathedral (page 81). The latter is a brilliantly sketchy composition, the basic idea for a highly complex work that the artist subsequently completed in a very different way, as we shall see. In the preparatory work, the figure of Christ, clothed in white and brilliantly lit, surges up out of the surrounding crowd, whilst one of the soldiers, in yellow, half emerges from the shadow, which flickers with the glint and reflections of raised weapons, faces and uniforms. The rapid, vibrant brushwork gives life and meaning to even the smallest area of the painting; it is a work that provides living proof of the creative power of the artist. It also shows how, at that time and possibly from the very start of his career, Goya visualized his paintings in the way that many years later, as an old man, living in Bordeaux, he confided to his friend Brugada: 'In Nature, neither colour nor line exist: there is only sun and shadow. Give me a piece of charcoal and I will do you a picture: every painting is the product of sacrifice and convention', and, dealing with artistic education, 'always lines and

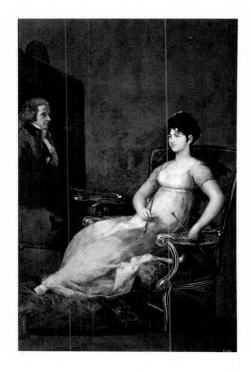

THE MARQUESA DE VILLAFRANCA
Oil on canvas; cm 195 × 126 (76⅞″ × 49⅝″)
Signed and dated: 'Goya 1804'
Madrid, Prado Museum (2448)
A competent artist, this woman was made a member of the Academy of Fine Arts; this portrait of her was exhibited at the Academia de San Fernando in Madrid, in 1805.

BARTOLOMÉ SUREDA
Oil on canvas; 119.7 × 79.4 (47⅛″ ×
31¼″) .
Circa 1804-1806
Washington, National Gallery
Director of the Buen Retiro porcelain
factory in 1804, he learned the technique
of mezzotint engraving during a visit to
London, and, according to his daughter,
he then taught Goya the process. In this
portrait, as in others of the period, we can
see how Goya's style had become richer
and more accomplished, particularly with
regard to the portrayal of his subjects'
psychological traits.

never bodies; but where are those lines to be found in Nature? I see only
illuminated bodies and bodies that are not illuminated, planes that
advance and planes that recede, relief and depth. My eye never perceives
either line or detail. I do not count the hairs in the beard of a man passing
by, nor do the buttons on a frock coat detain my gaze. My brush ought not
to be expected to see better than I'. Even though it means looking well into
the future, it should be noted that this rough draft of 'Jesus arrested by the
Soldiers' presents, on a small scale, what Goya achieved many years later,
on a large scale, in la Quinta; there, in themes taken from fantasy, the
figures emerge from a dark background of shadow, which increase the
feeling of mystery.

In the case of the painting in Toledo Cathedral the final work differed
greatly from what appears in the sketch (page 81). The painting is shaded in
a wide range of greenish and pink colours, without any stridency. The
figure of Christ, clad in a long pale tunic, stands out from the crowd of
soldiers, while the figures surrounding him are vividly and unequally lit.
The soldier on the right, leaning on a halberd (a figure perhaps inspired by

the work of Salvator Rosa) is carefully modelled in the painting, as is the figure whose silhouette can be clearly seen on the left. Goya put all his skill into this work, which was destined to compete with El Greco's glorious portrayal of the same subject in the sacristy of Toledo Cathedral, and he succeeded in achieving something that had the same richness of colour and yet was completely different. After having committed his original concept to paper in a totally expressionistic way, he then painted this great composition in the colours that were in vogue at the time, in a palette that coincided, as nearly as possible the current demands of Neoclassical taste. The painting was, in fact, highly praised by the Academy, to whom he showed it before sending it to Toledo.

The truth of the matter is that, during the closing years of the century, Goya became interested in the work of one of the strictest Neoclassicists of the time: John Flaxman. He did copies and imitations of the latter's work, using a pencil point to reproduce Flaxman's fine lines. One of these

Left:
FRANCISCA SABASA Y GARCÍA
Oil on canvas; cm 71 × 58 (28″ × 22⅞″)
Circa 1804-1808
Washington, National Gallery (Mellon 88)
This girl was the niece of the engraver Evaristo Pérez de Castro, and wife of the actor Manuel García de la Prada, whose portrait Goya also painted.

Right:
ISABEL DE PORCEL
Oil on canvas; cm 82 × 54 (32⅜″ × 21¼″)
Circa 1806
London, National Gallery (1473)
The subject is shown wearing traditional Spanish dress; Goya also painted a portrait of her husband, a friend of his, in hunting dress.

drawings bears the date 1795. Besides that, he did two others that are connected with the architectural fantasies of Boullée; one is the facade of a commemorative monument; the other is a triumphal arch in the form of a gigantic pyramid. The first may have been an idea for a tomb, probably the one that was to have been erected in honour of the Duchess of Alba, for which he also did a preparatory sketch *en grisaille*, to give a sculptural quality to the group portraying the Duchess, who had died in 1802, being carried by a number of hooded figures. It would appear that this tomb was intended for the Church of the Novitiate in Madrid, but was never approved by her heirs.

All this must be viewed in the context of what the artist had written years before, in 1787, to his friend Zapater: 'What is in style here now is the architectonic style'. By this he meant that the fashion in Madrid at the time was for what we would recognize as the Neoclassical style. This explains why Goya did his picture of *Cupid and Psyche* (now in the Cambó Collection, Barcelona Museum) and his one of the *Naked Maja*, which we have already discussed, as well as other lesser paintings that reveal strong Neoclassical undertones, both in their spirit and their composition. This influence is revealed elsewhere by the way in which Goya arranged the figures in his paintings, but only on a very few occasions did he paint with the perfect conciseness of the Neoclassicists, because, when the moment actually came to complete the work, his natural skills would take over.

Some years ago this fact was brought out by an analysis of one of Goya's most exacting works, the one that marked the high spot of his career during this period. I am referring to his portrait of the *Family of Charles IV*, in which he painted the whole Royal Family (page 89). He had only just

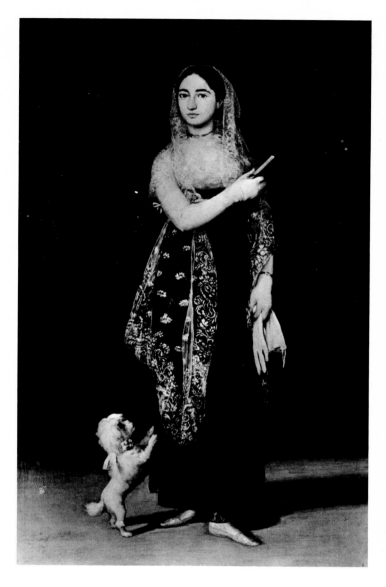

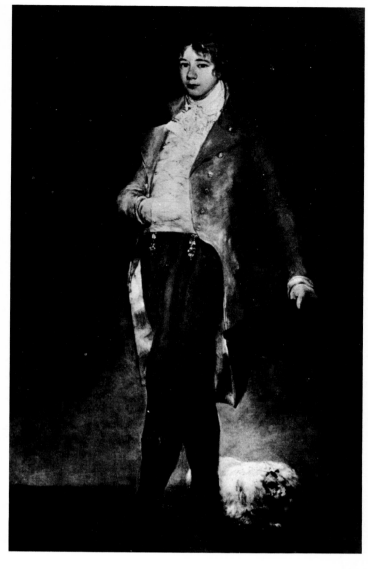

GUMERSINDA GOICOECHEA
Oil on canvas; cm 192 × 115 (75⅝″ ×
45⅜″)
1805-1806
Paris, heirs of the Comtesse de Noailles
Gumersinda married Xavier Goya in
1805.

XAVIER GOYA
Oil on canvas; cm 192 × 115 (75⅝″ ×
45⅜″)
1805-1806
Paris, heirs of the Comtesse de Noailles
This is the pair to the preceding portrait.
The two paintings were done by Goya to
celebrate the couple's marriage. On the
same occasion Goya also painted a series of
small miniatures on leather of members of
Gumersinda Goicoechea's family.

received official endorsement; in August 1798 he had been named *Primer Pintor de Cámara*, an honour that was accompanied by a substantial salary — 50,000 *reales*, with a further 500 ducats towards buying a carriage. This post involved him in painting a number of portraits of the King and Queen, amongst which are those of *Charles IV in Hunting Dress* and *María Luisa in a Mantilla* (page 86). It is very revealing to compare these with the paintings that he did of the royal couple on their accession to the throne. The latter show the pressures put on him to produce two official portraits; the one of the King, for example, has a richness that is made somewhat excessive by its iridescent colours, whereas the second portrait, a rather severe work, reveals the sober influence of Velázquez in a number of details. His portrait of the Queen, painted at the beginning of her reign, shows her wearing the style of dress that she hoped to impose on the ladies of the Court: a full skirt, in imitation of Spanish fashions of the 17th century, crowned by a vast *incroyable* hat in the French style, of the type popularized by Queen Marie Antoinette. The Court insisted on the adoption of this *moda a la española*, but the fashion never caught on because of its incongruity. In the 1799 portrait, by contrast, Queen María Luisa is portrayed in sober black dress against a broad, sweeping landscape. The main feature of the painting is the one aspect of her youthful beauty — and she had undoubtedly been beautiful as a young woman — that she still retained and showed with pride: her slender white arms, which emerge from the pale lace trimmings of her dress.
Shortly afterwards, Goya painted his equestrian portrait of the Queen on her horse Marcial, a present from Godoy (page 87), and also a similar one of

the King on horseback (page 86). The composition of both recalls the paintings done by Velázquez for Philip III and for Philip IV's first wife, Doña Isabel of France. Some months later, while at the court in Aranjuez, in the spring of 1800, Goya painted his great picture of the Royal Family, which is both a masterpiece and also the source of a number of aesthetic and human problems, which we shall have to deal with at greater length. We must remember what Goya said about the 'architectonic style', that is to say, Neoclassicism, as we encounter it in this painting in the way that the family is posed, frieze-like, against the wall of a *salon*, with the rigidity of the composition being broken by the division of the figures into groups. But this is the full extent of the picture's Neoclassicism, as the way in which the painting is otherwise executed is very different from that used by Neoclassical artists. Its dominant feature is the brilliance and agility of Goya's pictorial technique; all the figures wear extremely rich costumes, depicted with rapid brush strokes, something that decades later became one of the sources of inspiration for the French Impressionists, who greatly admired this work.

It should also be noted how Goya, who had previously portrayed himself with humility in earlier works, here depicted himself standing side by side with his masters; this could be because he was painting them reflected in a mirror (bearing in mind the mirror that Velázquez used in *Las Meninas*, which reflects the darkened images of Philip IV and Queen Mariana). If this seems an almost total improbability, perhaps he wanted to show the Royal Family present when Manuel Godoy was posing for his portrait. We should not forget that Godoy was the most important person in the Court at that time. Royal sponsorship had raised him with indecent haste from being an insignificant member of the provincial gentry to the status of the Queen's favourite and protégé, and husband of the King's niece, the Condesa de

MARAGATO THREATENS FRA PEDRO DE ZALDIVIA
Oil on panel; cm 29.2 × 38.5 (11 ½″ × 15 ⅛″)
1806-1807
Chicago, Art Institute (1933.1071)

FRA PEDRO TRIES TO DISARM MARAGATO
Oil on panel; cm 29.2 × 38.5 (11 ½″ × 15 ⅛″)
1806-1807
Chicago, Art Institute (1933.1072)

FRA PEDRO FIGHTS WITH MARAGATO
Oil on panel; cm 29.2 × 38.5 (11 ½″ × 15 ⅛″)
1806-1807
Chicago, Art Institute (1933.1073)

Chinchón. In addition to this, he maintained a mistress, Pepita Tudó, who had borne him several children and whom he had succeeded in having ennobled; he had also managed to obtain every title and honour for himself that he could have wished for. It is not certain, but it may have been this man that the Royal Family were watching being painted by their *Primer Pintor de Cámara*.

But, apart from this problem regarding the painting's composition, even if the theory above is true and the picture does represent a tacit apotheosis of the Royal favourite, there are other problems that demand our attention. In this extended group that comprises the Royal Family, a group that is soberly arranged and brilliantly portrayed, we see, at the centre, the King and Queen (with the Queen in the dominant position), the Prince of Asturias, in blue, together with his brothers and sisters, his brother-in-law and the Prince of Parma, his nephew, still a child in its mother's arms, and his uncles and aunts, the King's brothers and sisters. All these figures are people of varying historical importance, details of whose lives are known to some degree. Many of them were of little significance, such as Don Antonio

FRA PEDRO OVERCOMES MARA-GATO
Oil on panel; cm 29.2 × 38.5 (11½″ × 15⅛″)
1806-1807
Chicago, Art Institute (1933.1074)

FRA PEDRO FIRES AT MARAGATO
Oil on panel; cm 29.2 × 38.5 (11½″ × 15⅛″)
1806-1807
Chicago, Art Institute (1933.1075)

FRA PEDRO TIES UP MARAGATO
Oil on panel; cm 29.2 × 38.5 (11½″ × 15⅛″)
1806-1807
Chicago, Art Institute (1933.1076)
Goya drew his inspiration for this series of small pictures from an event of the time: the capture of the bandit Maragato by Brother Pedro de Zaldivia on 10 June 1806.

or Doña María Josefa, the King's brother and sister. But, and this is the extraordinary thing, next to the heir to the throne, who later became Ferdinand VII, there stands a woman, much fatter than him, a mysterious figure, who is turning away from us so as to make identification impossible. And yet this lady was definitely not a member of the Royal Family; she could not possibly have been. Could it be that her figure was included in order to be completed later by the addition of the face of any future wife that the Crown Prince might have had? This is one explanation that has been put forward, but without any documentary support. Or, alternatively, as has also been surmised, does this vast painting, executed with such care (from the bills Goya appears to have done up to ten preparatory studies of his subjects), contain a hidden 'in joke' of the Royal family concerning some disastrous attempt by the Crown Prince at finding a wife? I myself do not think that this is at all likely, but I am unable to hazard a guess as to who this non-existent person in the midst of the Royal Family is. And if it is the case that the figure's face was to be that of Ferdinand VII's first wife, why was it not completed on the occasion of the latter's marriage to María Antonia of Naples?

The painting also conceals another small enigma, whose solution is easily found in my opinion, since it may well be of no significance; merely by treating it as an enigma one runs the risk of critical pedantry. It so happens that on the back wall of the room, in front of which the Royal Family are standing, there are two paintings: the one on the right is merely a landscape, while the one on the left, in very dark colours, shows a man in an amorous pose with two naked woman. Before the picture was cleaned a few years ago, and the layers of dirt and discoloured varnish were removed, the scene of the left was scarcely visible, even though old photographs and engravings from the previous century gave proof of its existence. On seeing

it for the first time, my reaction was instantaneous: Goya had unashamedly portrayed *himself* in the company of two naked women. It is possible that this supposed self-portrayal was purely involuntary, merely the result of a mechanical repetition of his own features, such as a great many artists have done in drawing or painting some figure or other. If this is the case, then the scene has no significance. The man with Goya's features, accompanied by two female figures in a mythological composition, was not an element intended to be plainly visible: it remains in the shadow to the far left of the scene, exactly above the artist working at his easel. A number of broad dark brush strokes make the scene even darker. Recently, however, people have sought to give this composition a meaning, suggesting that it is a criticism of the Court, on the grounds that it represents Lot and his daughters, Biblical symbols of depravity. It has also been put forward as a theory, on the basis of pure supposition, that this group of three figures is an allusion to Manuel Godoy, who married the Condesa de Chinchón without abandoning his relationship with Pepita Tudó, by whom he had several children; according to one Ambassador, they both sat officially at his table.

I myself do not believe in any of these interpretations. It is my opinion that the group has no significance: it was merely a way of filling a space on the wall, and Goya portrayed himself out of pure instinct.

This belief of mine is based on reasons that I consider to be very important. Goya was always a cautious man, who, like everybody else, had certain ideas concerning the world, and his written reflections and his drawings are both important and worthy of consideration. But Goya was also an example of someone who knew how to survive in a constantly changing world, full of hatred, ambition and rivalry, in which he moved with continual wariness. Godoy, the Royal favourite, was at the height of his power in 1800. Goya would not have presented a picture containing a general criticism, however veiled, of the Court to which he was *primer pintor*, nor, even worse, would he have made a specific criticism of the man who held all the reins of power.

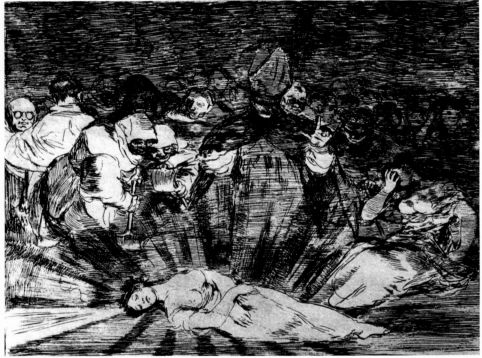

TRUTH HAS DIED
('Murió la Verdad')
Etching; cm 17.5 × 22 (6⅞″ × 8⅝″)
Circa 1815-1820
From the *Disasters of War* (Plate 79)

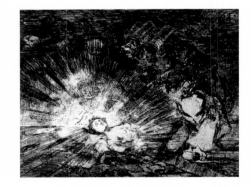

WILL SHE RISE AGAIN?
('Si resucitará?')
Etching; cm 17.5 × 22 (6⅞″ × 8⅝″)
Circa 1815-1820
From the *Disasters of War* (Plate 80)

Nonetheless, there is another aspect of this painting to be considered. We know that the then heir to the Spanish throne had refused to have his portrait painted by Goya when Jovellanos had suggested it some years earlier, perhaps as a result of the friendship and protection given the artist by his parents. He only appears in this one official portrait, quite unlike Charles IV and María Luisa, who were portrayed on several occasions by Goya and in different poses, the likenesses being subsequently repeated by the artist's workshop for official use, with Goya himself taking little part in their execution.

Goya painted Godoy's portrait on a number of occasions, even through we are familiar with only one of these works. It would seem that he acted as Goya's sponsor for a time, even though this has not been clearly established by authorities on the artist's career. It may even be that Goya's copies of Velázquez' work were the result of Godoy's support for the young painter. We do know, however, that Godoy supported and realized a series of undertakings dear to the hearts of members of the Enlightenment, in that he was both a sponsor of the arts and a great collector. From the political point of view, he possessed, along with others, certain traits that reveal a lust for power and an arrogance that deserve to be criticized; he was, however, definitely not the nonentity that his enemies proclaimed him to be. Perhaps the fact that Goya had been his protégé was enough for the Prince of Asturias, Ferdinand, not to want to have anything to do with someone who had enjoyed the support of a man whom he considered,

100

rightly, to be an enemy. Maybe this is the reason that he turned down Jovellanos' suggestion that he should have his portrait painted by Goya. Recently, however, a document has been published that proves that Goya did a number of satires on the Royal favourite, possibly engraved for public distribution, for which he received payment from the Prince, but, as yet, these works have not been identified. There did, therefore, exist a relationship between the artist and the heir to the throne during the period immediately preceding the downfall of the favourite. Goya was later commissioned by the Academy to paint Ferdinand VII's portrait on the occasion of his accession to the throne, and he also did, on known dates, a number of studies for his great equestrian portrait and other paintings. We will return to these at the appropriate time.

Even though Ferdinand appears next to a non-existent woman in Goya's

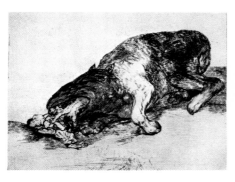

FIERCE MONSTER!
('Fiero monstruo!')
Drypoint and burin etching; cm 17.5 × 22 (6⅞″ × 8⅝″)
Circa 1815-1820
From the *Disasters of War* (Plate 81)

On right:
THIS IS THE TRUTH
('Esto es lo verdadero')
Drypoint, burin, etching and aquatint; cm 17.5 × 22 (6⅞″ × 5⅝″)
Circa 1815-1820
From the *Disasters of War* (Plate 82)
Plates 65-82 were added by Goya to the 'Disasters of War' proper, which had been completed between 1810 and 1815 and portrayed dramatic and shocking episodes of war that he had either witnessed personally or heard described.

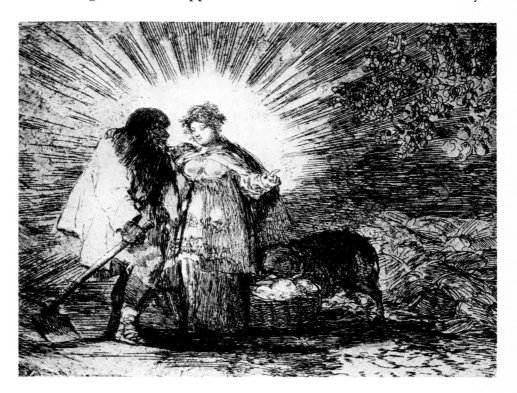

portrait of the Royal Family, something that may have been a Court joke and could possibly have irritated the Prince, the artist continued to be *Primer Pintor de Cámara*. It is also a fact that he was commissioned to paint Ferdinand VII by the Academy, and that after the short reign of Joseph Bonaparte he continued to call himself *primer pintor de cámara* under Ferdinand VII, continuing also to receive his salary throughout this troubled period. Nevertheless, it is also a fact that he was never again commissioned to do a portrait for the Royal Family. We know of no other portraits of Charles IV and María Luisa, apart from those already mentioned: *Charles IV in Hunting Dress* and *María Luisa in a Mantilla*, *Charles IV* and *María Luisa* in court dress, painted in 1789, and finally the two equestrian portraits, all of which precede the painting of the Royal Family. After that, despite the period of eight years that elapsed before the events leading to the King's abdication, Goya never painted the Royal couple again. It is not certain whether Goya ever did a portrait of Joseph Bonaparte, but we do know that his studio used an engraving to produce a laudatory portrait in the town hall in Madrid. During the era of Ferdinand VII, alienated from the palace and from the King's political policies, Goya only painted the monarch's portrait when commissioned by various institutions, but never for the Royal Family; neither did he paint the King's first wives. He only did one painting for the palace: a picture for the Queen's private apartments. Since his portrait of the Royal Family he had become a sort of honorary *primer pintor de cámara*, receiving a large salary,

FERDINAND VII ON HORSEBACK
Oil on canvas; cm 285 × 205 (112¼″ ×
80¾″)
1808
Madrid, Real Academia de San Fernando
(679)

Facing:
VICTOR GUYE
Oil on canvas; cm 106.7 × 85.1 (42″ ×
33½″)
1810
Washington, National Gallery (1471)
The subject of this portrait was grandson
of the French general Nicolas Guye,
whom Goya also painted.

JUAN ANTONIO LLORENTE
Oil on canvas; cm 189.2 × 114.3 (74½″
× 45″)
1810-1812
Sao Paulo, Museu de Arte

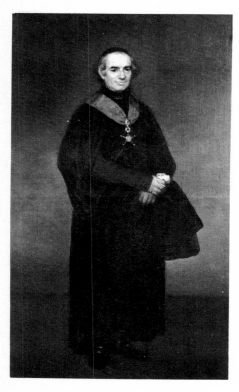

but no commissions. A strange state of affairs, for which no explanation has been found.

In April 1800 he painted Godoy's wife, the *Condesa de Chinchón,* during her pregnancy (page 91), and also, about the same time, he did several portraits of her brother *Luis, Cardinal of Toledo.* In 1801, after the war against Portugal — the so-called 'War of the Oranges' — he painted his great portrait of the *Príncipe de la Paz,* seated next to the Portuguese banners which he was subsequently allowed to include in his coat of arms (pages 92-93). It is a reminder of the easily won war and of the great honours that enhanced Godoy's personal prestige and also the loathing of his enemies, many of whom were friends of Goya's.

There next followed a marvellous series of portraits: of the *Conde* and *Condesa de Fernán Núñez* (page 92), of the *Marquesa de Villafranca* (page 94), the *Marquesa de Lazán* and the *Condesa de Haro.* He also painted such members of the premier nobility as the *Marqués de San Adrián* and the *Marquesa de Santa Cruz,* as well as many other socially prominent people. In addition, he painted several personal friends, ranging from *Archbishop Joaquim Company* to the naturalist *Félix de Azara,* an Aragonese, whose brother, the Ambassador José Nicolás, may have helped him during his stay in Rome. That particular portrait is exceptional, in having a background of display cabinets full of stuffed birds (page 106). He also painted portraits of architects such as *Don Juan de Villanueva,* academicians such as *Don José Vargas Ponce,* a friend of his, and the art collector *Don Manuel García de la Prada,* who bequeathed all his paintings to the Royal Academy and was also a personal friend of Goya's. There are further paintings of people like *Bravo de Rivero,* a Spaniard who had made his fortune in Peru, rich industrialists like *Tomás Peréz de Estala,* who had made his money in Segovia, *Bartolomé Sureda* (page 95) and his wife, and the beautiful female bookseller of the Calle de Carretas, the no less beautiful *Lorenza Correa,* an exceptional singer of the day, and her husband *Manuel García,* who was also an artist, and *Isabel de Porcel* (page 96). He also painted another portrait, which I believe to be of a famous actress, nowadays identified as *Francisca Sabasa y García* (page 96) and one of the actor *Isidoro Máiquez* in 1807, as well as some enchanting studies of the Soria children and countless other works besides. He did not, however, do portraits solely of his friends during this period; he also painted some of Godoy's intimates, such as the *Marqués and Marquesa Caballero,* who took Godoy's side in the various palace intrigues and supported him in his opposition to Jovellanos.

As well as these groups of portraits, as beautiful as they are varied, the marriage of Goya's only son Xavier in 1805 inspired him to do another exceptional series of portraits: of the young couple, of his daughter-in-law's parents and of their family. His two paintings of the young newly weds are full-length portraits (page 97); Xavier is elegantly dressed in grey, and Gumersinda de Goicoechea, his wife, is shown standing, wearing a white mantilla with a small lap-dog playing at her feet. The other members of the family were immortalized in a series of small miniatures in oil; the bride's parents, Martín Miguel de Goicoechea and Juana Galarza, their four daughters and a young man presumed to be Xavier, the bridegroom, but who could also be a son-in-law. The only reason for supposing that this miniature is of the artist's son is that it bears a certain resemblance to other works depicting him.

Subsequently, a mixture of political events and family problems combined to produce a profound spiritual crisis in Goya, which transformed his art. It was only from this moment that his work became a direct and heartfelt expression of his innermost thoughts. The political events that brought about this crisis began at Aranjuez, where, on 17 March 1808, the people rose up in protest at Godoy's misgovernment, with the tacit backing of Ferdinand, the Crown Prince, and a large number of aristocrats and liberal friends of Goya's. The uprising was successful and two days later, on 19

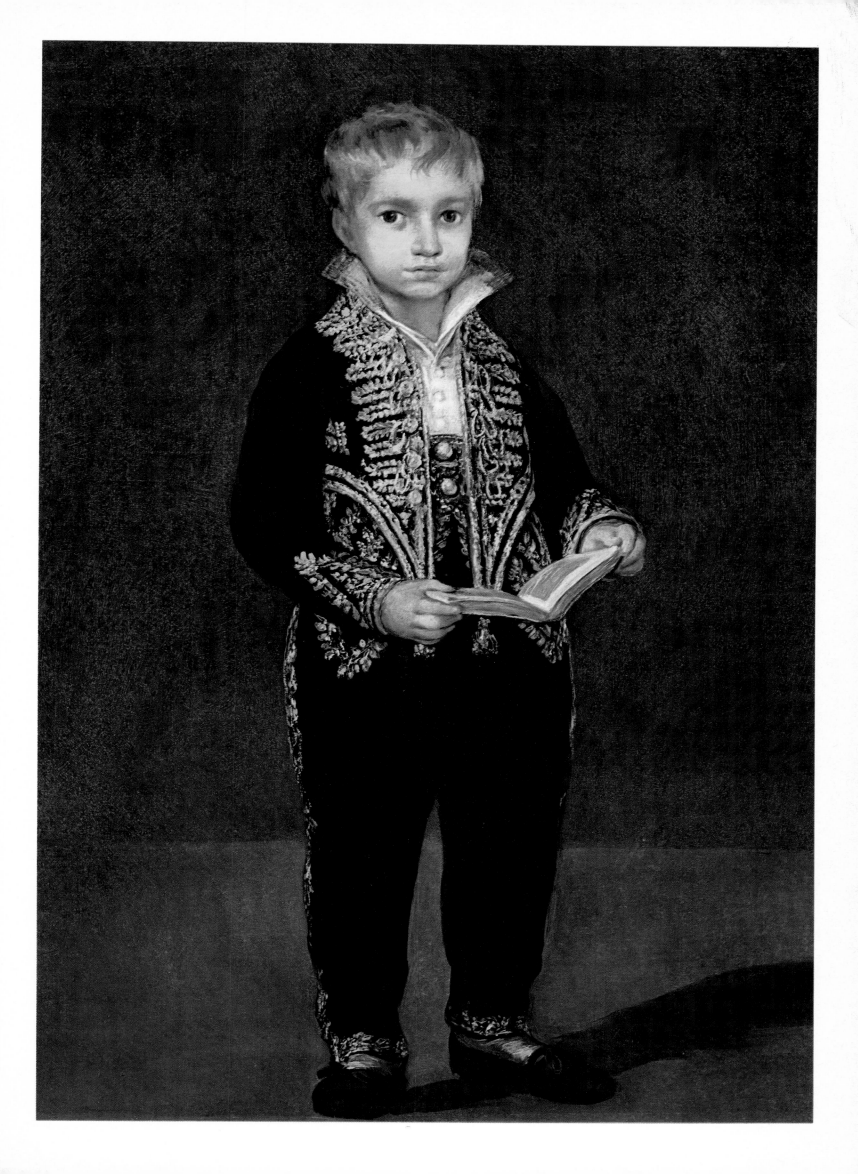

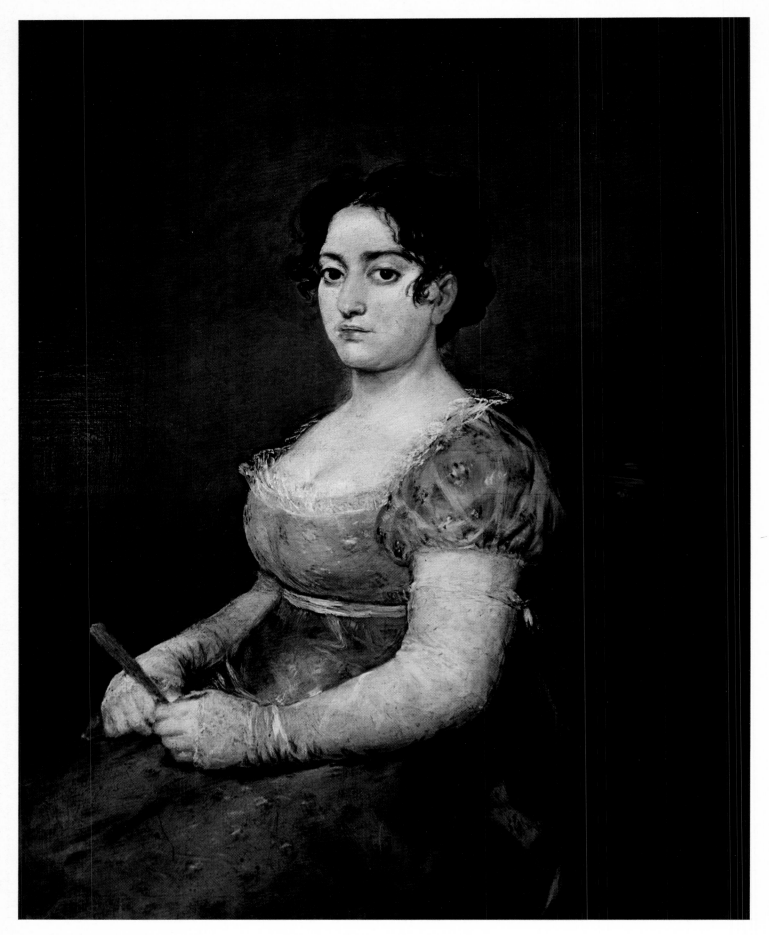

March, Charles IV abdicated in favour of his son. This event marked the end of Godoy, who subsequently escaped the fury of the people by being arrested and taken into protective custody by the French army. His portraits, together with everything else of his that fell into the hands of the mob, were destroyed.

These events caused only a partial transformation in Spain's history. In order to understand them properly, they should be viewed in the context of

European history, against the background of the rivalry between France and England. Napoleon, who had as little regard for Godoy as he did for Charles IV and María Luisa, wanted to extend his Continental Blockade throughout Europe, thereby bringing England to her knees. He had therefore asked for his armies to be granted free passage through Spain in order to fight in Portugal, a request that was granted, but only, it has to be said in Godoy's favour, after a certain degree of resistance on the part of the favourite. The French armies, however, acting on much more far-reaching instructions, had installed themselves in various Spanish strong-holds such as Figueras, Barcelona and Pamplona. Under the guise of conducting a campaign against Portugal, Napoleon was embarking on a much more ambitious plan. He was convinced that Spain, the Royal Crown and the whole structure of the country were so corrupt and disorganized that they

MANUEL SILVELA
Oil on canvas; cm 95 × 68 (37⅜" × 26¾")
Circa 1809-1812
Madrid, Prado Museum (2450)
Silvela was magistrate of the Council of Castille during the government of Joseph Bonaparte.

ANTONIA ZÁRATE
Oil on canvas; cm 103.5 × 81.9 (40¾" × 32¼")
Circa 1810
Blessington (Ireland), Sir Alfred Beit Collection

On left
WOMAN WITH FAN
Oil on canvas; cm 103 × 83 (40½" × 32⅝")
Circa 1805-1810
Paris, Musée du Louvre (RF 1132)

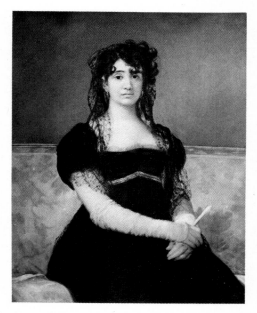

were ripe for his political ends. He believed that Spain would fall into his hands and that he would then be able to install one of his brothers on the throne, as he indeed did. He hoped to achieve something similar to what he had done in Naples, after having discovered the Queen's pro-English sympathies.

Ignoring the orders that he had received to proceed with caution, General Murat entered Madrid on 22 March at the head of his army and placed Godoy under guard. King Charles IV and Queen María Luisa immediately left for France in order to obtain an audience with the Emperor and obtain his support. Ferdinand VII was also advised to hold talks with the French Emperor, who was said to be about to enter Spain for that purpose. Having failed to meet him at Burgos, or at Bayonne, he entered France and was taken prisoner by Napoleon. The latter gleefully recorded in his correspondence the confrontation that he witnessed between father and son, and how he succeeded in securing Ferdinand's abdication in favour of his father, who in turn surrendered the country's sovereignty to the Emperor, who then proclaimed his brother, Joseph Bonaparte, King of Spain. The scene, recorded in detail in his letters, more than satisfied his taste for recreating situations parallel to those in Classical tragedy.

However, the unexpected happened. On 2 May, after the remaining members of the Royal Family had gradually left the palace for the north, the people of Madrid rose up at the sight of the little Infante Francisco de Paula entering the city in the carriage of the Queen of Etruria. This revolt by the people of Madrid against the invaders spread throughout Spain, helped by the intervention of the disorganized remnants of the Spanish army, who gained a victory at Bailén, as well as putting the French to flight on a number of other occasions. In addition, an English army, under the command of Wellington, landed in Portugal and conducted a highly effective

campaign throughout the six years of the war, finally achieving a decisive victory at Vitoria.

It was a new type of war, in which armies of professional soldiers were not the only protagonists; the ordinary people of the country played a major part. An outstanding role was played by the guerrillas, who continually harassed the French forces and obliged them to adopt new methods of waging war, some of which — the most cruel — were directed at the civilian population, who assisted in the struggle whenever possible. Terrifying acts of vengeance and reprisal were carried out against them. The war itself, however, was so varied and episodic that we can only deal here with certain individual events.

The French Emperor's armies twice installed Joseph Bonaparte as King in Madrid, Wellington's forces having entered the capital and been forced to

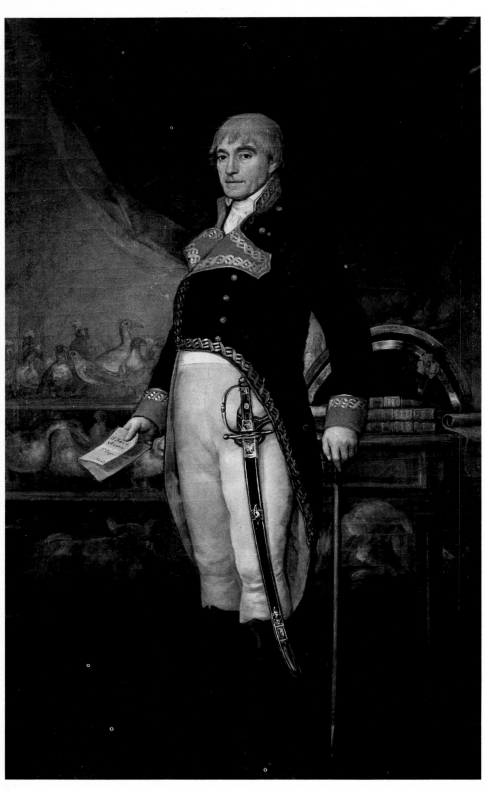

FÉLIX DE AZARA
Oil on canvas; cm 212 × 124 (83½″ × 48⅞″)
Signed and dated: 'Dⁿ. Felix de / Azara / pʳ. Goya / 1805'
Saragossa, Provincial Museum of Fine Arts (165)
The subject was a noted naturalist and brother to the famous ambassador and politician José Nicolás de Azara.

ALLEGORY OF THE CITY OF MADRID
Oil on canvas; cm 260 × 195 (102½″ × 76⅞″)
1810
Madrid, Municipal Museum (1048)
This painting was commissioned by Madrid City Council so that they could display a portrait of the new King Joseph Bonaparte. When the French retreated, the portrait was covered by the word 'constitución', but the likeness of Joseph Bonaparte was subsequently refurbished, only to be obliterated once more in 1813 by the word 'constitución'. In 1814 Vicente López inserted a portrait of Ferdinand VII, which he repainted in 1823. In 1843 the King's likeness was yet again covered over and replaced by the word 'constitución', until finally the legend 'Dos de Mayo' was placed in the cartouche. These different overpaintings are an accurate reflection of political events in Spain during the first half of the 19th century.

withdraw. There were places such as Gerona and Saragossa, whose beleaguered populations resisted to the limits of human endurance, and where the heroism of the defenders reached extraordinary heights. In Cadiz, meanwhile, a liberal constitution was being enacted and Spain's colonies were, with English support, setting out on the road to independence.

Ferdinand VII, on his return to Spain as King, following the Treaty of Valençay in 1813, immediately abolished the Cadiz Constitution and declared himself absolute King; he also re-established the Inquisition, albeit more on paper than in reality. Spain's colonies, however, were gradually asserting their independence more and more openly, and the outcome of this was that the country found itself completely ruined, racked by poverty, plunged into a deepening crisis, with its government in chaos. As we already mentioned, Xavier de Goya, the artist's only surviving son, had married Gumersinda de Goicoechea in 1805. On the eve of the wedding, according to documents dated 7 July of that year, Goya gave his son a marriage settlement, in which he pledged 'to keep the couple in a house, supporting them and their children, and any servants they may have besides ... for all the time that they may wish to stay in his company', stipulating that in the 'unhoped for' case 'of their wanting to separate from him and set up house by themselves, he assigns them a covenant of 13055 *reales de vellon* in metal coin, annually, being the income of 84000 deposited in the Royal Life Pension Fund ... and in addition their own house situated in Madrid in the Calle de los Reyes, indicated by the number 7...' For whatever reason, some months later, on 1 January 1806, the young couple decided to set up house on their own, leaving their parents' home and thereby availing themselves of the second proposal in the marriage settlement, as Goya himself noted in a document of 24 July. We can only guess at the reasons for their decision: it may have resulted from differences between the two couples, but perhaps it hinged on the artist's relationship with Leocadia Zorrilla de Weiss, who subsequently played such an important part in Goya's life and whose personality we shall discuss later. We do not know when this relationship started, nor exactly what sort of a relationship it was, although we can guess. It is possible that Xavier and Gumersinda were unable to tolerate Leocadia's presence in the house, particularly if she had entered it as if a member of the family and started running it herself, as we know she did following the death of Josefa Bayeu, Goya's wife. An inventory was drawn up after Josefa's death, in which Xavier was given his father's paintings and others in the house, and he mistrustfully marked them all with an X and the inventory number; this action, and his coldness towards Leocadia and her daughter in Bordeaux, would seem to support the theory that it was the presence of Leocadia that made it impossible for Xavier and Gumersinda to live with Goya after only a few months of marriage. From what we know of Goya himself, it appears that he had certain eccentricities, as is often the case with genius, whereas his son Xavier remained a nonentity; having been reared in a well-to-do household of the rising middle class, he spent the rest of his life looking after his possessions. As for Josefa Bayeu, the artist's wife and Xavier's mother, we know nothing about either her personality or her life. I believe that she is the young woman whose portrait hangs in the Prado (page 74), as I have already stated, and she is undoubtedly the woman, well advanced in years, stout and showing not a spark of intelligence or charm, whom Goya drew in 1805; she was, in all probability, a person of no significance who merely lived with the great man and bore him a number of children, of which Xavier was the sole survivor.

There have been more written about Goya's affair with the Duchess of Alba than it possibly deserves: the artist undoubtedly suffered from pangs of love and jealousy, but for the Duchess it was little more than a flirtation. Besides being a pillar of Spanish society and a very beautiful woman, she

THE DUKE OF WELLINGTON
Sanguine and 'graffito'; cm 32.2 × 17.5
(9⅛" × 6⅞")
1812
London, British Museum (1862.7.12.185)

108

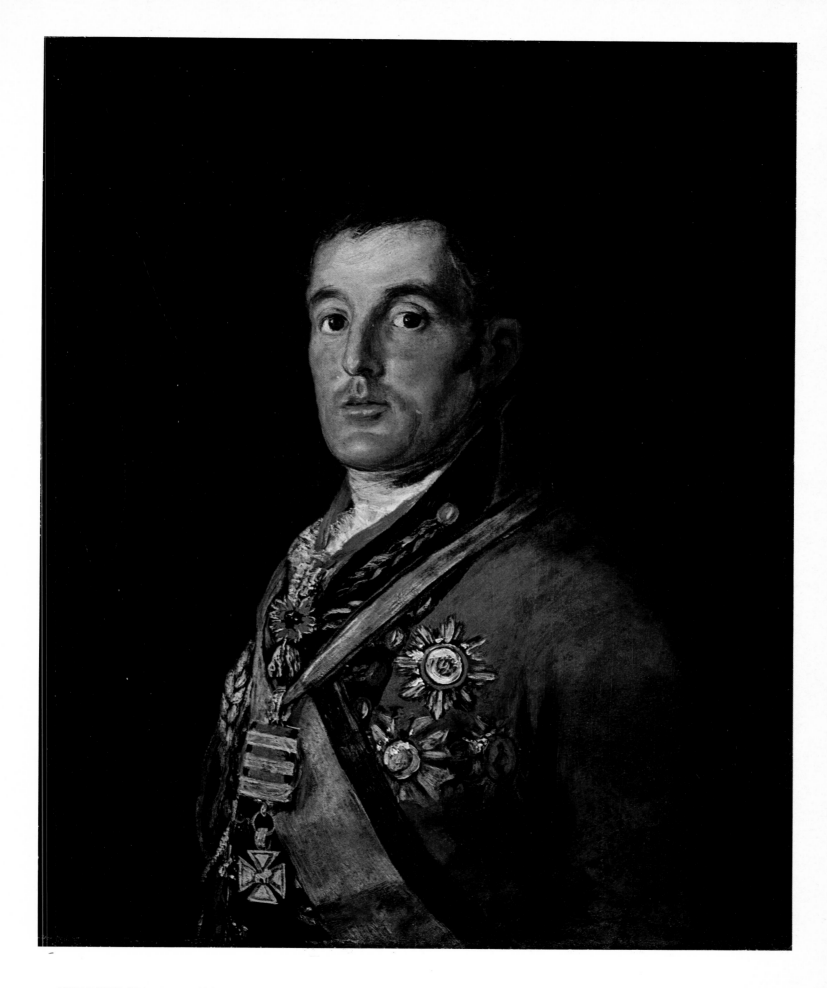

THE DUKE OF WELLINGTON
Oil on panel; cm 60 × 51 (23⅝″ ×
20⅛″)
1812-1814
London, National Gallery (6322)

Goya did a number of drawings and
paintings of the Duke of Wellington,
which date from between his entrance
into Madrid in 1812, following the Battle
of Arapiles, and the return of Ferdinand
VII in 1814.

BUTCHER'S COUNTER
Oil on canvas; cm 45 × 62 (17¾" × 24⅜")
Signed: 'Goya'
Paris, Musée du Louvre (RF 1937.120)

was, like so many of her female contemporaries, a person of few scruples and many whims. Very little emphasis, however, has been placed on the woman who filled the closing years of Goya's life: Leocadia Zorrilla de Weiss. She was a relation of the Goicoecheas, who had married, in 1807, a man called Weiss, a trader and watchmaker of German origins, with whom she had had an unhappy married life. She had a number of children by him, the eldest of whom, Guillermo, had been born before their marital problems began; problems that are attested by a document of 1811, in which Weiss petitioned for a separation, both personal and material, on the grounds of his wife's conduct. We do not, however, know what the legal results of the proceedings were. But, less than a year later, on 25 April 1812, when Leocadia was already living with Goya, Weiss initiated a second set of proceedings against his wife, accusing her of 'infidelity, unlawful conduct and unseemly behaviour, added to which is her arrogant and threatening attitude'. We do not know whether this second petition was successful either, or whether it was withdrawn, but it is a fact that October 1814 saw the birth of Rosario Weiss, whose paternity was attributed in law to her legal father. Goya called her 'Mariquita' in letters to friends, and on one occasion, whilst writing to his friend Ferrer urging him to treat her 'as if he

HENS
Oil on canvas; cm 46 × 54 (18" × 21¼")
Circa 1808-1812
Madrid, Prado Museum

were his daughter', he hinted that she was a genius at painting. However, she was never more than a passable miniaturist, dying, as she did, at an early age. Matheron once wrote something, using rather ambiguous phraseology, which allows us to suppose that some of Goya's friends considered Rosario to be his daughter, even though the artist's neglect of her and her mother in his will would seem to suggest the opposite.

That Leocadia was a violent and self-willed woman is confirmed by her life and also by what Moratín said about her in his letters. It is perfectly feasible that one or other of Goya's portraits depicts her: undoubtedly she was immortalized on the walls of la Quinta, in the black-clad figure of *Una Manola* leaning against a tomb on a mound (page 147). As we shall see later, when we try to understand the significance of the decoration of La Quinta del Sordo, for Goya her counterpart was Judith, who appears next to her in the paintings.

FRUIT, BOTTLES AND BREAD
Oil on canvas; cm 45 × 62 (17¾″ × 24⅜″)
Signed: 'Goya'
Circa 1808-1812
Winterthur, Reinhart Collection (78)
The three still lifes shown here form part of a group of twelve, mentioned in the 1812 inventory and marked with an 'X' by Xavier Goya.
See pages 112-113 for detail

Josefa Bayeu was only a shadowy figure in Goya's life, who early on facilitated his entry into the influential group of painters headed by her brother Francisco; for all that she went through, she still helped him climb the ladder of success. The Duchess of Alba, for very possibly only a brief moment, infatuated Goya, both because of what she represented in Madrid life and also because of her beauty; the pangs of jealousy aroused by this passion caused him much bitterness and pain, and it was something that he never succeeded in forgetting. Leocadia Weiss was the woman with whom he shared his declining years and, being possibly his last mistress, she had a great influence on his life. The move to Bordeaux was caused not so much by Goya's liberal ideas as by those of Leocadia and her son Guillermo, a militant nationalist and as such liable to harassment under the laws passed by Ferdinand VII. To a great extent it was they who were responsible for the artist's exile, since Ferdinand VII agreed to maintain both Goya's official status and his salary up until the end of his life.

This digression, however, has prevented us from commenting on a piece of information contained in a document that is vital to our knowledge of Goya's final years, and which we have already mentioned. In 1812 Josefa Bayeu died, and as she and Goya had made no settlement on the occasion of their marriage concerning the division of their possessions — there was nothing to divide — everything that the artist owned at the moment of his wife's death was deemed to have been acquired jointly by them, and he was therefore obliged to divide it equally with his wife's heirs. Their son Xavier, the only surviving child, was his mother's heir, and so following the inven-

tory of the house the couple's possessions were divided into two portions: Goya received jewellery and other goods, which perhaps indicates that he was already thinking of leaving Spain, or perhaps the division was a mere formality, since all his paintings, even the most personal ones, were assigned to his son, who promptly marked them with an X, as has already been mentioned. Thanks to this inventory we know that the series of paintings which tell the story of the capture of the bandit Maragato, was completed before 1812 (pages 98-99). The events portrayed took place in 1806 and captured the public's imagination; Goya himself undoubtedly found the inspiration for his work in the many engravings on the subject that were circulating at the time. Neither Maragato himself nor the reasons for his notoriety would be of interest to us, were it not for the fact that they show how Goya's train of thought developed. In the *Caprices* he had already

revealed his aversion to, or lack of interest in, representations based on traditional symbolism. Even though he sometimes made use of traditional symbols, Goya liked to express himself by means of a series of drawings or paintings that were to be treated as a single entity. A study of the complete series reveals the whole sequence of thought that lies behind it. Perhaps a better way of putting it would be to say that Goya did not express himself by synthesizing his thoughts or feelings, but by presenting them at different moments of analysis. In the case of the bandit's capture, the pictures show the various scenes of the attack and attempted robbery, the friar's defence and the overcoming and seizure of his assailant. This method of expression results in much greater clarity, as we can see from some of the plates in the collection of etchings in the *Disasters of War* series — plates 44 and 45, for example, which are entitled *'I saw it'* and *'And this too'*, respectively. In the first instance (the story of Maragato), the moral is implicit in the

THE MASSACRE
Oil on tin; cm 29 × 41 (11½″ × 16⅛″)
Circa 1808-1814
Madrid, Prado Museum (740i)

114

MARTYRDOM
Oil on panel; cm 31 × 45 (12⅛" ×
17¾")
Circa 1808-1814
Besançon, Musée des Beaux Arts
(896.1.176)
This work forms part of a group that is
traditionally identified as showing the
martyrdom of two French Jesuit mission-
aries in Canada, at the hands of Iroquois
Indians. The incident had created a great
stir and become a *cause célèbre* of the
time.

development of the tale. In the second, Goya shows two aspects of the same
event: the horrors of a rout. There are other examples in the drawings in his
albums, but the ones above provide an adequate illustration of this
technique.

We have already mentioned how the works of Goya's final years are char-
acterized by the growing importance of their personal content. By this I
mean that in his final series of drawings and paintings, and even in those
that seem at first sight to represent ideas, dreams or fantasies, we are able to
recognize expressions of real-life experiences: events from his own life,
transformed to a greater or lesser extent.

The war against the French to restore the Spanish throne to Ferdinand VII,
the idol of the people, who considered him to be the victim of Napoleon,
inspired a great number of paintings, in addition to the drawings and
engravings in the *Disasters of War* series. These paintings are of varying
importance: the two greatest ones, in every respect, including their size, are
Goya's world-famous *The Second of May 1808* and *The Third of May 1808*,
which are now in the Prado (pages 132, 133). They were completed in 1814,

THE BONFIRE
Oil on tin; cm 32 × 43 (12⅝" × 17")
Circa 1808-1814
Madrid, Prado Museum (740j)

a date confirmed by documents recording that Goya received a special fee, which he himself had requested; the paintings, according to the instructions of his commission, were to represent 'the most notable and heroic scenes of our glorious uprising against the tyrant of Europe'. It has been suggested that they were intended to decorate a triumphal arch, but there is no proof of this. We do know, however, that they went into the Museum with other works from the Spanish Royal Collection. *The Second of May 1808* depicts the revolt of the people of Madrid at the Puerta del Sol and their attack on the Mamelukes on that day, while *The Third of May in 1808* shows the retaliatory shootings carried out by the French troops on the following evening. We now know some of the details of those tragic events, which, although they in no way alter the significance of the paintings, do underline the existence of the strong personal element that we have already mentioned as being characteristic of Goya's later work, since the artist was himself closely affected by the horrors of that day, and the memory of this trauma lives on in the painting.

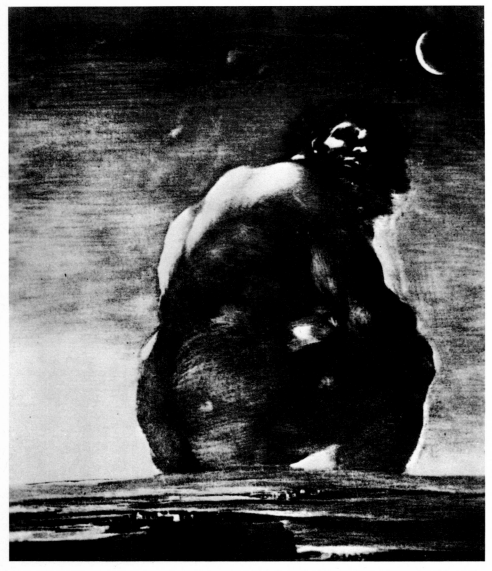

THE COLOSSUS
Mezzotint; cm 28.5 × 21 (11¼″ × 8¼″)
Circa 1810-1818
Paris, Bibliothèque Nationale (A.3122)
This work echoes the 'Colossus' on the page opposite, but in a much calmer and less threatening version.

On right
THE COLOSSUS
Oil on canvas; cm 116 × 105 (45¾″ × 41⅜″)
Circa 1808-1814
Madrid, Prado Museum (2785)
The heavy symbolism of this painting has been variously described as referring to terror, hurricanes and war.

Recently, a close look has been taken at the reminiscences of a man who had fought with the French army and witnessed the events in the Plaza de la Puerta del Sol. They contain information that verifies the fact that amongst the first victims of the uprising were members of a family who were very close to Goya, being not only personal friends, but also relations by marriage. In a book, published in 1834 under the strange title of *Vert et Blanc*, J.T. Merle, a soldier in the French army, recalled the events of that fateful day.

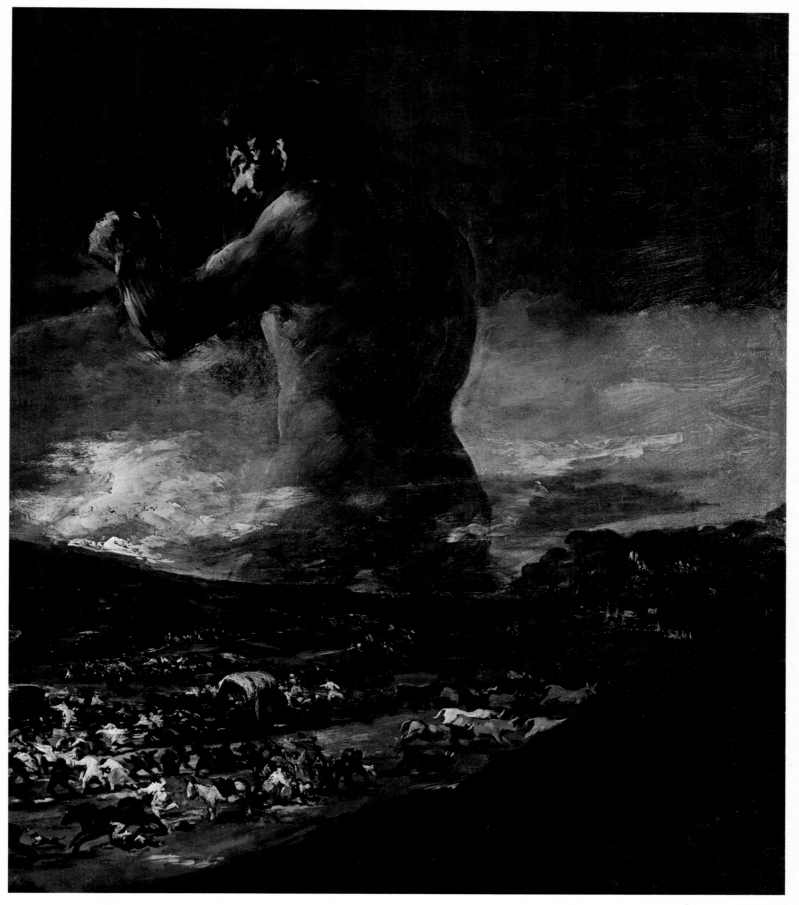

The Puerta del Sol was full of protesting townspeople when the Guardia, followed by the Mamelukes, advanced down a street, called the Carrera de San Jerónimo, that led into the square. As they entered the square, shots rang out from one of the main houses there, hitting a Mameluke, who fell from his horse. Two servants then came out of the house and retrieved the wounded man, whereupon the Mamelukes launched a frenzied attack on the house, killing everyone they found inside, men, women and children, a total of fifteen people in all. The house belonged to the banker Don

117

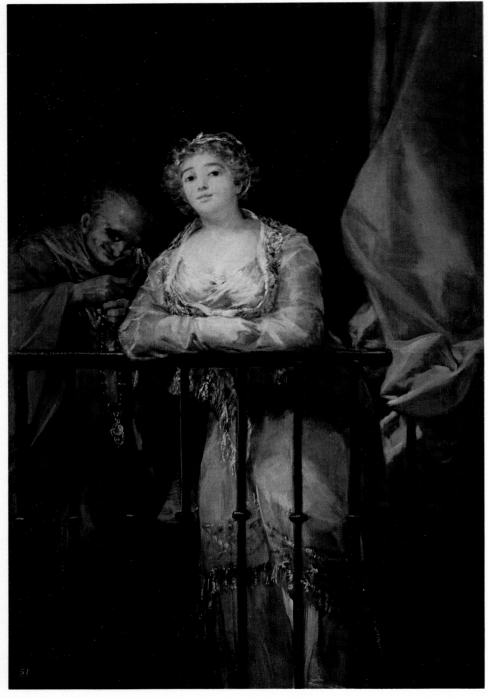

MAJA AND CELESTINA AT THE
BALCONY
Oil on canvas; cm 116 × 108 (65½" ×
42½")
Circa 1808-1812
Madrid, Bartolomé March Collection
A 'Celestina' was a well known figure in
Spanish literature and equivalent to the
modern 'procuress'.

Gabriel Balez, and the victims were himself, his family and their servants.
As will be remembered, Xavier de Goya, the artist's son, was married to
Gumersinda de Goicoechea y Galarza, the daughter of Martín Miguel de
Goicoechea. The latter had gone into business with a cousin of his, forming
the Sociedad Galarza y Goicoechea, which in 1808 was run by Gabriel
Balez, the son-in-law of Galarza, and by Martín Miguel de Goicoechea
himself, Xavier Goya's father-in-law. The painter, therefore, in producing
this great and famous picture, was unable to forget either the incident of
the fallen Mameluke or the slaughter of a family who had been so close to
him. The Balez were people that he knew intimately; he knew all their
family stories and all the other details about them which are now forgotten.
In his great painting Goya glorified the rising up of the people of Madrid
against the French, revelling in the sight of the Mameluke falling like a
dummy from his horse and the *majos* attacking the invaders. Even if the
scene was not exactly as he portrayed it, Goya managed to capture its essen-
tial element: the butchering of a group of people very close to his heart.
All this points to the need for us to reconsider something that in recent years
has been regarded as a mere flight of literary fancy by one of Spain's roman-
tic writers, Antonio Trueba, who, in *Madrid por fuera*, repeated a story told

THE YOUNG GIRLS or THE LETTER
Oil on canvas; cm 181 × 122 (71⅜″ × 48″)
Circa 1810-1812
Lille, Musée des Beaux Arts (349)

TIME AND THE OLD WOMEN
Oil on canvas; cm 181 × 125 (71⅜″ × 49¼″)
Circa 1810-1812
Lille, Musée des Beaux Arts (350)

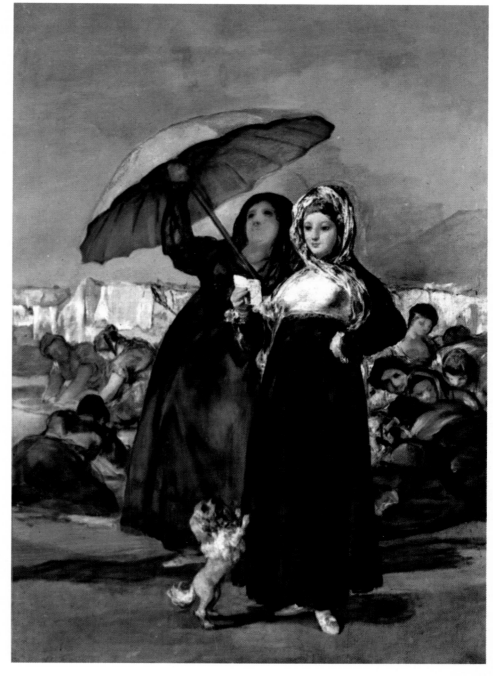

him by an old gardener of Goya's. He gives the date of his conversation with the latter as 1 May 1836, eight years after the painter's death. Isidro, the gardener, told Trueba that on May 3rd 'from the window' — they were at La Quinta — 'he [Goya] saw the shootings at Montana del Príncipe Pío, with a telescope in his right hand and a loaded blunderbuss ... in the left' and that he had later ordered him to accompany him, armed, to see the corpses by moonlight and had made notes on the bodies by the light of the moon. Despite certain romantic embellishments, there is reason to believe that Trueba's account does have a core of truth; apart from anything, his other writings do not show him to be the kind of man to indulge in wild flights of fancy.

It has seemed to many people that the fact that Goya acquired his Quinta property in 1819, that is to say, eleven years after the Madrid uprising and repressive measures that followed, was proof that Trueba had made his story up. But the 1812 inventory, which we have already referred to, mentions a telescope as being amongst Goya's personal possessions in his house. Of course, the mere fact that he owned one does not prove that he used it on 3 May, but he definitely did have one. And there is something else: prior to 1812 Goya had painted the great picture that now hangs in

Lille Museum, since that also appears in the inventory. It is a hard painting to understand. It shows two elegantly dressed *majas* reading a letter, or a note, with a small dog at their feet, but the curious thing about the painting is that it seems as if Goya wanted to show something more than just two female figures. What it was that he wished to convey, however, is impossible to make out. The setting of the picture is one of the places on the banks of the Manzanares where the women went to do their washing, and the background consists of a number of these washerwomen at work on their knees. What can the connection be between these beautifully dressed young ladies and the washerwomen? This particular aspect of the painting does not concern us here. What is of interest to us is the fact that maps show that these washing places were situated on the banks of the Manzanares directly below La Quinta, which tells us that Goya was familiar with this district before 1812. Is it not possible that he had rented a place there before the war? And could he not have subsequently bought it, or one next to it, in 1819? We do not know of any document that proves this theory, but many things happen for which we have no documentary proof. Let us just accept it as a possibility that his great *Third of May* painting was the portrayal of something that he had himself experienced on that moonlit night, and that the expressions of those about to die are a living reminder, perhaps, of a scene that he had himself witnessed through his telescope from the bank of the Manzanares opposite where the patriots were being executed.

The war inspired other paintings by Goya, described in the 1812 inventory: acts of brutality and violence depicted in various series of small, sombrely painted pictures, in which the action takes place in the fringes of the shadows. In these works, as in the series of engravings (some of which are dated 1810), Goya's position is unequivocal: the ones who kill, shoot and torture are French, and those who defend themselves, who suffer or who die, are Spaniards. The one exception is the plate in which some generals are portrayed entitled *'They disagree'*. In dealing with this series, it should also be noted that it was not, in fact, published by Goya himself; its publi-

Facing, above:
PEDRO ROMERO KILLING THE HALTED BULL
Etching and aquatint; cm 24.5 × 35.5 (9⅝″ × 14″)
1815-1816
Tauromachia (Plate 30)
The first thirteen plates of 'Tauromachia' are dedicated to the origins of bull-fighting and follow the outline of a work by Nicolás Fernández Moratín; the other plates deal with events actually witnessed by the artist.

Facing, below:
A SPANISH HORSEMAN KILLS THE BULL ON FOOT
Etching and aquatint; cm 24.5 × 35 (9⅝″ × 13¾″)
1815-1816
Signed: 'Goya'
Tauromachia (Plate 9)

THE FAMOUS MARTINCHO PLACES THE 'BANDERILLAS' WHILST SIDE-STEPPING
Etching and aquatint; cm 25 × 35 (9⅞″ × 13¾″)
1815-1816
Tauromachia (Plate 15)
This series was published by Goya himself, and their sale was simultaneously announced in the *'Diario de Madrid'*.

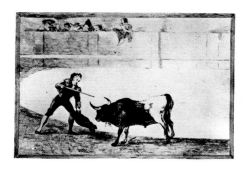

THE DREADFUL DEATH OF THE MAYOR OF TORREJÓN
Etching and aquatint; cm 24.5 × 35.5
(9⅝″ × 14″)
1815-1816
Tauromachia (Plate 21)
The mayor of Torrejón was gored to death by a bull that had escaped from the ring.

cation occurred several years later, when it was acquired by the Real Academia de San Fernando. The Academy altered its original title, which it had perhaps originally been given by Ceán Bermúdez, since there is one copy in which he has corrected the titles that Goya himself had written on in pencil. When the series was published in 1863, the Academy broadened its scope by entitling it *Disasters of War*. The one suggested by Ceán Bermúdez was much more long-winded and explicit, and also less concise: *The fateful consequences of the bloody war in Spain against Napoleon, and other significant caprices.*

The fateful consequences of the war, which are shown in this series, are not only the bloody ones that appear in the early plates: also the ones resulting from the famine of 1811 and 1812. The second group of plates deals with the same theme, whereas Ceán's *Caprichos enfáticos* ('significant caprices') form the series' final grouping: from plate 65 to plate 82, if we include nos 81 and 82, even though they did not figure in the Academy's editions, being acquired by them several years later. The scenes of war, like the scenes of famine, are either the remembrances of things Goya had witnessed personally — as we mentioned earlier, two of them illustrate this very clearly (they possibly refer to the flight of King Joseph Bonaparte's Court to Valencia) — or they are the remembrances of events related to him by friends or acquaintances, animated by the passion that affected the whole of the Spanish people, even though Goya's own position was, as we shall see, somewhat ambivalent on occasion.

The *Caprichos enfáticos* mark the beginning of a new stage in Goya's artistic career. They reveal the thoughts and mental images of the deaf and solitary old man that he was at that time. The political background of his life, his ideas on man and humanity in general, his horror and despair all culminate in plate 79, *'Truth has died'*, and 80, *'Will she rise again?'*, which follows on from it, and in plate 82 (a paean of hope that is not included in the first editions): *'This is the Truth'* (pages 100, 101). These plates provide a thematic introduction to the last series that Goya engraved,

THE FORGE
Oil on canvas; cm 181.6 × 125 (71 ½ ″ ×
49 ¼ ″)
Circa 1812-1816
New York, Frick Collection
There is also a preparatory drawing of this
work in existence.

his 'Proverbs', to which we shall return at the appropriate time.

We have already noted the growing perfection and technical complexity of Goya's engravings, and, on a different level, how their anecdotal quality raises them to the status of works of universal merit. The engravings of the first group, which show things from the Spanish point of view, with the French armies cast in the role of the cruel enemy, end up by becoming, because of the profound truths they contain, a universal criticism of the horrors of war.

During the war years Goya continued to produce portraits, but not only family ones like those of his son's parents-in-law, *Martín Miguel de Goicoechea and his wife*, and the ones he did of his grandson *Mariano*, standing; he also painted many friends and relations, such as *Silvela* or

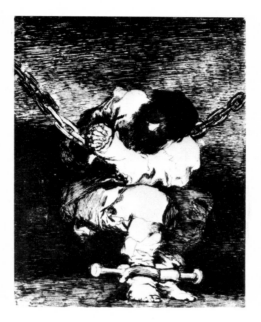
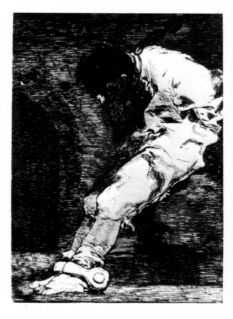

DETENTION AS BARBARIC AS THE
CRIME
('Tan bárbara la seguridad como el
delito')
Etching; cm 11 × 8.5 (4⅜″ × 3⅜″)
Circa 1810-1820

THE CUSTODY OF A CRIMINAL
DOES NOT DEMAND TORTURE
('La seguridad de un reo no exige
tormento')
Etching; cm 11.5 × 8.5 (4½″ × 3⅜″)
Circa 1810-1820

IF HE IS GUILTY, LET HIM DIE
QUICKLY
('Si es delinquente qᵉ. muera presto')
Etching; cm 11.5 × 8.5 (4½″ × 3⅜″)
Circa 1810-1820

Antonia Zárate (page 105), or *Juliá* or *The Bonells*, as well as a group of French soldiers and *afrancesados*. Of the former, his portrait of *General Guye* is among the most outstanding (page 103), while the most exceptional work in the second category is that of *Canon Llorente*, a liberal and historian of the Inquisition, who is depicted flaunting the great cross of the Order of Spain, which was founded by Joseph Bonaparte (page 102). That particular work illustrates the diversity of Goya's connections and also his divided loyalties. On the one hand, he felt a kinship with the *afrancesados* (literally Frenchified) because of his Enlightenment sympathies and also because many of them were his friends, while on the other, he identified deeply with the emotions felt by so many of his fellow Spaniards. Our knowledge of his life during these years reveals a certain ambivalence on the artist's part. We know, for example, that he visited Saragossa between the two sieges, and it appears that he did some paintings of the siege, which were commissioned by General Palafox, the city's defender, and are reputed to have been destroyed by the French troops after their capture of Saragossa. He also painted a beautifully studied half-length portrait of *Wellington* during the latter's stay in Madrid (page 109), and also a less successful equestrian portrait. At the same time, however, he was also completing the so-called *Allegory of the City of Madrid* (page 107), which contained, in a rather apotheosizing fashion, the portrait of Joseph Bonaparte; the painting's composition was, in fact, altered in the light of subsequent political developments, and an inscription in honour of the second of May was substituted for the portrait. It should also be added that it was Goya who selected the Spanish paintings that went to enrich the Musée Napoléon, and that King Joseph Bonaparte bestowed the cross of the Order of Spain on him and regarded him as his '*pintor*'.

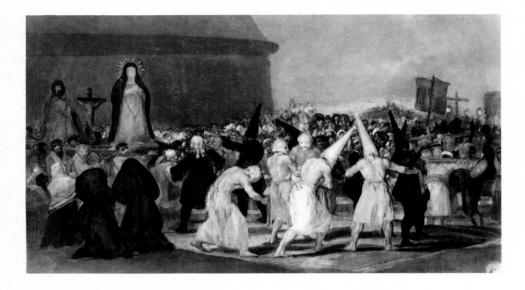

FLAGELLANTS
Oil on panel; cm 46 × 73 (18″ × 28¾″)
Circa 1812-1819
Madrid, Real Academia de San Fernando
(674)

I believe that Goya's position was that described by the English writer John Bacon in 1838, when he wrote of the agonizing dilemma faced by 'reformists' during the final years of Charles IV's reign. These men, following Napoleon's placing of his brother Joseph on the Spanish throne, found themselves in a situation that was 'very embarrassing for those who supported reform and representative government; since ... by relying on the help of the French to rule their country, they found themselves in opposition to the very men that they had chosen to be their rulers. To side with the enemy meant accepting the insult and renouncing one's nationality: to side with the nation in its fight against Napoleon could well lead to the perpetuation of those very abuses that they were seeking to correct'.

Whilst on the subject of Goya's activities during the war years, we should also mention the many works that he did for himself: a series of still lifes to decorate his dining room, twelve in all (pages 110, 111 and 112-113); the group of large compositions with *mujerio* ('womenfolk') themes, as Sánchez Cantón described them, also done for his own house; the ones of labourers at work, the most outstanding of which is *The Forge* (page 122), and, as proof of his versatility, a growing number of scenes from everyday life. He sometimes repeated themes developed during his youth, whilst at other times he experimented with new ones; amongst the latter were a number of fantasies that bore no relation to either his *Caprices* or subsequent works.

TRIBUNAL OF THE INQUISITION
Oil on panel; cm 46 × 73 (18″ × 28¾″)
Circa 1812-1819
Madrid, Real Academia de San Fernando
(673)

BURIAL OF THE SARDINE
Oil on panel; cm 82.5 × 62 (32½" ×
24⅜")
Circa 1812-1819
Madrid, Real Academia de San Fernando
(676)
There is also a preparatory study for this
work, which varies in many respects from
the final version.
See pages 126-127 for detail

The most extraordinary work of all, which had no artistic precedent at all, is
the one we now know as *The Colossus* (page 117), but which was described
in the 1812 inventory as 'A Giant'. The only other work of art that bears any
relation to it is an aquatint done by Goya himself during the same period
(page 116), an extremely strange work, which depicts the solitary and
gigantic figure but in a very different pose from the one in the painting. In
the engraving he is shown seated, facing away from us, while in the
painting he stands with his fist clenched, rearing threateningly up amongst
the clouds. In the broad swathe of countryside that forms the foreground of
the painting, crowds of people can be seen running in terror. Some scholars
have sought to explain the figure as being an allegory of the spirit of war, or
as representing Napoleon, or the people of Spain rising up against him.
The most likely interpretation put forward is that it is connected with the
verses of Juan Bautista Arriaza, who, in his *Profecía del Pirineo*, a patriotic-
ally inspired composition that enjoyed great popularity at the time, refers
to a giant *Guardián titular ... de las Españas*, the personification of the
nation's spirit, which rises up against the foreign invader.
The discovery of a copy of the three engravings of *Prisoners* in the *Disasters
of War* volume, the captions of which Ceán Bermúdez had amended, has
led to the belief that these engravings are contemporary with the series and
possibly, therefore, connected with Goya's portrait of the penalist

Lardizábal, follower of Beccaria, since the three captions in question relate to the moral necessity of making the punishment fit the crime and of avoiding the infliction of needless cruelty on those who find themselves in prison. They read as follows: 'detention as barbaric as the crime', 'the custody of a criminal does not demand torture' and 'if he is guilty, let him die quickly'. We have not been able, in our researches, to find quotations that correspond exactly to these phrases, but they do undoubtedly correspond to the preoccupations of the penalists who were interpreting and transmitting Beccaria's thoughts throughout Spain. In any case, they would seem not to correspond, either linguistically or stylistically, to other writings by Goya, although the painter did favour conciseness and, on many occasions, succeeded in writing in a precise and expressive style. In these compositions Goya portrayed scenes of prison life, whose brutality runs completely contrary to the moral concepts that his friends maintained were a vital basis for justice. They do not refer to a specific event, but perhaps to something that he himself had witnessed, or had heard about from other people, which he used as a starting point and then transformed in his imagination.

This use of past remembrance as a source of inspiration occurs in Goya's third series of engravings: *Tauromachia*. Some of its plates are dated 1815, but the series as a whole was not published until the following year. Carderera, who knew so much about the artist's life and works, wrote that he completed *Tauromachia* at the beginning of the century. It may have been the success of Antonio Carnicero's work, which had a similar theme, that inspired Goya to do his series.

We know that Goya was an *aficionado* of bull-fighting, a fact that is supported by a great deal of evidence. There is, for example, the cartoon of the *novillada*, executed in 1779, which includes a possible self-portrait, and his conversations with Moratín, which the latter reported in his letters from Bordeaux, when Goya, then an old man, asserted that he had himself fought bulls in his youth. As well as all the artistic and documentary evidence, there are also passages in his own correspondence that refer very explicitly to his enthusiasm for bull-fighting. There are, for example, the letters that he wrote to his brother-in-law Francisco Bayeu, himself an *aficionado* of bull-fighting, and a particular admirer of Costillares; the portraits he did of the famous bull-fighting brothers, the Romeros; the series of small bull-fighting paintings that formed part of the works submitted to the Academy in 1793. Everything confirms this passion that achieved such eloquent expression in this particular series of engravings.

The plates of the 33 engravings, from which the Calcografía Nacional pulled the first edition in 1855, have been preserved. There are other engravings on the reverse side on the plates, which Goya did not include when he sent the series to his friend Ceán Bermúdez, perhaps for him to correct the captions. They were, however, later pulled in the edition made by Loizeret, who made use of them after Goya had for some unknown reason rejected them. There is also evidence that he did other engravings, of which only the drawings have survived, the original plates having been lost. We cannot here go into detail about the problems posed by the engravings as a group, but it should be noted that they contain a number of stylistic differences, both in the proportions of the figures and in the nature of their composition, which is sometimes confused and at other times simple.

In general terms it would be safe to say that the series is composed of engravings whose theme is the history of bull-fighting, with the first 13 being inspired by the writings of the elder Moratín and Pepe Hillo; almost all the remainder refer to events from *corridas* of the day, and some of them show that Goya himself very possibly witnessed the events portrayed.

We have already mentioned how Carderera says that Goya began engraving the series at the beginning of the century, and how some of the plates bear the date 1815. There is, however, some disagreement as to which of the two groups is the earliest: whether it is the ones on the history of bull-fighting,

MANUFACTURING BULLETS
Oil on panel; cm 33 × 52 (13″ × 20½″)
Circa 1810-1814
Madrid, Royal Palace
This painting deals with the Spanish people's struggle against the French invader: in 1810, in the village of Almudevar (Aragon), a shoemaker, José Mallen, started up a workshop making gunpowder.
See pages 130-131 for detail

which followed the text of the *Carta histórica* written by Moratín, the father of Goya's friend Leandro Nicolás, or the ones that record *corridas* whose dates and other details we know. The figures in the first are larger, in relation to the actual size of the engravings, whereas the second group, which has smaller figures, shows a considerable complexity of composition. Some of these contain such brilliant use of light and shade, of pale and dark, that they are amongst his most impressive graphic works. Goya succeeded in capturing the full dramatic force of man's encounter with the bull, and in giving full and vivid expression to such tragedies as Pepe Hillo's horrific death in the ring, or the killing of the mayor of Torrejón, who was gored to death by a bull in the ringside seats (page 121). There are three engraved versions of the death of Pepe Hillo, which shows the trouble taken by Goya to provide a true representation of the terrible scene that he had very possibly been present at himself. In his engraving of the death of the mayor, impaled on the horns of a bull in the ringside, Goya has highlighted the tragedy by depicting the partially empty seats around them.

The fact that the engravings depicting the history of bull-fighting have other scenes of contemporary events, with much more involved compositions, on the reverse of their plates (the ones that Goya ignored and which were first printed in Loizeret's edition), means that we must consider the possibility that Goya began his series with bull-fighting incidents that he remembered from his early days, and that, at some point before 1815, he decided to do a series depicting the history of his favourite pastime. He therefore sought inspiration in Moratín's *Carta*, and engraved those compositions with large figures, which, despite their technical mastery, are less interesting than those portraying things that he himself had seen. The series was a product of his growing isolation, and his disillusionment with life in Ferdinand's Spain; it was a confession of his desire to escape from the world around him by means of his engraving. Further confirmation of this could be seen in the fact that, in the copy of the album that Goya sent to Ceán Bermúdez, he included the plate from his *Proverbs* (or *Disparates*) called '*A way of flying*' (page 159), a work that contains elements that indi-

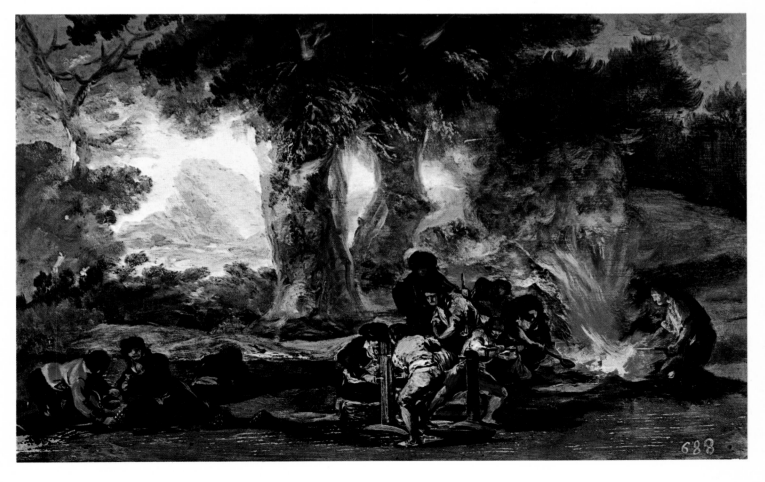

cate it was engraved at the same time as the bull-fighting ones. Perhaps Goya regarded bull-fighting as a means of rising above the mundane realities of everyday life!

The *Proverbs* or *Disparates* ('ollies') series, the last great series that Goya completed in Madrid, is composed of the same kind of fantastic representations as appear in the Quinta pictures, the 'black paintings', whose date we know, because he finished them after recovering from his serious illness in 1819, between 1820 and 1824, the year of his departure to Bordeaux.

In order to understand the situation better, we must take a look at Goya's life during the years following the end of the war. What happened in Spain during that period has a great bearing on the way in which his art evolved. The return of Ferdinand VII and the events that followed Napoleon's defeat left Goya with a feeling of frustration and disillusionment, as was the case with so many other Spaniards. As we have already mentioned, Goya maintained, albeit with certain reservations, the same vigórous hostility against the French as other people in Spain. Throughout the war, however, he found himself in a position that can only be described as ambiguous, since, although he naturally sympathized with the people in their rebellion against the Napoleonic armies, his ideas coincided with the principles behind many of the reforms undertaken by Joseph Bonaparte's government. In March 1813 King Joseph I left Madrid for good, and while retreating to France he was overwhelmingly defeated at Vitoria, on 21 June of the same

THE SECOND OF MAY 1808
Oil on canvas; cm 268 × 347 (105 ½ ″ × 136¾ ″)
1814
Madrid, Prado Museum (748)
The setting for the scene depicted here is traditionally held to have been near the Puerta del Sol in Madrid, where a group of Spaniards launched a surprise attack on a detachment of the Mamelukes of the Napoleonic Imperial Guard.

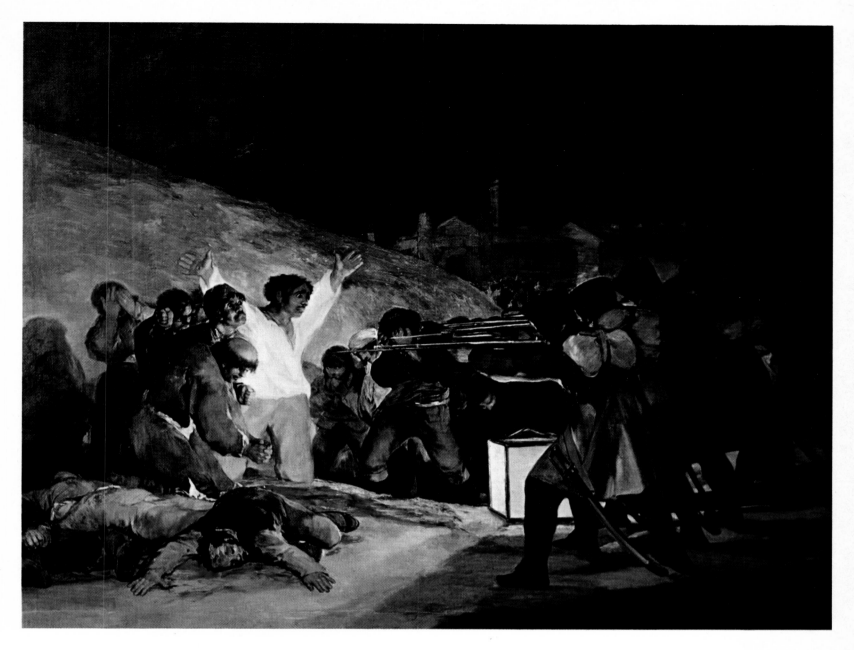

THE THIRD OF MAY 1808
Oil on canvas; cm 268 × 347 (105 ½ ″ ×
136 ¾ ″)
1814
Madrid, Prado Museum (749)
As a reprisal for the popular uprising,
there were indiscriminate executions of
'Madrileños' in the vicinity of the
Montaña del Príncipe Pío, next to
Moncloa.

See pages 135-135 for detail

year. In the meantime, a Council of Regency was formed in 1814 to rule the country pending the arrival of King Ferdinand VII, who entered Madrid on 7 May 1814. A few months earlier, in February, Goya had addressed a letter to the Regency, expressing a desire to immortalize with his brush 'the glorious insurrection against the tyrant of Europe'. It has been pointed out, with reason, that this petition to the Regency, in which Goya stated that he was in dire financial straits due to not having received his salary as *pintor de cámara*, does not coincide with the true facts, as revealed in his wife's will, by which he had received in 1812 jewellery and a large sum of cash: more than 140,000 *reales*. But it is possible that the underlying sentiment behind this request, besides his very real feeling of patriotism, of which there is ample proof, was his anxiety that his activities as a 'collaborator' should be forgotten; there was ample documentary proof of these too.

He succeeded in being reappointed *pintor de cámara*, after having passed through a vetting process that was compulsory for all officials. In April 1815 Goya and his son received official notice of their rehabilitation; both of them were placed in the first category, which signified that they had been completely exonerated. The portraits that he had done of members of the pro-Joseph faction, both civilian and military, were forgotten, as was the part that he had played in selecting Spanish paintings to be sent to the Musée Napoléon in Paris. Goya had been a member of the Commission in charge of choosing suitable works, and, to do the Commission justice, it must be said that they did select the best Spanish paintings available.

But although Goya had managed to achieve official rehabilitation and

avoid the odium of the King and his followers, this was not the case with the 'afrancesados' and the liberal members of the Cortes in Cadiz, whose constitution was abolished by the King. The latter were to suffer a long and cruel persecution that drove many of Goya's closest friends into exile: notably, Moratín and Menéndez Valdés. But, despite his rehabilitation and the fact that he avoided this persecution, Goya never regained the same favoured status at Court that he had enjoyed under the King's parents and grandparents. The most popular painter in the Court of Ferdinand VII was Vicente López. Goya, who was now almost in his seventieth year, was no longer a fashionable painter, and, as we have already mentioned, he had not even enjoyed the King's confidence when the latter was Crown Prince. While waiting for his official rehabilitation, he also had to negotiate the danger posed by the appearance of his two *Majas* in the collection of paintings confiscated from Godoy. They were both judged to be obscene and, along with several other works, were passed to the Inquisition, who called on their author to appear before it. We do not know what the final outcome of the case was, since the relevant papers have since disappeared, but possibly Goya succeeded in having the proceedings suspended. Since its revival, the Inquisition lacked both the power and authority of earlier days. Goya, however, felt alienated from what was happening, and he felt that he was in danger of being persecuted either for his ideas or for his works. Also, despite the fact that he had been retained as chief *pintor de cámara*, he felt that he was being ignored. Proof that the tastes of the new Court did not

THE BOARD OF THE PHILIPPINES COMPANY
Preparatory sketch
Oil on canvas; cm 54 × 70 (21¼″ × 27½″)
Circa 1815
Berlin, Staatliche Museen Preussischer Kulturbesitz (1619)

THE BOARD OF THE PHILIPPINES COMPANY
Oil on canvas; cm 327 × 417 (128⅞″ × 164¼″)
Circa 1815
Castres, Musée Goya (49)
This painting shows a meeting of the 'Real Companía de Filipinas'. Goya's friend Munarriz, a director, commissioned the artist to immortalize on canvas the King's presence at the meeting.

coincide with his own is provided by the case of decoration of the boudoir of Queen Isabel of Braganza, Ferdinand VII's second wife. Her apartment in the Palace was decorated with paintings *en grisaille*: two of them were painted by Vicente López, and one was done by a mediocre Neoclassical artist, José Aparicio, of whose work Ferdinand VII was very fond, while the remainder were shared out between Zacarías Velázquez, Camarón and Goya, who was thereby relegated to secondary status.
Goya was at the peak of his artistic abilities, and, despite his advancing years, was still full of energy. During his last years in Madrid he was able to produce two of his most outstanding works, and also some of his most incisive portraiture. Two self-portraits from the time give proof of this vitality (pages 6 and 140), one of which, now in the Academy, bears the date 1815.

In neither of them does he look his 69 years, either facially or in the strength of his expression and his gaze. Two years later, in 1817, he signed himself on his great painting of *St. Justa and St. Rufina* in Seville Cathedral with the lengthy and rambling inscription 'Francisco de Goya y Lucientes Cesaraugustano y primer Pintor de Cámara del Rey' (Caesaraugusta was the Roman name for Saragossa). Restoration of the picture has recently revealed the full impact of its composition, the extraordinarily luminous quality of its colours, and the masterful strength of its figures (page 143). The picture also shows how he tried to adapt the lines of its composition to an earlier tradition (that of Murillo, amongst others), in the disposition of the Saints in front of the distant silhouette of the city of Seville. He did this in order to conform with contemporary taste, since this painting is Goya's version of David's Neoclassicism, which was the latest fashion in Madrid at the time. He quite clearly used the same technique in his portrait of the *Duchess of Abrantes*, one of the daughters of the Duke and Duchess of Osuna, which is dated 1816 (page 141). This work was done in a palette of pale, sharp colours, in which there is very little use of yellow, as in his painting of the Saints in Seville. The portrait of the *Duchess of Abrantes* can only be compared, as far as its colouring is concerned, with his one of *Miguel Fernández,* the Bishop of Marcopolis and Apostolic Administrator of Quito, which is painted in brilliant reds and blues. Both portraits differ radically from the others done by Goya during those years, which were generally painted in dull colours, with a great use of black.

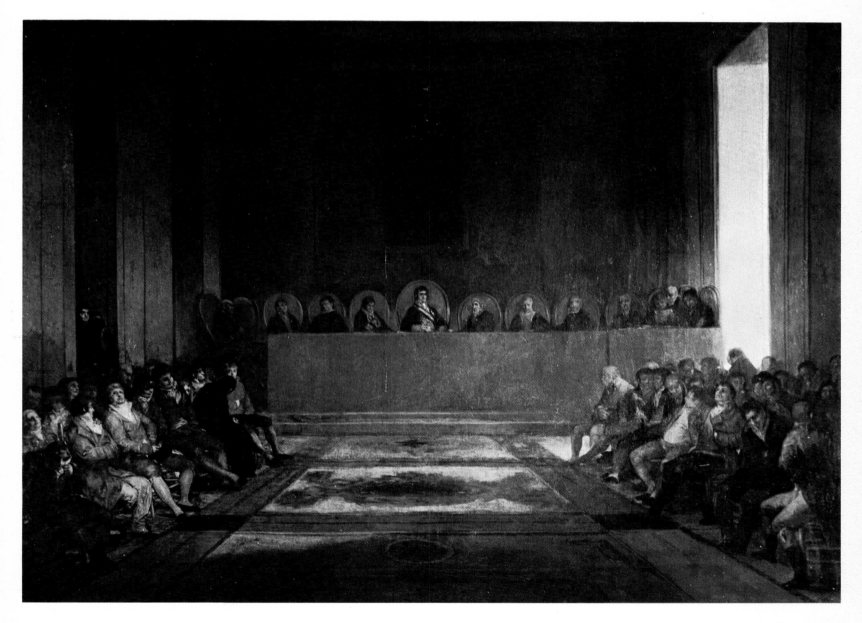

All these pictures, however, are dwarfed by a single large, group portrait, which was one of the largest works that Goya ever undertook. It shows the general assembly of the *Real Compañía de Filipinas* (page 137), which took place in 1815, with the King presiding. The painting was commissioned by José Luis Munarriz, who, after being secretary of the Real Academia de San Fernando, had become director of the company. It portrays the stock-holders of the company, seated along the two sides of the room, with a large table in the centre background, at which the King is seated, together with the other people presiding over the meeting. The picture is important because of the artistic problem it posed: how to portray a meeting in a vast room, unevenly lit by large, open windows on the right (as in Velázquez' painting of *Las Meninas*), which imbued the whole scene with a feeling of austere solemnity. It is also important for the event that it commemorates. The Royal Philippines Company had been reduced to near bankruptcy as a result of the war against the French. Its major stock-holder was the King, since both he and his parents had taken shares in it when it was founded. And Ferdinand, being an autocratic monarch, was therefore presiding over this meeting, which was designed to try and revitalize the company, in his capacity both as King and as major stockholder. This action of his reflects the way in which a commercial middle class was gradually developing, something that Spanish society was slow to come to terms with. Goya did other portraits of *Munarriz*, who was Minister for Overseas Affairs, *Miguel de Lardizábal* and *Ignacia Omulryan,* all of whom were closely connected with the company and also with this painting, in which they appear, in miniature, presiding over the meeting.

The year 1820 began with an event that transformed the Spanish political scene, and which, undoubtedly, must have given Goya a great deal of pleasure. On 1 January General Rafael Riego rose up against the absolutist government of Ferdinand VII. The uprising was successful and the King was forced to accept the insurgents' demands. On 9 March he swore to a new liberal Constitution; the Inquisition was abolished, the Jesuits expelled , and many convents closed down.

For someone with the same ideals as Goya, the events were a triumph. Despite the fact that his advancing years had forced him to live a relatively isolated life, he went, for the last time, to the Academy in order to swear his allegiance to the new constitution. Very possibly, it was at this moment that he handed Ceán the copy of the *Disasters* which we have already mentioned, with a view to their publication. Up until that time, their second part — the 'symbolic caprices' — had prevented the series' publication, because many of their plates could have been considered to be contrary to the beliefs enforced by Ferdinand VII, in his capacity as absolute monarch. This new state of affairs, which could have led to Spain's development along normal political lines, was soon disrupted by disorders, internecine struggles and personal vendettas. As a result of these disturbances, Ferdinand sought help from the Holy Alliance, who, in 1822, at Verona, decided to intervene militarily in order to reestablish the absolute power of the King. The expedition of the so-called 'Hundred Thousand Sons of St. Louis', under the command of the Duke of Angoulême, entered Spain, and, having encountered no resistance, within three months had reached Cadiz, where they found Ferdinand VII in the hands of the liberals. The capture of the Trocadero fortress, on 30 August 1823, marked the victorious conclusion of the expedition. The King was reestablished on the throne, as an absolute monarch, and he immediately embarked on a systematic persecution of all those who had fought on the side of the liberals. Some were executed and others were deported. The fear and vengeance of the King spread throughout Spain, and many liberals emigrated.

Goya felt compromised and took a variety of precautionary measures. He went into hiding in the house of a close friend, Don José de Duaso y Latre, whom he painted, together with his nephew (pages 158, 159), and, in order to ensure the safety of his possessions, he gave his Quinta property, by the

FERDINAND VII WEARING THE ROYAL ROBES
Oil on canvas; cm 280 × 125 (110⅜″ × 49¼″)
1814-1815
Saragossa, Museum of Fine Arts (172)
Painted on commission for the 'Sociedad del Canal Imperial de Aragón'.

Manzanares, to his grandson Mariano. Leocadia Weiss must have felt equally compromised, since, apart from her liberal ideas, we know that her elder son Guillermo had been a member of the national militia, and as such could easily have been prosecuted and punished. It was undoubtedly this possibility that led to their emigration. We also know that Rosario, her daughter, was sent to stay with a friend of Goya's, Tiburcio Pérez, from which it can be deduced that she lived apart from her mother. We do not know exactly what happened to Leocadia herself during this time, but she must also have gone into hiding somewhere, since she was never arrested. The new political situation caused Goya much grief and disquiet. He had also, in 1819, suffered a serious bout of illness, from which he recovered thanks to the care given to him by Dr. Arrieta. An exceptional self-portrait, from 1820, in which Goya depicted himself in agony, being carefully

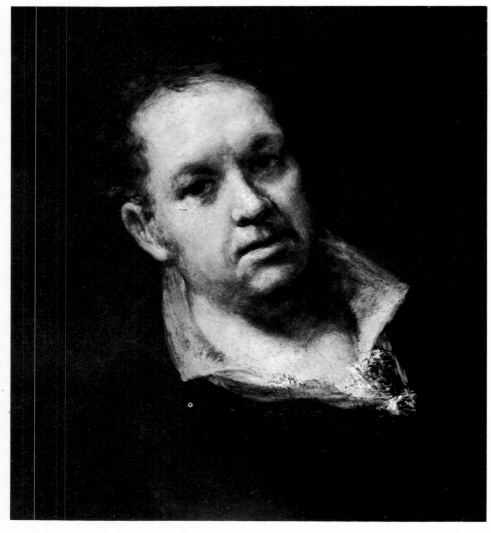

SELF-PORTRAIT
Oil on panel; cm 51 × 46 (20⅛″ × 18″)
Signed and dated: 'Goya 1815'
Madrid, Real Academia de San Fernando
(669)

tended by the doctor, records not only his illness, but his gratitude to the man who had cared for him (pages 153, 154-155).
During the period immediately prior to this illness, Goya had returned to doing major works with religious themes. We have already stressed the importance of the many religious paintings that he did throughout his life, and also how certain decades proved particularly productive. In May 1819, after the completion of his *St. Justa and St. Rufina* in Seville Cathedral, which we have already discussed, the fathers of the Escuelas Pías de San Antón in Madrid commissioned him to do a large altarpiece of St. Joseph Calasanctius (San José de Calasanz), the founder of the Order (page 156). Goya completed it during the months preceding the church's consecration, which took place on 27 August.
The compositions show an unprecedented spiritual intensity, which is exceptional even when considered in the universal context of painting.

Both *The Last Communion of St. Joseph Calasanctius* and *The Agony in the Garden* have a totally different expressive quality from his paintings of the two Saints in Seville Cathedral, a work that impresses by the power of its figures and the brilliance of its colours. For *The Last Communion of St. Joseph Calasanctius* Goya sought inspiration in a highly praised work by Ribera, which at that time was in the Escorial; it was from there that the pose of the officiant is derived, as well as the darkened surroundings and the group of figures whose concentration is centred on the last moments of the Saint, whose expression is uniquely moving. The richness and variety of the black or dark grey that surrounds the golden vestments of the officiant, gives a feeling of emotionally charged mystery to the scene. *The Agony in the Garden* is also a work of exceptional intensity, which, with regard to its composition, recalls the plate in the *Disasters* entitled '*Sad forebodings of*

 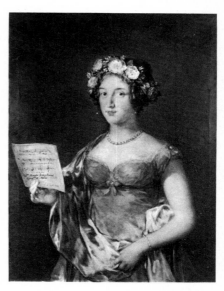

things to come', a similarity that has led some people to classify the latter as the lay version of *The Agony in the Garden*.

During the first part of 1819, Goya was extremely active. Not only did he paint the religious pictures mentioned, but, in February 1819, he put his signature to what may well have been his first ever lithograph, his *Old Woman Spinning*, which was produced in Madrid's first lithographic studio, opened by José María Cardano, who had learned the new printing technique in Paris. This work was followed by other smaller ones, but it was not until Bordeaux that he produced his truly great lithographs, which we will deal with when the time comes. As well as producing works in this new graphic medium, from 1815 onwards, at dates we cannot pinpoint with any precision, he worked on a series of etchings, which we have already mentioned. This group of works, known as the *Proverbs* or *Disparates*, mark the high spot of Goya's graphic work; executed in a variety of different techniques, they contain some extraordinary *chiaroscuro* effects. He never published the collection himself, however: this only happened many years after his death, when his grandson sold eighteen of the plates to the Spanish Royal Academy. Goya had pulled a few proofs, though, on which he wrote, in his own hand, the title *Disparates*: '*Feminine Folly*', '*Carnival Folly*', '*The Folly of Little Bulls*'and so on. The significance of these titles, whatever it may have been, was not recognized by the Academy, who published them untitled, under the general heading of *Proverbs*, and it was under this name that they came to be known until the discovery of those with Goya's own handwritten titles. Harris, the author of the basic work on these etchings, reverted to using the titles they were given when published by the Academy, and tried to discover, from the vast repertory of Spanish sayings, one that would correspond to each of the works in the series. Some of his matches are very convincing and clear, whereas others seem to be somewhat contrived. In any case, the existence of a particular saying does not explain

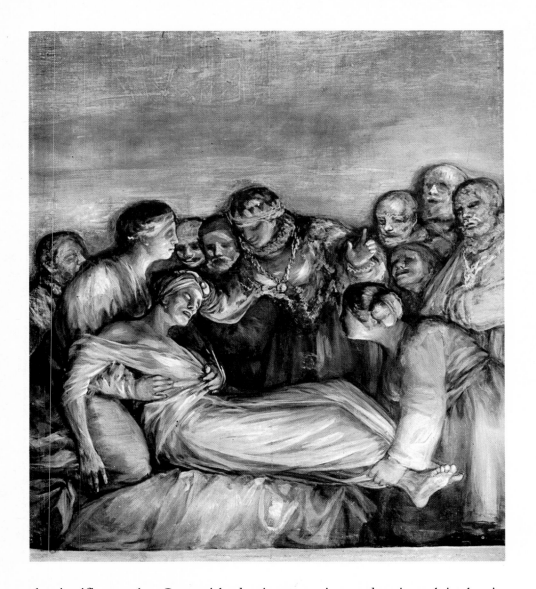

ST. ELIZABETH ASSISTING A SICK
WOMAN
Tempera on *grisaille;* cm 169 × 129
(66½″ × 50⅞″)
1816-1817
Madrid, Royal Palace
This work formed part of a decorative
scheme commissioned by Ferdinand VII
for Queen Isabel of Braganza.

the significance that Goya wished to impart to it, nor does it explain the cir-
cumstances of its application. Their true meaning is still a mystery, and the
preparatory drawings that have survived, which differ in many respects
from the final engravings, are of no help to us in trying to resolve it.
It is my belief that the anxiety and danger in which Goya lived during the
years prior to 1820, and also in the years following the restoration of the
King's absolute power, were the reasons for his not having published them,
and that, in order to protect himself from any possible danger that might
result from their interpretation, he only kept a series of proofs, to which he
gave these vague titles, under the general heading of *Disparates*, so as to
render them completely innocuous. They thereby became totally devoid of
comment or criticism — mere 'disparates' — even though initial purpose
may have been to criticize actual deeds or events. Their meaning would
only be apparent to those who knew his own hidden thoughts and opinions
concerning the political situation of the time. The same spirit lay behind
them as lay behind the paintings on the walls of the two rooms in his Quinta
property: the 'black paintings', so called because of the dominance of that
colour.
This property, from the bill of sale dated 27 February 1819, consisted of
some ten hectares of cultivated ground and a small house, situated on the
far side of the Manzanares, with extensive views over the city. The house was
enlarged by Goya, and he himself decorated two rooms in this extension,
one on each of its two floors. One was intended to be used as a reception
room, and the other as a dining room. He painted them in a way that was
unusual by any standards, since, from a technical point of view, it is
extremely rare for oil paints to be applied directly to plain whitewashed

walls. It is also a technique that renders the paint highly susceptible to deterioration.

The fourteen paintings that comprise the two groups were completed after his serious illness in 1820. The mysterious quality of the different scenes depicted and the fact that their meaning is so hard to interpret, does not mean that they developed piecemeal as work progressed, with no previous overall plan. In the inventory drawn up by Brugada after Goya's death, mention is made of seven small preparatory sketches, which shows that he prepared this decorative scheme with the same care that he gave all his other works. In fact, a number of small sketches have recently come to light that may well have been done by Goya, and it is possible that they are the same ones that Brugada came across while preparing his inventory.

Personally, I am unconvinced by the various attempts to explain the two

ST JUSTA AND ST RUFINA
Preparatory study
Oil on panel; cm 45 × 29 (17¾″ × 11½″)
Circa 1817
Madrid, Prado Museum (2650)

ST JUSTA AND ST RUFINA
Oil on canvas; cm 313 × 185 (123⅜″ × 73″)
Signed and dated : 'Francisco de Goya y Lucientes Cesar- / augustano y primer Pintor de camara / del Rey, Madrid, ano de 1817'
Seville, Cathedral Sacristy
Goya received the commission for this work through the influence of his friend Ceán Bermúdez.
See pages 144-145 for detail

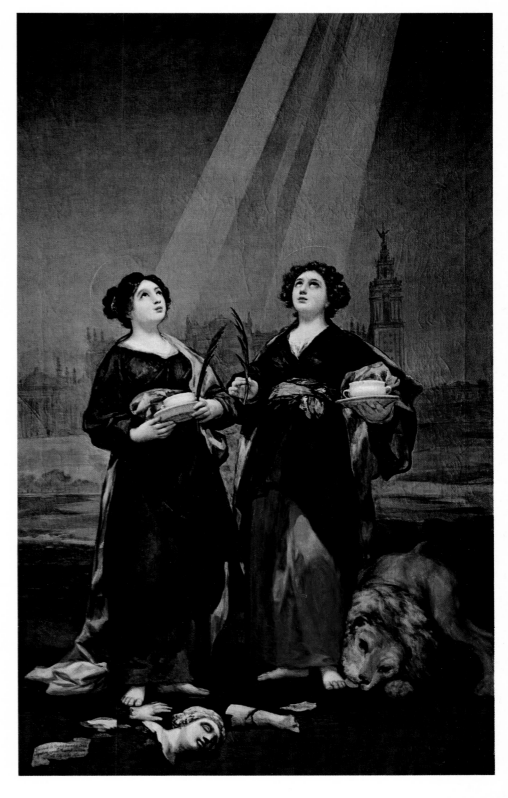

143

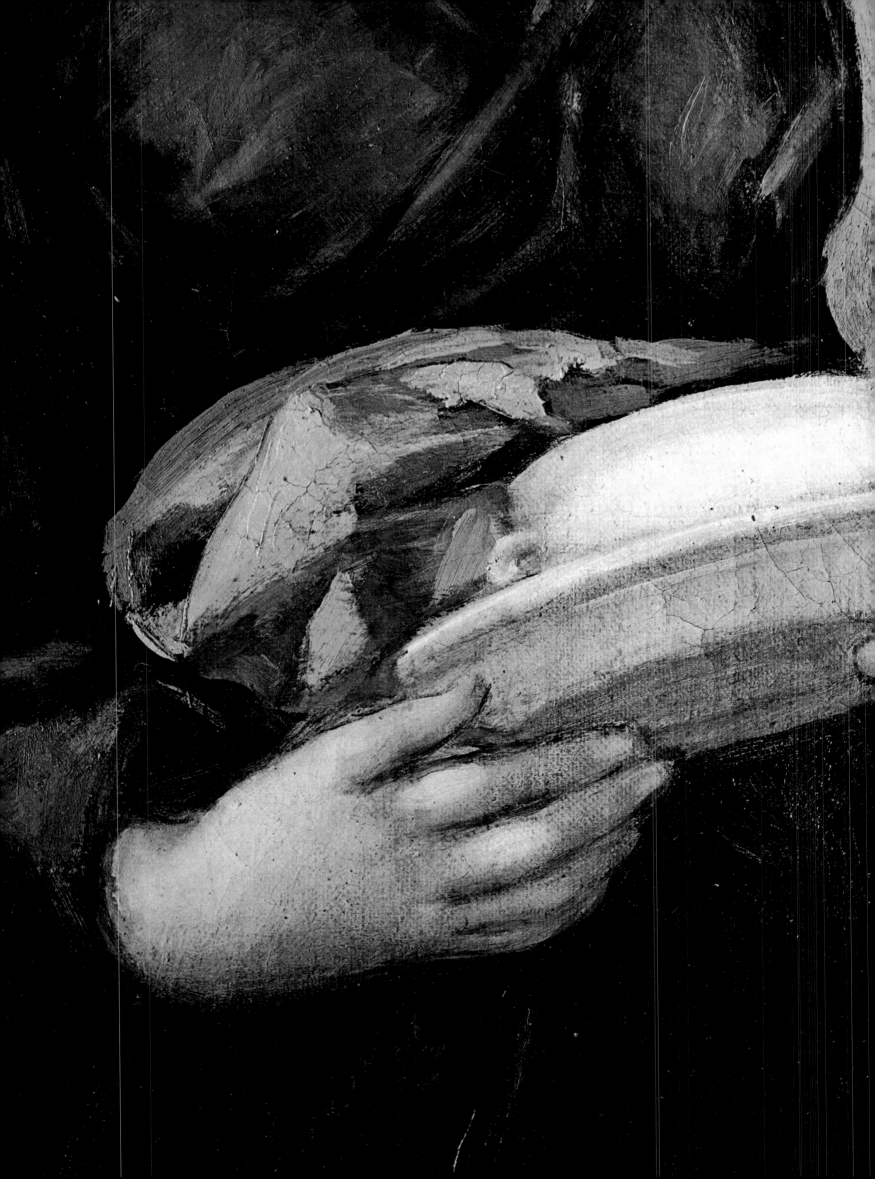

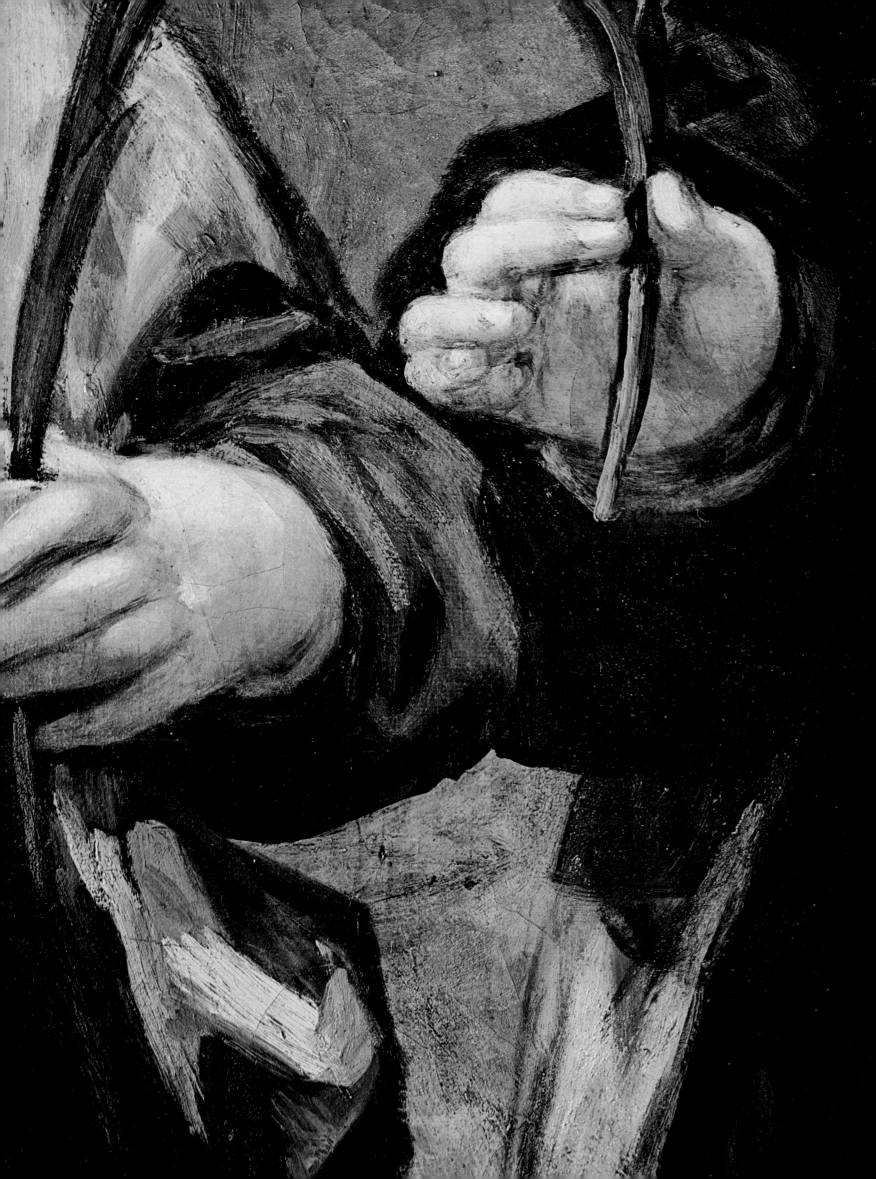

groups of paintings in terms of their philosophical and symbolic meaning, but there does undoubtedly exist a relationship between the different compositions, and in order to interpret them — to read them — we must examine precisely the way in which they relate physically one to another, both side by side and face to face. It also seems certain that the underlying feeling which Goya gave the paintings was linked to his relationship with Leocadia Weiss, a young and beautiful woman, who was living with him at the time, as well as to a conscious awareness of his old age, the inevitability of death and a general disillusionment with life and his fellow men. All these elements combined to make him paint these great, nightmarish compositions. Their colouring is not 'black': there are other shades and tones,

which combine to produce an overpowering feeling of gloom, nowadays further accentuated by the condition of the paintings. 'Black', however, would certainly describe Goya's mental state as revealed by the pictures, which can only be described as reflections of deep-seated pessimism. We have no alternative but to interpret them by using the titles given them by his family, which we know through Brugada's inventory and a later description of the pictures by Yriarte. Both of these sources agree with each other on all the main points and they confirm that the traditional titles were still being used by the family in 1867.

In the room on the ground floor, on each side of the main door, the inventories state that there were two portraits, of the master and mistress of the house, with, on the left hand side, *la Leocadia* — this was the name by which Leocadia Weiss, the woman who lived with Goya, was commonly known — leaning against a mound surmounted by a low railing, which must be interpreted as belonging to a grave (pages 147, 148-149). It is also possible that the pose was derived from an engraving by Ribera, known as *The Poet*. On the right are the *Two Old Men*, one of whom, a symbolic portrayal of the artist, is shown as an old man with a long beard, like the one depicted in the drawing entitled *'I am still learning'* (page 168); to his right, a spirit or demon is shouting into his ear. In order to understand this image, we should remember Goya's deafness: it is because of this that the demon of his inspiration has to shout at him. We can only guess at the significance of the grave next to Leocadia; perhaps Goya is showing her waiting for the death of her husband, without which she could never legally marry the artist, or perhaps she is awaiting his own death, thereby giving the whole thing the significance of a *descente aux enfers*.

ATROPOS or THE FATES
Oil on gesso; cm 123 × 266 (48½″ × 104⅞″)
Circa 1820-1823
Madrid, Prado Museum (757)
In 1819 Goya bought a country house on the banks of the Manzanares; in 1823 he gave it to his grandson Mariano: the so-called 'black paintings' must have been completed between those dates.

What is certain is that on the walls opposite the door into the room, on each side of the window, we again encounter the two protagonists, hidden behind the cloak of their symbolic representation: Leocadia appears as Judith, an obvious allusion to the latter's victory over Holofernes by virtue of beauty and treachery, while Goya appears as Saturn eating one of his children. Saturn symbolizes melancholy and the passing hours devoured by him. It has recently been suggested on the basis of early photographs that Saturn appeared with his member erect, a representation which would give a clear picture of the reasons for the liaison with Leocadia: a picture completed by the portrait of Judith and Holofernes. If that was indeed the case, then Goya's relationship with Leocadia through those long, lonely years,

LA LEOCADIA or UNA MANOLA
Oil on gesso; cm 147 × 132 (58″ × 52″)
Circa 1820-1823
Madrid, Prado Museum (754)
Two large rooms in La Quinta were decorated by Goya; this scene, on the ground floor, has been identified as portraying Leocadia Weiss, Goya's companion during the two last years of his life: a 'manolo' or 'manola' was a low class inhabitant of Madrid
See pages 148-149 for detail

THE DOG
Oil on gesso; cm 134 × 80 (52¾″ × 31½″)
Circa 1820-1823
Madrid, Prado Museum (767)
This strange painting was on the first floor of la Quinta.

could be explained by a combination of his desire for her and a terror of becoming her victim, as Holofernes had become the victim of Judith.

Next to Leocadia, on the main wall, was a portrayal of *The Witches' Sabbath*, in which the Devil appears as a horned goat, surrounded by his female disciples, all of them hags, except for the enigmatic figure of a young woman, almost a child, who bears no relation to the bestial conclave in which she finds herself. The significance of this figure in the composition, however, remains a mystery.

On the opposite side of the room was the *Pilgrimage of St. Isidore* (pages 150-151), in which groups of people and couples wander through an arid landscape in the far distance, while in the foreground a group of young figures are singing at the top of their voices. If one compares this scene with that of the *Meadow of St. Isidore* (page 48), painted in 1788, the extent of

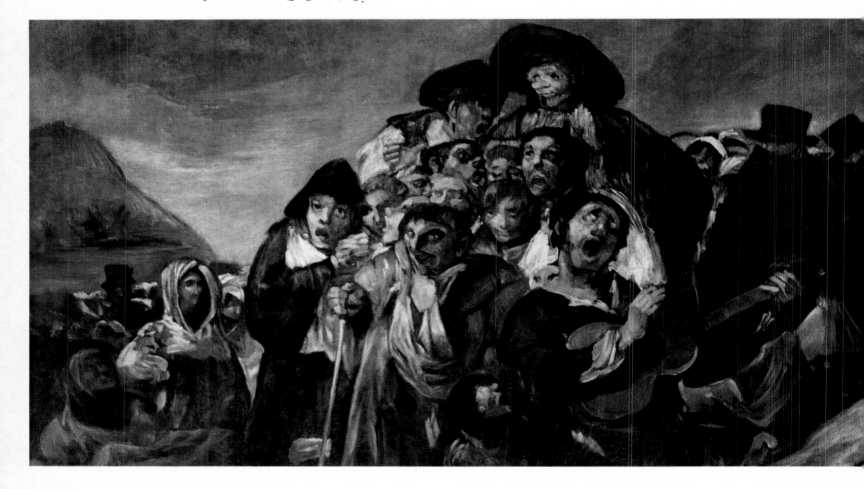

Goya's profound spiritual transformation becomes immediately apparent. The latter exudes all the *joie de vivre* of a spring evening, with the buildings of Madrid bathed in a pink and white light in the distance, and the *majos* and *majas* picnicking and chatting on the grass. In Quinta del Sordo, in the painting that both inventories describe as *Pilgrimage of St. Isidore*, the countryside is scorched and the men wander aimlessly through it. The *joie de vivre* has become melancholy, with an element of violent anguish in the expressions of the frenzied singers in the foreground. Between *la Leocadia* and the counterpart portrait of Goya, above the door, was the painting of *Two Old Men Eating*, probably an illusion to the door's function: it may well have been the one through which dishes from the kitchen were brought in.

In order to visualize the appearance of either room, we must bear in mind what Yriarte wrote, and also what the paintings themselves tell us. The rooms were of 'very modest dimensions', which would have made the figures in the paintings seem larger: certainly larger than they now appear in the museum in which they are housed. This would also have made them

appear even more overpowering. It should be remembered, too, that, according to the inventories, the furniture was upholstered in yellow, which would have further emphasized the gloominess of the paintings, as would the matching yellow curtains that in all probability framed the doors and windows.

In the case of the first floor room, we have not been able to establish such clear links between the different compositions, but undoubtedly the overall theme was that of death, and, as has already been said, the significance of each painting would have been enhanced by its physical relationship to others in the group. To the left of the door was *Atropos* or *The Fates* (page 146), a picture that still remains an enigma: there are, as is well known, only three Fates, but what, then, is the identity of the fourth figure, whose wrists appear to be bound? The next scene, on the other side

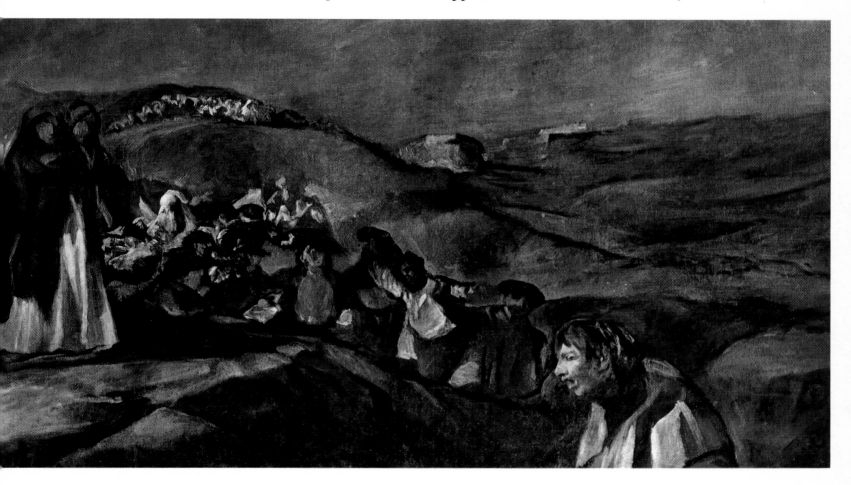

THE PILGRIMAGE OF ST. ISIDORE
Oil on gesso; cm 140 × 438 (55⅛″ × 172½″)
Circa 1820-1823
Madrid, Prado Museum (760)
This painting adorned the walls of the ground floor of la Quinta. There were fourteen frescoes in all: seven on the ground floor and seven on the first floor.

of the door or window, was the one called *The Strangers* or *Cowherds* in the inventories, which is commonly known as *The Fight with Cudgels*. It shows two men fighting with cudgels, locked in mortal combat and imprisoned up to their knees in mud or sand. In painting this composition, Goya was recalling Saavedro Fajardo's 75th allegory or 'emblem', *Bellum colligit qui discordias seminat*, which, according to the author's interpretation, means: 'Medea sows [in order to prepare for the theft of the Golden Fleece] ... / ... the teeth of serpents ... and squadrons of armed men spring forth, who, fighting amongst each other, are destroyed...'. The engraving of the scene shows a fight between men who seem to be buried up to their waists or half submerged in water. Saavedra went on to clarify his allegory by explaining how some Princes stir up discord, and thereby find themselves faced by wars and unrest within their countries. By fermenting disharmony, they think they will be able to enjoy peace and quiet, but things turn out quite contrary to their designs. At the time that Goya was recalling this allegory, it could well have been applied to the policies of Ferdinand VII and to Spanish politics in general.

Opposite the wall of the entrance door, on both sides of the door or window, were the compositions of *Two Men*, as it is called in Brugada's inventory, or *The Politicians*, as Yriarte describes it, and *Two Women* (Brugada) or, alternatively, *Two Women laughing their heads off* (Yriarte). The latter painting, which shows two women laughing at a man indulging in the vice of Onan, would seem to hold the key to the meaning of both works. The incessant talk of the politicians, one of whom is reading a newspaper that they seem to be passing comment on amongst themselves, was perhaps, in Goya's eyes, as sterile as the solitary pleasure which the women are making fun of.

On the wall to the right of the entrance door, which must have been divided by a door or window, were the *Pilgrimage to the fountain of St. Isidore* and *Asmodea*. 'Asmodea' is spelled with the feminine 'a' ending, rather than as 'Asmodeus', the conventional spelling for the evil slayer of husbands, but we do not know the reason for this change of gender; nor do we know why she is shown flying over groups of warring soldiers or what significance there is in the mountain that dominates the scene in the background. In the case of the *Pilgrimage* (also known as *the Holy Office*), however, with its figures in 17th century dress, we can assume that there is a connection with the steps taken by Ferdinand VII to revive the Inquisition soon after his restoration to the throne. This was an anti-liberal measure, which Goya seems to have classified as anachronistic by the old-fashioned dress he gave the black-clad man on the right, with his large collar, like the ones worn during the 16th and 17th centuries. There is also an implicit criticism in the grotesque way that he has portrayed the monks in the procession.

Finally, next to the door was the most enigmatic of all the paintings: *The*

On right
GOYA AND HIS DOCTOR ARRIETA
Oil on canvas; cm 117 × 79 (46″ × 31⅛″)
Signed and dated: 'Goya agradecido, á su amigo Arrieta: por el acierto y esmero con qᶜ. le salvó la vida en su aguda y / peligrosa enfermedad, padecida á fines del ano 1819, a los setenta y tres de su edad. Lo pintó en 1820'
Minneapolis, Institute of Arts (52.14)
This work is one of Goya's last self-portraits and shows the doctor tending his patient.
See pages 154-155 for detail

THE FIGHT WITH CUDGELS
Oil on gesso; cm 123 × 266 (48½″ × 104⅞″)
Circa 1820-1823
Madrid, Prado Museum (758)
This is one of the paintings on the first floor of la Quinta.

Dog, whose significance Yriarte clarified by defining it as *A Dog fighting against the Current* (page 147). Perhaps this is how Goya saw his own situation: as a dog who was barely able to keep his head above the water or the sand, a personification of the proverbial 'swimming against the current'. We have already stated on several occasions that these murals in La Quinta were conceived in the same spirit as the *Proverbs*. There are also a number of

Goya agradecido, á su amigo Arrieta: por el acierto y esmero con q.º le salvó la vida en su aguda y peligrosa enfermedad, padecida á fines del año 1819. a los setenta y tres de su edad. Lo pintó en 1820.

other, small compositions that were inspired by the same sentiments: the four in Besancon Museum, for example, and other series, of which four are in the museum in Munich and two are in Spanish collections (pages 160, 161). All of these contain certain elements that link them thematically to some of the lithographs of the same period. As far as portraits from this time are concerned, their scarcity indicates Goya's growing isolation, since

153

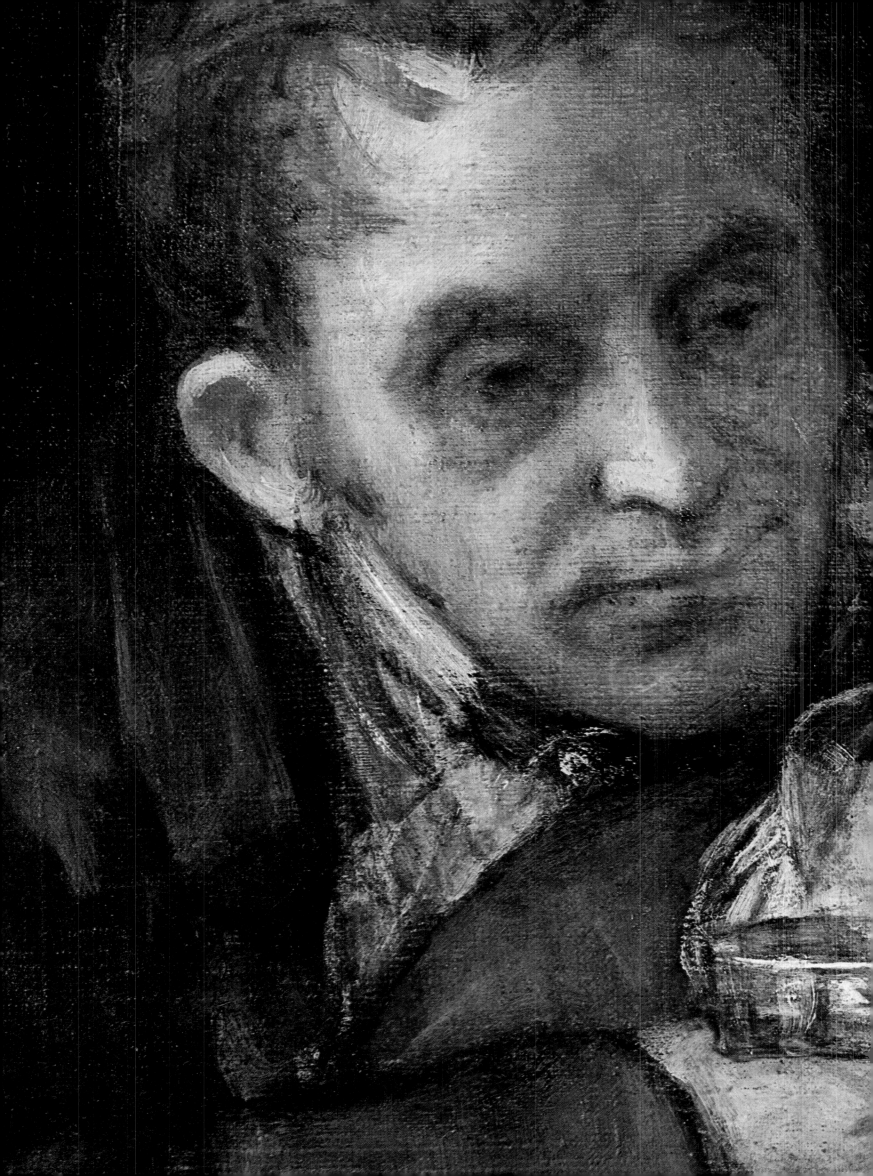

the only ones that he did paint were of his closest friends: men such as Dr. Arrieta, who, as has already been mentioned, appears in a portrait along with the artist himself, and also *Ramón Satué* and *Tiburcio Pérez Cuervo*, in whose house Rosario Weiss took refuge, and *Don José Duaso* (page 159), in whose home the artist himself sought refuge during the early months of 1824, when he felt that he was in danger of arraignment. As well as these, he did a portrait drawing of *Francisco Otín*, Duaso's nephew, and an extremely fine portrait of *María Martínez de Puga*, about whom we know nothing, but in whose portrait, by his sober composition and his brilliant use of black, Goya achieved a monumental quality similar to that of his later Bordeaux portraits.

THE LAST COMMUNION OF ST. JOSEPH CALASANCTIUS
Preparatory study
Oil on panel; cm 45.5 × 33.5 (17⅞″ × 13⅛″)
Circa 1819
Bayonne, Musée Bonnat (11)

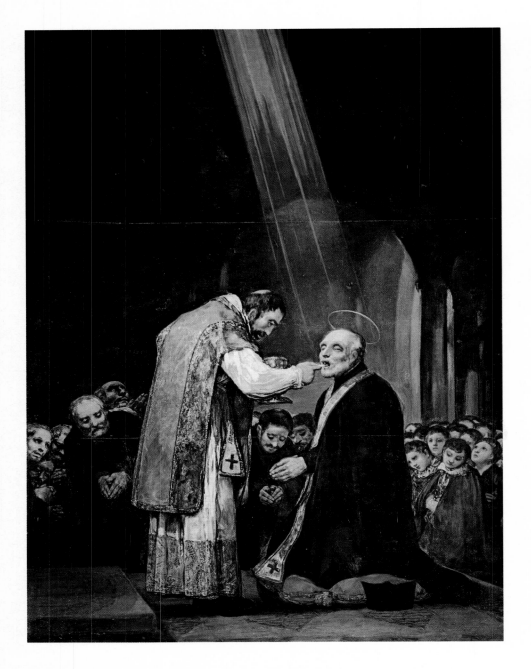

On left
THE LAST COMMUNION OF ST. JOSEPH CALASANCTIUS
Oil on canvas; cm 250 × 180 (98½″ × 71″)
Signed and dated: 'Franc^co. Goya / Año 1819'
Madrid, Escuelas Pías de San Antón (chapel)
Goya waived his fee for this commission, which supports the theory that he had been educated with the Piarists at the Escuelas Pías in Saragossa.

In Bordeaux the old painter sought tranquillity, and it was there that he died. We have already told how the reinstatement of Ferdinand VII as absolute monarch led to a wave of repression and persecution of those who had figured prominently in the liberal movement. On 13 November 1823 General Riego was executed, an event that was followed by other executions and the settling of many personal vendettas. There then followed a period of systematic repression, accompanied by a tightening up of censorship and

the setting up of new Commissions of 'political purification', whose job it was to investigate the lives and activities of all military or civilian officials. Goya feared for his safety; it was for this reason that he made over the Quinta property to his grandson Mariano, thereby preparing for his departure from Spain some months later and also saving part of his personal fortune. Taking advantage of the amnesty declared on 1 May 1824, Goya requested the Palace for permission to leave Spain for six months to take the waters at Plombières, so that he would be able to absent himself from Madrid without losing his position as *pintor de cámara* and the salary that went with it. On 30 May Ferdinand VII granted his request, and at the end of June the French police recorded his passage through Bayonne, en route

THE AGONY IN THE GARDEN
Oil on panel; cm 47 × 35 (18½" × 13¾")
Signed and dated: 'Goya fecit. año 1819'
Madrid, Escuelas Pías de San Antón
This work was also presented to the Piarist community by Goya.

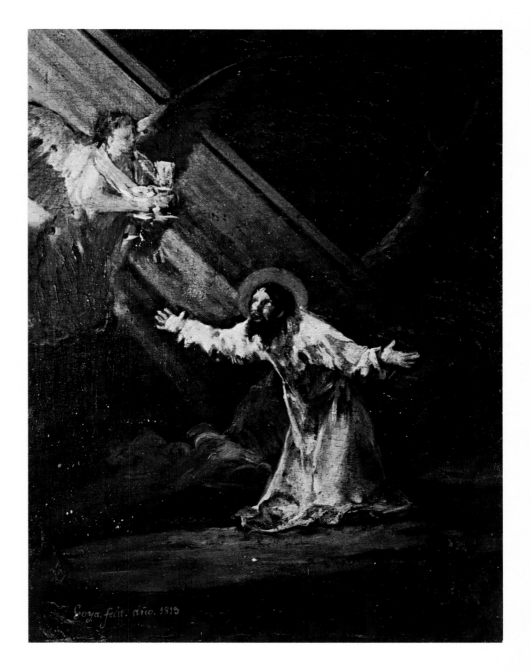

for Paris. At the time of this journey Goya was 78 years old. He stopped in Bordeaux to see his friends Leandro Moratín and Manuel Silvela, who were in exile there, and left immediately for Paris, where he spent two months. He stayed in the Hotel Favart, in Rue Marivaux, where one of the Goicoecheas, a cousin of his daughter-in-law Gumersinda, was also staying.
French police records give no hint of any suspicious activities on Goya's

part: he went out seldom, and then mainly for walks. He was, however, in close contact with Joaquín María Ferrer, who was involved in the banking business and whom the police regarded as a revolutionary. Goya painted his portrait, as well as that of his wife, and also painted a bull-fighting scene for them. He kept in touch with other old friends and acquaintances from Spain, both revolutionaries and non-revolutionaries, who were living in Paris at the time: people such as the lawyer González Arnao, the Duke of San Carlos, the Condesa de Chinchón and the Condesa de Pontejos. Undoubtedly he would have visited the Louvre, where he could contemplate Old Masters, as well as the paintings of modern French artists such as David, Gérard, Girodet and Vernet. He must have seen works by the two greatest French painters of the day, since, apart from anything else, he would have had time to visit that year's Salon, as it opened five days before his departure for Bordeaux. In it, the two leading lights of French Romantic painting competed with each other with works of outstanding quality: Ingres presented his *Pledge of Louis XIII* and Delacroix his *Massacre at Chios*. At the same time he could also have seen works by English artists, the novelty of whose technique was causing sensation: works like the landscapes of Constable and Bonington, and the portraits of Lawrence.

We have no idea of what his reaction was to all this. The only Frenchmen whom we find mentioned in his letters is the 'incomparable Monsieur Martin', who, as I wrote many years ago, was a deaf mute. Possibly it was this fact that made him seem so 'incomparable' to Goya, who was also totally deaf and accustomed to communicating in sign language; but in which language? There does exist a letter from Goya to Zapater in French, but could he speak it? Martin was, in addition, a miniaturist, and, as we shall see, Goya became interested in this art form after his return to Bordeaux, where he painted a number of miniatures using a highly individual technique. He himself described this technique as being nearer to Velázquez than to Mengs. It has also been suggested that Goya may have visited workshops in Paris to examine the way in which lithographs were made. The most outstanding works produced in this medium were by Charles and Horace Vernet, and in Bordeaux Rosario Weiss studied under a relation of theirs, also a Vernet, who was a painter of no consequence, heavily influenced by the works of English portraitists, particularly Lawrence.

However, even though there is no actual proof of it at the moment, it is my belief that Goya's haste in travelling to Paris can be explained in economic, rather than artistic terms. Goya was a man who took great care in financial

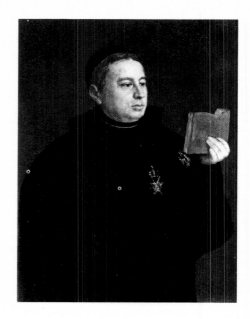

RAMÓN SATUÉ
Oil on canvas; cm 107 × 83.5 (42⅛″ × 32⅞″)
Signed and dated: 'D. Ramon Satue / Alcalde de corte / pr. Goya'
1823
Amsterdam, Rijksmuseum (988B1)

RIDICULOUS FOLLY
('Disparate ridiculo')
Etching and aquatint; cm 24.5 × 35 (9⅝″ × 13¾″)
Circa 1815-1824
Proverbs (Plate 3)

A WAY OF FLYING
('Modo de volar')
Etching and aquatint; cm 24.5 × 35 (9⅝″ × 13¾″)
Circa 1815-1820
Proverbs (Plate 13)
The *Proverbs* series was completed by Goya between 1815 and 1824. The title 'Proverbs' was given to them by the Academia de San Fernando, who had acquired eighteen of them, which they published in 1864, after Goya's death. On fourteen of the artist's proofs Goya had himself written a number of titles, each of which began with the words *Disparate* (absurdity or folly).

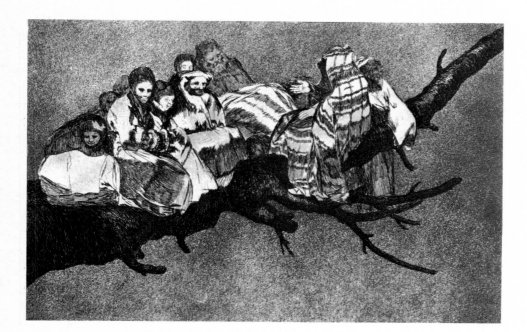

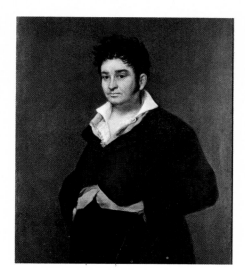

JOSÉ DUASO Y LATRE
Oil on canvas; cm 74 × 59 (29⅛″ × 23¼″)
Signed: 'D. Jose Duaso / Por Goya de 78 anos'
1824
Seville, Provincial Museum of Fine Arts
It was in this man's house that Goya found shelter when, in 1824, he feared that he was about to fall victim to Ferdinand VII's proscription of liberals.

matters, and he had succeeded in amassing a considerable fortune. When his son, for example, came to Bordeaux to visit him during his final illness, he did so by travelling from Madrid to Cadiz and then taking a boat to France. This strange itinerary can only be explained by the existence of some economic reason, which made it necessary for him to take this particular route. Goya's connection with the banker Ferrer may also have had its roots in the same financial considerations.

He left Paris in the company of Martín Miguel de Goicoechea and the latter's daughter Manuela, who was married to Don José Francisco Muguiro. They arrived in Bordeaux and took up residence in a pleasant house in the Cours de Tourny, where they were joined a few days later by Doña Leocadia and her children Guillermo and Rosario. Police records state that Leocadia was going to join her husband (!) — who, in fact, was living quietly in Spain — and contain highly imaginative information concerning the ages of her two children. In Bordeaux Goya painted the portraits of some of the people closest to him: *Moratín*, who was now an old man, *Juan Bautista de Muguiro* (page 162), on whose portrait Goya proudly stated that he had painted it at the age of 81, *José Pío de Molina*, and the businessman *Jacques Galós*, administrator of the Bank of Bordeaux. He also did a portrait of his grandson Mariano, when he went to Madrid in 1827 to seek an extension of his permit to stay abroad. In addition, he did a number of paintings of other people, the most outstanding of which is the *Dairymaid of Bordeaux* (page 163), a work that, according to a letter written by Leocadia when she wanted to sell it, was his last painting.

He also did a small series of pictures of bulls, in which he experimented with new techniques, using cane spatulas rather than conventional brushes. He produced an endless flow of drawings, too, during this period, many of which were done with a thick, lithographic pencil and form part of different series. The coarseness of the figures, which are portrayed with no regard for

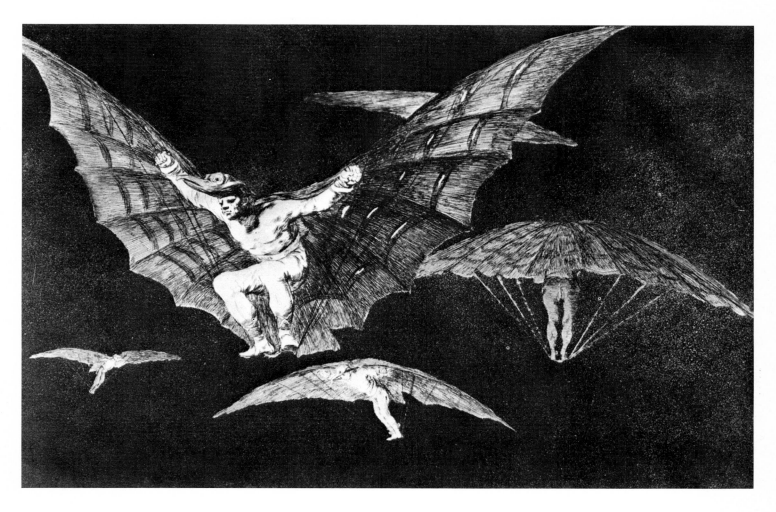

A DUEL
Oil on panel; cm 31.3 × 21 (12⅜″ × 8¼″)
Circa 1820-1824
Munich, Alte Pinakothek (8617)
This work is normally compared to a lithograph with the same title and theme.

academic proportion, gives them an extremely expressive quality: there are madmen with contorted faces, remembrances of things that Goya had seen on the streets, circus people, costumes from Paris and Bordeaux, everything that had made an impact on him, or that he had imagined or fantasized. He also completed, according to Ferrer, a collection of forty miniatures, in which there appear the same strange figures as in his drawings: lunatics, old people, *majas*, some nude and some with very Moorish faces.

He also, of course, did his famous *'I am still learning'*, one of his last drawings, in which he portrayed himself as an old man with a long white beard, walking with the aid of sticks (page 168). Not only did he experiment with miniatures done in a totally new technique and with oil paintings done using a cane spatula, he also made use of unusual materials to colour his oil paints. Goya's insatiable curiosity stayed with him until the end of his days, and he conducted all manner of experiments, using the most outlandish techniques. Such was the case when he traced on the lithographer's stone the design for a group of lithographs, which must surely be

CARNIVAL SCENE
Oil on panel; cm 31 × 20.5 (12⅛" × 8")
Circa 1820-1824
Madrid, Private Collection

amongst the most beautiful and emotive works ever produced in this medium. His portrait of the lithograher *Gaulon* dated 1825, in whose workshop his *Bulls of Bordeaux* was produced, is truly a masterpiece. And those four scenes of bulls, which he published in a single edition, and a fifth lithograph, of which only one proof exists and which Goya possibly decided against publishing because of its confused composition, are all extremely fine. In the four that were published, the bull-fighting scenes stand out concisely and expressively from the surrounding circles of agitated spectators — or the barriers around the ring — which both isolate and emphasize them. They are beautifully executed works, in which Goya's vivid portrayal of movement bears witness to his continuing vigour and also to the way in which his extraordinary talent for recapturing the memory of past events had remained unimpaired.

The first booklet dedicated to Goya, by Laurent Matheron, published in 1858, and based mainly on the reminiscences of Brugada, a Spanish painter exiled in Bordeaux, who was Goya's companion during the final years,

explains the process that he used to produce his extraordinary lithographic effects. Apparently, he used to place the stone on an easel, as though it were a canvas, and draw his design on it. First he would cover the whole surface with grey, then scrape away the parts that were to remain pale, and then intensify the black areas, varying the strength of his brush strokes in order to achieve different effects of light and shade and to mould the figures. He worked on his feet, so as to be able to stand back and consider the overall effect of what he was doing, and, in order to ensure that his strokes were true, he used a magnifying glass, without which he was unable to work finely. This highly personal technique produced outstanding results, and in these great compositions we can clearly see the realization of a concept that Goya, throughout his life, considered to be the essential function of all painting: the representation of an unevenly lit group of objects, whether animate or inanimate, in which mass and form advance and recede according to their volume. From the very beginning, Goya mastered the technique of neglecting detail in order to achieve the desired overall effect, concentrating only on what was essentially significant.

We have letters that Goya sent to his friend Ferrer asking him to find a market in Paris for his lithographs, works which the banker cannot have liked. We also know that, in his letter of reply to Ferrer, Goya wrote that he could not produce another edition of the *Caprices*, since they were the property of the Calcografía Real, and that he had better ideas anyway: a remark which, in view of his age, typifies Goya's whole character.

In 1825, when Goya's six month permit had expired, his son applied to the King on his behalf, asking for an extension so that he could take the waters at Bagnères. On 13 January of that year Ferdinand VII granted his request, and when Goya fell seriously ill during that spring and Xavier asked for another extension, that too was granted. It was during this period that Goya completed the four great lithographs that we have just mentioned. In December of the same year he wrote to Ferrer: '[I have] neither sight, nor strength, nor pen nor ink, I lack everything, all that remains is my will.'

On 30 March 1826, after his eightieth birthday, Goya dedicated to Juan Galós the portrait that he had just done of him. When the time came and his permit was expiring, he set out for Madrid in order to obtain his pension. On 17 June 1826, Ferdinand VII granted it to him in full, in recognition of the services that he had rendered to his parents and to the Crown; perhaps he was also acknowledging that moment, long ago, when they had both struggled against the all-powerful Godoy.

During his stay in Madrid, Vicente López painted him in a portrait that was academically faultless and executed with his customarily minute attention to detail, which, on this occasion at least, involved no attempts at embellishment, whatever else one might say about it. The portrait was, however, one of those in which López, forgetting to display his rococo virtuosity, affected a certain degree of Neoclassical severity. But this portrait, when compared to the ones signed and dated by Goya during the same year and the year after, illustrates the great gulf in execution and conception that lay between the academic art of Vicente López and the art of the eighty year old Goya. Despite the fact that López managed to impart a certain monumentality to his subject, it is not the same lively and expressive monumentality that Goya succeeded in giving his sitters. The latter quality anticipated what was to be the prime characteristic of 19th century painting, despite the fact that 19th century artists ignored the works of the old master, even though they shared a common path as regards technique and the concept of what a portrait should be. This may be because Goya's last works, amongst them the portraits that he did during his old age, stayed in private collections and were not discovered and evaluated by the critics until well into this century.

We do not know the reasons for Goya making another trip to Madrid the following year, but there is documentary proof of it, as well as a portrait of

JUAN BAUTISTA DE MUGUIRO
Oil on canvas; cm 101 × 89 (39¾″ × 35″)
Signed and dated: 'Dⁿ. Juan de Muguiro, por / su amigo Goya á los / 81 años, en Burdeos / Mayo de 1827'
Madrid, Prado Museum (2898)
A banker from Navarre, this man became a great friend of Goya during the latter's stay in Bordeaux.

JOSÉ PÍO DE MOLINA
Oil on canvas; cm 60 × 50 (23⅝″ × 19⅝″)
Circa 1827-1828
Winterthur, Reinhart Collection (80)

his grandson Mariano. He was now 81 years old. During the same year of 1827, Goya recorded his age in the inscription and dedication on a portrait of great *gravitas* and serenity, which he did of his friend, the banker *Juan Bautista Muguiro*, who was brother-in-law to the artist's son Xavier, by virtue of his marriage to a younger sister of Gumersinda Goicoechea. This work, in its technique and its style, was a forerunner of the portraits of Millet and Manet. His next painting was the *Dairymaid of Bordeaux*, which may be a fragment of a larger picture. The technique that he used in this work — small, interwoven brush strokes in pale colours — in turn anticipate what later came to be known as the Impressionist technique. As has already been mentioned, according to a letter written by Leocadia, this was the last painting ever undertaken by Goya.

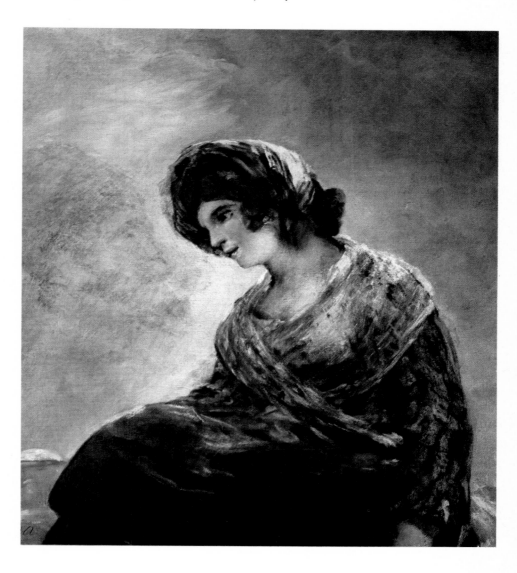

THE DAIRYMAID OF BORDEAUX
Oil on canvas; cm 74 × 68 (29⅛″ × 26¾″)
Signed: 'Goya'
1825-1827
Madrid, Prado Museum (2899)

In March 1828, Xavier and Mariano, his son and grandson, arrived in Bordeaux, having heard the news of his worsening health. In a letter, Goya had added a few lines telling his son that he was in bed, awaiting his arrival in the near future with pleasure. On 2 April he awoke to find his body paralysed, and on 16 April, at 2 o'clock in the morning, he died. With him were the painter Brugada and Pío de Molina, a friend whose portrait he was in the process of completing. He was buried in Bordeaux, in the tomb of the Goicoechea family, and in 1901 his remains were taken to Madrid. The story of the transfer of the body has a macabre touch, since, when his tomb was opened, his skull was found to be missing. His remains are now in the Church of San Antonio de la Florida, in the small chapel that he himself decorated at the zenith of his career.

His fortune passed to his son and then to his grandson, who frittered it away, selling the many works in the family's possession and breaking up the albums of drawings. His son treated Leocadia Weiss and her daughter Rosario, both of whom had kept the artist company in Bordeaux, very harshly. They received nothing, despite the great affection that Goya had felt for 'Rosarito'. This fact rather weakens the theory that Goya was her father, as was suggested during the artist's own lifetime and even during the compilation of this book.

Goya's works were never completely forgotten, although the degree of appreciation accorded them has fluctuated over the years. One school of Spanish Romantic painters did try to continue his work, imitating it and even forging it: artists such as Alenza, who died a young man, Pérez Rubio, and most notably Eugenio Lucas. Goya's *Caprices* soon came to be widely known in France, and also in England, and in the Musée Espagnol there were a great many of his works, illustrating almost every aspect of his art. He captured the imagination of Delacroix, while his *Caprices* attracted the critical attention of Baudelaire, Victor Hugo, Mérimée, Musset and other lesser members of the Romantic movement. It was in France that the first books on his life and his art were published, those of Matheron and Yriarte, and, despite the criticisms of the Englishman Hammerton, connoisseurs of graphics soon began collecting his engravings.

Fifty years after his death, painters like Mariano Fortuny were still copying him, while the Impressionists, travelling through Spain, saw his great works in the Prado and began to appreciate the possibilities of his non-academic style. If his 'Black Paintings' did not meet with approval when they were shown in the Paris Exhibition of 1878, it was because the most popular works of his at the time were those from his youth and later ones that reflected the grace and spirit of the 18th century. The Madrid Exhibition of 1900 established his reputation as an exceptional painter, and from that time on his works began to be bought by museums and galleries throughout the world, with critical appreciation of the artistic output of his final years coinciding with the growth of German Expressionism.

It is now acknowledged that, as an engraver, Goya is comparable to such great exponents of the art as Dürer and Rembrandt. As a painter who expressed every aspect of man's being, as well as his own comments and cri-

'SUERTE DE VARAS'
Oil on canvas; cm 50 × 61 (19 ⅝" × 24")
1824
Rome, Collection of the Marquesa de la Gándara
The reverse of this canvas bears the inscription: 'Pintado en París en Julio de 1824. / Por / Dⁿ. Francᶜᵒ. Goya / JMF' (Jose María Ferrer).

'SUERTE DE VARAS'
Oil on canvas; cm 23 × 40 (9″ × 15¾″)
1824-1825
Madrid, Prado Museum (3047)
These last nostalgic works have a theme —
the *corrida* — which harks back to the
themes of his youth.
See pages 166-167 for detail

ticism, and who revealed, in his portraits, clients and friends as they really were, laying bare their innermost secrets, Goya established himself as one of the world's greatest portraitists. He was, in addition, an exceptional decorative painter: if his work in San Antonio de la Florida marked the zenith of 18th century decorative art, his paintings on the walls of La Quinta, apart from being unique, contain certain elements that link them directly to the art of today.

Goya is an artist of many facets, each of which has been the subject of a growing bibliography, emanating from many countries and written in countless languages. He is one of the greatest artists of all time, whose genius not only explored areas and aspects of the human soul never before discovered, but also succeeded in capturing them in a lifetime's work, as vast as it is varied. He had the ability to raise the anecdotal to the level of something of universal and everlasting value; he could blend beauty with horror and tenderness with cruelty and ugliness. If Goya did have a failing, it was that of being too human.

It seems right to end this study of Spain's greatest artist with his own image of his own optimism, his continual will to experiment. Just as he was ready to learn all his life long, so, through his work, that seaks to us across the centuries, we too can learn.

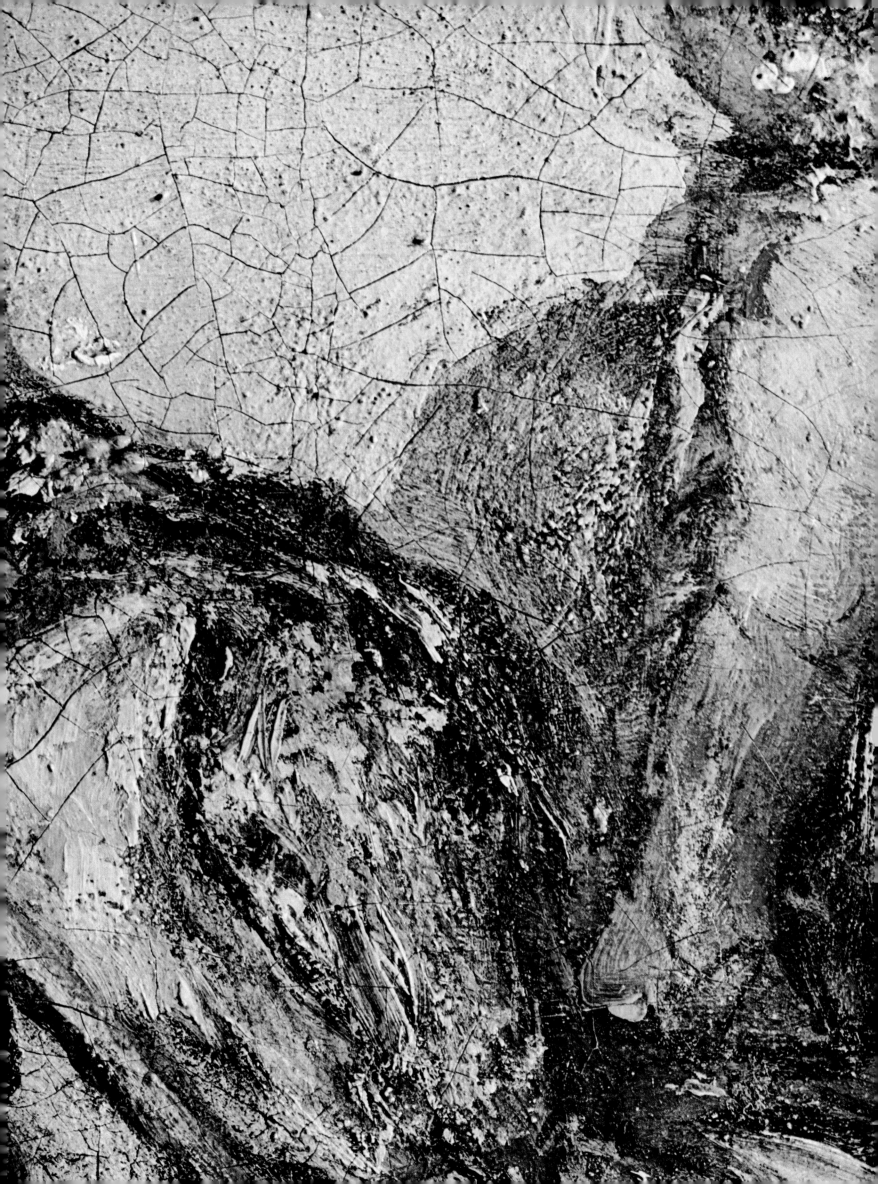

I AM STILL LEARNING
('Aún aprendo')
Black lithographic pencil
Circa 1824-1828
Madrid, Prado Museum (416)
From the *Album G,* also called the
Bordeaux Album (No. 54)

MAJA AND CELESTINA
Oil on ivory; cm 5.4 × 5.4 (2⅛″ × 2⅛″)
1824-1825
London, Collection of Lord Clark
In the winter of 1824-1825, Goya experimented with a new technique: painting with oils on ivory. He did some forty of these miniatures, according to a letter that he wrote to Joaquin María Ferrer in 1825. Of these, only twenty-one are known to us, either in the original or from photographs.

Catalogue of Goya's Work

The following catalogue of Goya's work is based, for the most part, on the writings of J. Gudiol ('Goya, Biografía, Estudio analítico y Catálogo de sus pinturas', Barcelona 1970) and P. Gassier & J. Wilson ('Vie et oeuvre de Francisco Goya, L'oeuvre complete illustrée: peintures, dessins, gravures', Paris 1970; English edition published 1971). To the works contained in these two volumes have been added a number of newly discovered ones, and also several hitherto unpublished, but well documented ones. It has also been decided to leave out those works whose attribution we consider debatable, while we have included others whose authenticity is still in doubt and which are not universally accepted by the specialists.

1

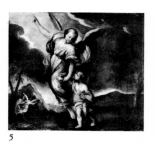

5

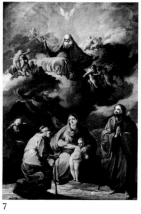

7

9

12

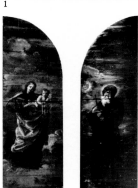

2 3

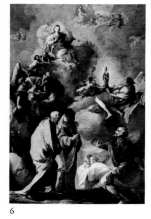

6

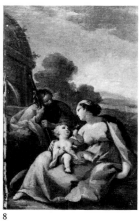

8

10

13

4

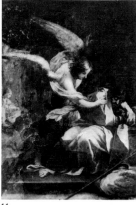

11

3. 'St. Francis de Paula'
Oil on panel;
cm 180 × 65 (71″ × 25⅜″)
Circa 1762
Formerly Fuendetodos, Parish Church (destroyed)

4. 'Apparition of the Virgin of the Pillar'
Oil on panel;
cm 180 × 130 (71″ × 51¼″)
Circa 1762
Formerly Fuendetodos, Parish Church (destroyed)

5. 'Tobias and the Angel'
Oil on canvas;
cm 89 × 100 (35″ × 39⅜″)
Granada, Private Coll.

6. 'Apparition of the Virgin of the Pillar'
Oil on canvas;
cm 79 × 55 (31⅛″ × 21⅝″)
Circa 1768-1769
Saragossa, Pascual de Quinto Coll.

7. 'Holy Family'
Oil on canvas;
cm 79 × 55 (31⅛″ × 21⅝″)
Madrid, Conde de Orgaz Coll.

8. 'Rest on the Flight to Egypt'
Oil on canvas;
cm 31 × 20 (12⅛″ × 7⅞″)
Circa 1768-1769
Paris, Private Coll.

9. 'Lament over the Dead Christ'
Oil on paper;
cm 36 × 20 (14¼″ × 7⅞″)
Circa 1768-1770
Paris, Private Coll.

10. 'Mary beside the Dead Christ'
Oil on alabaster;
cm 33 × 25 (13″ × 9⅞″)
Circa 1768-1770
Barcelona, Private Coll.

11. 'Dream of St. Joseph'
Oil on canvas;
cm 130 × 95 (41¼″ × 37⅜″)
Circa 1770-1772
Saragossa, Provincial Museum of Fine Arts (162)

12. 'The Visitation'
Oil on canvas;
cm 130 × 80 (51¼″ × 31½″)
Circa 1770-1772
Florence, Contini Bonacossi Coll.

13. 'Burial of Christ'
Oil on canvas;
cm 130 × 95 (51¼″ × 37⅜″)
Madrid, Lázaro Galdeano Museum (M. 2003)

1. 'Reliquary'
Oil on panel and fresco;
cm 300 × 300 (118¼″ × 118¼″) Circa 1762
Formerly Fuendetodos, Parish Church (destroyed)

2. 'The Virgin of El Carmen'
Oil on panel;
cm 180 × 65 (71″ × 25⅜″) Circa 1762
Formerly Fuendetodos, Parish Church (destroyed)

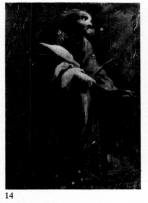

14

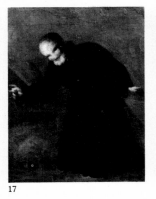

17

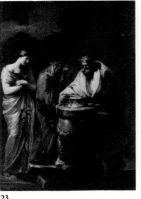

23

26

30

15

18

24

27

31

16

19

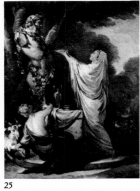

25

28

32

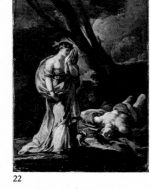

21

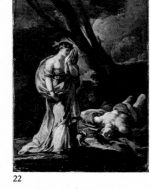

22

14. 'St. Joachim'
Oil on plaster;
cm 37 × 30 (14⅝″ ×
11⅞″)
Circa 1770-1772
Whereabouts unknown

15. 'St. Anne'
Oil on canvas;
cm 37 × 30 (14⅝″ ×
11⅞″) 1770-1772
Whereabouts unknown

16. 'St. Vincent Ferrer'
Oil on canvas;
cm 37 × 30 (14⅝″ ×
11⅞″) 1770-1772
Whereabouts unknown

17. 'St. Cajetan'
Oil on canvas;
cm 37 × 30 (14⅝″ ×
11⅞″) 1770-1772
Bilbao, Olabarria Coll.

**18. 'The Rising of
Squillace'**
Oil on canvas;
cm 46 × 60 (18″ ×
23⅜″) 1767-1770
Paris, Private Coll.

**19. 'Charles III Issuing his
Edict Expelling the Jesuits'**
Oil on canvas;
cm 46 × 60 (18″ ×
23⅜″) 1767-1770
Paris, Private Coll.

**20. 'The Pardon of
Haman'**
Oil on canvas;
cm 39 × 52 (15⅜″ ×
20½″) 1771
Paris, Private Coll.

**21. 'The Feast of Esther
and Ahasuerus'**
Oil on canvas;
cm 39 × 52 (15⅜″ ×
20½″)
Paris, Private Coll.

22. 'Venus and Adonis'
Oil on canvas;
cm 23 × 12 (9″ × 4¾″)
Zürich, Private Coll.

23. 'Sacrifice to Vesta'
Oil on canvas;
cm 33 × 24 (13″ × 9½″)
Circa 1771-1775
Barcelona, José Gudiol
Ricart Coll.

24. 'Sacrifice to Pan'
Oil on canvas;
cm 33 × 24 (13″ × 9½″)
Barcelona, José Gudiol
Ricart Coll.

25. 'Sacrifice to Pan'
Oil on canvas;
cm 40 × 30 (15¾″ ×
11⅞″) Circa 1771
Paris, Private Coll.

**26. 'Manuel de Vargas
Machuca'**
Oil on canvas;
cm 77 × 62 (30⅜″ ×
24⅜″)
Signed and dated:
'Francisco J. de
Goya/1771'
São Paulo (Brazil), P.M.
Bardi Coll.

27. 'Self-Portrait'
Oil on canvas;
cm 58 × 44 (22⅞″ ×
17⅜″)
Circa 1771-1775
Madrid, Marquesa de
Zurgena Coll.

**28. 'Adoration of the
Name of God' (sketch)**
Oil on canvas;
cm 75 × 152 (29½″ ×
59⅞″) 1772
Barcelona, José Gudiol
Ricart Coll.

**29. 'Adoration of the
Name of God'**
Fresco;
c. 7 × 15 m (c. 274″ ×
585″) 1772
Saragossa, Basílica del Pilar

30. 'St. Ambrose'
Oil on gesso;
c. 250 cm high (c. 98½″)
Circa 1772
Muel, Sanctuary of the
Virgin of the Fountains

31. 'St. Augustine'
Oil on gesso;
c. 250cm high (c. 98½″)
Circa 1772
Muel, Sanctuary of the
Virgin of the Fountains

**32. 'St. Gregory the
Great'**
Oil on gesso;
c. 250cm high (c. 98½″)
Circa 1772
Muel, Sanctuary of the
Virgin of the Fountains

33. 'St. Jerome'
Oil on gesso;
c. 250cm high (c. 98½″)
Circa 1772
Muel, Sanctuary of the
Virgin of the Fountains

33

170

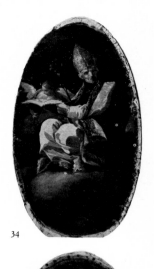

34

38

42

35

39

43

40

44

36

41

45

47

37

46

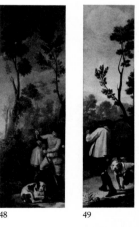

48 49

34. 'St. Ambrose'
Oil on canvas;
c. 180cm high (c. 71″)
Circa 1772
Remolinos, Parish Church

35. 'St. Augustine'
Oil on canvas;
c. 180cm high (c. 71″)
Circa 1772
Remolinos, Parish Church

36. 'St. Gregory'
Oil on canvas;
c. 180cm high (c. 71″)
Circa 1772
Remolinos, Parish Church

37. 'St. Jerome'
Oil on canvas;
c. 180cm high (c.71″)
Remolinos, Parish Church

38. 'The Annunciation to St. Joachim'
Oil on gesso;
cm 306 × 844 (120½″ × 332½″) 1774
Saragossa, Monastery of Aula Dei

39. 'Birth of the Virgin'
Oil on gesso;
cm 306 × 790 (120½″ × 311¼″) 1774
Saragossa, Monastery of Aula Dei

40. 'Marriage of the Virgin'
Oil on gesso;
cm 306 × 790 (120½″ × 311¼″) 1774
Saragossa, Monastery of Aula Dei

41. 'The Visitation'
Oil on gesso;
cm 306 × 790 (120½″ × 311¼″) 1774
Saragossa, Monastery of Aula Dei

42. 'The Circumcision'
Oil on gesso;
cm 306 × 1025 (120½″ × 403⅞″) 1774
Saragossa, Monastery of Aula Dei

43. 'The Presentation in the Temple'
Oil on gesso;
cm 306 × 520 (120½″ × 204⅞″) 1774
Saragossa, Monastery of Aula Dei

44. 'Adoration of the Magi'
Oil on gesso;
cm 306 × 1025 (120½″ × 403⅞″) 1774
Saragossa, Monastery of Aula Dei

45. 'The Boar Hunt'
Oil on canvas;
cm 249 × 173 (98⅛″ × 68⅛″) 1775
Madrid, Royal Palace

46. 'Dogs on the Leash'
Oil on canvas;
cm 112 × 170 (44⅛″ × 67″)
Madrid, Prado Museum

47. 'Shooting Scene with Decoy and Net'
Oil on canvas;
cm 112 × 176 (44⅛″ × 69⅜″) 1775
Madrid, Prado Museum

48. 'Hunter loading his Gun'
Oil on canvas;
cm 292 × 51 (115″ × 20⅛″) 1775
Madrid, Prado Museum, on loan to the Ministry of Education

49. 'The Hunter and the Dogs'
Oil on canvas;
cm 262 × 71 (103¼″ × 28″) 1775
Madrid, Prado Museum

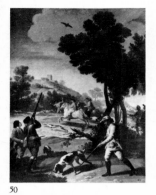

50

51 52

53

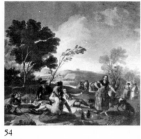

54

55

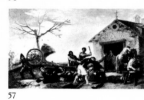

56

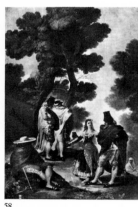

57

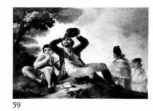

59

60

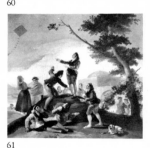

61

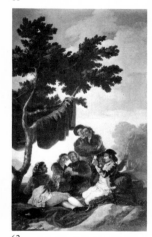

62

‹3

64

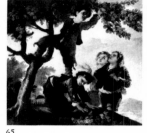

65

66

67

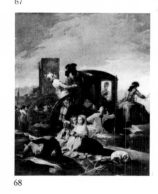

68

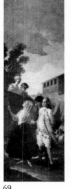

69 70

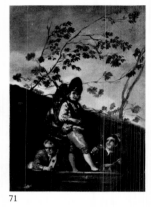

71

50. 'The Quail Shoot'
Oil on canvas;
cm 290 × 226 (114¼″ ×
89″) 1775
Madrid, Prado Museum

51. 'The Fisherman'
Oil on canvas;
cm 292 × 113 (115″ ×
44½″) 1775
Madrid, Prado Museum,
on loan to the Ministry of
Education

**52. 'Boys Hunting with a
Decoy'**
Oil on canvas;
cm 292 × 50 (115″ ×
19⅝″) 1775
Barcelona, Vinas Coll.

53. 'Dead Game'
Oil on canvas;
cm 170 × 100 (67″ ×
39⅜″)
Madrid, Patrimonio
Nacional (lost, known only
in tapestry form)

54. 'The Picnic'
Oil on canvas;
cm 272 × 295 (107⅛″ ×
116¼″) 1776
Madrid, Prado Museum

**55. 'Dance on the Banks
of the Manzanares'**
Oil on canvas;
cm 272 × 295 (107⅛″ ×
116¼″) 1777
Madrid, Prado Museum

**56. 'The Fight at the
"New Inn"'** (sketch)
Oil on canvas;
cm 41.9 × 67.3 (16½″ ×
26½″) 1777
Switzerland, Private Coll.

**57. 'The Fight at the
"Cock Inn"'**
Oil on canvas;
cm 275 × 414 (108⅜″ ×
163⅛″) 1777
Madrid, Prado Museum

**58. 'The Maja and the
Men in Cloaks'**
Oil on canvas;
cm 275 × 190 (108⅜″ ×
74⅞″) 1777
Madrid, Prado Museum

59. 'The Drinker'
Oil on canvas;
cm 107 × 151 (42⅛″ ×
59½″) 1777
Madrid, Prado Museum

60. 'The Parasol'
Oil on canvas;
cm 104 × 152 (41″ ×
59⅞″) 1777
Madrid, Prado Museum

61. 'The Kite'
Oil on canvas;
cm 269 × 285 (106″ ×
112¼″) 1778
Madrid, Prado Museum

62. 'Card Players' (sketch)
Oil on canvas;
cm 87 × 58 (34¼″ ×
22⅞″) Circa 1778
Winterthur, Reinhart Coll.

63. 'Card Players'
Oil on canvas;
cm 270 × 167 (106⅜″ ×
65¾″) 1778
Madrid, Prado Museum

**64. 'Boys Inflating a
Balloon'**
Oil on canvas;
cm 116 × 124 (45¾″ ×
48⅞″) 1778
Madrid, Prado Museum

65. 'Boys Picking Fruit'
Oil on canvas;
cm 119 × 122 (46⅞″ ×
48″) 1778
Madrid, Prado Museum

**66. 'The Blind Man with
the Guitar'**
Oil on canvas;
cm 260 × 311 (102½″ ×
122½″) 1778
Madrid, Prado Museum

67. 'The Madrid Fair'
Oil on canvas;
cm 258 × 218 (101⅛″ ×
85⅞″) 1779
Madrid, Prado Museum

**68. 'The Crockery
Vendor'**
Oil on canvas;
cm 259 × 220 (102″ ×
86⅝″) 1779
Madrid, Prado Museum

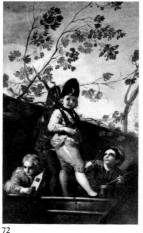

72

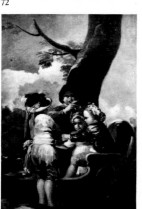

73

74

75

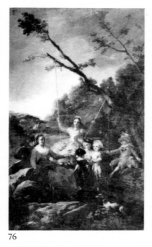

76

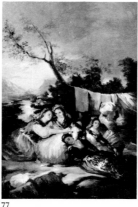

77

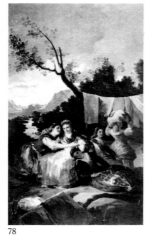

78

79

80

81

82

83

84 85

86

**69. 'The Officer and the
Lady'**
Oil on canvas;
cm 259 × 100 (102″ ×
39⅜″) 1779
Madrid, Prado Museum

**70. 'The Girl Selling
Azaroles'**
Oil on canvas;
cm 259 × 100 (102″ ×
39⅜″) 1779
Madrid, Prado Museum

**71. 'Children Playing at
Soldiers'** (sketch)
Oil on canvas;
cm 39 × 28 (15⅜″ ×
11″) Circa 1779
Seville, Yandurri Coll.

**72. 'Children Playing at
Soldiers'**
Oil on canvas;
cm 146 × 94 (57½″ ×
37″) 1779
Madrid, Prado Museum

73. 'Children with a Cart'
Oil on canvas;
cm 146 × 94 (57½″ ×
37″) 1779
Ohio, Toledo Museum

**74. 'The Game of Bat
and Ball'** (study)
Oil on canvas;
cm 35 × 50 (13¾″ ×
19⅝″)
Circa 1779
Whereabouts unknown

**75. 'The Game of Bat
and Ball'**
Oil on canvas;
cm 261 × 470 (102⅞″ ×
185⅛″) 1779
Madrid, Prado Museum

76. 'The Swing'
Oil on canvas;
cm 260 × 165 (102½″ ×
65″) 1779
Madrid, Prado Museum

77. 'The Washerwomen'
(sketch)
Oil on canvas;
cm 86.5 × 59 (34⅛″ ×
23¼″) Circa 1780
Winterthur, Reinhart Coll.

78. 'The Washerwomen'
Oil on canvas;
cm 218 × 166 (85⅞″ ×
65½″) 1780
Madrid, Prado Museum

79. 'The Bullfight'
Oil on canvas;
cm 259 × 136 (102″ ×
53½″) 1780
Madrid, Prado Museum

80. 'The Dog'
Oil on canvas;
cm 267 × 75 (105⅛″ ×
29½″)
Madrid, Patrimonio
Nacional (lost; known only
in tapestry form)

81. 'The Fountain'
Oil on canvas;
cm 200 × 75 (78⅞″ ×
29½″) 1780
Madrid, Patrimonio
Nacional (lost; known only
in tapestry form)

82. 'The Tobacco Guard'
(study)
Oil on canvas;
cm 85 × 65 (33½″ ×
25⅜″) Circa 1780
Gothenburg, Borjessons
Konsthandel

83. 'The Tobacco Guard'
Oil on canvas;
cm 262 × 137 (103¼″ ×
54″) 1780
Madrid, Prado Museum

**84. 'The Boy with the
Bird'**
Oil on canvas;
cm 262 × 40 (103¼″ ×
13¾″) 1780
Madrid, Prado Museum

85. 'The Boy in the Tree'
Oil on canvas;
cm 262 × 40 (103¼″ ×
14¾″) 1780
Madrid, Prado Museum

86. 'Woodcutters'
Oil on canvas;
cm 141 × 114 (55½″ ×
45″) 1780
Madrid, Prado Museum

173

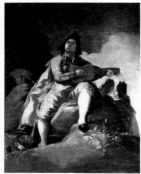

87

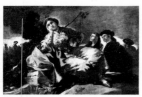

88

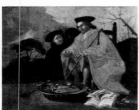

89

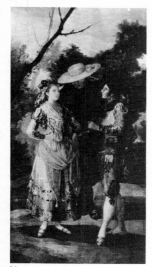

90

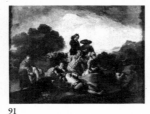

91

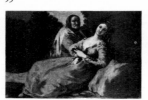

92

93

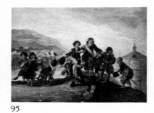

95

96

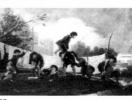

97

98

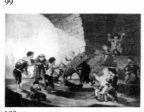

99

101

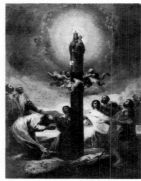

102

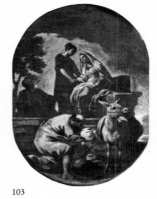

103

104

105

106

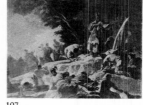

107

108

100

87. 'The Majo with the Guitar'
Oil on canvas;
cm 137 × 112 (54″ × 44⅛″) 1780
Madrid, Prado Museum

88. 'The Rendezvous'
Oil on canvas;
cm 100 × 151 (39¾″ × 59½″) 1780
Madrid, Prado Museum

89. 'The Doctor'
Oil on canvas;
cm 94 × 121 (37″ × 47⅛″)
Edinburgh, Scottish National Gallery (1628)

90. 'A Maja and two Majos'
Oil on canvas;
cm 183 × 100 (72⅛″ × 39¾″)
Circa 1776-1777
Houston (Texas), M Kress Coll. (61.57)

91. 'The Picnic'
Oil on canvas;
cm 42 × 54.5 (16½″ × 21½″) 1776-1778
Munich, Staatsgemälde-sammlungen

92. 'The Picnic'
Oil on canvas;
cm 46 × 54 (18″ × 21¼″) 1776-1778
Madrid, Private Coll.

93. 'The Dance'
Oil on canvas;
cm 46 × 54 (18″ × 21¼″) 1776-1778
Madrid, Private Coll.

94. 'Maja and Celestina'
Oil on canvas;
cm 75 × 113 (29½″ × 44½″) 1778-1780
Madrid, Antonio MacCrohon Coll.

95. 'Children Playing at Soldiers'
Oil on canvas;
cm 29 × 42 (11½″ × 16½″) 1777-1785
Glasgow, Pollock House

96. 'Children and a Swing'
Oil on canvas;
cm 29 × 42 (11½″ × 16½″) 1777-1785
Glasgow, Pollock House

97. 'Children Squabbling over Chestnuts'
Oil on canvas;
cm 29 × 41 (11½″ × 16⅛″) 1777-1785
Zürich, Mme Anda-Bührle Coll.

98. 'Children Birdsnesting'
Oil on canvas;
cm 29 × 41 (11½″ × 16⅛″) 1775-1785
Zürich, Mme Anda-Bührle Coll.

99. 'Children Playing Leapfrog'
Oil on canvas;
cm 29 × 41 (11½″ × 16⅛″) 1777-1785
Valencia, Provincial Museum of Fine Arts (579)

100. 'Children Playing at Bullfighting'
Oil on canvas;
cm 29 × 41 (11½″ × 16⅛″) 1777-1785
Madrid, Duke of Santa Masca Coll.

101. 'The Master'
Oil on canvas;
Size unknown
Circa 1777-1785
Whereabouts unknown

102. 'Apparition of the Virgin of the Pillar'
Oil on canvas;
cm 120 × 98 (47¼″ × 38⅝″) 1775-1780
Barcelona, Julio Munoz Coll.

103. 'The Visitation'
Oil on paper;
cm 60 × 47 (23⅛″ × 18½″) 1775-1780
Madrid, García Coll.

104. 'St. Barbara'
Oil on canvas;
cm 95 × 78 (37⅜″ × 30¾″) 1775-1780
Barcelona, Federico Torello Coll.

105. 'St. Luke'
Oil on canvas;
cm 75 × 61 (29⅞″ × 24″) 1775-1780
Madrid, Ricardo Boguerín Coll.

106. 'Moses and the Brazen Serpent'
Oil on canvas;
Size unknown
Circa 1775-1780
Formerly Madrid, Duke of Aveyro Coll.

107. 'Moses Making the Water Flow from the Rock'
Oil on canvas;
Size unknown
Circa 1775-1780
Formerly Madrid, Duke of Aveyro Coll.

108. 'Sacrifice of Isaac'
Oil on canvas;
Size unknown,
Circa 1775-1780
Formerly Madrid, Duke of Aveyro Coll.

109

110

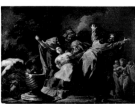

111

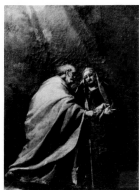

112

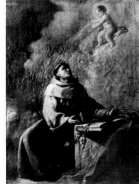

113

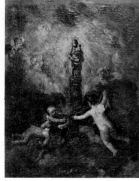

114

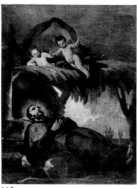

115

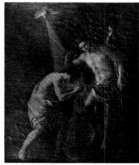

116

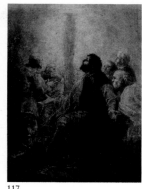

117

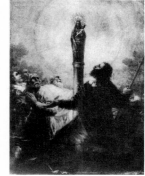

118

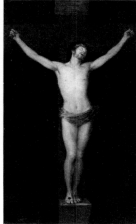

119

120

123

124

125

126

122

109. 'Sacrifice of Iphigenia'
Oil on canvas;
Size unknown
Circa 1775-1780
Formerly Madrid, Duke of Aveyro Coll.

110. 'Lot and his Daughters'
Oil on canvas;
cm 90 × 125 (35⅜″ × 49¼″) 1775-1780
Formerly Bilbao, Linker Coll.

111. 'Sacrifice of Iphigenia'
Oil on canvas;
cm 97 × 72 (38⅛″ × 28⅜″) 1775-1780
Madrid, J.L. Varez Fisa Coll.

112. 'St. Joachim and St. Anne'
Oil on canvas;
Size unknown
Circa 1775-1780
Formerly Valencia Cathedral (lost in 1936)

113. 'Vision of St. Anthony'
Oil on canvas;
Size unknown
Circa 1775-1780
Formerly Valencia Cathedral (lost in 1936)

114. 'The Virgin of the Pillar'
Oil on canvas;
cm 78 × 52 (30¾″ × 20½″) 1775-1780
Saragossa, Provincial Museum of Fine Arts (169)

115. 'Death of St. Francis Xavier'
Oil on canvas;
cm 78 × 52 (30¾″ × 20½″) 1775-1780
Saragossa, Provincial Museum of Fine Arts (167)

116. 'Baptism of Christ'
Oil on canvas;
cm 45 × 39 (17¾″ × 15⅜″) 1775-1780
Madrid, Conde de Orgaz Coll.

117. 'Apparition of the Virgin of the Pillar'
(sketch)
Oil on canvas;
cm 33 × 25 (13″ × 9⅞″) 1775-1780
Madrid, Private Coll.

118. 'Apparition of the Virgin of the Pillar'
Oil on canvas;
Size unknown
Circa 1775-1780
Formerly Madrid, Rosillo Coll.

119. 'The Crucifixion'
Oil on canvas;
cm 255 × 154 (100½″ × 60⅝″) 1780
Madrid, Prado Museum

120. 'Regina Martyrum'
(sketch)
Oil on canvas;
cm 85 × 165 (33½″ × 65″) 1780
Saragossa, Diocesan Museum

121. 'Regina Martyrum'
(sketch)
Oil on canvas;
cm 85 × 165 (33½″ × 65″) 1780
Saragossa, Diocesan Museum

122. 'Regina Martyrum'
Fresco in the cupola
1780-1781
Saragossa, Basílica del Pilar

123. 'Faith'
Fresco on pendentive
1781
Saragossa, Basílica del Pilar

124. 'Patience'
Fresco on pendentive
1781
Saragossa, Basílica del Pilar

125. 'Fortitude'
Fresco on pendentive
1781
Saragossa, Basilica del Pilar

126. 'Charity'
Fresco on pendentive
1781
Saragossa, Basílica del Pilar

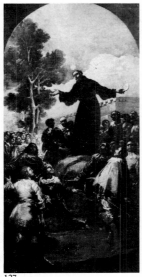

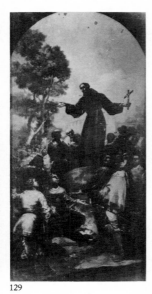

127

129

132

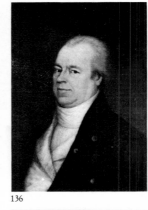

136

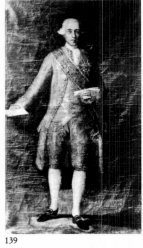

139

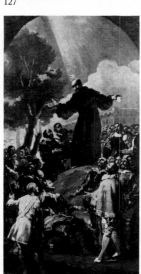

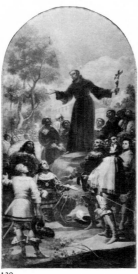

128

130

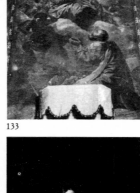

133

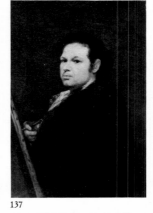

137

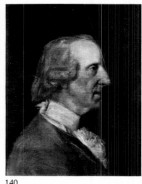

140

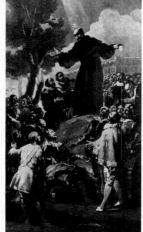

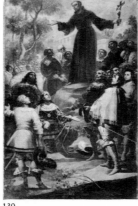

134

138

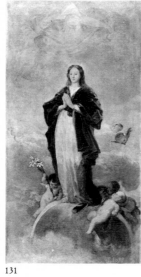

131

135

127. 'St. Bernardino of Siena' (study)
Oil on canvas;
cm 62 × 31 (24⅜″ × 12⅛″) 1781-1782
Madrid, Condesa de Villagonzalo Coll.

128. 'St. Bernardino of Siena' (sketch)
Oil on canvas;
cm 62 × 33 (24⅜″ × 13″) 1781-1782
Madrid, Condesa de Villagonzalo Coll.

129. 'St. Bernardino of Siena' (sketch)
Oil on canvas;
cm 140 × 80 (55⅛″ × 31½″) 1782-1783
Saragossa, Bergua Oliván Coll.

130. 'St. Bernardino of Siena'
Oil on canvas;
cm 480 × 300 (189⅛″ × 118¼″) 1782-1783
Madrid, Church of San Francisco el Grande

131. 'The Immaculate Conception' (sketch)
Oil on canvas;
cm 80 × 41 (31½″ × 16⅛″) 1784
Madrid, Prado Museum

132. 'Apparition of the Virgin of the Pillar'
Oil on canvas;
Size unknown
Circa 1780-1785
Valladolid, García Rodríguez Coll.

133. 'Apparition of the Virgin of the Pillar'
Oil on canvas;
Size unknown
Circa 1780-1785
Formerly Teruel, Parish Church of Urrea de Gaén (destroyed in 1936)

134. 'The Holy Family'
Oil on canvas;
cm 203 × 148 (80″ × 58⅜″)
Circa 1780-1785
Madrid, Prado Museum

135. 'Francisco Bayeu'
Oil on canvas;
cm 49 × 35 (19¼″ × 13¾″)
Circa 1780
Madrid, Marqués de Casa Torres Coll.

136. 'Cornelius van der Gotten'
Oil on canvas;
cm 62 × 47 (24⅜″ × 18½″)
Madrid, Prado Museum

137. 'Self-Portrait'
Oil on canvas;
cm 86 × 60 (33⅞″ × 23⅝″) 1783
Agen, Museé des Beaux Arts (274 Cn)

138. 'The Conde de Floridablanca and Goya'
Oil on canvas;
cm 262 × 166 (103¼″ × 65½″)
Signed and dated: 'Al Excmo. Seño/Florida Blanca/Ano 1783 Señor/Franc° Goya'
Madrid, Urquijo Bank

139. 'The Conde de Floridablanca'
Oil on canvas;
cm 175 × 112 (69″ × 44⅛″) Circa 1783
Madrid, Marqués de Casa Torres Coll.
presented to the Prado Museum

140. 'The Infante Don Luis de Borbón'
Oil on canvas;
cm 42 × 37 (16½″ × 14⅝″) 1783
Madrid, Duchess of Sueca Coll.

141

145

149

152

155

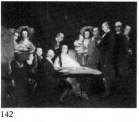

142

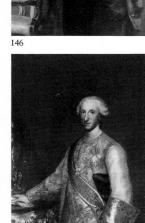

146

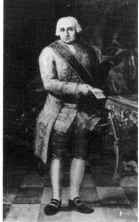

150

153

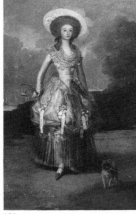

156

143

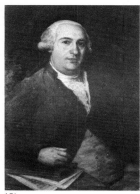

147

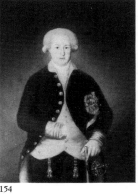

151

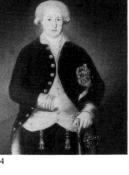

154

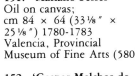

157

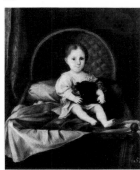

144

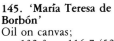

148

141. 'María Teresa de Vallabriga'
Oil on panel;
cm 48 × 39.5 (18⅞″ × 15⅝″) 1783
Madrid, heirs of the Marqués de Acapulco

142. 'The Family of the Infante Don Luis'
Oil on canvas;
cm 248 × 330 (97¾″ × 130″) 1783
Italy, Private Coll.

143. 'Luis María de Borbón'
Oil on canvas;
cm 134 × 114 (52¾″ × 45″) 1783
Madrid, Private Coll.

144. 'The Duchess of San Fernando'
Oil on canvas;
cm 134 × 114 (52¾″ × 45″) 1783
Madrid, Private Coll.

145. 'María Teresa de Borbón'
Oil on canvas;
cm 132.3 × 116.7 (52⅛″ × 46″) 1783
Washington, Bruce Mellon Coll.

146. 'María Teresa de Vallabriga'
Oil on canvas;
cm 151.2 × 97.8 (59⅝″ × 38⅛″) 1783
Munich, Alte Pinakothek

147. 'The Infante Don Luis de Borbón'
Oil on canvas;
cm 152.7 × 100 (60⅛″ × 39⅜″) 1783
Cleveland (Ohio), Museum of Art (66.14)

148. 'The Infante Don Luis and Ventura Rodríguez'
Oil on canvas;
cm 25 × 20 (9⅞″ × 7⅞″) 1783-1784
Paris, Musée Jacquemart André

149. 'Ventura Rodríguez'
Oil on canvas;
cm 106 × 79 (41¾″ × 31⅛″)
Signed and dated:
Stockholm, Nationalmuseet

150. 'Miguel Muzquiz, Conde de Gausa'
Oil on canvas;
cm 200 × 114 (78⅞″ × 45″) 1784-1785
Madrid, Private Coll.

151. 'Mariano Ferrer'
Oil on canvas;
cm 84 × 64 (33⅛″ × 25⅛″) 1780-1783
Valencia, Provincial Museum of Fine Arts (580)

152. 'Gaspar Melchor de Jovellanos'
Oil on canvas;
cm 185 × 110 (73″ × 43⅜″) 1784-1785
Barcelona, Valls y Taberner Coll.

153. 'Admiral Don José de Mazarredo'
Oil on canvas;
cm 105 × 85 (41⅜″ × 33⅛″) 1784-1785
Jacksonville (Florida), Cummer Gallery of Art

154. 'The 9th Duke of Osuna'
Oil on canvas;
cm 111 × 82 (43¾″ × 32⅜″) 1785
Jedburgh (UK), Marc Oliver Coll.

155. 'The Condesa-Duquesa de Benavente'
Oil on canvas;
cm 104 × 80 (41″ × 31½″) 1785
Madrid, Bartolomé March Coll.

156. 'The Marquesa de Pontejos'
Oil on canvas;
cm 211 × 126 (83⅛″ × 49⅝″) Circa 1786
Washington, National Gallery (Mellon 85)

157. 'Juan Agustín Ceán Bermúdez'
Oil on canvas;
cm 100 × 70 (39⅜″ × 27½″) Circa 1785
Madrid, Conde de Cienfuegos Coll.

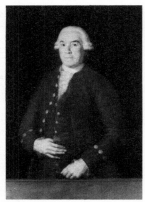

158

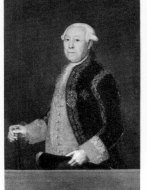

161

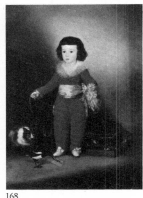

164

171

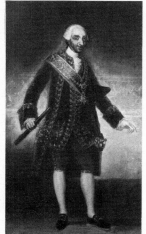

159

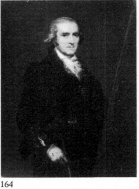

162

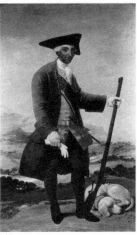

165

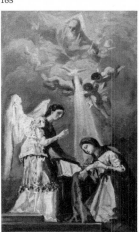

169

172

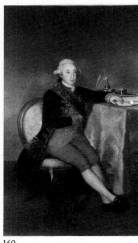

160

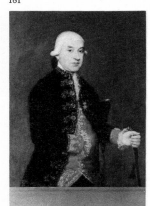

163

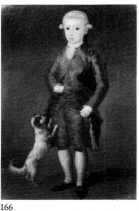

166

170

173

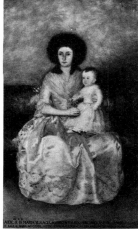

167

158. 'José del Toro y Zambrano'
Oil on canvas;
cm 113 × 68 (44½″ × 26¾″) 1785
Madrid, Banco de España

159. 'Charles III'
Oil on canvas;
cm 194 × 110 (76½″ × 43⅜″) 1787
Madrid, Banco de España

160. 'The Conde de Altamira'
Oil on canvas;
cm 177 × 108 (69¾″ × 42½″) 1787
Madrid, Banco de Espana

161. 'The Marqués de Tolosa'
Oil on canvas;
cm 112 × 78 (44⅛″ × 30¾″) 1787
Madrid, Banco de Espana

162. 'Francisco Javier de Larrumbe'
Oil on canvas;
cm 113 × 77 (44½″ × 30⅜″) 1787
Madrid, Banco de Espana

163. 'The Conde de Cabarrús'
Oil on canvas;
cm 210 × 127 (83¾″ × 50″) 1788
Madrid, Banco de Espana

164. 'Francisco Bayeu'
Oil on canvas;
cm 109 × 82 (43″ × 32⅜″)
Valencia, Provincial Museum of Fine Arts (582)

165. 'Charles III in Hunting Dress'
Oil on canvas;
cm 206 × 130 (81⅛″ × 51¼″)
Circa 1786-1788
Madrid, Duchess of Fernán Núñez Coll.

166. 'Vicente Osorio'
Oil on canvas;
cm 135 × 110 (53⅛″ × 43⅜″) 1786-1787
New York, Charles S. Payson Coll.

167. 'The Condesa de Altamira and her daughter'
Oil on canvas;
cm 195 × 115 (76⅞″ × 45⅜″) 1787-1788
New York, Metropolitan Museum (Lehman Coll.)

168. 'Manuel Osorio'
Oil on canvas;
cm 110 × 80 (43⅜″ × 31½″) Circa 1788
Signed: 'Dⁿ. Francᵒ Goya'
New York, Metropolitan Museum (Bache 49.7.41)

169. 'The Annunciation' (sketch)
Oil on canvas;
cm 42 × 26 (16½″ × 10¼″) Circa 1785
Madrid, Private Coll.

170. 'The Annunciation'
Oil on canvas;
cm 287 × 177 (113″ × 69¾″) 1785
Espejo, Duchess of Osuna Coll.

171. 'The Death of St. Joseph' (study)
Oil on canvas;
cm 54.5 × 40.5 (21½″ × 15¾″) Circa 1787
Flint (Michigan) Institute of Arts

172. 'The Death of St. Joseph'
Oil on canvas;
cm 220 × 160 (86⅜″ × 63″) 1787
Valladolid, Convent of Santa Ana

173. 'The Miracle of St. Bernard'
Oil on canvas;
cm 220 × 160 (86⅜″ × 63″) 1787
Valladolid, Convent of Santa Ana

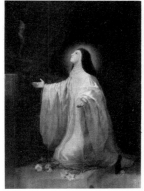

174

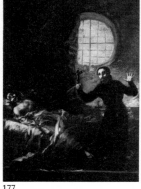

177

180

183

175

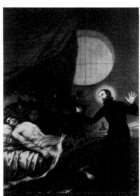

178

184

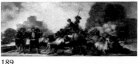

185

176

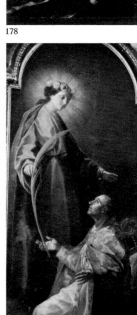

179

181

186

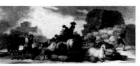

187

188

189

190

174. 'St Lutgarde'
Oil on canvas;
cm 220 × 160 (86⅝" × 63") 1787
Valladolid, Convent of Santa Ana

175. 'St. Francis Borgia Bidding Farewell to his Family' (sketch)
Oil on canvas;
cm 38 × 29 (15" × 11½") 1788
Madrid, Marqués de Santa Cruz Coll.

176. 'St. Francis Borgia Bidding Farewell to his Family'
Oil on canvas;
cm 350 × 300 (138" × 118¼") 1788
Valencia Cathedral

177. 'St. Francis Borgia and the Dying Impenitent' (sketch)
Oil on canvas;
cm 37 × 26 (14⅝" × 10¼") 1788
Madrid, Marqués de Santa Cruz Coll.

178. 'St. Francis Borgia and the Dying Impenitent'
Oil on canvas;
cm 350 × 300 (138" × 118¼") 1788
Valencia Cathedral

179. 'The Virgin Appears to St. Julian'
Oil on canvas;
cm 250 × 90 (98½" × 35⅜") Circa 1790
Valdemoro, Parish Church

180. 'The Greasy Pole'
Oil on canvas;
cm 169 × 98 (66½" × 38⅝") 1786-1787
Madrid, Duke of Montellano Coll.

181. 'The Kite'
Oil on canvas;
cm 169 × 98 (66½" × 38⅝") 1786-1787
Madrid, Duke of Montellano Coll.

182. 'The Fall'
Oil on canvas;
cm 169 × 98 (66½" × 33⅜") 1786-1787
Madrid, Duke of Montellano Coll.

183. 'The Attack on the Coach'
Oil on canvas;
cm 169 × 127 (66½" × 50") 1786-1787
Madrid, Duke of Montellano Coll.

184. 'The Building'
Oil on canvas;
cm 166 × 154 (65½" × 60⅛") 1786-1787
Madrid, Conde de Romanones Coll.

185. 'Village Procession'
Oil on canvas;
cm 169 × 137 (66½" × 54") 1786-1787
Madrid, Conde de Yebes Coll.

186. 'Penning of the Bulls'
Oil on canvas;
cm 165 × 285 (65" × 112¼") 1786-1787
Formerly Budapest, Baron Herzog Coll.

187. 'Spring' (sketch)
Oil on canvas;
cm 35 × 24 (13¾" × 9½") 1786
Madrid, Duke of Montellano Coll.

188. 'Spring'
Oil on canvas;
cm 277 × 192 (109⅛" × 75⅝") 1786-1787
Madrid, Prado Museum

189. 'The Threshing Ground'
Oil on canvas;
cm 34 × 76 (13⅜" × 29⅞") 1786
Madrid, Lázaro Galdeano Museum (M.2510)

190. 'The Threshing Ground'
Oil on canvas;
cm 276 × 641 (108¾" × 252½") 1786-1787
Madrid, Prado Museum

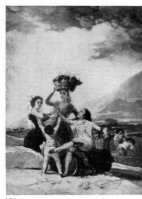

191

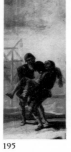

195 196

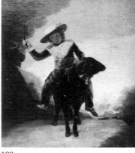

199

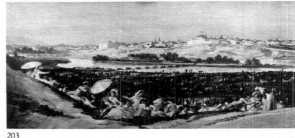

203

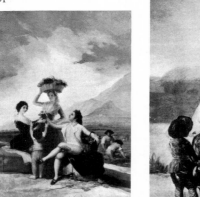

192

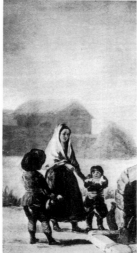

197

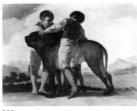

200

204

207

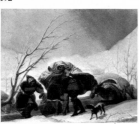

193

201

205

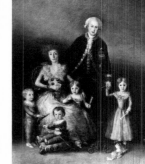

208

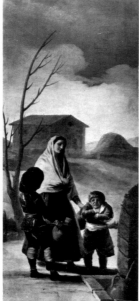

198

202

206

209

194

191. 'The Vintage'
(sketch)
Oil on canvas;
cm 36 × 24 (14¼″ ×
9½″) Circa 1786
Williamstown
(Massachusetts), Clark Art
Institute

192. 'The Vintage'
Oil on canvas;
cm 275 × 190 (108⅜″ ×
74⅞″) 1786-1787
Madrid, Prado Museum

193. 'The Snowstorm'
(sketch)
Oil on canvas;
cm 31.7 × 33 (12½″ ×
13″) 1786
Chicago, Everett D. Graff
Coll.

194. 'The Snowstorm'
Oil on canvas;
cm 275 × 293 (108⅜″ ×
115½″) 1786-1787
Madrid, Prado Museum

**195. 'The Drunken
Mason'** (sketch)
Oil on canvas;
cm 35 × 15 (13¾″ ×
5⅞″) 1786
Madrid, Prado Museum

196. 'The Injured Mason'
Oil on canvas;
cm 286 × 110 (105½″ ×
43⅜″) 1786-1787
Madrid, Prado Museum

**197. 'Poor People at the
Fountain'** (sketch)
Oil on canvas;
cm 38 × 14 (15″ × 5½″)
1786
New York, E.V. Thaw
Coll.

**198. 'Poor People at the
Fountain'**
Oil on canvas;
cm 277 × 115 (109⅞″ ×
45⅜″) 1786-1787
Madrid, Prado Museum

**199. 'The Boy on the
Ram'**
Oil on canvas;
cm 124 × 110 (48⅞″ ×
43⅜″) 1786-1787
Chicago, Chauncey
McCormick Coll.

**200. 'Two Children with
Two Mastiffs'**
Oil on canvas;
cm 112 × 145 (44⅛″ ×
57⅛″) 1786-1787
Madrid, Prado Museum

**201. 'Hunter beside a
Spring'**
Oil on canvas;
cm 130 × 134 (51¼″ ×
52¾″) 1786-1787
Madrid, Prado Museum

**202. 'Shepherd Playing
the Flageolet'**
Oil on canvas;
cm 130 × 134 (51¼″ ×
52¾″) 1786-1787
Madrid, Prado Museum

**203. 'The Meadow of St.
Isidore'**
Oil on canvas;
cm 42 × 90 (16½″ ×
35⅜″) 1788
Madrid, Prado Museum

**204. 'The Hermitage of
St. Isidore'**
Oil on canvas;
cm 42 × 44 (16½″ ×
17⅜″) 1788
Madrid, Prado Museum

205. 'The Picnic'
Oil on canvas;
cm 41 × 25 (16⅛″ ×
9⅞″)
London, National Gallery

206 'Blind Man's Buff'
(sketch)
Oil on canvas;
cm 42 × 44 (16½″ ×
17⅜″) 1788
Madrid, Prado Museum

207. 'Blind Man's Buff'
Oil on canvas;
cm 269 × 350 (106″ ×
138″) 1788-1789
Madrid, Prado Museum

210

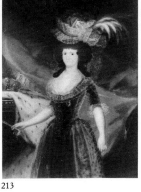

213

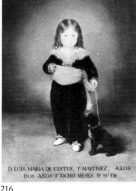

216

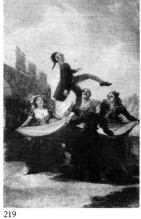

219

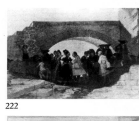

222

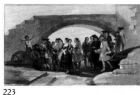

223

211

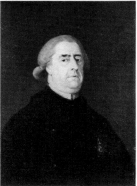

214

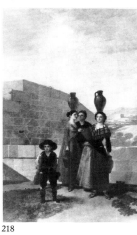

217

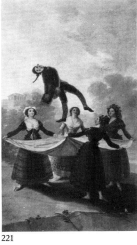

220

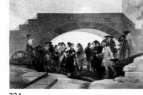

224

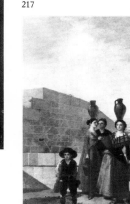

215

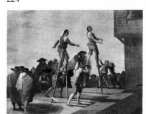

225

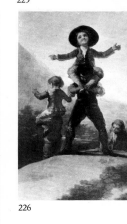

221

212. 'Charles IV'
Oil on canvas;
cm 137 × 110 (54" ×
43⅜") 1789
Madrid, Academia de la
Historia

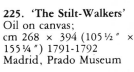

226

208. 'Juan Martín de Goicoechea'
Oil on canvas;
cm 86 × 66 (33⅞" ×
26") 1789
Madrid, Conde de Orgaz
Coll.

209. 'The Family of the Duke of Osuna'
Oil on canvas;
cm 225 × 171 (88⅝" ×
67⅜") 1788
Madrid, Prado Museum

210. 'Charles IV'
Oil on canvas;
cm 203 × 137 (80" ×
54") 1789
Madrid, Prado Museum

211. 'Queen María Luisa'
Oil on canvas;
cm 205 × 132 (80¾" ×
52") 1789
Madrid, Prado Museum

213. 'Queen María Luisa'
Oil on canvas;
cm 137 × 110 (54" ×
43⅜") 1789
Madrid, Academia de la
Historia

214. 'Martín Zapater'
Oil on canvas;
cm 83 × 65 (32⅛" ×
25⅜")
Signed and dated: 'Mi
Amigo Martⁿ. Zapater.
Con el/mayor trabajo/te a
hecho el/Retrato/Goya/
1790'
The Hague, Cramer
Gallery

215. 'Ramón de Pignatelli'
Oil on canvas;
cm 29.5 × 62 (11⅝" ×
24⅜") Circa 1790
Madrid, Duchess of
Villahermosa Coll.

216. 'Luis María de Cistué'
Oil on canvas;
cm 125 × 90 (49¼" ×
35⅜") 1791
New York, Rockefeller
Coll.

217. 'Girls with Jugs'
(sketch)
Oil on canvas;
cm 34 × 21 (13⅜" ×
8¼") Circa 1791
Madrid, Antonio
MacCrohon Coll.

218. 'Girls with Jugs'
Oil on canvas;
cm 262 × 160 (103¼" ×
63") 1791-1792
Madrid, Prado Museum

219. 'The Manikin'
(sketch)
Oil on canvas;
cm 34 × 15 (13⅜" ×
5⅞") 1791
Madrid, Private Coll.

220. 'The Manikin'
Oil on canvas;
cm 44.5 × 25.4 (17½" ×
10") 1791
New York, Mrs Rush H.
Kress Coll.

221. 'The Manikin'
Oil on canvas;
cm 267 × 160 (105⅛" ×
63") 1791-1792
Madrid, Prado Museum

222. 'The Wedding'
(sketch)
Oil on canvas;
cm 34.5 × 51 (13⅜" ×
20⅛") 1791
Formerly Buenos Aires,
Jockey Club (destroyed)

223. 'The Wedding'
(sketch)
Oil on canvas;
cm 48.2 × 81.5 (19" ×
32⅛") 1791
United States, Private
Coll.

224. 'The Wedding'
Oil on canvas;
cm 267 × 293 (105⅛" ×
115½") 1791-1792
Madrid, Prado Museum

225. 'The Stilt-Walkers'
Oil on canvas;
cm 268 × 394 (105½" ×
155¼") 1791-1792
Madrid, Prado Museum

226. 'The Little Giants'
Oil on canvas;
cm 137 × 104 (54" ×
41") 1791-1792
Madrid, Prado Museum

227

228

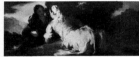

229

230

231

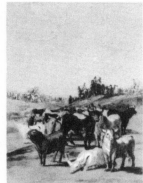

232

233

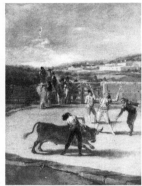

234

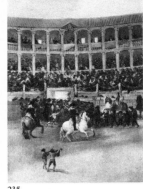

235

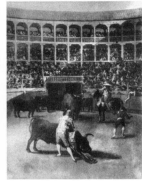

236

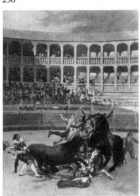

237

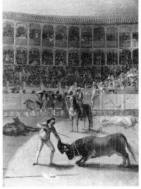

238

239

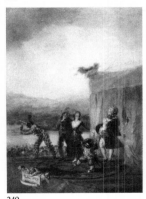

240

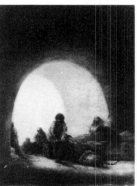

241

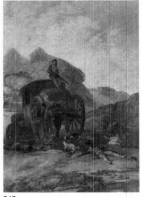

242

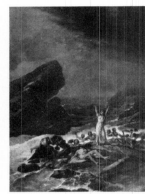

243

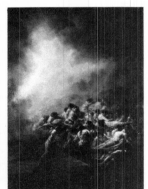

244

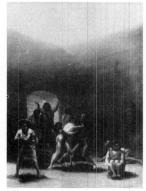

245

227. 'Boys Climbing a Tree'
Oil on canvas;
cm 141 × 111 (55½″ × 43¾″) 1791-1792
Madrid, Prado Museum

228. 'The Kite'
Oil on canvas;
cm 80 × 167 (31½″ × 65¾″) 1791-1792
Madrid, Patrimonio Nacional (known only in tapestry form)

229. 'Gossiping'
Oil on canvas;
cm 69 × 155 (27⅛″ × 61″) Circa 1792
Hartford (Connecticut), Wadsworth Atheneum Coll. (1929.4)

230. 'Siesta'
Oil on canvas;
cm 59 × 145 (23¼″ × 57⅛″) Circa 1792
Madrid, Antonio MacCrohon Coll.

231. 'Woman Selling Wine'
Oil on canvas;
Size unknown
1780-1792
Formerly Madrid, Marqués de Chiloeches Coll.

232. 'Bulls at Pasture'
Oil on tin;
cm 42.5 × 31.5 (16¾″ × 12⅜″) 1793
Paris, Private Coll.

233. 'Capturing a Bull'
Oil on tin;
cm 43 × 31 (17″ × 12⅛″) 1793
Madrid, Marqués de la Torrecilla Coll.

234. 'Planting the ''banderillas'' '
Oil on tin;
cm 43 × 31 (17″ × 12⅛″) 1793
Madrid, Private Coll.

235. 'Clearing the Arena'
Oil on tin;
cm 43 × 31 (17″ × 12⅛″) 1793
Madrid, Private Coll.

236. 'A Pass with the Cape'
Oil on tin;
cm 43 × 31 (17″ × 12⅛″) 1793
Madrid, Private Coll.

237. 'Picador Caught on the Horns'
Oil on tin; .
cm 43 × 32 (17″ × 12⅝″) 1793
New York, Cotnareanu Coll.

238. 'The Moment of Truth'
Oil on tin;
cm 43 × 32 (17″ × 12⅝″) 1793
Madrid, Marquesa de Cardona Coll.

239. 'Dragging the Bull Away'
Oil on tin;
cm 43 × 32 (17″ × 12⅝″) 1793
Seville, Duchess of Medinaceli Coll.

240. 'Strolling Players'
Oil on tin;
cm 43 × 32 (17″ × 12⅝″) 1793
Madrid, Prado Museum

241. 'Interior of a Prison'
Oil on copper;
cm 42.9 × 31.7 (16⅞″ × 12½″) 1793
Barnard Castle (UK), Bowes Museum (29)

242. 'Bandits Attacking a Coach'
Oil on tin;
cm 50 × 32 (19⅝″ × 12⅝″) 1793-1794
Madrid, Private Coll.

243. 'Shipwreck'
Oil on tin;
cm 50 × 32 (19⅝″ × 12⅝″) 1793-1794
Madrid, Marqués de Oquendo Coll.

244. 'Fire'
Oil on tin;
cm 43.8 × 32 (17¼″ × 12⅝″) 1793-1794
Madrid, Fisa Coll.

245. 'Madhouse Yard'
Oil on tin;
cm 43.8 × 32.7 (17¼″ × 12⅞″) 1794
Dallas, Meadows Museum

246

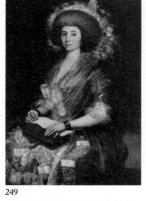

249

253

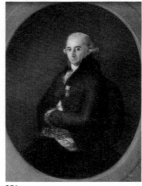

256

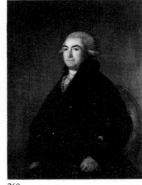

260

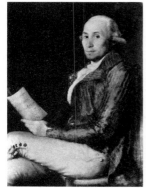

247

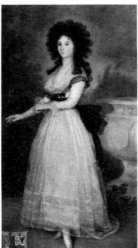

250

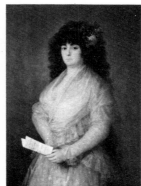

254

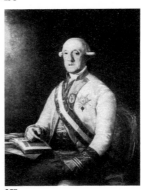

257

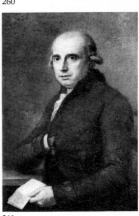

261

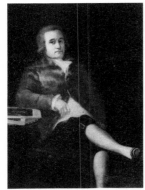

255

262

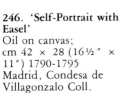

248

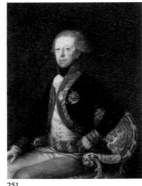

251

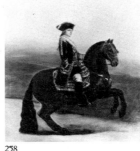

258

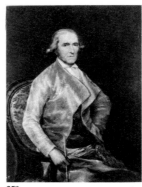

259

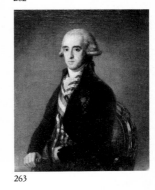

263

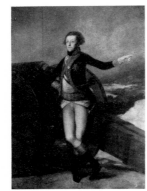

252

246. 'Self-Portrait with Easel'
Oil on canvas;
cm 42 × 28 (16½″ × 11″) 1790-1795
Madrid, Condesa de Villagonzalo Coll.

247. 'Sebastián Martínez'
Oil on canvas;
cm 92.9 × 67.6 (36½″ × 26⅝″)
New York, Metropolitan Museum (06.289)

248. 'Juan Agustín Ceán Bermúdez'
Oil on canvas;
cm 122 × 88 (48″ × 34⅝″)
Circa 1792-1793
Madrid, Marqués de Perinat Coll.

249. 'Senora Bermúdez'
Oil on canvas;
cm 121 × 84.5 (47″ × 33¼″)
Circa 1792-1793
Budapest, Museum of Fine Arts (3792)

250. 'Tadea Arias de Enriquez'
Oil on canvas;
cm 191 × 84 (75¼″ × 33⅛″)
Circa 1793-1794
Madrid, Prado Museum

251. 'General Antonio Ricardos'
Oil on canvas;
cm 112 × 84 (44⅛″ × 33⅛″)
Circa 1793-1794
Madrid, Prado Museum

252. 'General Antonio Ricardos'
Oil on canvas;
cm 225 × 150 (88⅝″ × 59⅛″) Circa 1794
Seville, Marqués de Valencia del Alcor

253. 'Félix Colón de Larriategui'
Oil on canvas;
cm 110.7 × 84.1 (43⅝″ × 33⅛″)
Indianapolis, J.K. Lilley Coll.

254. 'María del Rosario Fernández' ('La Tirana')
Oil on canvas;
cm 112 × 79 (44⅛″ × 31⅛″)
Madrid, Juan March Coll.

255. 'The Marquesa de la Solana'
Oil on canvas;
cm 183 × 124 (72⅛″ × 48⅞″) Circa 1794-1795
Paris, Musée du Louvre

256. 'Ramón Posada y Soto'
Oil on canvas;
cm 113 × 87.5 (44½″ × 34½″) 1794
San Francisco, De Young Museum (K. 1973)

257. 'The Marqués de Sofraga'
Oil on canvas;
cm 108.3 × 82.6 (42⅝″ × 32½″) Circa 1795
San Diego, Fine Arts Gallery (38.244)

258. 'Don Manuel Godoy on Horseback' (study)
Oil on canvas;
cm 55.2 × 44.5 (21¾″ × 17½″) 1794-1795
Dallas, Meadows Museum

259. 'Francisco Bayeu'
Oil on canvas;
cm 113 × 84 (44½″ × 33⅛″) 1795
Madrid, Prado Museum

260. 'Gil de Tejada'
Oil on canvas;
cm 112 × 84 (44⅛″ × 33⅛″) 1794-1795
Madrid, Duke of el Infantado Coll.

261. 'Juan José Arias de Saavedra'
Oil on canvas;
cm 82 × 55 (32⅜″ × 21⅝″) 1794-1795
Madrid, Conde de Cienfuegos Coll.

183

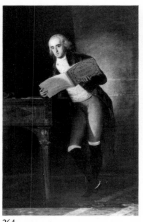

264

265

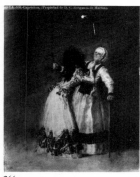

266

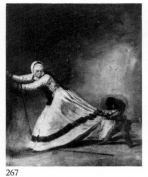

267

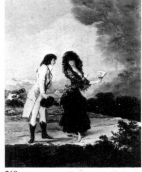

268

269

270

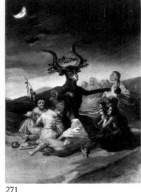

271

272

273

274

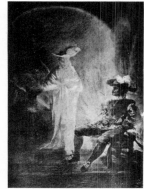

275

276

277

278

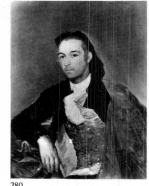

279

280

262. 'The Marquesa Viuda de Villafranca'
Oil on canvas;
cm 87 × 72 (34¼″ × 28⅜″) Circa 1795
Madrid, Marquesa de Villafranca Coll. (2447)

263. 'The Duke of Alba'
Oil on canvas;
cm 86.3 × 68.5 (34″ × 27″) Circa 1795
Chicago, Chauncey McCormick Coll.

264. 'The Duke of Alba'
Oil on canvas;
cm 195 × 126 (76⅞″ × 49⅝″) 1795
Madrid, Prado Museum

265. 'The Duchess of Alba'
Oil on canvas;
cm 194 × 130 (76½″ × 51¼″)
Madrid, Alba Coll.

266. 'The Duchess of Alba and her Duenna'
Oil on canvas;
cm 31 × 25 (12⅛″ × 9⅞″)
Madrid, de Martín Coll.

267. 'Duenna with Children'
Oil on canvas;
cm 31 × 25 (12⅛″ × 9⅞″)
Madrid, de Martín Coll.

268. 'Flirtation'
Oil on canvas;
cm 41 × 31 (16⅛″ × 12⅛″)
Circa 1793-1797
Madrid, Marquesa de la Romana Coll.

269. 'The Duchess of Alba'
Oil on canvas;
cm 210.2 × 149.3 (82⅞″ × 58⅞″)
New York, Hispanic Society (A.102)

270. 'Flying Witches'
Oil on canvas;
cm 43.5 × 30.5 (17⅛″ × 12″) 1797-1798
Bilbao, Sota Coll.

271. 'Witches' Sabbath'
Oil on canvas;
cm 44 × 31 (17⅜″ × 12⅛″) 1797-1798
Madrid, Fundación Lázaro

272. 'Conjuration'
Oil on canvas;
cm 45 × 32 (17¾″ × 12⅝″) 1797-1798
Madrid, Fundación Lázaro

273. 'The Witches' Cauldron'
Oil on canvas;
cm 45 × 32 (17¾″ × 12⅝″) 1797-1798
Mexico, Private Coll.

274. 'The Devil's Lamp'
Oil on canvas;
cm 42 × 32 (16½″ × 12⅝″)
1797-1798
London, National Gallery

275. 'Don Juan and the Commendatore'
Oil on canvas;
cm 45 × 32 (17¾″ × 12⅝″)
1797-1798
Whereabouts unknown

276. 'Self-Portrait'
Oil on canvas;
cm 20 × 14 (7⅞″ × 5½″)
Signed: 'Goya'
Circa 1795-1797
Formerly Madrid, Alejandro Pidal Coll.

277. 'Martín Zapater'
Oil on canvas;
cm 83 × 64 (32⅞″ × 25⅛″)
Signed and dated: 'Goya. A su amigo Martin Zapater. 1797'
Bilbao, Sota Coll.

278. 'Bernardo de Iriarte'
Oil on canvas;
cm 108 × 84 (42½″ × 33⅛″)
Strasbourg, Musée des Beaux Arts (308)

279. 'Meléndez Valdés'
Oil on canvas;
cm 73.3 × 57.1 (28⅞″ × 22½″)
Barnard Castle (UK), Bowes Museum (26)

280. 'Pedro Romero'
Oil on canvas;
cm 84.1 × 65 (33⅛″ × 25⅜″)
Circa 1795-1798
Fort Worth (Texas), Kimbell Foundation

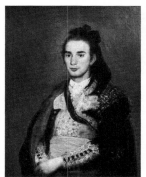

281

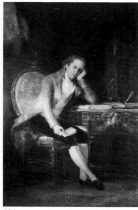

284

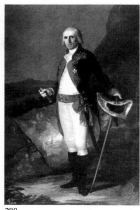

288

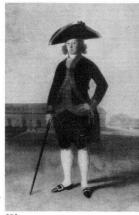

292

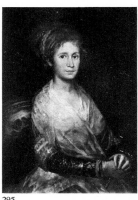

295

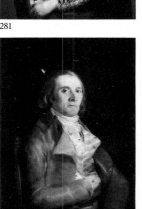

282

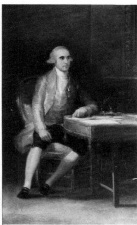

285

289

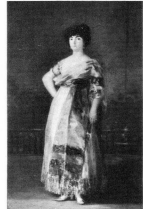

293

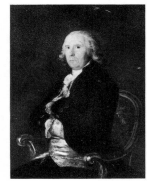

296

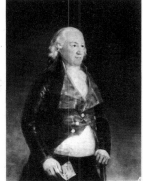

283

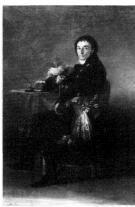

286

290

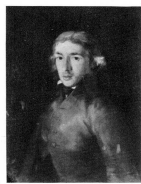

294

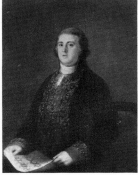

297

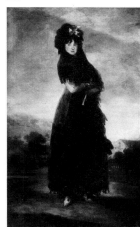

287

291

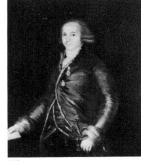

298

281. 'José Romero'
Oil on canvas;
cm 93 × 76 (36⅝″ ×
29⅞″)
Circa 1795-1798
Philadelphia, Museum of
Art (63.116.8)

282. 'Andrés de Peral'
Oil on panel;
cm 95 × 65 (37⅜″ ×
25⅜″)
Circa 1797-1798
London, National Gallery

**283. 'The 9th Duke of
Osuna'**
Oil on canvas;
cm 113 × 83.2 (44½″ ×
32¾″)
Circa 1797-1799
New York, Frick
Collection (A.523)

**284. 'Gaspar Melchor de
Jovellanos'**
Oil on canvas;
cm 205 × 123 (80¾″ ×
48½″)
Madrid, Prado Museum

**285. 'Francisco de
Saavedra'**
Oil on canvas;
cm 196 × 118 (77¼″ ×
46½″)
1798
London, Courtauld
Institute

**286. 'Ferdinand
Guillemardet'**
Oil on canvas;
cm 185 × 125 (73″ ×
49¼″)
1798
Paris, Musée du Louvre

**287. 'The Marquesa de la
Mercedes'**
Oil on canvas;
cm 142 × 97 (56″ ×
38⅛″)
Circa 1797-1798
Paris, David-Weill Coll.

**288. 'General José de
Urrutia'**
Oil on canvas;
cm 200 × 132 (78⅞″ ×
52″) 1798
Madrid, Prado Museum

289. 'Self-Portrait'
Oil on canvas;
cm 63 × 49 (24⅞″ ×
19¼″) Circa 1797-1800
Castres, Musée Goya

290. 'Self-Portrait'
Oil on canvas;
cm 54 × 39.5 (21¼″ ×
15⅝″)
Circa 1797-1800
Bayonne, Musée Bonnat

291. 'Asensio Juliá'
Oil on canvas;
cm 56 × 42 (22″ ×
16½″)
1798
Lugano-Castagnola,
Thyssen-Bornemisza Coll.

**292. 'The Marqués de
Bondad Real'**
Oil on canvas;
cm 225 × 140 (88⅝″ ×
55⅛″)
New York, Hispanic
Society (A.99)

293. 'La Tirana'
Oil on canvas;
cm 206 × 130 (81⅛″ ×
51¼″)
Madrid, Real Academia de
San Fernando (677)

**294. 'Leandro Fernández
de Moratín'**
Oil on canvas;
cm 73 × 56 (28¾″ ×
22″) 1799
Madrid, Real Academia de
San Fernando (671) 185

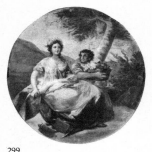

299

300

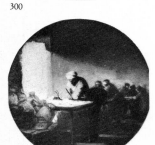

301

302

303

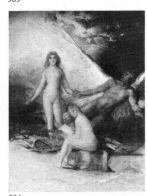

304

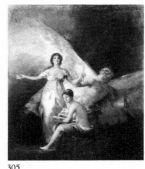

305

306

307

308

309

310

311

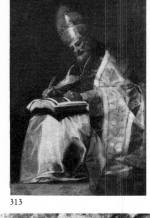

313

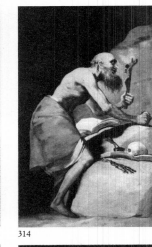

312

315

316

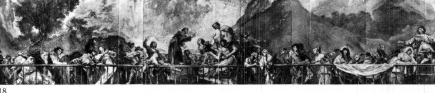

318

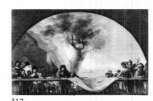

319

317

295. 'Josefa Bayeu'
Oil on canvas;
cm 81 × 56 (31⅞″ ×
22″) Circa 1798
Madrid, Prado Museum

**296. 'Man with Grey
Jacket'**
Oil on canvas;
cm 105 × 84 (41⅜″ ×
33⅛″)
Circa 1797-1800
Boston, Museum of Fine
Arts (10.33)

297. 'Antonio Gasparini'
Oil on canvas;
cm 107 × 81.5 (42⅛″ ×
32⅛″)
Circa 1790-1800
Madrid, Marquesa de
Zurgena Coll.

**298. 'Mariano Luis de
Urquijo'**
Oil on canvas;
cm 128 × 97 (50½″ ×
38⅛″) Circa 1798-1799
Madrid, Real Academia de
la Historia

299. 'Agriculture'
Tempera on canvas;
diameter, cm 227 (89½″)
1797-1800
Madrid, Prado Museum

300. 'Industry'
Tempera on canvas;
diameter, cm 227 (89½″)
1797-1800
Madrid, Prado Museum

301. 'Commerce' (sketch)
Oil on canvas;
diameter, cm 31.8 (12½″)
1797-1800
New York, Private Coll.

302. 'Commerce'
Tempera on canvas;
diameter, cm 227 (89½″)
1797-1800
Madrid, Prado Museum

303. 'Poetry'
Oil on canvas;
cm 300 × 326 (118¼″ ×
128½″) 1797-1800
Stockholm, National-
museet

**304. 'Time, Truth and
History'** (sketch)
Oil on canvas;
cm 42 × 32.5 (16½″ ×
12¾″) 1797-1800
Boston, Museum of Fine
Arts (27.1330)

**305. 'Time, Truth and
History'**
Oil on canvas;
cm 294 × 244 (115⅞″ ×
96⅛″) 1797-1800
Stockholm, National-
museet

**306. 'Parable of the
Wedding Guests'**
Oil on canvas;
cm 146 × 340 (57½″ ×
134″) 1796-1797
Cadiz, Santa Cueva

**307. 'The Miracle of the
Loaves and Fishes'** (sketch)
Oil on canvas;
cm 22.4 × 38.7 (8⅝″ ×
15¼″) 1796-1797
Whereabouts unknown

**308. 'The Miracle of the
Loaves and Fishes'**
Oil on canvas;
cm 146 × 340 (57½″ ×
134″) 1796-1797
Cadiz, Santa Cueva

309. 'The Last Supper'
(sketch)
Oil on canvas;
cm 25 × 42 (9⅞″ ×
16½″) 1796-1797
Formerly Kleinberger Coll.

310. 'The Last Supper'
Oil on canvas;
cm 146 × 340 (57½″ ×
134″) 1796-1797
Cadiz, Santa Cueva

311. 'St. Ambrose'
Oil on canvas;
cm 190 × 113 (74⅞″ ×
44½″) 1796-1799
Cleveland (Ohio),
Museum of Art (69.23)

312. 'St. Augustine'
Oil on canvas;
cm 190 × 115 (74⅞″ ×
45⅜″) 1796-1799
Madrid, Monjardin Coll.

**313. 'St. Gregory the
Great'**
Oil on canvas;
cm 190 × 115 (74⅞″ ×
45⅜″) 1796-1799
Madrid, Museo Romántico

314. 'St. Jerome'
Oil on canvas;
cm 193 × 114.5 (76″ ×
45⅛″) 1796-1799
Fullerton (California),
Norton Simon Foundation

**315. 'The Miracle of St.
Anthony of Padua'**
Oil on canvas;
cm 26 × 38 (10¼″ ×
15″) 1797-1798
Madrid, Condesa de Villa-
gonzalo Coll.

320

321

327

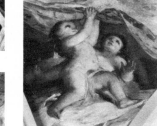
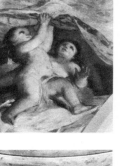

332

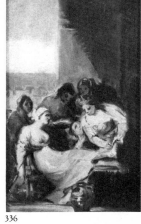

322

323

333

336

316. 'The Miracle of St. Anthony of Padua'
Oil on canvas;
cm 26 × 36.8 (10¼" × 14½") 1797-1798
Johannesburg, H. Oppen heimer Coll.

317. 'The Miracle of St. Anthony of Padua'
Oil on canvas;
cm 26 × 36.8 (10¼" × 14½") 1797-1798
Johannesburg, H. Oppen heimer Coll.

318. 'The Miracle of St. Anthony of Padua' (reduced version)
Oil on canvas;
cm 55.3 × 266 (21¾" × 104⅞") 1797-1798
Pittsburgh, Carnegie Institute (65.15)

319. 'The Miracle of St. Anthony of Padua'
Fresco;
diameter, cm 550 (216¾")

320. 'The Adoration of the Trinity' (sketch)
Oil on canvas;
cm 26 × 38 (10¼" × 15") 1797-1798
Madrid, Conde de Villa gonzalo Coll.

321. 'The Adoration of the Trinity'
Fresco;
diameter, cm 550 (216¾")
Madrid, San Antonio de la Florida (321-333)

322. 'Angels'
Fresco beneath north-east arch;
cm 900 × 160 (354⅝" × 63")

324

325

326

323. 'Angels'
Fresco beneath south-west arch;
cm 900 × 160 (354⅝" × 63")

324. 'Angels and Cherubs'
Fresco beneath north-west arch and on side walls (lower part);
cm 900 × 140 (354⅝." × 55⅛")

328

329

330

331

325. 'Angel'
Fresco in north-west lunette (left half);
cm 250 × 200 (98½" × 78⅞")

326. 'Angel'
Fresco in north-east lunette (right half);
cm 250 × 200 (98½" × 78⅞")

327. 'Angels'
Fresco beneath south-east arch and on side walls (lower part);
cm 900 × 140 (354⅝" × 55⅛")

328. 'Angel'
Fresco in south-east lunette (left half);
cm 250 × 200 (98½" × 78⅞")

334

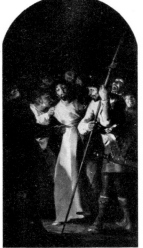

335

329. 'Angel'
Fresco in south-east lunette (right half)
cm 250 × 200 (98½" × 78⅞")

330. 'Cherub'
Fresco on pendentive;
width, c. 300cm (c. 118")

331. 'Cherub'
Fresco on pendentive;
width, c. 300cm (c. 118")

337

332. 'Cherub'
Fresco on pendentive;
width, c. 300cm (c. 118")

333. 'Cherub'
Fresco on pendentive;
width, c. 300cm (c. 118")

334. 'The Taking of Christ' (sketch)
Oil on canvas;
cm 40 × 23 (15¾" × 9") 1798
Madrid, Prado Museum

335. 'The Taking of Christ'
Oil on canvas;
cm 246.5 × 138.5 (97⅛" × 54½") 1798
Toledo, Cathedral Sacristy

336. 'St. Elizabeth Curing the Sick'
Oil on canvas;
cm 33 × 23 (13" × 9")
Circa 1798-1800
Madrid, Fundación Lázaro

337. 'Apparition of St. Isidore'
Oil on canvas;
cm 44.2 × 23.5 (17⅜" × 9¼")
1798-1800
Buenos Aires, Museum of Fine Arts (2563)

338

339

340

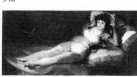

341

342

343

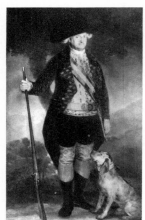

344

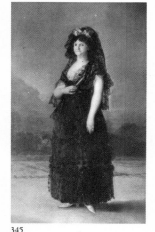

345

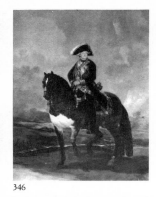

346

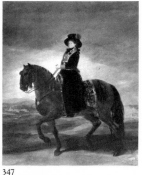

347

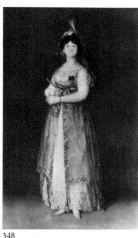

348

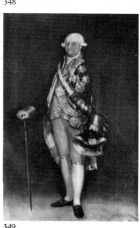

349

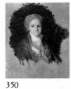

350 352

351 353

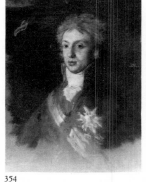

354

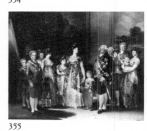

355

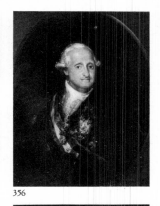

356

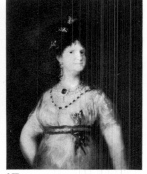

357

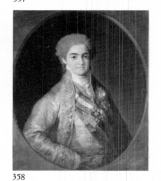

358

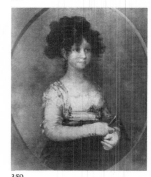

359

338. 'St. Hermenegildus in Prison'
Oil on canvas;
cm 33 × 23 (13″ × 9″)
Circa 1798-1800
Madrid, Fundación Lázaro

339. 'Children's Masquerade'
Oil on canvas;
cm 31 × 95 (12⅛″ × 37⅜″)
Circa 1798-1800
Florence, Contini-Bona cossi Coll.

340. 'The Naked Maja'
Oil on canvas;
cm 98 × 191 (38⅝″ × 75¼″) Circa 1790-1795
Madrid, Prado Museum

341. 'The Maja Clothed'
Oil on canvas;
cm 95 × 188 (37⅜″ × 74″) Circa 1803-1805
Madrid, Prado Museum

342. 'Cupid and Psyche'
Oil and canvas;
cm 221 × 156 (87″ × 61½″)
Circa 1800-1805
Barcelona, Museum of Fine Arts (Cambó 33)

343. 'Sleep'
Oil on canvas;
cm 44.5 × 76.5 (17½″ × 30⅛″)
Circa 1798-1808
Dublin, National Gallery

344. 'Charles IV in Hunting Dress'
Oil on canvas;
cm 210 × 130 (82¾″ × 51¼″) 1799
Madrid, Royal Palace

345. 'María Luisa in a Mantilla'
Oil on canvas;
cm 210 × 130 (82¾″ × 51¼″) 1799
Madrid, Royal Palace

346. 'Charles IV on Horseback'
Oil on canvas;
cm 336 × 282 (132⅜″ × 111⅛″) 1800
Madrid, Prado Museum

347. 'Queen María Luisa on Horseback'
Oil on canvas;
cm 338 × 282 (133⅛″ × 111⅛″) 1799
Madrid, Prado Museum

348. 'María Luisa in Court Dress'
Oil on canvas;
cm 210 × 130 (82¾″ × 51¼″) 1800
Madrid, Royal Palace

349. 'Charles IV in the Uniform of a Bodyguard'
Oil on canvas;
cm 202 × 126 (79½″ × 49⅝″) 1799
Madrid, Royal Palace

350. 'The Infante Carlos María Isidro' (study)
Oil on canvas;
cm 72 × 59 (28⅜″ × 23¼″) Circa 1800
Madrid, Prado Museum

351. 'The Infanta María Josefa' (study)
Oil on canvas;
cm 72 × 59 (28⅜″ × 23¼″) Circa 1800
Madrid, Prado Museum

352. 'The Infante Francisco de Paula Antonio' (study)
Oil on canvas;
cm 72 × 59 (28⅜″ × 23¼″) Circa 1800
Madrid, Prado Museum

353. 'The Infante Antonio Pascual' (study)
Oil on canvas;
cm 72 × 59 (28⅜″ × 23¼″) Circa 1800
Madrid, Prado Museum

354. 'Luis de Borbón, Prince of Parma' (study)
Oil on canvas;
cm 74 × 60 (29⅛″ × 23⅛″) Circa 1800
Madrid, Prado Museum

355. 'The Family of Charles IV'
Oil on canvas;
cm 280 × 336 (110⅜″ × 132⅜″) 1800-1801
Madrid, Prado Museum

356. 'Charles IV'
Oil on canvas;
cm 84 × 67 (33⅛″ × 26⅜″) 1800
Paris, Private Coll.

357. 'María Luisa'
Oil on canvas;
cm 81.5 × 66.9 (32⅛″ × 26⅜″) 1800
Cincinnati, Taft Museum

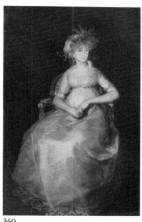
360

363

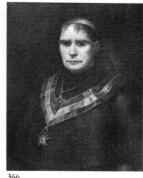
366

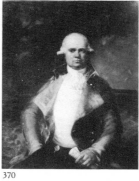
370

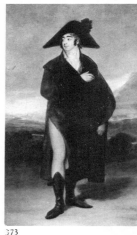
373

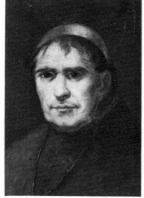
364

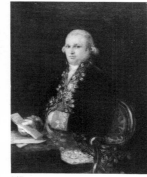
367

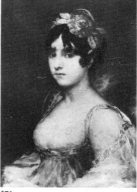
371

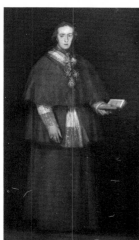
361

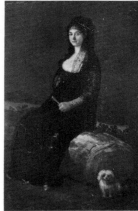
374

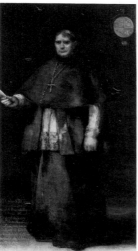
365

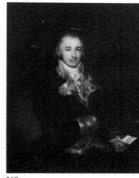
368

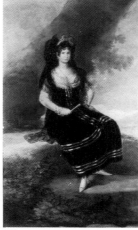
372

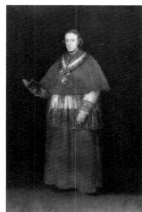
362

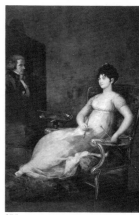
375

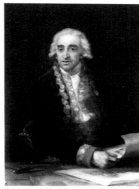
369

358. Prince Ferdinand,
Oil on canvas;
cm 83.2 × 66.7 (32¾" ×
26¼") 1800
New York, Metropolitan
Museum (51.70)

**359. 'The Infanta María
Isabel'**
Oil on canvas;
cm 84 × 67 (33⅛" ×
26⅜") 1800
Whereabouts unknown

**360. 'The Condesa de
Chinchón'**
Oil on canvas;
cm 216 × 144 (85⅛" ×
56¾") 1800
Madrid, Duchess of Sueca
Coll.

**361. 'Cardinal Luis María
de Borbón'**
Oil on canvas;
cm 200 × 106 (78⅞" ×
41¾") Circa 1800
Sao Paulo, Museu de Arte

**362. 'Cardinal Luis María
de Borbón'**
Oil on canvas;
cm 214 × 136 (84⅜" ×
53½") Circa 1800
Madrid, Prado Museum

363. 'Manuel Godoy'
Oil on canvas;
cm 180 × 267 (71" ×
105⅛") 1801
Madrid, Real Academia de
San Fernando (670)

**364. 'Archbishop Joaquín
Company'** (study)
Oil on canvas;
cm 44 × 31 (17⅜" ×
12⅛") Circa 1800
Madrid, Prado Museum

**365. 'Archbishop Joaquín
Company'**
Oil on canvas;
cm 212 × 130 (83½" ×
51¼") Circa 1800
Valencia, Church of San
Martín (destroyed)

366. 'Joaquín Company'
Oil on canvas;
cm 72 × 55 (28⅜" ×
21⅛") Circa 1800
Louisville (Kentucky), J.B.
Speed Art Museum (58.16)

367. 'Antonio Noriega'
Oil on canvas;
cm 102.6 × 80.9 (40½"
× 31¾")
Signed and dated: 'el S^or.
D^n./Antonio/
Noriega/Tesorero/
General/F. Goya/1801'
Washington, National
Gallery (Kress 1626)

368. 'José Queralto'
Oil on canvas;
cm 101.5 × 76.1 (40" ×
30")
Signed and dated: 'D^n.
Josef Queralto/Por/Goya/
1802'
Munich, Alte Pinakothek

369. 'Juan de Villanueva'
Oil on canvas;
cm 90 × 67 (35⅜" ×
26⅜")
Circa 1800-1805
Madrid, Real Academia de
San Fernando

**370. 'Tomás Pérez de
Estala'**
Oil on canvas;
cm 102 × 79 (40⅛" ×
31⅛")
Circa 1800-1805
Hamburg, Kunsthalle

**371. 'The Condesa de
Haro'**
Oil on canvas;
cm 59 × 36 (23¼" ×
14¼") Circa 1802-1803
Switzerland, Private Coll.

**372. 'The Condesa de
Fernán Núñez'**
Oil on canvas;
cm 211 × 137 (83⅛" ×
54")
Madrid, Duke of Fernán
Núñez Coll.

**373. 'The Conde de
Fernán Núñez'**
Oil on canvas;
cm 211 × 137 (83⅛" ×
54")
Madrid, Duke of Fernán
Núñez Coll.

374. 'Joaquina Candado'
Oil on canvas;
cm 166 × 111 (65½" ×
43¾")
Circa 1802-1804
Valencia, Provincial
Museum of Fine Arts

**375. 'The Marquesa de
Villafranca'**
Oil on canvas;
cm 195 × 126 (76⅞" ×
49⅝")
Madrid, Prado Museum

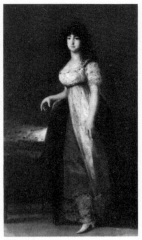

376

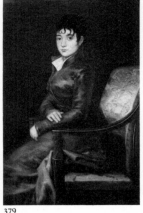

379

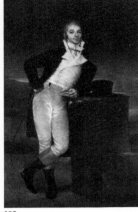

382

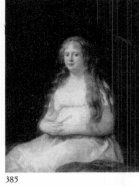

385

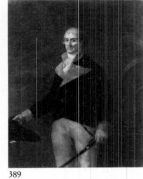

389

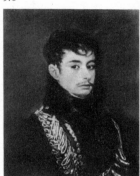

377

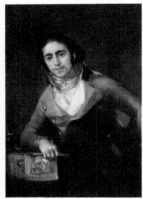

380

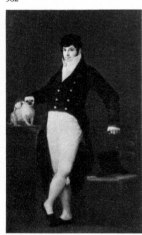

383

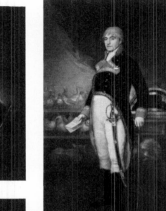

386

390

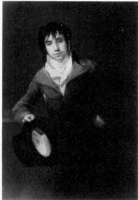

378

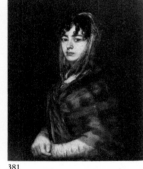

381

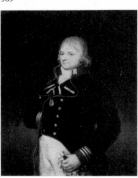

384

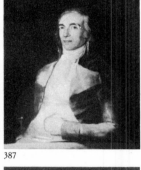

387

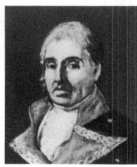

388

391

376. 'The Marquesa de Lazán'
Oil on canvas;
cm 193 × 115 (76″ × 45⅜″) Circa 1804
Madrid, Alba Coll.

377. 'The Conde de Teba'
Oil on canvas;
cm 63.2 × 48.9 (25″ × 19¼″) Circa 1804
New York, Frick Collection

378. 'Bartolomé Sureda'
Oil on canvas;
cm 119.7 × 79.4 (47⅛″ × 31¼″) Circa 1804
Washington, National Gallery (548)

379. 'Teresa Sureda'
Oil on canvas;
cm 119.7 × 79.4 (47⅛″ × 31¼″) Circa 1804
Washington, National Gallery (549)

380. 'Evaristo Pérez de Castro'
Oil on canvas;
cm 99 × 69 (39″ × 27⅛″)
Circa 1804-1808
Paris, Musée du Louvre

381. 'Francisca Sabasa y Garcia'
Oil on canvas;
cm 71 × 58 (28″ × 22⅞″)
Circa 1804-1808
Washington, National Gallery (Mellon 88)

382. 'The Marqués de San Adrián'
Oil on canvas;
cm 209 × 127 (82⅜″ × 50″)
Pamplona, Diputación Foral

383. 'Manuel García de la Prada'
Oil on canvas;
cm 212 × 128 (83½″ × 50½″)
Circa 1804-1808
Des Moines (Iowa), Art Center (53.15)

384. 'Ignacio Garcini'
Oil on canvas;
cm 104.1 × 83.2 (41″ × 32¾″)
New York, Metropolitan Museum (55.145.1)

385. 'Josefa Castilla de Garcini'
Oil on canvas;
cm 104 × 82 (41″ × 32⅜″)
New York, Metropolitan Museum (55.145.2)

386. 'The Marquesa de Castrofuerte'
Oil on canvas;
cm 91 × 71 (36″ × 28″)
Circa 1804-1808
Montreal, Museum of Fine Arts (45.955)

387. 'The Marqués de Castrofuerte'
Oil on canvas;
cm 91.5 × 71.1 (36″ × 28″)
Circa 1804-1808
Montreal, Museum of Fine Arts (49.954)

388. 'Alberto Foraster'
(study)
Oil on canvas;
cm 46 × 37.4 (18″ × 14¾″)
Circa 1804
New York, Private Coll.

389. 'Alberto Foraster'
Oil on canvas;
cm 138 × 109.5 (54⅜″ × 43⅛″)
Signed and dated: 'Alberto Foraster Por Goya 1804'
New York, Hispanic Society (A.103)

390. 'Félix de Azara'
Oil on canvas;
cm 212 × 124 (83½″ × 48⅞″)
Signed and dated: 'D. Felix de/Azara/Pᵉ Goya/1805'
Saragossa, Provincial Museum of Fine Arts (165)

391. 'José de Vargas y Ponce'
Oil on canvas;
cm 104 × 82 (41″ × 32⅜″)
Madrid, Real Academia de la Historia

392. 'The Marquesa de Santa Cruz'
Oil on canvas;
cm 130 × 210 (51¼″ × 82¾″)
Bilbao, Valdés Coll.

393. 'The Marquesa de Santa Cruz'
Oil on canvas;
cm 126.5 × 207.6 (49⅞″ × 81¾″)
Signed: 'Goya'
Circa 1805
Los Angeles, County Museum of Art (M.58.8)

394. 'María Vicente Baruso Valdés'
Oil on canvas;
cm 104.7 × 83.7 (41¼″ × 33″)
Johannesburg, H. Oppenheimer Coll.

392

393

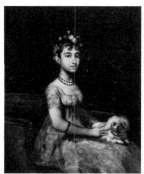

394

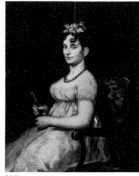

395

396

397

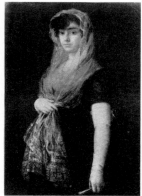

398

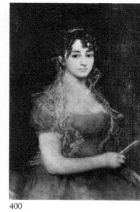

400

401

403

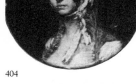

404

405

406

407

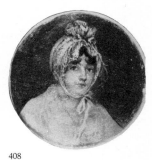

408

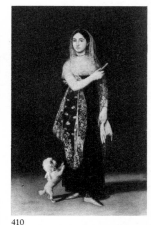

409

399

402

410

411

395. 'Leonora Valdés de Baruso'
Oil on canvas;
cm 105 × 84 (41⅜" × 33⅛")
Johannesburg, H. Oppenheimer Coll.

396. 'A Child of the Soria Family'
Oil on canvas;
cm 112 × 80 (44⅛" × 31½")
Circa 1804-1808
Paris, Private Coll.

397. 'Clara de Soria'
Oil on canvas;
cm 112 × 80 (44⅛" × 31½")
Circa 1804-1808
Paris, Private Coll.

398. 'Pedro Mocarte'
Oil on canvas;
cm 78 × 57 (30¾" × 22⅜")
Circa 1805-1806
New York, Hispanic Society (A.1890)

399. 'The Bookseller'
Oil on canvas;
cm 109.9 × 78.2 (43⅜" × 30⅞")
Circa 1805-1808
Washington, National Gallery (1903)

400. 'Lorenza Correa'
Oil on canvas;
cm 80 × 58 (31½" × 22⅞") 1802/3
Paris, heirs of the Comtesse de Noailles

401. 'Manuel García'
Oil on canvas;
cm 81.5 × 58 (32⅛" × 22⅞") 1802-1808
Boston, Museum of Fine Arts (48.558)

402. 'Leona de Valencia'
Oil on canvas;
cm 75.2 × 52.7 (29⅝" × 20¾") 1804/8
Dallas, Meadows Museum

403. 'Xavier Goya'
Oil on leather;
diameter, cm 8.1 (3⅛")
1805-1806
Paris, Private Coll.

404. 'Gumersinda Goicoechea'
Oil on leather;
diameter, cm 8 (3⅛")
1805-1806
Paris, Private Coll.

405. 'Manuela Goicoechea'
Oil on canvas;
diameter, cm 7.6 (2⅞")
1805-1806
Madrid, X. de Salas Coll.

406. 'Gerónima Goicoechea'
Oil on leather;
diameter, cm 8 (3⅛")
Providence (R.I.), Museum of the School of Design

407. 'Cesarea Goicoechea'
Oil on leather;
diameter, cm 8 (3⅛")
Providence (R.I.), Museum of the School of Design

408. 'Juana Galarza'
Oil on leather;
diameter, cm 8 (3⅛")
1805-1806
Formerly Madrid, Alejandro Pidal Coll.

409. 'Martín Miguel de Goicoechea'
Oil on leather;
diameter, cm 8 (3⅛")
1805-1806
Formerly Madrid, Alejandro Pidal Coll.

410. 'Gumersinda Goicoechea'
Oil on canvas;
cm 192 × 115 (75⅝" × 45⅜")
1805-1806
Paris, heirs of the Comtesse de Noailles

411. 'Xavier Goya'
Oil on canvas;
cm 192 × 115 (75⅝" × 45⅜")
1805-1806
Paris, heirs of the Comtesse de Noailles

191

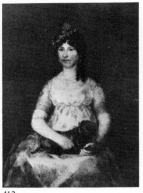

412

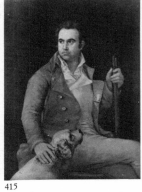

415

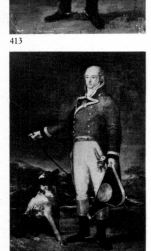

413

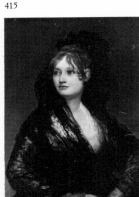

414

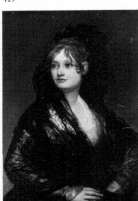

416

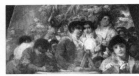

417

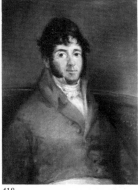

418

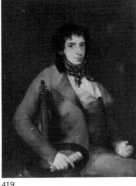

419

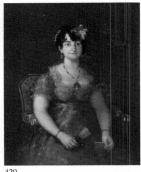

420

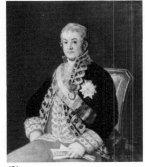

421

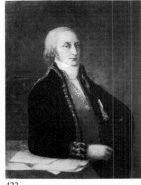

422

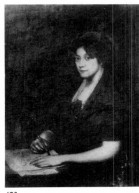

423

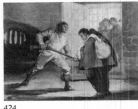

424

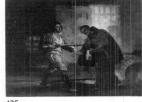

425

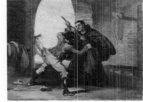

426

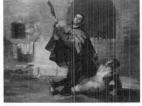

427

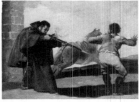

428

429

412. 'Francisca Vicenta Chollet y Caballero'
Oil on canvas;
cm 103 × 81 (40½″ × 31⅛″)
Signed and dated:
'DªFrancª. Vicenta Chollet y/Cavallero/Por Goya, ano 1806'
Paris, Countess Bismarck Coll.

413. 'Tadeo Bravo de Rivero'
Oil on panel;
cm 22 × 12 (8⅝″ × 4¾″)
Signed: 'Borron de Dn. Tadeo Bravo de Rivero, Goya'
Circa 1806
Madrid, Private Coll.

414. 'Tadeo Bravo de Rivero'
Oil on canvas;
cm 208 × 125 (82″ × 49¼″)
Signed and dated: 'Dⁿ. Tadeo Bravo de/Rivero por su amº. Goya/1806'
Brooklyn, Art School Museum (34.490)

415. 'Antonio Porcel'
Oil on canvas;
cm 113 × 82 (44½″ × 32⅜″)
Formerly Buenos Aires, Jockey Club (destroyed)

416. 'Isabel de Porcel'
Oil on canvas;
cm 82 × 54 (32⅜″ × 21¼″) Circa 1806
London, National Gallery

417. 'Students of the Pestalozzi Institute'
(fragment)
Oil on canvas;
cm 55 × 96.8 (21⅝″ × 38⅛″) 1806
Dallas, Meadows Museum

418. 'Isidoro Máiquez'
Oil on canvas;
cm 77 × 58 (30⅜″ × 22⅞″) 1807/
Madrid, Prado Museum

419. 'Isidro González Velázquez'
Oil on canvas;
cm 93.3 × 67.2 (36¾″ × 26½″)
United States, Private Coll.

420. 'The Marquesa de Caballero'
Oil on canvas;
cm 105.3 × 84.4 (41½″ × 33¼″)
Signed and dated: 'Exmª. Srª. Mar/de Caballero/ Goya. 1807'
Munich, Alte Pinakothek

421. 'The Marqués de Caballero'
Oil on canvas;
cm 105.5 × 84 (41⅝″ × 33⅛″)
Budapest, Museum of Fine Arts (3274)

422. 'Antonio Raimundo Ibanez'
Oil on canvas;
cm 96.5 × 72.4 (38″ × 28½″) Circa 1805-1808
Baltimore, Museum of Art

423. 'Portrait of an Unknown Woman'
Oil on canvas;
cm 95 × 69 (38⅜″ × 27⅛″)
Whereabouts unknown

424. 'Maragato Threatens Fra Pedro de Zaldivia'
Oil on panel;
cm 29.2 × 38.5 (11½″ × 15⅛″) 1806-1807
Chicago, Art Institute (1933.1071-1076)

425. 'Fra Pedro Tries to Disarm Maragato'
Oil on panel;
cm 29.2 × 38.5 (11½″ × 15⅛″) 1806-1807

426. 'Fra Pedro Fights with Maragato'
Oil on panel;
cm 29.2 × 38.5 (11½″ × 15⅛″) 1806-1807

427. 'Fra Pedro Overcomes Maragato'
Oil on panel;
cm 29.2 × 38.5 (11½″ × 15⅛″) 1806-1807

428. 'Fra Pedro Fires at Maragato'
Oil on panel;
cm 29.2 × 38.5 (11½″ × 15⅛″) 1806-1807

429. 'Fra Pedro Ties up Maragato'
Oil on panel;
cm 29.2 × 38.5 (11½″ × 15⅛″) 1806-1807

430. 'The Spinners'
Oil on canvas;
cm 95 × 107 (37⅜″ × 42⅛″) Circa 1806-1810
United Kingdom, Private Coll.

431. 'The Drunkards'
Oil on canvas;
cm 101.5 × 80 (40″ × 31½″)
Raleigh, North Carolina Museum (G.56.13.1)

430

431

432

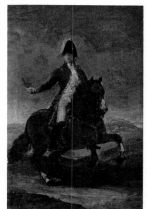

433

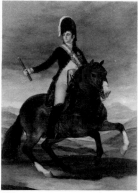

434

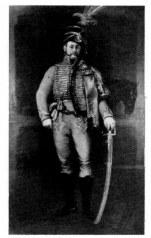

435

436

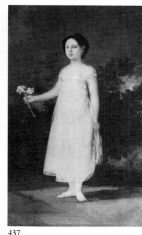

437

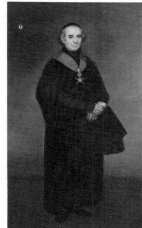

438

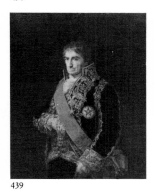

439

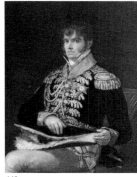

440

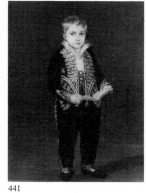

441

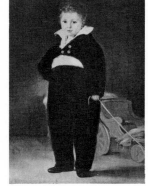

442

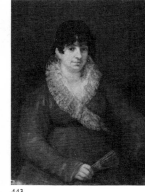

443

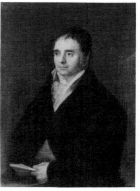

444

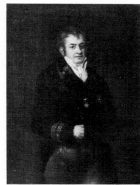

445

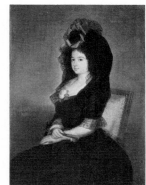

446

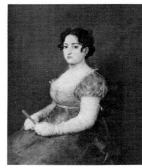

447

432. 'Allegory of the City of Madrid'
Oil on canvas;
cm 260 × 195 (102½″ × 76⅞″) 1810
Madrid, Town Hall (1048)

433. 'Ferdinand VII on Horseback' (sketch)
Oil on canvas;
Circa 1808
Agen, Musée des Beaux Arts (271Ch)

434. 'Ferdinand VII on Horseback'
Oil on canvas;
cm 285 × 205 (112¼″ × 80¾″) 1808
Madrid, Real Academia de San Fernando (679)

435. 'Pantaleón Pérez de Nenin'
Oil on canvas;
cm 206 × 125 (81⅛″ × 49¼″)
Madrid, Banco Exterior de España

436. 'The Marquesa de Santiago'
Oil on canvas;
cm 212 × 125 (83½″ × 49¼″) 1809
Madrid, Duke of Tamames Coll.

437. 'The Marquesa de Monte Hermoso'
Oil on canvas;
cm 170 × 103 (67″ × 40½″)
Circa 1808-1810
Paris, Private Coll.

438. 'Juan Antonio Llorente'
Oil on canvas;
cm 189.2 × 114.3 (74½″ × 45″) 1810-1812
São Paulo, Museu de Arte

439. 'General Manuel Romero'
Oil on canvas;
cm 105.3 × 87.6 (41½″ × 34½″) Circa 1810
Chicago, Chauncey McCormick Coll.

440. 'General Nicolas Guye'
Oil on canvas;
cm 106 × 85.7 (41¾″ × 33⅜″) 1810
Richmond, Virginia Museum (M.318)

441. 'Victor Guye'
Oil on canvas;
cm 106.7 × 85.1 (42″ × 33½″) 1810
Washington, National Gallery (1471)

442. 'Mariano Goya'
Oil on canvas;
cm 113 × 78 (44½″ × 30¾″) 1809-1810
Malaga, de Larios Coll.

·443. 'Juana Galarza Goicoechea'
Oil on canvas;
cm 82 × 59 (32⅜″ × 23¼″)
Madrid, Marquesa de Casa Riera Coll.

444. 'Martín Miguel de Goicoechea'
Oil on canvas;
cm 82 × 59 (32⅜″ × 23¼″) 1810
Madrid, Marquesa de Casa Riera Coll.

445. 'Juan Baptista de Goicoechea'
Oil on canvas;
cm 112 × 80 (44⅛″ × 31½″) Circa 1810
Karlsruhe, Staatliche Kunsthalle (2515)

446. 'Narcissa Baranana de Goicoechea'
Oil on canvas;
cm 112.3 × 78 (44¼″ × 30¾″)
Circa 1810
New York, Metropolitan Museum (29.100.180)

447. 'Woman with Fan'
Oil on canvas;
cm 103 × 83 (40½″ × 32⅛″)
Circa 1805-1810
Paris, Musée du Louvre (RF.1132)

193

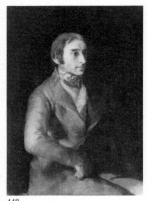

448

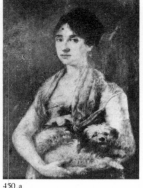

450,a

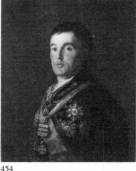

454

458

463

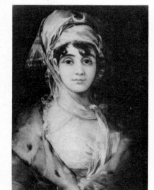

449

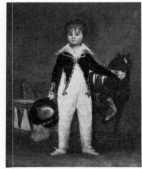

451

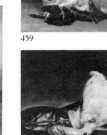

455

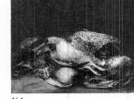

459

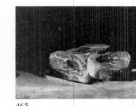

464

450

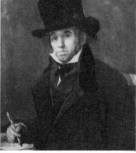

452

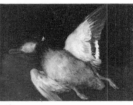

460

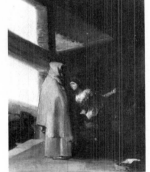

465

453

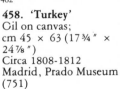

461

466

456

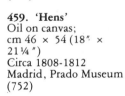

462

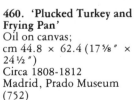

467

457

448. 'Manuel Silvela'
Oil on canvas;
cm 95 × 68 (37⅜″ ×
26¾″)
Circa 1809-1812
Madrid, Prado Museum
(2450)

449. 'Antonia Zárate'
Oil on canvas;
cm 103.5 × 81.9 (40¾″
× 32¼″) Circa 1810
Blessington (Ireland), Sir
Alfred Beit Coll.

450. 'Antonia Zárate'
Oil on canvas;
cm 71 × 58 (28″ ×
22⅞″) Circa 1811
Leningrad, Hermitage
Museum

**450a. 'Portrait of an
Unknown Woman'**
This work has been lost.

**451. 'Fernanda Bonells de
Costa'**
Oil on canvas;
cm 87.3 × 65.4 (35⅜″ ×
25¾″) 1808-1813
Detroit, Institute of Arts
(41.80)

194

**452. 'Pepito Costa y
Bonells'**
Oil on canvas;
cm 105.1 × 84.5 (41½″
× 33¼″) 1813
New York, Metropolitan
Museum (61.259)

**453. 'Wellington on
Horseback'**
Oil on canvas;
cm 294 × 240 (115⅞″ ×
94½″) 1812
London, Wellington
Museum (W.M.1566-1948)

**454. 'The Duke of
Wellington'**
Oil on panel;
cm 60 × 51 (23⅝″ ×
20⅛″) 1812-1814
London, National Gallery
(6322)

**455. 'General Palafox on
Horseback'**
Oil on canvas;
cm 248 × 224 (97¾″ ×
88¼″)
Signed and dated: 'El
Exmo. Sor. Dn. Josef
Palafox y Melci/por Goya,
año de 1814'
Madrid, Prado Museum
(725)

456. 'Asensio Juliá'
Oil on canvas;
cm 73.4 × 57.3 (28⅞″ ×
22⅝″)
Williamstown
(Massachusetts), Clark Art
Institute

457. 'Butcher's Counter'
Oil on canvas;
cm 45 × 62 (17¾″ ×
24⅜″)
Circa 1808-1812
Paris, Musée du Louvre (RF
1937.120)

458. 'Turkey'
Oil on canvas;
cm 45 × 63 (17¾″ ×
24⅞″)
Circa 1808-1812
Madrid, Prado Museum
(751)

459. 'Hens'
Oil on canvas;
cm 46 × 54 (18″ ×
21¼″)
Circa 1808-1812
Madrid, Prado Museum
(752)

**460. 'Plucked Turkey and
Frying Pan'**
Oil on canvas;
cm 44.8 × 62.4 (17⅝″ ×
24½″)
Circa 1808-1812
Madrid, Prado Museum
(752)

461. 'Fish on the Beach'
Oil on canvas;
cm 45 × 63 (17¾″ ×
24⅞″)
Circa 1808-1812
Paris, David-Weill Coll.

462. 'Duck'
Oil in canvas;
cm 44.5 × 62 (17½″ ×
24⅜″)
Circa 1808-1812
Zürich, Mme Anda-Bührle
Coll.

463. 'Hares'
Oil on canvas;
cm 45.1 × 62.9 (17¾″ ×
24¾″) 1808-1812
New York, Private Coll.

464. 'Woodcock'
Oil on canvas;
cm 45.1 × 62.9 (17¾″ ×
24¾″) 1808-1812
New York, Private Coll.

465. 'Slices of Salmon'
Oil on canvas;
cm 44 × 62 (17⅞″ ×
24⅜″) 1808-1812
Winterthur, Reinhart Coll.
(79)

**466. 'Fruit, Bottles and
Bread'**
Oil on canvas;
cm 45 × 62 (17¾″ ×
24⅜″) 1808-1812
Winterthur, Reinhart Coll.
(78)

467. 'The Monks' Visit'
Oil on canvas;
cm 40 × 32 (15¾″ ×
12⅝″) 1808-1812
Madrid, Marqués de la
Romana Coll.

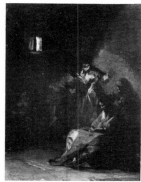

468

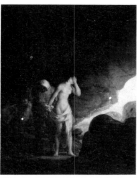

469

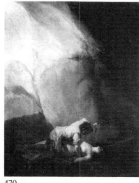

470

471

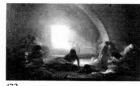

472

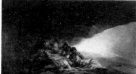

473

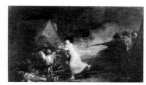

474

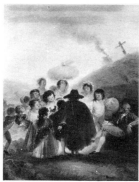

474,a

475

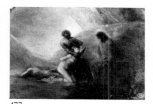

476

477

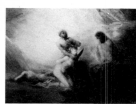

478

479

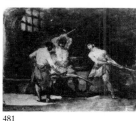

480

481

482

483

484

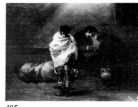

485

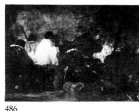

486

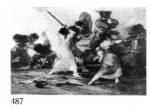

487

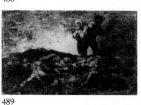

488

489

490

468. '**Interior of a Prison**'
Oil on canvas;
cm 42 × 32 (16½" ×
12⅝") 1808-1812
Madrid, Marqués de la
Romana Coll.

469. '**Bandit Stripping a Woman**'
Oil on canvas;
cm 41 × 32 (16⅛" ×
12⅝") 1808-1812
Madrid, Marqués de la
Romana Coll.

470. '**Bandit Stabbing a Woman**'
Oil on canvas;
cm 40 × 32 (15¾" ×
12⅝") 1808-1812
Madrid, Marqués de la
Romana Coll.

471. '**Bandits Shooting Prisoners**'
Oil on canvas;
cm 41 × 32 (16⅛" ×
12⅝") 1808-1812
Madrid, Marqués de la
Romana Coll.

472. '**Plague Hospital**'
Oil on canvas;
cm 32 × 56 (12⅝" ×
22") 1808-1812
Madrid, Marqués de la
Romana Coll.

473. '**Smugglers in a Cave**'
Oil on canvas;
cm 32 × 56 (12⅝" ×
22") 1808-1812
Madrid, Marqués de la
Romana Coll.

474. '**Attack on a Field Hospital**'
Oil on canvas;
cm 32 × 58 (12⅝" ×
22") 1808-1812
Madrid, Marqués de la
Romana Coll.

474a. '**The Puppet Seller**'
Oil on tin;
cm 42 × 32 (16½" ×
12⅝") 1808-1812
Switzerland, Private Coll.

475. '**Martyrdom**'
Oil on panel;
cm 31 × 45 (12⅛" ×
17¾") 1808-1814
Besançon, Musée des
Beaux Arts (896.1.176)

476. '**Martyrdom**'
Oil on panel;
cm 31 × 50 (12⅛" ×
18⅛") 1808-1814
Besançon, Musée des
Beaux Arts (896.1.177)

477. '**The Massacre**'
Oil on panel;
cm 33 × 47 (13" ×
18½") 1808-1814
Madrid, Condesa de
Villagonzalo Coll.

478. '**The Bonfire**'
Oil on panel;
cm 33 × 47 (13" ×
18½") 1808-1814
Madrid, Condesa de
Villagonzalo Coll.

479. '**The Massacre**'
Oil on tin;
cm 29 × 41 (11½" ×
16⅛") 1808-1814
Madrid, Prado Museum
(740i)

480. '**The Bonfire**'
Oil on tin;
cm 32 × 43 (12⅝" ×
17") 1808-1814
Madrid, Prado Museum
(740j)

481. '**The Forge**'
Oil on tin;
cm 31.5 × 40.5 (12⅜" ×
16") 1808-1814
Madrid, Private Coll.

482. '**Scene of Violation**'
Oil on panel;
cm 30.5 × 39.8 (12" ×
15⅝") 1808-1812
Frankfurt, Städelsches
Kunstinstitut (1980)

483. '**The Aftermath**'
Oil on panel;
cm 30.5 × 39.8 (12" ×
15⅝") 1808-1812
Frankfurt, Städelsches
Kunstinstitut (1981)

484. '**The Hanged Monk**'
Oil on panel;
cm 31 × 39.2 (12⅛" ×
15½") 1808-1812
Chicago, Art Institute
(1936.225)

485. '**Prisoners**'
Oil on panel;
cm 31.5 × 40 (12⅜" ×
15¾") 1808-1812
Guadalupe (Spain),
monastery

486. '**Procession**'
Oil on panel;
cm 30.5 × 39.5 (12" ×
15⅝") 1808-1812
Oslo, National Gallery
(1347)

487. '**The Fight**'
Oil on canvas;
cm 20 × 28 (7⅞" × 11")
Circa 1808-1814
Formerly Madrid,
Traumann Coll.

488. '**Stripping the Dead**'
Oil on canvas;
cm 21 × 25 (8¼" ×
9⅞") 1808-1814
France, Private Coll.

489. '**Searching among the Corpses**'
Oil on canvas;
cm 19 × 29 (7½" ×
11½") 1808-1814
Formerly Madrid, Juan
Lafora Coll.

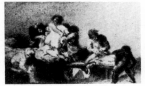

491

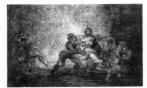

492

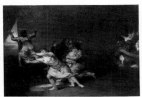

493

494

495

496

497

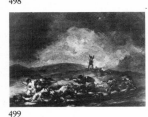

498

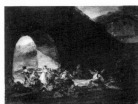

499

501

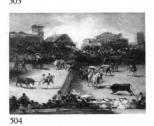

502

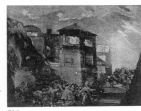

503

506

507

507,a

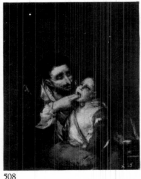

508

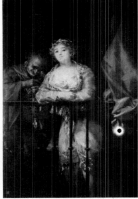

509

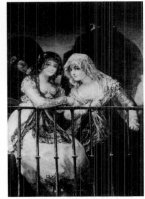

510

500

504

505

490. 'Pile of Corpses'
Oil on canvas;
cm 20 × 28 (7⅞″ × 11″)
Circa 1808-1814
Formerly Madrid, Lázaro
Coll.

**491. 'The Wounded in
Hospital'**
Oil on canvas;
cm 31 × 41 (12⅛″ ×
16⅛″) 1808-1814
Zumaya (Spain), Zuloaga
Coll.

**492. 'Fleeing through the
Flames'**
Oil on canvas;
cm 20.5 × 31 (8″ ×
12⅛″) 1808-1814
Madrid, Private Coll.

**493. 'Women Surprised
by Soldiers'**
Oil on panel;
Size unknown
Circa 1808-1814
Formerly Madrid, Duke of
Tamames Coll.

**494. 'Moving the
Wounded'**
Oil on canvas;
cm 19 × 29 (7½″ ×
11½″) 1808-1814
Buenos Aires, Private Coll.

495. 'The Shooting'
Oil on canvas;
cm 31 × 41 (12⅛″ ×
16⅛″) 1808-1814
Zumaya (Spain), Zuloaga
Coll.

**496. 'Officer beside his
Horse'**
Oil on panel;
Size unknown
Circa 1808-1814
Whereabouts unknown

497. 'The Colossus'
Oil on canvas;
cm 116 × 105 (45¾″ ×
41⅜″) 1808-1814
Madrid, Prado Museum
(2785)

498. 'The Fire'
Oil on canvas;
cm 72 × 100 (28⅜″ ×
39⅜″) 1808-1812
Buenos Aires, Museum of
Fine Arts (6986)

499. 'Scene of Banditry'
Oil on canvas;
cm 72 × 100 (28⅜″ ×
39⅜″) 1808-1812
Buenos Aires, Museum of
Fine Arts (6985)

500. 'Popular Dance'
Oil on canvas;
cm 72.5 × 100 (28½″ ×
39⅜″) 1808-1812
Buenos Aires, Museum of
Fine Arts (2561)

501. 'The Hurricane'
Oil on canvas;
cm 73 × 100 (28¾″ ×
39⅜″)
Formerly Buenos Aires,
Jockey Club (destroyed)

502. 'The Greasy Pole'
Oil on canvas;
cm 80 × 103 (31½″ ×
40½″) 1808-1812
Madrid, Duke of Tamames
Coll.

**503. 'Procession to
Valencia'**
Oil on canvas;
cm 105 × 126 (41⅜″ ×
49⅝″) 1810-1812
Zürich, Bührle Foundation

**504. 'Bullfight in a
Divided Arena'**
Oil on canvas;
cm 98.4 × 126.2 (38¾″
× 49¾″) 1810-1812
New York, Metropolitan
Museum (22.181)

505. 'Carnival Scene'
Oil on canvas;
cm 84 × 104 (33⅛″ ×
41″)
Circa 1812-1816
Formerly Budapest, Baron
Herzog Coll.

**506. 'Attacking a Fortress
on a Rock'**
Oil on canvas;
cm 83.8 × 104.2 (33″ ×
41⅛″)
Circa 1812-1816
New York, Metropolitan
Museum (29.100.12)

507. 'The Balloon'
Oil on canvas;
cm 105.5 × 84.5 (41⅝″
× 33¼″)
Circa 1812-1816
Agen, Musée des Beaux
Arts (335 Ch)

507a. 'The Fair'
Oil on canvas;
cm 102 × 82 (40⅛″ ×
32⅜″)
Circa 1812-1816
Madrid, J. Varez Fisa Coll.

**508. 'The "Lazarillo de
Tormes"'**
Oil on canvas;
cm 80 × 65 (31½″ ×
25⅜″)
Circa 1808-1812
Madrid, Marañón Coll.

**509. 'Maja and Celestina
at the Balcony'**
Oil on canvas;
cm 166 × 108 (65½″ ×
42½″)
Circa 1808-1812
Madrid, Bartolomé March
Coll.

**510. 'Majas on the
Balcony'**
Oil on canvas;
cm 162 × 107 (63⅞″ ×
42⅛″)
Circa 1808-1812
Paris, Private Coll.

**511. 'Majas on the
Balcony'**
Oil on canvas;
cm 194.8 × 125.7 (76¾″
× 49½″)
Circa 1800-1814
New York, Metropolitan
Museum (29.100.10)

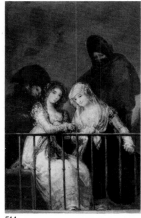

511

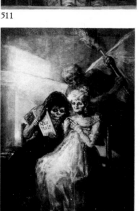

512

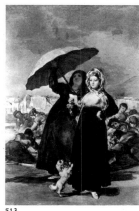

513

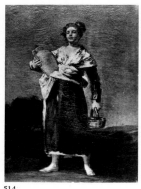

514

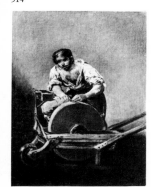

515

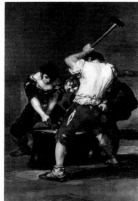

516

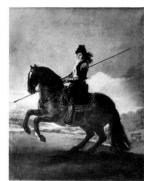

517

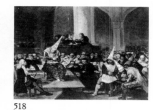

518

519

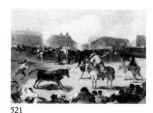

520

521

522

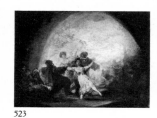

523

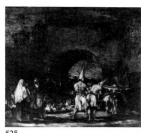

524

525

526

527

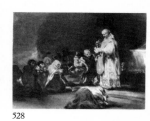

528

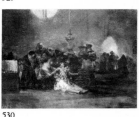

529

530

531

532

512. 'Time and the Old Women'
Oil on canvas;
cm 181 × 125 (71⅜" × 49¼")
Circa 1810-1812
Lille, Musée des Beaux Arts (350)

513. 'The Young Girls' or 'The Letter'
Oil on canvas;
cm 181 × 122 (71⅜" × 48")
Circa 1810-1812
Lille, Musée des Beaux Arts (349)

514. 'The Water Seller'
Oil on canvas;
cm 68 × 50.5 (26¾" × 19⅞")
Circa 1808-1812
Budapest, Museum of Fine Arts (760)

515. 'The Knife-Grinder'
Oil on canvas;
cm 68 × 50.5 (26¾" × 19⅞")
Circa 1808-1812
Budapest, Museum of Fine Arts (763)

516. 'The Forge'
Oil on canvas;
cm 181.6 × 125 (71½" × 49¼") 1812-1816
New York, Frick Coll.

517. 'The Lancer'
Oil on canvas;
cm 57 × 47 (22⅜" × 18½") 1808-1810
Madrid, Prado Museum (744)

518. 'Tribunal of the Inquisition'
Oil on panel;
cm 46 × 73 (18" × 28¾") 1812-1819
Madrid, Real Academia de San Fernando (673)

519. 'Flagellants'
Oil on canvas;
cm 46 × 73 (18" × 28¾")
Circa 1812-1819
Madrid, Real Academia de San Fernando (674)

520. 'Madhouse'
Oil on panel;
cm 45 × 72 (17¾" × 28⅜") c. 1812-1819
Madrid, Real Academia de San Fernando (672)

521. 'Village Bullfight'
Oil on panel;
cm 45 × 72 (17¾" × 28⅜") c. 1812-1819
Madrid, Real Academia de San Fernando (675)

522. 'Burial of the Sardine'
Oil on panel;
cm 82.5 × 62 (32½" × 24⅜") c. 1812-1819
Madrid, Real Academia de San Fernando (676)

523. 'Masked Ball'
Oil on canvas;
cm 30 × 38 (11⅜" × 15") Circa 1808-1820
Madrid, Duchess of Villahermosa Coll.

524. 'Scene under a Bridge'
Oil on canvas;
cm 31 × 36.8 (12⅛" × 14½")
Circa 1808-1820
Washington, Spanish Embassy

525. 'Flagellants'
Oil on canvas;
cm 51.5 × 57.5 (20¼" × 22⅝")
Circa 1812-1820
Buenos Aires, Museum of Fine Arts (6987)

526. 'Mass of Purification'
Oil on canvas;
cm 53 × 77 (20⅞" × 30⅜") c. 1812-1820
Agen, Musée des Beaux Arts (276 Ch)

527. 'Mass of Purification'
Oil on tin;
cm.32 × 42 (12⅝" × 16½") c. 1812-1820
Formerly Madrid, Torrecilla Coll.

528. 'The Communion'
Oil on canvas;
cm 34.3 × 43.3 (13½" × 17") c. 1812-1820
Williamstown (Massachusetts), Clark Art Institute (750)

529. 'The Hunchback's Wedding'
Oil on tin;
cm 29 × 41 (11½" × 16⅛") c. 1812-1820
Paris, Musée du Louvre (RF 1970.33)

530. 'Exorcism'
Oil on canvas;
cm 48 × 60 (18⅞" × 23⅜") Circa 1812-1820
Madrid, Prado Museum (747)

533

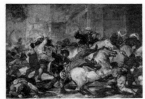

534

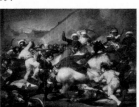

535

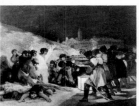

536

537

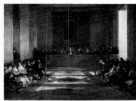

538

539

540

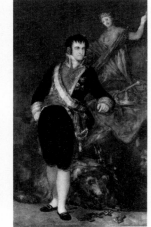

541

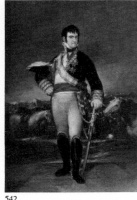

542

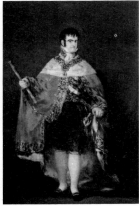

543

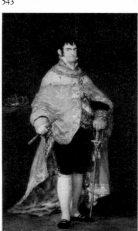

544

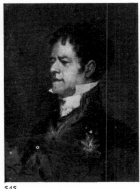

545

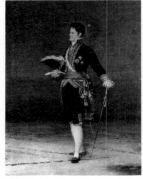

546

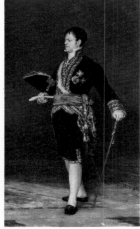

547

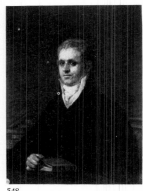

548

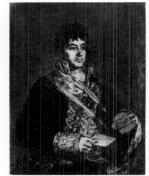

549

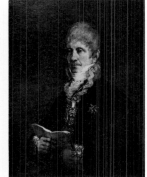

550

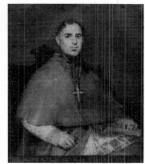

551

531. 'Manufacturing Gunpowder'
Oil on panel;
cm 33 × 52 (13″ × 20½″) Circa 1810-1814
Madrid, Royal Palace

532. 'Manufacturing Bullets'
Oil on panel;
cm 33 × 52 (13″ × 20½″) Circa 1810-1814
Madrid, Royal Palace

533. 'The Second of May 1808' (sketch)
Oil on panel;
cm 26.5 × 34 (10½″ × 13⅜″) Circa 1814
Formerly Madrid, Lázaro Coll.

534. 'The Second of May 1808' (sketch)
Oil on paper;
cm 24 × 32 (9½″ × 12⅛″) Circa 1814
Madrid, Duchess of Villahermosa Coll.

535. 'The Second of May 1808'
Oil on canvas;
cm 268 × 347 (105½″ × 136¾″) 1814
Madrid, Prado Museum (748)

536. 'The Third of May 1808'
Oil on canvas;
cm 268 × 347 (105½″ × 136¾″) 1814
Madrid, Prado Museum (749)

537. 'The Board of the Philippines Company' (sketch)
Oil on canvas;
cm 54 × 70 (21¼″ × 27½″) Circa 1815
Berlin, Staatliche Museen Preussischer Kulturbesitz (1619)

538. 'The Board of the Philippines Company'
Oil on canvas;
cm 327 × 417 (128⅞″ × 164¼″)
Circa 1815
Castres, Musée Goya (49)

539. 'Ferdinand VII'
Oil on canvas;
cm 103 × 82 (40½″ × 32⅜″) 1814
Pamplona, Diputación Foral

540. 'Ferdinand VII'
Oil on canvas;
Size unknown
Circa 1814
Formerly Madrid, Duke of Tamames Coll.

541. 'Ferdinand VII'
Oil on canvas;
cm 225.5 × 124.5 (88⅞″ × 49″) 1814
Santander, Municipal Museum

542. 'Ferdinand VII in an Encampment'
Oil on canvas;
cm 207 × 140 (81″ × 55⅛″)
Signed: 'Goya' 1814
Madrid, Prado Museum (724)

543. 'Ferdinand VII Wearing the Royal Robes'
Oil on canvas;
cm 200 × 143 (78⅞″ × 56⅜″) 1814
Madrid, Prado Museum (735)

544. 'Ferdinand VII Wearing the Royal Robes'
Oil on canvas;
cm 280 × 125 (110⅜″ × 49¼″) 1814-1815
Saragossa, Museum of Fine Arts (172)

545. 'The Duke of San Carlos' (study)
Oil on panel;
cm 59 × 43 (23¼″ × 17″) Circa 1815
Madrid, Condesa de Villagonzalo Coll.

546. 'The Duke of San Carlos' (reduced version)
Oil on canvas;
cm 77 × 60 (30⅜″ × 23⅛″)
Circa 1815
Madrid, Marquesa de Santa Cruz Coll.

547. 'The Duke of San Carlos'
Oil on canvas;
cm 280 × 125 (110⅜″ × 49¼″) 1815
Saragossa, Museum of Fine Arts (168)

548. 'José Luis Munárriz'
Oil on canvas;
cm 85 × 64 (33½″ × 25⅛″) 1815
Madrid, Real Academia de San Fernando (680)

552

553

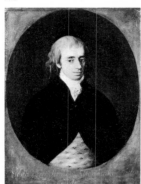

554

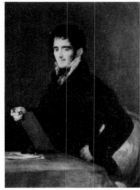

555

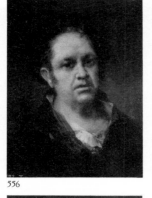

556

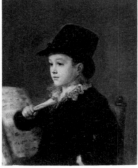

557

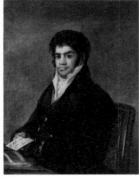

558

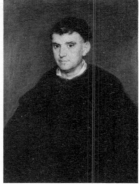

559

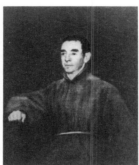

560

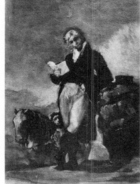

561

562

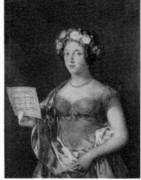

563

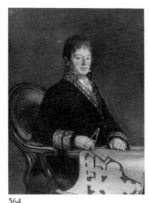

564

565

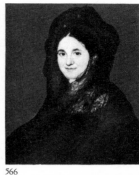

566

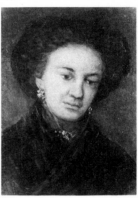

567

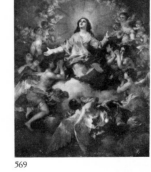

568

569

549. 'Miguel de Lardizábal'
Oil on canvas;
cm 86 × 65 (33⅞″ × 25⅜″)
Signed and dated:
'Fluctibus Reipublicae/ expulsus/Pintado pʳ. Goya. 1815'
Prague, National Gallery (01577)

550. 'Ignacio Omulryan'
Oil on canvas;
cm 83.8 × 64.8 (33″ × 25½″) 1815
Kansas City, Nelson Atkins Museum (30.22)

551. 'Miguel Fernández Flores'
Oil on canvas;
cm 100 × 84 (39⅜″ × 33⅛″) 1815
Worcester (Massachusetts), Art Museum (1911.25)

552. 'Manuel Quijano'
Oil on canvas;
cm 85 × 58.5 (33½″ × 23⅛″)
Signed and dated:
'Quixano. Compositor/de Musica. pʳ. Goya 1815'
Barcelona, Museo Cambó (34)

553. 'Judge Altamirano'
Oil on canvas;
cm 82.8 × 61.9 (32⅝″ × 24⅜″)
Signed: 'Goya a su Amigo Altamirano Oidor/de Sevilla'
Circa 1815
Montreal, Museum of Fine Arts (61)

554. 'Rafael Esteve'
Oil on canvas;
cm 99.5 × 74.5 (39⅛″ × 29⅜″)
Signed and dated: 'Dⁿ. Rafael Esteve. pʳ. Goya. a 1815'
Valencia, Museum of Fine Arts (584)

555. 'Self-Portrait'
Oil on panel;
cm 51 × 46 (20⅛″ × 18″)
Madrid, Real Academia de San Fernando (669)

556. 'Self-Portrait'
Oil on canvas;
cm 46 × 35 (18″ × 13¾″)
Signed: 'Fr. Goya/ Aragones/Por el mismo'
Circa 1815
Madrid, Prado Museum (723)

557. 'Mariano Goya'
Oil on panel;
cm 59 × 47 (23¼″ × 18½″)
Signed on back
Madrid, Duke of Albuquerque Coll.

558. 'Francisco del Mazo'
Oil on canvas;
cm 90 × 71 (35⅜″ × 28″) Circa 1815
Castres, Musée Goya (50)

559. 'Fra' Juan Fernández de Rojas'
Oil on canvas;
cm 75 × 54 (29½″ × 21¼″) Circa 1815
Madrid, Academia de la Historia

560. 'Franciscan Monk'
Oil on canvas;
cm 82 × 68 (32⅜″ × 26¾″)
Circa 1810-1815
Formerly Berlin, Kaiser Friedrich Museum (16.19B)

561. 'The 10th Duke of Osuna' (sketch)
Oil on panel;
cm 32.5 × 24.5 (12¾″ × 9⅛″) Circa 1816
Formerly Bremen, Kunsthalle (destroyed)

562. 'The 10th Duke of Osuna'
Oil on canvas;
cm 202 × 140 (79½″ × 55⅛″) 1816
Bayonne, Musée Bonnat (10)

563. 'The Duchess of Abrantes'
Oil on canvas;
cm 92 × 70 (36¼″ × 27½″)
Signed and dated: 'Dⁿᵃ. Manuela Giron y Pimentel/Duqˢᵃ. de Abrantes/pʳ. Goya 1816'
Madrid, Conde del Valle de Orizaba Coll.

564. 'Juan Antonio Cuervo'
Oil on canvas;
cm 120.2 × 87 (47⅜″ × 34¼″) 1819
Cleveland (Ohio), Museum of Art (43.90)

199

570

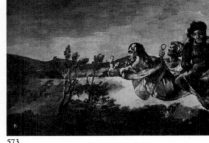

573

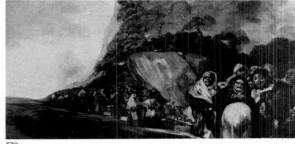

578

571

574

579

572

575

576

580

577

581

582

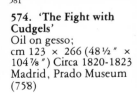

583

565. 'The Condesa de Baena'
Oil on canvas;
cm 92 × 160 (36¼" × 63")
Zumaya, Zuloaga Coll.

566. 'Woman in a Black Mantilla'
Oil on canvas;
cm 54 × 43 (21¼" × 17") Circa 1815-1824
Dublin, National Gallery (572)

567. 'Rita Luna'
Oil on canvas;
cm 43 × 35.5 (17" × 14")
Circa 1814-1818
Fort Worth (Texas), Kimbell Foundation

568. 'Portrait of an Unknown Woman'
Oil on canvas;
cm 61 × 51 (24" × 20⅛") Circa 1815-1824
United States, Private Coll.

569. 'The Assumption'
Oil on canvas;
cm 311 × 240 (122½" × 94½") Circa 1812
Chinchón (Spain), Parish Church

570. 'St. Elizabeth Assisting a Sick Woman'
Tempera on *grisaille*;
cm 169 × 129 (66½" × 50⅞") 1816-1817
Madrid, Royal Palace

571. 'St. Justa and St. Rufina' (sketch)
Oil on panel;
cm 45 × 29 (17¾" × 11½") Circa 1817
Madrid, Prado Museum (2650)

572. 'St. Justa and St. Rufina'
Oil on canvas;
cm 313 × 185 (123⅜" × 73")
Signed and dated:
'Francisco de Goya y Lucientes Cesar-/augustano y primer Pintor de camara/del Rey, Madrid, ano de 1817'
Seville, Cathedral Sacristy

573. 'Atropos' or 'The Fates'
Oil on gesso;
cm 123 × 266 (48½" × 104⅞")
Circa 1820-1823
Madrid, Prado Museum (757)

574. 'The Fight with Cudgels'
Oil on gesso;
cm 123 × 266 (48½" × 104⅞") Circa 1820-1823
Madrid, Prado Museum (758)

575. 'Two Men'
Oil on gesso;
cm 126 × 66 (49⅝" × 26") Circa 1820-1823
Madrid, Prado Museum (766)

576. 'Two Women'
Oil on gesso;
cm 125 × 66 (49¼" × 26") Circa 1820-1823
Madrid, Prado Museum (765)

577. 'Pilgrimage' (study)
Oil on canvas;
cm 33 × 57.5 (13" × 22⅝")
Circa 1820-1823
Paris, Private Coll.

578. 'Pilgrimage to the Fountain of St. Isidore'
Oil on gesso;
cm 123 × 266 (48½" × 104⅞")
Circa 1820-1823
Madrid, Prado Museum (755)

579. 'Asmodea' (study)
Oil on canvas;
cm 20 × 48.5 (7⅞" × 19⅛")
Circa 1820-1823
Basle, Kunstmuseum (G 1958.75)

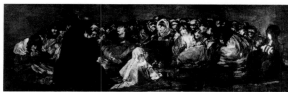

584

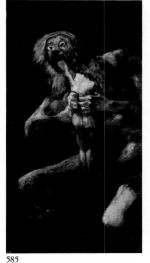

585

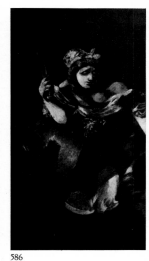

586

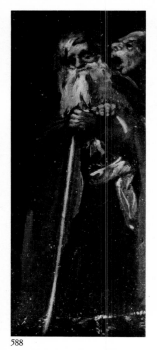

588

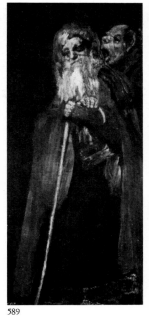

589

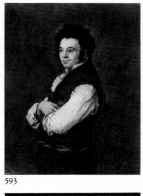

593

594

587

590

591

595

592

580. 'Asmodea'
Oil on gesso;
cm 123 × 265 (48½″ ×
104½″)
Circa 1820-1823
Madrid, Prado Museum
(756)

581. 'The Dog'
Oil on gesso;
cm 134 × 80 (52¾″ ×
31½″)
Circa 1820-1823
Madrid, Prado Museum
(767)

582. 'Leocadia Weiss'
(study)
Oil on canvas stuck to
panel;
cm 33 × 27 (13″ ×
10⅛″)
Circa 1820-1823
Madrid, Private Coll.

**583. 'La Leocadia' or 'Una
Manola'**
Oil on gesso;
cm 147 × 132 (58″ ×
52″)
Circa 1820-1823
Madrid, Prado Museum
(754)

**584. 'The Witches'
Sabbath'**
Oil on gesso;
cm 140 × 438 (55⅛″ ×
172½″)
Circa 1820-1823
Madrid, Prado Museum
(761)

**585. 'Saturn Devouring
one of his Children'**
Oil on gesso;
cm 146 × 83 (57½″ ×
32⅝″)
Circa 1820-1823
Madrid, Prado Museum
(763)

**586. 'Judith and
Holofernes'**
Oil on gesso;
cm 146 × 84 (57½″ ×
33⅛″)
Circa 1820-1823
Madrid, Prado Museum
(764)

**587. 'The Pilgrimage of
St. Isidore'**
Oil on gesso;
cm 140 × 438 (55⅛″ ×
172½″)
Circa 1820-1823
Madrid, Prado Museum
(760)

588. 'Two Old Men'
(study)
Oil on canvas;
cm 65 × 15 (25⅜″ ×
5⅞″)
Circa 1820-1823
Salamanca, Private Coll.

589. 'Two Old Men'
Oil on gesso;
cm 144 × 66 (56¾″ ×
26″)
Circa 1820-1823
Madrid, Prado Museum
(759)

**590. 'Two Old Men
Eating'** (study)
Oil on gesso;
cm 15 × 65 (5⅞″ ×
25⅜″)
Circa 1820-1823
Salamanca, Private Coll.

**591. 'Two Old Men
Eating'**
Oil on gesso;
cm 53 × 85 (20⅞″ ×
33½″)
Circa 1820-1823
Madrid, Prado Museum
(762)

**592. 'Goya and his Doctor
Arrieta'**
Oil on canvas;
cm 117 × 79 (46″ ×
31⅛″)
Signed and dated: 'Goya
agradecido, á su amigo
Arrieta: por el acierto y
esmero con qᵉ. le salvó la
vida en su aguda
y/peligrosa enfermedad,
padecida á fines del ano
1819, a los setenta y tres de
su edad. Lo pintó en 1820'
Minneapolis, Institute of
Arts (52.14)

**593. 'Tiburcio Pérez y
Cuervo'**
Oil on canvas;
cm 102.1 × 81.3 (40¼″
× 32″)
Signed and dated: 'Goya/a
Tiburcio Perez. 1820'
New York, Metropolitan
Museum (30.95.242)

594. 'Tío Paquete'
Oil on canvas;
cm 39 × 31 (15⅜″ ×
12⅛″)
Circa 1820-1823
Lugano-Castagnola,
Thyssen-Bornemisza Coll.

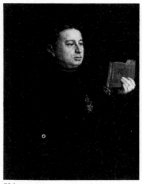

596

600

601

602

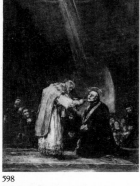

597

598

605

603

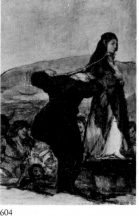

604

608

606

607

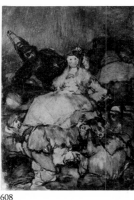

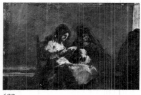

609

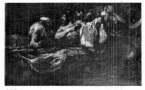

610

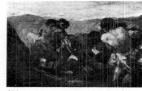

611

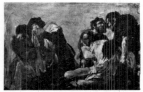

612

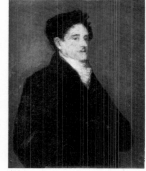

613

599

595. 'Ramón Satué'
Oil on canvas;
cm 107 × 83.5 (42⅛″ ×
32⅞″)
Amsterdam, Rijksmuseum
(988B1)

596. 'José Duaso y Latre'
Oil on canvas;
cm 74 × 59 (29⅛″ ×
23¼″)
1824
Seville, Provincial Museum
of Fine Arts

597. 'María Martínez de Puga'
Oil on canvas;
cm 80 × 58.4 (31½″ ×
23″)
Signed and dated: 'Goya
1824'
New York, Frick Collection
(A.302)

598. 'The Last Communion of St. Joseph Calasanctius' (sketch)
Oil on panel;
cm 45.5 × 33.5 (17⅞″ ×
13⅛″) Circa 1819
Bayonne, Musée Bonnat
(11)

599. 'The Last Communion of St. Joseph Calasanctius'
Oil on canvas;
cm 250 × 180 (98½″ ×
71″)
Signed and dated: 'Franco
Goya/Ano 1819'
Madrid, Escuelas Pías de
San Antón (chapel)

600. 'The Agony in the Garden'
Oil on panel;
cm 47 × 35 (18½″ ×
13¾″)
Madrid, Escuelas Pías de
San Antón

601. 'St. Peter'
Oil on canvas;
cm 72.4 × 64.2 (28½″ ×
25¼″)
Signed: 'Goya'
Circa 1820-1824
Washington, Phillips Coll.

602. 'St. Paul'
Oil on canvas;
cm 74 × 64.5 (29⅛″ ×
25⅜″) c. 1820-24
United States, Private Coll.

603. 'Group of Old People'
Oil on panel;
cm 31.1 × 21 (12¼″ ×
8¼″) Circa 1820-1824
Munich, Alte Pinakothek
(8615)

604. 'Execution of a Witch'
Oil on panel;
cm 31 × 21 (12⅛″ ×
8¼″) c. 1820-1824
Munich, Alte Pinakothek
(8616)

605. 'A Duel'
Oil on panel;
cm 31.3 × 21 (12⅜″ ×
8¼″)
Circa 1820-1824
Munich, Alte Pinakothek
(8617)

606. 'The Wounded Man'
Oil on panel;
cm 31.3 × 20.8 (12⅜″ ×
8⅛″)
Circa 1820-1824
Munich, Alte Pinakothek
(8618)

607. 'Bandits Killing Men and Women'
Oil on panel;
cm 31 × 20 (12⅛″ ×
7⅞″)
Circa 1820-1824
Rosario (Argentina), Museo
Castagnino

608. 'Carnival Scene'
Oil on panel;
cm 31 × 20.5 (12⅛″ ×
8″)
Madrid, Private Coll.

609. 'The Reading'
Oil on tin;
cm 22 × 32.5 (8⅝″ ×
12¾″)
Besan con, Musée des
Beaux Arts (896-1.342)

610. 'Joseph's Coat'
Oil on tin;
cm 22 × 32.5 (8⅝″ ×
12¾″)
Besan con, Musée des
Beaux Arts (896.1.330)

611. 'The Fight'
Oil on tin;
cm 22 × 32.5 (8⅝″ ×
12¾″)
Besan con, Musée des
Beaux Arts (896.1.331)

612. 'The Victim'
Oil on tin;
cm 22 × 32.5 (8⅝″ ×
12¾″) the preceding 4 c.
1820-1824
Besan con, Musée des
Beaux Arts (896.1.343)

613. 'Joaquín María Ferrer'
Oil on canvas;
cm 73 × 59 (28¾″ ×
23¼″)
Rome, Marquesa de la
Gándara Coll.

202

614

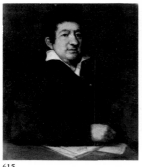

615

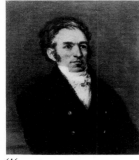

616

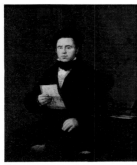

617

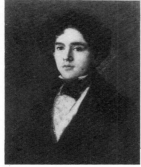

618

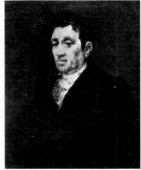

619

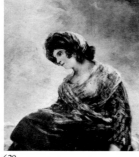

620

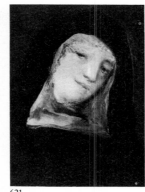

621

622

623

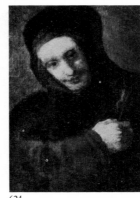

624

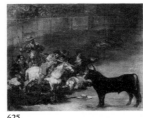

625

626

627

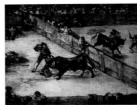

628

629

630

631

632

614. 'Manuela Alvárez Coinas de Ferrer'
Oil on canvas;
cm 73 × 60 (28¾″ × 25⅝″)
Signed and dated: 'Goya 1824'
Rome, Marquesa de la Gándara Coll.

615. 'Leandro Fernández de Moratín'
Oil on canvas;
cm 54 × 47 (21¼″ × 18½″)
Signed: 'Goya'
1824
Bilbao, Museum of Fine Arts

616. 'Jacques Galós'
Oil on canvas;
cm 55 × 46 (21⅝″ × 18″)
Signed and dated: 'Dⁿ. Santiago Galos/pintado por Goya de/edad de 80 años/en 1826'
Merion (Pennsylvania), Barnes Foundation

617. 'Juan Bautista de Muguiro'
Oil on canvas;
cm 101 × 89 (39¾″ × 35″)
Signed and dated: 'Dⁿ. Juan de Muguiro, por/su amigo Goya á los/81 años, en Burdeos/Mayo de 1827'
Madrid, Prado Museum (2898)

618. 'Mariano Goya'
Oil on canvas;
cm 52 × 41.2 (20½″ × 16¼″)
1827
Lausanne, Georges A. Embiricos Coll.

619. 'José Pío de Molina'
Oil on canvas;
cm 60 × 50 (23⅝″ × 19⅝″)
Circa 1827-1828
Winterthur, Reinhart Coll. (80)

620. 'The Dairymaid of Bordeaux'
Oil on canvas;
cm 74 × 68 (29⅛″ × 26¾″)
Signed: 'Goya'
1825-1827
Madrid, Prado Museum (2899)

621. 'A Nun'
Oil on canvas;
cm 38.7 × 24 (15¼″ × 9½″)

622. 'A Monk'
Oil on canvas;
cm 40 × 32.5 (15¾″ × 12¾″)
Signed and dated on the back: 'Por Goya 1827'
UK, Private Coll.

623. 'Old Man in Ecstasy'
Oil on canvas;
cm 56 × 43 (22″ × 17″)
Circa 1819-1827
Formerly Madrid, Marqués de la Torrecilla Coll.

624. 'A Monk with a Crucifix'
Oil on canvas;
cm 56 × 43 (22″ × 17″)
Circa 1819-1827
Formerly Madrid, Marqués de la Torrecilla Coll.

625. 'Suerte de varas'
Oil on canvas;
cm 50 × 61 (19⅝″ × 24″) 1824
Rome, Marquesa de la Gándara Coll.

626. 'Suerte de varas'
Oil on canvas;
cm 23 × 40 (9″ × 15¾″)
1824-1825
Madrid, Prado Museum (3047)

627. 'Spanish Entertainment'
Oil on canvas;
cm 44 × 57 (17⅜″ × 22⅜″) 1824-1825
Oxford, Ashmolean Museum (252)

628. 'The Divided Arena'
Oil on canvas;
cm 46 × 58 (18″ × 22⅞″) 1824-1825
Oxford, Ashmolean Museum (253)

629. 'Maja and Celestina'
Oil on ivory;
cm 5.4 × 5.4 (2⅛″ × 2⅛″) 1824-1825
London, Lord Clark Coll.

630. 'Three Drinkers'
Oil on ivory;
cm 5.5 × 5.5 (2⅛″ × 2⅛″)
1824-1825
Whereabouts unknown

633

637

640

644

647

634

638

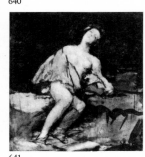

641

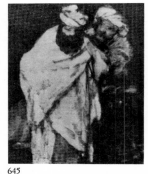

645

648

635

639

642

646

649

636

643

631. 'The Smoker'
Oil on ivory;
cm 5.5 × 5.5 (2⅛" ×
2⅛")
Whereabouts unknown

632. 'Man Searching for Fleas'
Oil on ivory;
cm 6 × 5.9 (2⅜" × 2⅜")
1824-1825
Los Angeles, Vincent Price Coll.

633. 'Madmen'
Oil on ivory;
cm 9 × 9 (3⅝" × 3⅝")
1824-1825
Whereabouts unknown

634. 'Judith and Holofernes'
Oil on ivory;
cm 8.7 × 8.5 (3½" ×
3⅜") 1824-1825
Whereabouts unknown

635. 'Susanna and the Elders'
Oil on ivory;
cm 5.5 × 5.5 (2⅛" ×
2⅛") 1824-1825
London, S. Sebba Coll.

636. 'Man Delousing his Dog'
Oil on ivory;
cm 8.8 × 8.6 (3½" ×
3⅜") 1824-1825
Dresden,
Kupferstichkabinett
(1899.40)

637. 'An Old Beggar'
Oil on ivory;
cm 5.5 × 5.5 (2⅛" ×
2⅛")
1824-1825
Whereabouts unknown

638. 'A Monk and an Old Woman'
Oil on ivory;
cm 5.5 × 5.5 (2⅛" ×
2⅛") 1824-1825
Whereabouts unknown

639. 'Man Eating'
Oil on ivory;
cm 6.2 × 5.6 (2½" ×
2¼") 1824-1825
Dresden,
Kupferstichkabinett
(1899.41)

640. 'Two Children Reading'
Oil on ivory;
cm 5 × 5 (2" × 2")
1824-1825
Providence (R.I.), Museum of the School of Design
(21.129)

641. 'Naked Woman Leaning Against a Rock ('Venus')
Oil on ivory;
cm 8.8 × 8.6 (3½" ×
3⅜") 1824-1825
Boston, Museum of Fine Arts (63.1081)

642. 'Majo and Maja'
Oil on ivory;
cm 8.8 × 8.3 (3½" ×
3¼") 1824-1825
Stockholm,
Nationalmuseet (NMB
1879)

643. 'Woman with her Dress Blown Out by the Wind'
Oil on ivory;
cm 9 × 9.5 (3⅝" × 3¾")
1824-1825
New York, R. Kirk Ashew Jr. Coll.

644. 'Woman Kneeling'
Oil on ivory;
cm 8.7 × 7.8 (3½" × 3")
1824-1825
Whereabouts unknown

645. 'Two Moors'
Oil on ivory;
cm 8.5 × 8 (3⅜" × 3⅛")
1824-1825
Whereabouts unknown

646. 'Child Frightened by a Man'
Oil on ivory;
cm 5.9 × 6 (2⅜" × 2⅜")
1824-1825
Cambridge
(Massachusetts), Private
Coll.

647. 'Woman and Child'
Oil on ivory;
cm 5.5 × 5.5 (2⅛" ×
2⅛") 1824-1825
Madrid, Private Coll.

648. 'Man's Head'
Oil on ivory;
cm 5.5 × 5.5 (2⅛" ×
2⅛") 1824-1825
Madrid, Private Coll.

649. 'Old Man and Child'
Oil on ivory;
cm 8.8 × 8.8 (3½" ×
3½") 1824-1825
Madrid, Duke of Casa Torres Coll.

The author and editor would like to thank Dr. Mercedes Agueda, assistant to the Department of Modern Art History in Madrid University, for the way in which she collaborated with the author, particularly in drawing up the catalogue of Goya's paintings.

Comparative table

Below is the comparative table of the works listed in this book (in heavy type) and the corresponding numbers from the most recent and comprehensive catalogues of Goya's works: J. Gudiol, 'Goya', Barcelona 1970, and P. Gassier — J. Wilson, Goya — His Life and Work (London 1971, Fribourg 1970). Hyphens indicate that the work's authenticity has not been accepted by the relevant cataloguer, or that it has not come to his attention, as a result of its whereabouts or existence having been unknown until recently.

	G.	G.W.		G.	G.W.		G.	G.W.		G.	G.W.		G.	G.W.		G.	G.W.		G.	G.W.
1	1	1	75	82	130	149	157	214	223	—	299	297	268	688	371	517	805	445	663	888
2	2	2	76	83	131	150	168	—	224	299	302	298	401	689	372	487	807	446	528	889
3	3	3	77	86	146	151	173	216	225	303	303	299	480	690	373	486	808	447	659	890
4	4	4	78	87	132	152	171	217	226	304	304	300	479	691	374	520	809	448	567	891
5	—	—	79	88	133	153	170	218	227	305	305	301	477	693	375	490	810	449	562	892
6	5	5	80	84	134	154	164	219	228	306	306	302	478	692	376	445	811	450	561	893
7	6	6	81	85	135	155	165	220	229	321	307	303	484	694	377	535	812	450a	—	—
8	7	7	82	—	147	156	266	221	230	322	308	304	482	696	378	533	813	451	523	894
9	8	8	83	91	136	157	172	222	231	187	309	305	483	695	379	534	814	452	662	895
10	9	9	84	90	137	158	163	223	232	137	317	306	362	708	380	530	815	453	557	896
11	17	10	85	89	138	159	213	224	233	273	318	307	363	710	381	527	816	454	556	897
12	18	11	86	95	139	160	212	225	234	274	319	308	364	709	382	493	818	455	620	901
13	19	12	87	92	140	161	211	226	235	275	320	309	365	712	383	572	819	456	625	902
14	20	13	88	94	141	162	243	227	236	276	321	310	366	711	384	491	820	457	596	903
15	21	14	89	93	142	163	249	228	237	227	322	311	179	713	385	492	821	458	589	904
16	22	15	90	49	148	164	209	229	238	278	323	312	178	714	386	563	822	459	590	905
17	23	16	91	272	149	165	261	230	239	279	324	313	180	715	387	564	823	460	593	906
18	—	17	92	60	150	166	210	231	240	344	325	314	181	716	388	488	825	461	592	907
19	—	18	93	61	151	167	250	232	241	470	929	315	380	718	389	489	824	462	586	908
20	11	19	94	50	153	168	251	233	242	347	327	316	—	719	390	494	826	463	588	909
21	12	20	95	191	154	169	166	235	243	346	328	317	—	720	391	495	827	464	587	910
22	13	21	96	199	155	170	167	234	244	345	329	318	—	721	392	496	828	465	595	911
23	14	22	97	194	156	171	245	237	245	343	330	319	381	717	393	497	829	466	591	912
24	15	23	98	205	157	172	246	236	246	96	331	320	395	723	394	498	830	467	351	914
25	—	24	99	202	158	173	248	238	247	310	333	321	396	722	395	499	831	468	352	915
26	10	25	100	207	159	174	247	239	248	318	334	322	390	724	396	519	832	469	348	916
27	36	26	101	189	159a	175	257	241	249	319	335	323	387	725	397	518	833	470	350	917
28	24	31	102	100	160	176	258	240	250	339	336	324	388	726	398	532	834	471	340	918
29	25	30	103	101	161	177	259	244	251	328	337	325	391	727	399	522	835	472	353	919
30	33	34	104	102	162	178	260	243	252	329	338	326	392	728	400	446	836	473	354	920
31	32	35	105	103	163	179	294	246	253	331	339	327	389	729	401	647	837	474	355	921
32	30	36	106	104	164	180	236	248	254	330	340	328	393	730	402	443	839	474a	—	326
33	31	37	107	106	165	181	237	249	255	341	341	329	394	731	403	—	844	475	475	922
34	29	38	108	105	166	182	234	250	256	342	342	330	382	732	404	—	845	476	476	923
35	27	39	109	107	167	183	235	251	257	337	343	331	384	733	405	506	846	477	474	924
36	26	40	110	108	168	184	238	252	258	332	344	332	383	734	406	504	847	478	472	925
37	28	41	111	109	169	185	239	253	259	335	345	333	385	735	407	505	848	479	473	926
38	40	42	112	110	170	186	240	254	260	453	346	334	397	737	408	502	849	480	471	927
39	41	43	113	111	171	187	214	256	261	409	347	335	398	736	409	503	850	481	681	928
40	42	44	114	112	172	188	215	262	262	244	348	336	460	738	410	500	851	482	608	930
41	43	45	115	113	173	189	216	257	263	336	349	337	459	739	411	501	852	483	609	931
42	44	46	116	114	174	190	217	263	264	333	350	338	461	740	412	524	853	484	607	932
43	45	47	117	—	—	191	218	258	265	334	351	339	466	742	413	508	—	485	606	933
44	46	48	118	115	175	192	219	264	266	368	352	340	539	743	414	508	854	486	605	934
45	52	57	119	116	176	193	220	259	267	367	353	341	540	744	415	510	855	487	600	936
46	53	58	120	117	178	194	221	265	268	324	354	342	541	745	416	509	817	488	604	937
47	51	50	121	118	179	195	224	260	269	371	355	343	323	746	417	538	857	489	603	938
48	54	60	122	119	177	196	225	266	270	360	659	344	418	774	418	542	858	490	601	939
49	55	61	123	128	180	197	222	261	271	356	660	345	419	775	419	437	859	491	—	940
50	56	63	124	129	181	198	223	267	272	358	661	346	422	776	420	543n	860	492	—	941
51	59	59	125	131	182	199	226	268	273	361	662	347	424	777	421	544	861	493	599	942
52	57	68	126	130	183	200	227	269	274	359	663	348	414	781	422	321	862	494	602	943
53	58	69	127	135	187	201	228	270	275	357	664	349	413	782	423	560	863	495	—	944
54	62	70	128	136	186	202	229	271	276	338	665	350	428	784	424	511	864	496	598	945
55	63	74	129	137	185	203	252	272	277	370	668	351	429	785	425	512	865	497	610	946
56	64	77	130	138	184	204	253	273	278	373	669	352	430	786	426	513	866	498	614	947
57	65	76	131	—	—	205	254	274	279	372	670	353	431	787	427	514	867	499	611	948
58	66	78	132	280	194	206	255	275	280	405	671	354	432	788	428	515	868	500	612	949
59	68	79	133	281	192	207	256	276	281	406	8672	355	434	783	429	516	869	501	613	950
60	67	80	134	182	195	208	270	277	282	377	673	356	439	789	430	584	870	502	671	951
61	69	81	135	97	199	209	292	278	283	399	674	357	440	790	431	581	871	503	668	952
62	—	143	136	134	200	210	285	279	284	376	675	358	441	791	432	555	874	504	615	953
63	70	82	137	139	201	211	288	280	285	400	676	359	442	792	433	546	876	505	669	954
64	72	83	138	140	203	212	286	281	286	375	677	360	425	793	434	547	875	506	667	955
65	71	84	139	142	204	213	287	282	287	340	678	361	447	794	435	548	878	507	667	956
66	73	85	140	144	206	214	293	290	288	374	679	362	448	795	436	549	879	507a	670	—
67	74	124	141	146	207	215	312	292	289	426	680	363	435	796	437	322	880	508	585	957
68	75	125	142	152	208	216	295	293	290	427	681	364	449	799	438	570	881	509	574	958
69	77	126	143	149	209	217	296	295	291	378	682	365	450	798	439	569	882	510	575	959
70	76	127	144	—	—	218	297	300	292	412	683	366	—	800	440	553	883	511	576	960
71	78	144	145	150	210	219	300	296	293	315	684	367	436	801	441	554	884	512	582	961
72	79	128	146	148	211	220	301	297	294	411	685	368	550	802	442	536	885	513	583	962
73	80	129	147	151	212	221	302	301	295	320	686	369	529	803	443	552	886	514	579	963
74	81	145	148	156	213	222	—	298	296	525	687	370	531	804	444	551	887	515	580	964

	G.	G.W.		G.	G.W.		G.	G.W.		G.	G.W.		G.	G.W.		G.	G.W.		G.	G.W.
516	682	965	535	623	982	554	645	1550	573	708	1615	592	697	1629	611	686	1657c	630	752	1677
517	242	255	536	624	984	555	637	1551	574	709	1616	593	698	1630	612	687	1657d	631	754	1678
518	462	966	537	665	1535	556	638	1552	575	710	1617	594	723	1631	613	735	1659	632	750	1679
519	463	967	538	666	1534	557	617	1553	576	711	1618	595	718	1632	614	736	1660	633	743	1680
520	464	968	539	629	1536	558	573	1554	577	712	1628a	596	719	1633	615	737	1661	634	741	1681
521	465	969	540	—	1537	559	640	1555	578	173	1619	597	720	1635	616	761	1662	635	746	1682
522	467	970	541	630	1538	560	537	1556	579	714	1628b	598	693	1639	617	762	1663	636	740	1683
523	468	972	542	631	1539	561	648	1558	580	715	1620	599	694	1638	618	765	1664	637	751	1684
524	—	973	543	632	1540	562	649	1557	581	716	1621	600	696	1640	619	768	1666	638	748	1685
525	677	974	544	633	1541	563	650	1560	582	—	—	601	725	1641	620	767	1667	639	753	1686
526	679	975	545	634	1543	564	691	1561	583	699	1622	602	726	1642	621	763	1668	640	749	1687
527	689	976	546	636	1544	565	692	1563	584	700	1623	603	732	1651	622	764	1669	641	739	1688
528	688	977	547	635	1542	566	722	1564	585	702	1624	604	733	1652	623	—	1670	642	738	1689
529	690	978	548	644	1545	567	656	1565	586	701	1625	605	731	1653	624	727	1671	643	742	1690
530	678	979	549	643	1546	568	721	1566	587	703	1626	606	730	1654	625	734	1672	644	744	1691
531	618	980	550	641	1547	569	559	1567	588	704	1628c	607	729	1655	626	760	1673	645	745	1692
532	619	981	551	642	1548	570	652	1568	589	705	1627	608	728	1656	627	758	1674	646	755	1693
533	—	983a	552	646	1549	571	653	1570	590	706	1628d	609	684	1657a	628	759	1675	647	—	—
534	621	983	553	403	667	572	654	1569	591	707	1627a	610	685	1657b	629	747	1676	648	—	—
																		649	—	—

Essential Bibliography

A. Beruete y Moret, 'Goya, pintor de retratos' (I), Madrid 1916 'Goya, composiciones y figuras' (II), Madrid 1917 'Goya, grabador' (III), Madrid 1918

A.F. Calver, 'Goya', London 1908

'Catálogo de las obras expuestas en el Ministerio de Instrucción Pública y Bellas Artes', Madrid 1900

E. Crispolti, "Goya y Lucientes", in the Enciclopedia Universale dell'Arte, VI, 1958

R. De Angelis, 'L'opera pittorica completa di Goya', Milan 1974

L. Delteil, 'Francisco Goya. *Le Peintre graveur illustré*', Paris 1922, New York 1969

X. Desparmet Fitz-Gerald, 'L'Oeuvre peinte de Goya', Paris 1928-50

Exhibition: 'Goya. Drawings, Etchings and Lithographs', The Arts Council, London 1954

Exhibition: 'Goya and his times', Royal Academy of Arts, London 1963-64

'Exposición de pinturas de Goya', Madrid 1928

Exhibition: 'Goya', Koninklijk Kabinet van Schilderifen, Mauritshuis, The Hague, and L'Orangerie, Paris 1970

'Exposition de l'Oeuvre gravée, de Peintures, de Tapisseries et de cent dix Dessins du Musée du Prado', Bibliothèque Nationale, Paris 1935

D. Formaggio, 'Goya', Novara 1967

P. Gassier, 'Dibujos de Goya. Los Albumes, Estudios para grabados y pinturas', Geneva 1973

P. Gassier — J. Wilson, 'Vie et oeuvre de Francisco de Goya', Fribourg 1970 (English edition, London 1971)

N. Glendinning, 'Goya and his Critics', New Haven and London 1977

M.E. Gómez Moreno, 'Un cuaderno de dibujos inéditos de Goya', A.E.A. XIV, 1941 pp. 155-63

J. Gudiol Ricart, 'Goya', Milan 1969

T. Harris, 'Goya, Engravings and Lithographs', Oxford 1964

P. Lafond, 'Nouveaux Caprices de Goya. Suite de trente-huit dessins inédits', Paris 1907

E. Lafuente Ferrari, 'Antecedentes, coincidencias e influencias del arte de Goya', Madrid 1947

P. Lecaldano, 'Goya. I disastri della guerra', Milan 1975

J. López-Rey, 'Goya's Caprichos. Beauty, Reason and Caricature', Princeton 1953

J. López-Rey, 'A cycle of Goya's drawings', London 1956

A.l. Mayer, 'Francisco de Goya', Barcelona 1925

X. de Salas, 'Sur les tableaux de Goya qui appartinrent à son fils', G.B.A. LXIII-1964, pp. 99-110

X. de Salas, 'Precisiones sobre pinturas de Goya: el Entierro de la Sardina, la serie de obras de gabinete de 1793-94 y otras notas', A.E.A. XLI-1968, pp. 1-16

X. de Salas, 'Sur deux miniatures de Goya récemment retrouvées', G.B.A. 1973, pp. 169-171

X. de Salas, 'Dos notas a dos pinturas de Goya, de tema religioso', A.E.A. XLVII-1974, pp. 383-396

X. de Salas, 'La Inmaculada del Colegio de Calatrava en Salamanca', A.E.A. L-1977

V. de Sambricio, 'Tapices de Goya', Madrid 1946

V. de Sambricio, 'Exposición Goya, IV Centenario de la Capitalidad', Madrid 1961

F.J. Sánchez Cantón, 'Los dibujos del viaje a Sanlúcar', Madrid 1928

F.J. Sánchez Cantón, 'Los Caprichos de Goya y sus dibujos preparatorios', Barcelona 1949

F.J. Sánchez Cantón, 'Vida y obras de Goya', Madrid 1951

F.J. Sánchez Cantón, 'Museo del Prado: Los dibujos de Goya', Madrid 1954

F.J. Sánchez Cantón — X. de Salas, 'Le pitture nere di Goya alla Quinta del Sordo', Milan-Barcelona 1963

E.A. Sayre, 'Goya's Bordeaux miniatures', "Boston Museum Bulletin" LXIV-1966, pp. 84-123

E.A. Sayre, 'The Changing Image: Prints by Francisco Goya'. Exhibition, Boston 1974

M.S. Soria, 'Las miniaturas y retratos-miniaturas de Goya', "Cobalto" no. 2, 1949, pp. 1-4

H.B. Wehle, 'Fifty Drawings by Francisco Goya', "The Metropolitan Museum of Art Papers" no. 7, New York 1938

Photographic References

A = above, B = below, C = centre, R = right, L = left

AME archive: pp. 42, 43, 64, 65L, 67B, 77B, 85 (Mori), 100, 101, 116, 120, 121, 123, 158B, 159B, 168L. Bevilacqua: p. 57. Chuzeville: p. 104. X. de Salas: pp. 32R, 142L. Fornari-Ziveri: pp. 30-31. Hinz: pp. 78, 111, 112-113. Kodansha: pp. 14, 45, 50, 74, 82-83, 95. Laski: pp. 72-73. Manso: pp. 10-11, 12, 13, 40, 58, 60, 81R, 81, 118, 126-127, 143R, 144-145, 156L, 161. Mas: pp. 8, 9, 15, 17L, 18R, 22, 23R, 24, 25, 26, 27L, 32L, 37, 46, 47, 56, 57L, 59, 60, 63, 70, 71, 77A, 79, 80, 81L, 86, 88, 92, 94, 96, 97, 102, 105, 106, 110, 115A, 119B, 124, 125, 136, 140, 141, 142, 147L, 156R, 158A, 159A, 162, 163A, 164, 168R. Nimatallah: pp. 100, 101, 103, 107, 117, 129, 139. Oronoz: pp. 27R, 38-39, 53, 75, 147R. Patrimonio Nacional: pp. 130-131. Prensa Espanola: pp. 28, 93, Ramos: pp. 9, 146, 152, 157. Scala: cover, pp. 6, 23L, 29, 48-49, 87, 132, 133, 150-151, 163B.

All photographs not quoted here have been kindly provided by the Museums and Collections in which the works are housed, whose names appear in the relevant captions.